THE
VENUS
FIXERS

THE
VENUS
FIXERS

The Remarkable Story of the
Allied Soldiers Who Saved Italy's Art
During World War II

ILARIA DAGNINI BREY

Farrar, Straus and Giroux
New York

Farrar, Straus and Giroux
18 West 18th Street, New York 10011

Library of Congress Cataloging-in-Publication Data
Brey, Ilaria Dagnini, 1955–
 The Venus fixers : the remarkable story of the allied soldiers who saved Italy's art during World
War II / Ilaria Dagnini Brey.— 1st American ed.
 p. cm.
 Includes bibliographical references and index.
 ISBN-13: 978-0-374-28309-4 (hardcover : alk. paper)
 ISBN-10: 0-374-28309-5 (hardcover : alk. paper)
 1. Art, Italian. 2. Art treasures in war—Italy—History—20th century. 3. Cultural property—
Protection—Italy—History—20th century. 4. Allied Forces. Supreme Headquarters. Monuments,
Fine Arts and Archives Section—Officials and employees. I. Title.

N6911.B74 2009
940.54'12—dc22 2008055446

Designed by Michelle McMillian

www.fsgbooks.com

1 3 5 7 9 10 8 6 4 2

For Carter

It was the wont of the finest spirits in all their actions, through a burning desire for glory, to spare no labour, however grievous, in order to bring their works to that perfection which might render them impressive and marvellous to the whole world; nor could the humble fortunes of many prevent their energies from attaining to the highest rank, whether in order to live in honour or to leave in the ages to come eternal fame for all their rare excellence.

—Giorgio Vasari, *Lives of the Painters, Sculptors, and Architects*

CONTENTS

ITALY

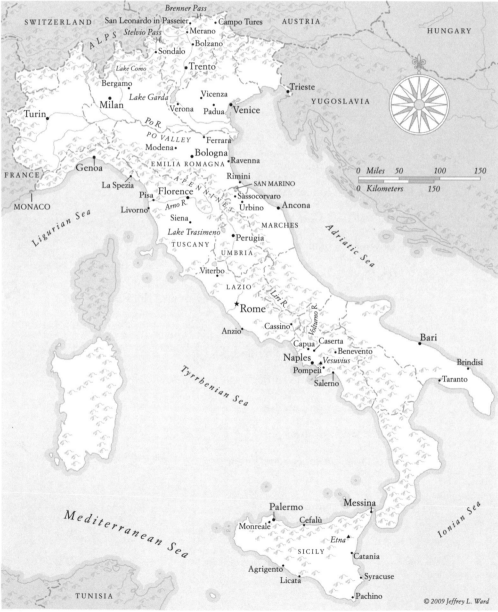

SWITZERLAND

Brenner Pass
San Leonardo in Passeier
Stelvio Pass • Merano • Campo Tures
AUSTRIA
HUNGARY
• Bolzano
• Sondalo
ALPS
Lake Como • Trento
Bergamo
Lake Garda Vicenza • Trieste
Turin Milan Verona Padua • Venice YUGOSLAVIA
Po R.
PO VALLEY • Ferrara
Modena • Bologna
Genoa EMILIA ROMAGNA • Ravenna
La Spezia APENNINES Rimini
FRANCE Pisa • Florence • SAN MARINO
MONACO Livorno *Arno R.* • Sassocorvaro
Siena Urbino • Ancona
Ligurian Sea
Lake Trasimeno MARCHES
TUSCANY • Perugia
UMBRIA
Adriatic Sea
• Viterbo
LAZIO
Liri R.
★ Rome
Anzio • Cassino
Volturno R.
Capua Caserta Bari
Naples • Benevento
Pompeii *Vesuvius* Brindisi
Salerno Taranto
Tyrrhenian Sea

Mediterranean Sea

Palermo Messina
Monreale Cefalù
Etna Ionian Sea
SICILY Catania
Agrigento Syracuse
Licata
TUNISIA Pachino

0 Miles 50 100 150
0 Kilometers 150

© 2009 Jeffrey L. Ward

TUSCANY

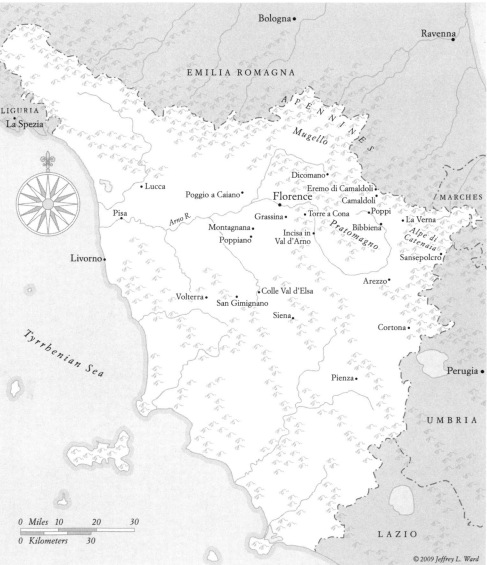

Bologna

Ravenna

EMILIA ROMAGNA

LIGURIA
La Spezia

A P E N N I N E S

Mugello

Lucca

Dicomano

Eremo di Camaldoli

Poggio a Caiano

Florence

Camaldoli

MARCHES

Pisa

Arno R.

Grassina

Torre a Cona

Poppi

Montagnana

Incisa in
Val d'Arno

Bibbiena

La Verna

Poppiano

Pratomagno

Alpe di
Catenaia

Livorno

Sansepolcro

Arezzo

Volterra

Colle Val d'Elsa

San Gimignano

Tyrrhenian Sea

Siena

Cortona

Pienza

Perugia

UMBRIA

0 Miles 10 20 30

0 Kilometers 30

LAZIO

© 2009 Jeffrey L. Ward

THE

VENUS

FIXERS

PROLOGUE

Florence looked pale and indistinct to Lt. Benjamin McCartney as he approached it aboard his Martin B-26 Marauder on the morning of March 11, 1944. It wasn't haze that blurred the city skyline on that morning; in fact, as he would later write, "the weather was perfect, the visibility unlimited." A sense of impending tragedy seemed to drain the beautiful city of its color in McCartney's eyes as it slowly came into view. He had told his crew—his pilot and friend, Capt. Leonard Ackermann, his co-pilot, Lt. Robert Cooke, and their three enlisted men—that they would soon see Santa Maria del Fiore, Our Lady of the Flower, a cathedral so massive and ambitious it took the Florentines 175 years to erect it; once built, in Giorgio Vasari's words, "it dared competition with the heavens." A few yards away stood the baptistery, Dante's "beautiful Saint John." "Tell me it's a real pretty city," the radio gunner Callahan said from the windowless interior of the bomber. It was. In fact, to Lieutenant McCartney, a twenty-eight-year-old Harvard graduate and a well-traveled man who had visited Florence five years before, the city had seemed lovelier and richer in art than any other in the world. Elusive also: "seeming to belong to time, not to us," he recalled. Since that trip, a few months before the onset of the war, he had often thought with concern of the city's fragile treasures, but found comfort in the notion that Florence's monuments would be its protection and that

the tide of war would never reach such a beautiful place. On that March morning, though, it was his job to bomb it.

"It's a compliment," the group bombardier told McCartney and his crew on leaving the briefing room that day. The target of the mission was the Campo di Marte marshaling yards, a narrow area dangerously close to the intricate web of old streets and alleys at the heart of Florence. The mission's success depended on the technique of precision bombing that had been greatly improved over the course of the war. In North Africa and later in Italy, Lieutenant McCartney and Captain Ackermann had been assigned to more and more difficult raids over harbors, bridges, and large supply depots, with smaller and smaller objectives. At that stage in the war, the American lieutenant could confidently declare that only a few groups of bombers in the world were capable of performing this difficult task.

"Sure got a lot of things we can't hit," a bombardier had said during the briefing as he looked at a map of Florence, where white squares marked historic buildings that were to be avoided. Indeed, there probably were more white squares than plain background on that map. But how could Lieutenant McCartney explain, in the few minutes preceding the mission, what it was that made those white markings so untouchable, and what surrounded them almost as precious: the lovely churches and elegant squares, the austere Renaissance palaces that hid dazzling treasures, the small medieval houses overhanging the slow-flowing Arno, the graceful arch of the Ponte Santa Trinita and the tiny goldsmith shops lining the Ponte Vecchio? As he boarded his bomber, McCartney's mind, he wrote later, was burdened by "one of the greatest responsibilities of the war, a responsibility felt, but not actually shared, by civilized people all over the world."

"How come we are bombing it? Just asking," Callahan said.

After circling above the city, the four planes came over their target and tightened their formation. The bomb bays slowly opened. At about four hundred feet wide and two thousand feet long, the Campo di Marte was a narrow strip to hit. Lieutenant McCartney patiently waited for the freight cars and the rail tracks to come under his crosshairs. He watched his bombs

fall "in languid, reluctant strings." The mission was successful. As the plane climbed to higher altitudes, the heart of Florence still huddled untouched, if alarmed, around its watchful dome, while the railway tracks were reduced to a tangle of bent steel. These, to answer Callahan's question, had connected the Italian war front, which for months had been trapped around the town of Cassino, several hundred miles to the south, to Germany through German-occupied Florence. Reluctantly, the Allied Supreme Command had come to recognize the necessity of bombing Florence, despite its artistic significance and the negative propaganda that such action would very likely provoke. As Lieutenant McCartney sorrowfully understood, despite its "loveliness and outward innocence," Florence in March 1944 was "an instrument of war."

On that same date, the northern city of Padua was also the target of an Allied bombardment. As the seat of some of the reconstituted Fascist government's ministries, the small medieval town with its old university was a far more obvious and less controversial strategic objective. Just as in Florence, the mission's goal was the destruction of the city's marshaling yards. No precision bombing was deemed necessary, though, even if close to the site stood the celebrated fourteenth-century Scrovegni Chapel, its simple exterior of red brick hiding one of the highest achievements of medieval painting, Giotto's frescoed stories from the New Testament and from the life of the Virgin Mary. The strike resulted in one of the worst artistic disasters of the Allies' Italian campaign. A couple hundred yards separated the chapel with Giotto's luminous frescoes from the Gothic Church of the Eremitani; tucked between the two, an old convent housed the Fascist military headquarters. Although the headquarters was not among the bombers' objectives that day, for months the parish priest of the Eremitani had pleaded with the Fascist authorities to vacate their seat on account of the grave danger it posed to the two monuments. On March 11, 111 B-17 Flying Fortresses unloaded three hundred tons of explosives. The bombs shook the Scrovegni walls, but Giotto's fragile work was undamaged. How-

ever, four bombs fell on the Eremitani, destroying its facade and a large part of its roof. To the right of the church's apse, the Ovetari Chapel, a rare example of early Renaissance fresco painting in northern Italy that had revealed the talent of Andrea Mantegna when first unveiled, was pulverized.

At the other end of the peninsula, in the Apulian town of Lecce, 2nd Lt. Frederick Hartt, a photo interpreter with the Allied forces in the Mediterranean, saw the aerial images of the raid on Padua only hours after the disaster. As he pored over the photos, he quickly located the site of the church and realized the enormous nature of the loss. An art historian in civilian life, the thirty-year-old Hartt could not sleep that night, but paced the streets of Lecce and cried. The story of the Ovetari's decoration, steeped in intrigue and murder, was deeply familiar to him. Mantegna, the son of a carpenter from a village near Padua, was only eighteen and the youngest of six artists when he started painting the chapel in 1448. Work had spanned a decade, and during those years the oldest among them, Giovanni d'Alemagna, had died suddenly, Antonio Vivarini had withdrawn from the project, and Nicolò Pizolo, a talented artist who was, however, "more keen on the use of arms than dedicated to the practice of painting," as Vasari remarked in his *Lives of the Painters*, was killed in a tavern brawl. The chapel's commissioner, Imperatrice Ovetari, proved as formidable a patron as befit her name, "Empress." She did not trust, at first, the young artist's competence, and called his old master, the Paduan painter and tailor Francesco Squarcione, to judge his work. Envious of his disciple's brilliance, Squarcione deemed Andrea's figures as hard as stone and "lacking the suppleness of flesh." At a later stage, the relentless Donna Imperatrice sued Mantegna for painting only eight of the twelve apostles she expected to see in the scene of the Virgin's Assumption. Still, at twenty-three, Mantegna was alone with virtually an entire chapel to fill with painted stories. Perched on the scaffolds, working away on the high walls and vaulted ceiling of the chapel, he brought the innovative language of the Tuscan Renaissance to the provincial town of Padua. While the paint was still fresh on the wall, Marquis Ludovico Gonzaga admired the young artist's work so much that

he invited him to Mantua, where Andrea would serve as his beloved court painter until his death.

Mantegna's exalted world of martyred saints and Roman warriors in glinting armor was now reduced to a pile of incinerated shards the size of stamps. A cloud of thick smoke hovered where the chapel had stood. Hartt told a friend years later that a gusting wind was probably responsible for the disaster. It had blown a cluster of bombs over the church. The image of the destroyed chapel, looking like a cardboard box crushed by a thuggish fist, haunted him, overlaying the memories of the time he had spent studying those frescoes, amid shuffling feet and the murmur of voices reciting a rosary, while the faint scent of candle wax lingered over the pews. Years before, in Mantua, he had stood for hours, rapt, craning his neck up at the enormous frescoes of Giulio Romano, the Mannerist artist who was the subject of his doctorate. "Mr. Hartt," the custodian of the Palazzo Te would say, "here are the keys. Will you put them back in my ward when you're finished, and switch the lights off, please?" For months, after joining the army in 1941, Hartt had wanted to be part of the team of men whose job it was, for the duration of the war, to fight to protect art. The destruction of the Ovetari Chapel sharpened his determination. On April 6, 1944, he wrote to Ernest De Wald, director of the Allied Subcommission for the Protection and Salvage of Artistic and Historic Monuments in War Areas, to beg for reassignment as a monuments officer:

Dear Maj. De Wald,

. . . [T]he Eremitani has been very badly hit, & the Ovetari Chapel, with all the Mantegnas, utterly wiped out. As a matter of fact, you can hardly tell there was a building there. The last of the stick of bombs missed the Arena chapel by a mere hundred yards . . . With Florence, Rome & Venice great care is being taken, but not with the other centers, and if you do not wish to see the great work of architecture & fresco painting ground off one by one, prompt action will be necessary . . . Right now I should characterize the situation as desperate.

Maj. Perkins and Maj. Newton turned up here about 10 minutes

after I located the Eremitani destruction, and before the initial shock had worn off. They were able to verify the tragedy in stereo.

I hope you will be able to fish me out of A-1.

With all best wishes

As ever,
Fred

ITALIAN ART GOES TO WAR

The Italian campaign—more, probably, than any other—abounds with drama and romance. The background, as it unfolded, evoked continual memories of Italy's great past; in the foreground in sharp strident contrast there was the momentous advance of modern armies . . . The scene called to mind Italian masters of every age and school: if the ruins of Cassino resembled the cold desolation of Dante's Nine Circles of Hell, the countryside very often recalled the canvases of Bellini.

—Gen. Harold Alexander,
commander in chief, Allied armies in Italy

Florence, whose robust towers and domes Lieutenant McCartney had so excitedly pointed out to his crew on the morning of March 11, 1944, had a ghostly wartime appearance at ground level. For nearly four years before the Allied air raid, the city's celebrated church facades had been walled in by sandbags, their windows boarded with timber. Lorenzo Ghiberti's bronze doors, praised by Michelangelo as "truly worthy of being the Gates of Paradise," had been removed from the Baptistery of Saint John, and the ancient octagonal building now stared as if from empty sockets at the cathedral in front. Statues, shrouded in plastic and cloth, had disappeared beneath bizarre-looking brick domes, and the whole city seemed like an infirm body wrapped in bandages for wounds yet to be inflicted.

These were the protective measures that Italian superintendents—the fine arts officials charged with the responsibility for galleries, monuments, libraries, and archives—had adopted all over the country when Italy entered into the world conflict on June 10, 1940. They were carried out in

compliance with the directives set out by the "War Law" issued by Mussolini's government in July 1938. The Ministry of Education, however, had only notified superintendents to implement them three days before the declaration of war. Hastily executed amid difficulties arising from the shortage of money, materials, and man power, the walls of bricks, the piles of sandbags, and the wooden scaffoldings looked flimsy and somewhat perfunctory: a rather unconvincing armor, they were a symbolic reminder that the country was indeed at war at a time when the battle raged far from Italy, in Belgium and in the skies over England. When some superintendents—Giovanni Poggi in Florence and Carlo Ceschi in Genoa, among others—expressed their concern to the Ministry of Education over the inadequacy of these defenses to withstand the full force of an aerial attack, or the pounding of artillery fire in the event of ground warfare, they were sternly rebuked. Any thought of an invasion on Italian soil was inconceivable and, if publicly expressed, dangerously unpatriotic.

Benito Mussolini, who had ruled Italy as a dictator since 1922, believed that his country's war on the side of Germany would be swift and victorious. Since the mid-1930s, the Italian dictator had been leaning toward Hitler's Germany while professing his hatred for Britain, a leading member of a bloc of nations that had imposed sanctions on Italy upon the latter's invasion of Ethiopia in 1935. In a speech in Milan in the fall of 1936, Mussolini first referred to a possible "Rome-Berlin axis." On an official visit to Hitler, in September 1937, he received an enthusiastic reception from a German crowd numbering in the hundreds of thousands; upon his return to Rome, he expressed his confidence that "the future of Europe will be fascist." In May 1939, he signed a military alliance, the "Pact of Steel," with Germany.

War was the response of a regime that seemed to have run out of ideas for the country's increasingly deteriorating economy. It was also the culmination of nearly two decades of Fascist ideology that had fostered a sense of unity and national pride by tracing Italy's lineage directly to ancient Rome's civilization and its empire. War, Mussolini insisted, was good for the Italians: it would make them tough and teach them discipline and fortitude.

Behind the rhetoric, however, the dictator was aware of the lamentable state of the Italian army, ill equipped and poorly trained. King Victor Emmanuel III, the commander in chief of Italian armed forces, strongly favored Italy's neutrality in the conflict; but his power had been eroded by Mussolini's regime, and ultimately the monarch accepted the dictator's view that victory in the war would secure the country a leading position in the Mediterranean. If Italy could not sustain an extended fight, it was key that it enter the conflict at the right time. Hot on the heels of Germany's invasion of Norway and Denmark, its attack on Belgium and Holland, and only days before its victorious entry into Paris, Mussolini declared war on Britain and France.

Contrary to the dictator's ill-founded optimism, the war was to unfold into a five-year-long tragedy for Italy. Mussolini's campaign against Greece in the fall of 1940 led to a disastrous rout, and Germany had to intervene to salvage vanquished Italian troops. Repeated defeats in North Africa at the hands of the British further showed how unprepared for battle the Italian army was. Still, against the country's vastly antiwar sentiment, in December 1941 Mussolini declared war on the United States. In the fall of 1942, Allied air strikes began targeting all major industrial cities of northern Italy— Genoa, Turin, Milan. The force of the raids was devastating. While the destructive power of incendiary bombs proved how inadequate and even dangerous the use of wood was in the shielding of monuments, the blazes that devoured church facades, gutted palaces, and liquefied frescoes illuminated the growing unreliability of a ministry whose directives were dictated by its government's blind triumphalism. The experience turned some superintendents from the Cassandras of an unheeding bureaucracy into the bold strategists of their own campaign to defend Italian art.

Having tardily realized how vulnerable Italian cities had become, in November 1942 the ministry's Directorate of Fine Arts ordered superintendents to remove all transportable artworks from urban centers and tuck them away in the countryside. In a colossal mobilization of man power during the remainder of 1942 and the better part of 1943, all important works of art—paintings and statues, but also carefully detached frescoes, stained-

glass windows, and terra-cotta friezes, whole libraries, and collections of coins, jewels, ceramics, and bronzes—were cached in the presumed safety of monasteries and the cool rooms of ancient villas, or behind the solid walls of castles and fortresses that had withstood bombardments and sieges for centuries. The superintendents' enterprise, fueled by a deep sense of pride in the national patrimony that they shared with technicians and even the humblest laborers in their employ, helped carry out an evacuation that the ministry—its coffers emptied by the war—supported but could hardly finance. Over nearly a year, more than one hundred repositories throughout the peninsula were filled with the treasures of Italian art. Paintings were crated, boxes labeled, and each piece of pottery wrapped with care. Drawing on the experience of World War I, when artworks had been stolen or misplaced during the chaos of the conflict and their retrieval after the end of the hostilities had proved a nearly impossible task, the superintendents made meticulous lists of the departing artworks. Teams of workers lifted huge altarpieces, carried heavy statuary, and hauled canvases through museum windows and down narrow staircases.

Thousands of masterpieces crisscrossed the peninsula, defying the air raids on treacherous roads and in often rudimentary transportation. In Naples, a small open van was all that the superintendent Bruno Molajoli could secure for the transport of ten huge paintings that decorated the gilded coffered ceiling of the superb Gothic Church of San Pietro a Maiella. The work of the seventeenth-century artist Mattia Preti, they depicted scenes from the life of Saint Pietro da Morrone, the church's namesake who became Pope Celestine V in 1294, only to abdicate five months later and forever be punished among the cowardly in Dante's *Inferno*. The little van swayed dangerously under the weight of the canvases, which were constantly at risk of getting caught in the trees that lined the road to the village of Liveri di Nola; during the trip, the driver frequently hopped off the vehicle and cut the offending branches before resuming the paintings' journey to safety in the Franciscan convent of Santa Maria a Parete, northeast of Mount Vesuvius. Among the more than one thousand paintings that left Venice was the magnificent cycle narrating the legend of Saint Ursula that

Vittore Carpaccio painted in the last decade of the fifteenth century. Ursula, princess of Brittany, had agreed to marry Ereo, the heir to England's throne, but asked that her fiancé be baptized and travel with her on a pilgrimage to Rome. During the trip, Ursula dreamed of her imminent martyrdom, with Ereo, at the hands of the Huns they had wished to convert to their faith in Cologne. Under the threat of bombs, the nine enormous *teleri,* "canvases," were taken from the Accademia Galleries, loaded on gondolas, and gently rowed down the Grand Canal. Leaving the pearly skies of the Veneto behind, Carpaccio's fantastic world of elegantly attired English ambassadors, princely Renaissance interiors, and cities by the sea continued its journey on trucks, along the curve of the Adriatic coast and across the hills of Romagna into the Marches and to the fortress of Sassocorvaro.

Nestled between the valleys of the rivers Foglia and Metauro, deep in the Apennines of the Marches, the Rocca of Sassocorvaro was the first of more than one hundred fortresses that the military engineer Francesco di Giorgio Martini designed for Duke Federico da Montefeltro in the mid-fifteenth century. Built in the shape of a tortoise, the symbol of fortitude, Sassocorvaro was one potent element of the massive defensive system that Federico, one of Renaissance Italy's fiercest military leaders and a major player on its political scene, erected to protect the borders of his small duchy. A war machine and a castle, Sassocorvaro was considered a marvel; when Cesare Borgia conquered the Rocca in 1502, Leonardo da Vinci, who was part of his retinue, studied and admired the fortress.

Centuries later, its solidity appealed to Pasquale Rotondi, superintendent for the small but artistically rich region of the Marches, for a different kind of defensive purpose. Well before the ministry's order, Rotondi had been searching the countryside for a suitable wartime repository for the art treasures in his constituency. Having surveyed half a dozen ancient fortifications in the area, he felt that only Sassocorvaro met his strict criteria. The fortress was not isolated, which might have encouraged theft and vandalism, but lay at the heart of a small village. It rose at a safe distance from Urbino, in case that hill town became the objective of an air raid, but was sufficiently close to it to allow the superintendent to pay frequent visits and

check on the state of the artworks. Three spacious reception rooms on the ground floor could house large-scale paintings and altarpieces, while the corridor that ran along the perimeter of the fortress could be filled with a great number of smaller artworks. The castle's thick walls, which had made it such a redoubtable bastion, gave the insidious humidity of the winter months and the warping heat of the summer little chance to creep in and damage the paintings.

A diminutive man, shrewd and tenacious beneath a humble appearance, Rotondi did not let such inconveniences as a ministry unforthcoming with funds get in the way of attending to the minutest details concerning the safety of the artworks in his guardianship. He brought the venerable fortress into the modernity of the 1940s by introducing a telephone line, fire extinguishers, and an alarm system consisting of a string of bells and a hand-operated siren that connected the castle with the local station of the carabinieri. "A small firm in Sassocorvaro has agreed to install it on credit, for I don't have a *lira*," he wrote in his diary. A team of fewer than half a dozen men helped with the transport, while four custodians were to watch day and night over the artworks. Rotondi knew them to be fiercely loyal. Still, leaving nothing to the vagaries of individual interpretation, the superintendent drew meticulous guidelines for them that even included a specific definition of "night" as the time "between sun down and eight in the morning." For the five years, three months, and eight days of their service, the foursome did an outstanding job at the fortress, with the chief custodian, Federico Pigrucci, giving the lie to an unpromising last name, Lazybones!

By far the largest structure in the village, the fortress had long forgotten its martial origins, and by and by its cavernous space had filled with the activities of peacetime. As is typical of many historic buildings in Italy, the venerable had mixed with the prosaically new: in the case of the Rocca, the metal and Formica desks of the local middle school, and the projection screen and ninety hard wooden seats of a small cinema. Students and artworks could be good neighbors, and classes followed their regular schedule, as long as the doors separating classrooms from storerooms were kept closed. Talking the mayor of Sassocorvaro into closing the cinema for the

duration of the war was a trickier proposition. The highly flammable films that were screened in the theater were a serious hazard to the safety of the paintings. But the theater was the only entertainment for the village's five thousand souls during the grim days of war, and the projector was brand-new and purchased with a huge outlay of Sassocorvaro's slim resources. However wistfully, the mayor acquiesced, for Piero della Francesca's two masterpieces, the *Flagellation* and the *Madonna of Senigallia*, were coming to stay at Sassocorvaro, together with the entire collection of artworks from the National Gallery of the Marches. It was the honor of the Sassocorvari-ans to take the best care of those treasures. Indeed, the castle's sturdiness as well as Rotondi's thoroughness was such a guarantee of protection that soon the superintendents of several northern Italian cities came asking for hospitality for their own works of art. Throughout the fall of 1940, the cas-tle received over six thousand paintings, archaeological objects, and books. By the time the treasures from the Brera museum in Milan and the Byzan-tine golden altar screen known as the *Pala d'Oro* from Saint Mark's Basilica in Venice reached the fortress, Sassocorvaro was one of the most colossal art troves ever gathered under one roof. No one, at that date, imagined that war could ever reach such a remote corner of Italy.

Charged with the care of the nation's richest artistic patrimony, Giovanni Poggi, superintendent of galleries and monuments of Florence, Arezzo, and Pistoia, orchestrated what was arguably the largest evacuation of artworks in Italy. A taciturn man in his early sixties, whose face, in his colleague Fil-ippo Rossi's description, resembled "a profile on a Renaissance medallion," Poggi possessed a field marshal's keen sense of the defensive potential of the rugged Tuscan countryside. Like Rotondi, and many other Italian col-leagues, he did not rely on his ministry's guidance. Whether or not he shared his government's confidence in a rapid and successful resolution of the conflict, he knew that the transfer of several hundred Florentine and Tuscan artworks would entail a lengthy and complex effort; should the war take a turn for the worse, he had better be prepared. As early as December 1941, Poggi began to look for repositories within a twenty-mile radius of

Florence that were removed from main thoroughfares, railroads, and other likely targets of air raids. He talked monks, priests, nuns, and aristocrats— all of them property rich—into accepting the daunting responsibility of becoming the wartime guardians of hundreds of Florentine masterpieces. By the time the order to evacuate came from the ministry, he had already located several depositories, from the wilderness of the Mugello and Casentino hills to the north and northeast of Florence, to the placid Elsa and Pesa valleys to the south. As if the Florentine artworks were the pilgrims of old days, or city dwellers in flight from the plague, they were sheltered in the monastery of Camaldoli, deep in a forest of centuries-old fir trees in the Casentino, where Lorenzo the Magnificent loved to take long summer walks with poets and philosophers. The superintendent cached more paintings in the nearby Castle of Poppi, sitting squat on a hill like a vigilant sentinel over the small village at its feet. He sought out never-heard-of places: villages whose names were barely legible on a local map, and villas built at the end of long, rough dirt roads that the notoriously violent Tuscan summer storms were likely to turn into torrents of slithery mud. Their near inaccessibility to foreigners, he trusted, would shield them from the looting and bombardments he hoped would stay in his anxious imagining.

Between the fall of 1942 and the summer of 1943, Florence was emptied of its art. The exodus was unprecedented, the effort to carry it out monumental. Thirty-seven of the one hundred art deposits in Italy contained Florentine and Tuscan works of art. Aided by Filippo Rossi, director of galleries for the city of Florence, and Ugo Procacci, an inspector with the superintendency, Poggi filled more than three thousand boxes and crates with what he called "the quiet but large and worrisome refugees from our churches, galleries, and museums." For months, the superintendency's trucks shuttled over the pitted roads between Florence and its rural surroundings.

Faced with the staggering amount of Florentine art to be moved over a relatively brief period of time, with little money and a few, if dedicated, men, Poggi proceeded methodically. No two masterpieces by the same artist were hidden in the same place. Sandro Botticelli's *Birth of Venus* was taken to the Castle of Poppi, while his *Primavera* was cached in the Castle

of Montegufoni in the Val di Pesa. Paolo Uccello's frescoes from the Green Cloister of the Church of Santa Maria Novella, which had been detached from the walls before the war for the purpose of restoration, were divided between Montegufoni and the Villa di Torre a Cona. As for the dilemma of what to remove and what to leave behind, nothing, apparently, seemed too delicate, too heavy, or too large to the superintendent to be taken to safety. Luca della Robbia's glazed terra-cottas of apostles and evangelists were delicately lowered from the walls of the Pazzi Chapel in the Church of Santa Croce; his nephew Andrea's enameled friezes of swaddled babies, glossy roundels of deep blue and dazzling white, were taken down from the facade of the Spedale degli Innocenti, the Foundling Hospital. The stained-glass windows from the cathedral, the Laurentian Library, and the churches of Santo Spirito, Santa Croce, Santa Maria Novella, and Orsanmichele were divided into five-square-foot pieces in order to be more easily transported. Ghiberti's weighty bronze doors for the baptistery were driven along the Arno valley and stored in the unused Sant'Antonio railway tunnel near the town of Incisa.

Two paintings stacked inside the fifty-seven boxes headed for the monastery of Camaldoli had been travel companions before in their long history. In 1631, Titian's *Venus of Urbino* and Piero della Francesca's *Urbino Diptych* had left the splendid court of Urbino and journeyed across the gentle hills of Montefeltro to Florence. That time, they had traveled on donkeys. As part of the dowry of Vittoria, the last descendant of the powerful della Rovere dynasty, who was marrying the Medici Grand Duke of Tuscany, Ferdinando II, the paintings told of two very different kinds of love. Titian's sensual *Venus* had so captivated Guidobaldo della Rovere, ruler of Urbino, that back in 1538 the besotted count had instructed his ambassador to Venice to borrow money if necessary to acquire the painting. The nobleman's infatuation with "that naked woman," as the ambassador had described the painted goddess, was only the beginning of the popularity of a picture that would become the most copied canvas during the Romantic era and the inspiration for Manet's *Olympia*.

By juxtaposing the profiles of Duke Federico da Montefeltro and his

wife, Battista Sforza, in his diptych, Piero, in his maturity, had painted the portrait of a marriage. Duke Federico, a man of letters and arms, his characteristic profile maimed by a wound received in a tournament, fixed his gaze on the pale face of his fair-haired and much younger wife. Raised with boys and educated in Latin, Greek, philosophy, and the natural sciences, Battista was bright and determined and her husband's equal. "Born to rule," as Bishop Campano called her in his eulogy, she capably held the duchy's government during her husband's many military campaigns. She frequently visited the duke at his camp, and her habit, such a display of independence in a woman, was much talked about in Italy. "The spouse of my good fortune," a disconsolate Federico called her on her death, from pneumonia, at twenty-six, only months after she had borne him his first male heir after eight girls.

The exodus continued well into 1943. In August of that year, the equestrian statue of Cosimo, first Grand Duke of Tuscany, the late sixteenth-century work of the Mannerist sculptor Giambologna, left the Piazza della Signoria for the villa of Poggio a Caiano on a cart drawn by four oxen. The great Medici's wartime retreat was to be on a family estate, the lovely villa that Cosimo's great-grandfather Lorenzo the Magnificent had built and always considered his favorite. There Cosimo's son Francesco I and his Venetian wife, Bianca Cappello, had met their deaths within a day of each other—poisoned, it was said, by Francesco's brother and successor, Cardinal Ferdinando de' Medici.

The statue's ten-mile trip took three days. The bronze horse's ears could not clear a bridge near the suburb of Rifredi, and the surface of the road had to be excavated at that spot. The rider and his horse were deposited in the villa's garden under the protection of a wooden shelter, the proud Medici looking oddly out of place in those pastoral surroundings, the horse lying on its side, as if resting after centuries of keeping its high-stepping pose in Florence's most famous square. Cosimo's bronze effigy was the last monument to leave Florence. As Giovanni Poggi paused to take stock of the titanic, yearlong endeavor, he looked back on "the cold and rainy months" of

the previous winter, when daily convoys had drained the city of its art, "leaving in the souls of us all, actors and spectators, a great sadness."

Recorded in the loose sheets of paper on which Poggi kept an almost daily log of his work during those days, sadness soon gave way to growing concern and anxiety. In the summer of 1943, at the very time when the evacuation of Florentine art was completed and just as Pasquale Rotondi, at Sassocorvaro, felt that the artworks were "perfectly safe" in the fortress, the war took a turn that the Italian Fascist regime had persistently called impossible only a few months before. The Allied Italian campaign, decided on by Roosevelt, Churchill, and Stalin at the Casablanca Conference of January 1943, was meant to divert German forces from the Russian front by opening a secondary one in southern Europe. The attack was to be brought against the weakest of Axis countries or, as Churchill described Italy at that junction, "Europe's soft underbelly." It began with the landings in Sicily of July 10, 1943, and the subsequent, swift capture of the island. The British Eighth Army, led by Gen. Bernard Montgomery, and the American Seventh Army, under Gen. George Patton, met with token resistance from the exhausted Italian forces, and within thirty-nine days the entire island was in Allied hands. The Allied invasion precipitated a political crisis that was ripe for explosion. While his unpopularity was skyrocketing, Mussolini still defended his strategy. "The war must continue until the last Italian is killed," he declared at the time. While publicly presenting the same overconfident, bombastic persona of his heyday, in private Mussolini was a sick and often depressed man who seemed, at times, to have lost touch with reality. Even some high-ranking party officials now doubted the dictator's capacity to continue to lead the country, and favored returning to the Crown some of the powers that Fascism had taken away from the king over the years. The Fascist Grand Council, which Mussolini had established in 1923 to replace Parliament and which had not met since 1939, was reconvened on the evening of July 24. That night the dictator received a vote of no confidence. The next morning King Victor Emmanuel III had him arrested and

charged Marshal Pietro Badoglio with forming a new, non-Fascist government. Mussolini was first taken to the island of Ponza and later jailed on the island of Maddalena, north of Sardinia; in late August, the ex-dictator was locked up in a deserted hotel on the top peak of the Gran Sasso mountain, near the town of L'Aquila in the Abruzzi region.

Exhausted by a disastrous three-year war, and finally rid of a hated dictator, the Italian population saluted Il Duce's deposition as a sign that the end of the conflict was in sight. Negotiations between the new Italian government and the Allies to reach a peace agreement, however, dragged on throughout the summer. Even at this grave hour for Italy, Victor Emmanuel, a feeble and indecisive monarch, seemed mostly concerned with saving his throne and his dynasty rather than acting in the best interest of the country. The war all but lost, he still refused to accept an unconditional surrender to the Allies. While holding talks with Allied generals, he secretly negotiated with Hitler. Judgment of the king and his conduct at the time was unanimously harsh. Noel Mason-Macfarlane, head of the Allied Control Commission in Italy, and Harold Macmillan, the British resident minister in the Mediterranean at the time, characterized Victor Emmanuel as a rather pathetic and stubborn old man. The former Italian foreign minister Carlo Sforza, who had spent seventeen years in exile during Mussolini's dictatorship, told Winston Churchill that the king "through his long complicity with fascism had brought upon Italy the most terrible disaster of her history." When an armistice was finally signed with the Allies on September 3, the captive dictator reacted with vintage wrath: the king, he fumed, was the greatest traitor in history and had invited into his country an army of "Hottentots, Sudanese, mercenary Indians, American negroes and other zoological specimens."

The armistice between the Allied nations and Italy's Badoglio government was not announced to the public until the evening of September 8, 1943. Until that date, the king had pledged his loyalty to Hitler. Within hours of the news of Italy's change of allegiance, Nazi Germany, transformed from ally into enemy, poured new armed divisions into Italy through the Alpine Brenner Pass; by mid-October, their number had risen

from seven to nineteen. The Italian army, whose mid-rank officers had been kept ignorant of their generals' negotiations, was caught unprepared by this sudden turn of events. Nazi officers disarmed Italian troops, while surrendering Italian soldiers were shot or taken as prisoners to Germany. Those who managed to escape simply returned to their homes, and the Italian army all but fell apart. Terrified by the scale and brutality of the German occupation, Marshal Badoglio and the king fled Rome on the dawn of September 9 for the town of Brindisi, in the Allied-liberated southeast of the peninsula, where they established "the King's Italy." Abandoned by the new government, Rome quickly became part of German-held territory. By mid-September, four-fifths of the country were occupied by German divisions. With the Allies only then beginning to fight their way up the peninsula from its southernmost regions, Italy was about to become the battlefield of two opposing armies. The war, far from being over, was in fact entering its worst phase.

The case of the Neapolitan art treasures that were sheltered in the ancient Abbey of Monte Cassino is the most tragic example of how Italy's state of complete disarray in September 1943 impeded the desperate efforts of superintendents to save its cultural heritage from destruction. The Ministry of Education's failure to provide clear guidance and sound intelligence led to a spectacularly ill-timed operation, with potentially catastrophic consequences for some of the artworks involved. In early September 1943, while Naples was being hard hit by Allied air raids, the superintendent of galleries Bruno Molajoli accompanied a convoy of trucks carrying, among hundreds of major artworks, the best Titians in the collections of the Capodimonte Museum and the choicest examples of ancient Roman jewelry and Pompeian bronzes from the National Archaeological Museum to the Abbey of Monte Cassino, seventy miles north of Naples. The convoy was harassed by the constant threat of bombs, but the artworks arrived safely at the abbey on the evening of September 8. Only upon his return to Naples, later that night, did Molajoli learn of the armistice between the Allied forces and Italy. Germany, Italy's ally when he had left Naples, was his country's oppo-

nent only a few days later: unwittingly, the superintendent had taken the most precious art from his city deeper into enemy territory, while Naples itself would be liberated by the Allies only three weeks later. "We were only two days shy of the armistice, and nobody in Rome bothered to tell us to put off that pointless and dangerous trip and, by doing so, save us so much anxiety over the fate of the bronzes!" Amedeo Maiuri, superintendent of archaeology in Naples, angrily wrote in his diary.

Nobody in Rome had stopped the operation because, at the date of Maiuri's frustrated remark, hardly anybody was left at the ministry who could do so. During those early days of September, while the two Neapolitan superintendents were busy salvaging their city's treasures, the king was arranging his flight to Brindisi. He appointed no one to rule in his stead in the capital. Mussolini, liberated from his captivity on the Gran Sasso by German forces on September 12, was taken to northern Italy. Within the confines of German-occupied Italy and at Hitler's insistence, on September 23, the discredited dictator agreed to resuscitate his Fascist government, which he now called the "Social Republic," with its seat in the small town of Salò on Lake Garda and its ministries scattered around various cities of the Veneto and Lombardy. With two armies battling each other, one absentee government in the Allied-controlled south of the country, and a new Fascist government in the north, it was tricky, for a state employee, to understand who ruled and where at that time.

The Fascist Ministry of Education had its new home in Padua. Virtually all of its officials, however, like most governmental personnel after the armistice, refused to follow the new minister, Carlo Alberto Biggini, and the new director of fine arts, the archaeologist Carlo Anti, to the northern city. Regardless of what their initial attitude toward the Fascist regime had been, very few fine arts officials in the fall of 1943 felt prepared to leave their families and homes in Rome while the capital was still in German hands, to go and serve an odious dictator and his puppet government in Padua. Besides, "who would take care of our works of art?" Palma Bucarelli wrote in her diary. As the director of the National Gallery of Modern Art in Rome, she had chosen to remain at her post in the city, and decided to simply ignore Min-

ister Biggini's request of an oath to the new Fascist government. If chal-
lenged to defend her decision, Bucarelli could persuasively have made the
case that her place was with the gallery's collections. This, unfortunately,
was no option for the ministry's officials—the inspector general of fine arts,
Emilio Lavagnino, and his colleagues Giulio Carlo Argan, Guglielmo De
Angelis d'Ossat, and Pietro Romanelli—who were ordered to follow the
government to the north. Upon their refusal to pledge their allegiance to
the reborn Fascist "republic," they were forced into early retirement at the
end of December 1943.

In these rapidly shifting political and military circumstances, some art
officials soon found themselves pitted against a ministry that, like an alle-
gorical creature of medieval poetry, had its head stuck in the north and its
severed body in Rome. While the war in Italy was entering its fourth and
most critical year, the burden of the superintendents' responsibility grew
heavier as a result of their increasing isolation. Amedeo Maiuri's venting
over the Monte Cassino mishap voiced the anger and dismay that many felt
toward a ministry that had withdrawn to its Fascist citadel in Padua, yet
treated as rebellious individuals those who had chosen to stay with the art
and the monuments and put their lives on the line to defend them. As petu-
lant as it was ineffective, the new Fascist ministry kept issuing orders; qui-
etly and as non-confrontationally as the circumstances permitted, some
superintendents reserved their right to disregard them, following their judg-
ment and instinct instead. Between the threat of bombs and the pounding
of artillery of the two armies, which, at the end of 1943, were battling around
Cassino, almost exactly halfway between Naples and Rome, their options to
find safety for the artworks in their care were, at best, extremely limited,
their chances of success alarmingly slim. With these increasingly adverse
odds, their response, a combination of ingeniousness, resourcefulness, and
reciprocal help, was surprisingly optimistic, given the circumstances. In
sharp contrast with the myopic and suspicious behavior of a moribund
government—"the Padua gang," as Emilio Lavagnino once sarcastically
called it—their conduct displayed gallant determination.

When, on January 8, 1944, the ministry summoned all Italian fine arts

superintendents to Padua, the absence of Pasquale Rotondi of the Marches was notable. The superintendent later blamed an incorrect date on his invitation and even in postwar days remained somewhat elusive over the Padua incident. His actions at the time, however, speak for themselves. While Minister Biggini was instructing all superintendents to keep their artworks in their countryside repositories, Rotondi had just successfully completed the evacuation of hundreds of masterpieces from Sassocorvaro to the Vatican, and was preparing a second transfer to the Holy See in a matter of days. While the ministry's response to an increasingly threatening military situation was inaction, Rotondi was on the move. Behind the paper-thin excuse of a clerical error, there were plenty of serious reasons to justify his tacit insubordination.

News of German troops approaching Sassocorvaro had first reached Rotondi in early October 1943. German SS officers intended to establish their command in the palace of the princes of Carpegna in a nearby village of the same name, where the superintendent had created a second deposit of slightly less important artworks. At the palace, his custodians informed him, a group of soldiers had already broken open a crate containing the composer Rossini's manuscripts from the Pesaro Conservatory but, having deemed them "worthless scraps of paper," had left them alone. More worrisome, in the fall of 1943 German army engineers were hard at work building the Gothic Line. The massive, 150-mile-long system of trenches, bunkers, observation posts, and weapon pits crossed Italy along its width and was to represent Germany's last bastion of defense during the winter of 1944–1945. Making the best use of the peaks, caves, and valleys of the northernmost range of the Apennines, the Gothic Line stretched from the western city of La Spezia on the Tyrrhenian coast to Pesaro and Rimini on the Adriatic. Its fortifications, to the east, rose right above the river Foglia, a few miles to the north of Sassocorvaro. The illusion that the backwater village would never be reached by the war was short-lived. Rotondi could not leave hundreds of art treasures in an area that the Germans intended to defend strenuously. He immediately drove to Sassocorvaro and filled his car with what he called "unrenounceable" masterpieces, as many as he possibly could

stuff in the trunk; he wrapped some more in blankets and laid them on the backseat. He hoped that in case of a German inspection, in the dark of night they might pass for his children, asleep after a long day of playing in the country. His plan was to drive the paintings back to Urbino and temporarily hide them in the basement of the Ducal Palace. Upon reaching the town gate, however, he was met by his wife, the art historian Zea Bernardini, who had rushed to alert him that SS squads were in town. Husband and wife then drove their charge—an art lover's dream, or an art thief's impossibly spectacular loot, including four of Giovanni Bellini's exquisite Madonnas, Giorgione's *Tempest*, and Mantegna's *St. George*—to the house they had been renting outside Urbino. That night, too excited to sleep, in the silence of the autumnal countryside, they sat by the paintings and kept vigil.

At around this time, Marino Lazzari, Carlo Anti's predecessor as director of fine arts at the ministry, had first broached the idea of seeking the hospitality of the state of the Vatican City for major Italian artworks. In the fall of 1943, with cities incessantly struck by Allied and German bombardments and the ground war making its slow progress northward, the neutral state seemed the safest place on the peninsula and perhaps the only chance of survival for hundreds of masterpieces. Despite being arrested and temporarily detained in Padua for his refusal to swear allegiance to the new Fascist government, Lazzari was able to reach an agreement with the Holy See. "The Vatican will welcome all artworks that you will deem necessary to store in the rooms of its picture galleries," Pope Pius XII wrote. In a letter dated December 18, 1943, only days before his forced retirement, Lazzari informed Rotondi that everything was ready for the trip to Rome: the superintendent should consign the artworks to Emilio Lavagnino, who would escort them to the Vatican.

Emilio "Mimmi" Lavagnino had been a friend of Rotondi's since their college days in Rome. A slight man with a fiercely open mind, he was a specialist on medieval art and had been the ministry's inspector general of fine arts before his own forced retirement. Like Rotondi, he had early recognized the threat posed to Italian art by the advancing ground war and

hadn't waited for ministerial enlightenment to take action. That fall he had got behind the wheel of his tiny Fiat Topolino, or "Little Mouse," fitted with tires borrowed from his friend Palma Bucarelli—"my poor car, after four years of inactivity, I hope it doesn't burst at the seams," he wrote in his diary—and collected artworks from the region of Lazio to take them behind the walls of the Vatican. All roads led to Rome for Mimmi Lavagnino. "I shall stop at every village along the Via Aurelia," he wrote as, like an indefatigable Roman centurion, he crisscrossed that network of ancient roads, "and the Via Cassia, the Tiberina, the Flaminia, the Salaria, the Tiburtina, and, if possible, the Casilina." His was a rush against time and, occasionally, a fight against the resistance of village priests and local authorities who did not want to hand over their treasures. "It is absolutely hard to believe that the population of the small towns will not be persuaded that the war will inevitably sweep through Lazio and Umbria and Tuscany and everywhere," he wrote. "Our fate is to be crushed by this war," he added despairingly.

On December 22, 1943, and again on January 13, 1944, Lavagnino led a small convoy of trucks to Sassocorvaro and Urbino. Arrangements for the small expedition had met with considerable difficulties, as vehicles and gasoline were becoming scarce in Rome and few moving companies were willing to brave the risks of an out-of-town trip. The mission also required the presence of a German officer, in the person of the historian and SS lieutenant Peter Scheibert, who had provided the necessary permits and passes for travel on German-controlled territory. Once the trucks reached Urbino, Rotondi, who was suspicious of German officers after the vandalism at the deposit in Carpegna, insisted that Scheibert not take any part in the loading operations. Nor did he let the SS lieutenant sign the artworks' release papers. "On this," he wrote, "I am quite adamant." Well mannered and soft-spoken, Rotondi had a quiet authoritativeness and a take-no-prisoners attitude underneath his gentleness that may have persuaded the much younger Scheibert to take a walk around the grounds and admire the mighty structure of that Renaissance military gem, while he and Lavagnino took care of the business at hand. Between the loading and stacking of crates on

the trucks, Lavagnino took the time to observe the German officer: "Lieutenant Scheibert wears a very light raincoat (unlike us, who are all wrapped in great coats) which excessively models his figure. When he walks, he is all aflutter and thrusts his chest forward: he's obviously keen to appear energetic." When everything was ready for the drive back to the capital, Rotondi handed Lavagnino a package for his colleague Giulio Carlo Argan, who was soon to join the ranks of the ministry's prematurely retired art officials: wrapped in brown paper was a gift of flour, *salame*, and homemade tagliatelle from the village of Sant'Agata Feltria for a soon-jobless friend facing the new year in an increasingly hungry city.

Only after all the artworks were safely ensconced in the Vatican did Rotondi make the trip to Padua. He turned up punctually at the ministry on February 8, 1944, the date he insisted had been printed on the telegram inviting him to the superintendents' meeting. Clad in his Fascist uniform, Minister Biggini frowningly examined the offending telegram that Rotondi produced as proof of his version of the story. Compared with that of the minister, the attitude of Professor Anti, the director of fine arts, seemed "more sympathetic" to the superintendent, although perplexingly out of touch with the reality of his and many of his colleagues' plight. Anti, who, for fear of air raids, visited his office only in the evening, expressed his appreciation of Rotondi's work and dedication. However, he encouraged him to intensify his protective measures by scattering more artworks in village churches around the Marches countryside. "Does he truly not realize how dangerous this course of action would be at this point?" Rotondi wondered in his diary. It is not surprising that Lavagnino, who had a shorter fuse and, for the last several months, had been doing the exact opposite of Anti's recommendation, would describe the ministry's orders of those days as "idiotic."

Rotondi probably did not question the minister's sincerity or Anti's commitment to the protection of the country's artistic heritage. Carlo Anti was one of Italy's most respected archaeologists; as the dean of the venerable University of Padua, he had invited the classicist Concetto Marchesi, a well-known anti-Fascist, to be on the faculty during Mussolini's regime.

Carlo Alberto Biggini, a jurist, had been the dean of the prestigious University of Pisa before his appointment with the Fascist Republic of Salò. But they were both Fascist, and their unstinting loyalty, this late in the game, was synonymous in Rotondi's mind with complete subservience to whatever orders might come from Nazi Germany. When asked to write up a list of the masterpieces he had entrusted to the Vatican, Rotondi bought himself time and claimed that he could not draw up an inventory from memory and risk omissions and inaccuracies. He would send a complete one, he promised, once back in Urbino. When, later that night, he left Padua, it was with a deep sense of relief and the firm intention never to submit such a list to the minister.

The Ministry of Education's subsequent order reversed its January directive and confirmed Rotondi's misgivings. On June 15, 1944, Minister Biggini instructed superintendents to transfer all movable artworks into Nazi-occupied northern Italy. The ministry's fear that Italian works of art might fall into the hands of the Allied armies who were advancing on Italian territory, and by then had reached southern Tuscany, motivated its decision. This was seemingly reached without any consideration for the lack of money, fuel, or vehicles that would have made this counter-exodus possible. Nor, apparently, did the ministry and the Directorate of Fine Arts dwell on the problem of the blown-up bridges and mine-infested roads that the German army was leaving behind in its slow but methodical retreat. Last, Nazi Germany, the Fascist government's ally, was the rest of Italy's enemy. At that stage in the war, many superintendents were increasingly wary of the kind of protection that Hitler was ready to offer.

An alarming rumor that had been circulating in Italy for some months had contributed to a deepening dread of "German protection" among Italian superintendents. It concerned the Neapolitan artworks cached at Monte Cassino, those same treasures that had been perilously transported to the abbey just before the armistice of September 8, 1943. In response to the Allies' landings on the Italian mainland, the Göring Division had taken it upon itself to remove the artworks and drive them back to Rome, where

they were to be stored in the Vatican. The German division had not involved, or even informed, the Italian fine arts authorities of its mission, which was completed in early November. Also unknown to the Italians was that for a month after their departure from Cassino, the artworks were kept in a German supply depot in the Umbrian town of Spoleto. An indignant and rather powerless Marino Lazzari, still the director of fine arts at the time, wrote to the secretary of the Fascist Party, Alessandro Pavolini: "It is imperative that this paradoxical situation be resolved. I do not doubt that the Germans have no other intention than to take our treasures to safety. A collection of very precious art, however, is at this very moment traveling around Italy, and we don't even know where it is."

The Göring Division returned the Neapolitan artworks to Rome on December 8, 1943. They were greeted by an official ceremony, a crowd mostly composed of German officers, many speeches, and much attention in the German-controlled press; a celebratory dinner at the Excelsior Hotel followed, which most Italian officials, despite their chronically empty stomachs, declined to attend. As it soon transpired, not all that was loaded on the German trucks at Monte Cassino made it back to Rome. In the vast courtyard of the massive Renaissance Palazzo Venezia—of the infamous balcony, from which Mussolini had addressed Italian crowds for two decades—Lavagnino began checking the contents of the boxes before they were driven to the Vatican. While ironically remarking that he had never been busier than since his "retirement," he wrote, "It is hard work, standing on my feet for hours among boxes, nails, and hammers, but at long last I get to see some beautiful paintings, and that is so good for my spirit." While inspecting the crates in those bleak days of January, he noticed unmistakable traces of tampering and suspected that some of them at least might have been opened and later resealed. He also heard from a colleague the disturbing news that two of the trucks that had left Spoleto had allegedly been delayed along the road and had never reached Rome. Lavagnino expressed his apprehension over the missing trucks to Lieutenant Scheibert, the SS officer who had traveled with him to Sassocorvaro, who dismissed the report as false. Lavagnino intended to look into the matter more care-

fully the following day. Instead, on January 22, a breathless Scheibert stormed into his room to announce that the Allies had landed at Anzio, a mere thirty miles south of Rome, and could be in the capital in a matter of days. There wasn't a moment to lose, everything had to be taken to the Vatican immediately.

Since Scheibert couldn't possibly know at that stage that it would take the Allies not days but nearly six months to close that thirty-mile distance from Rome, he may have acted out of the panic that seized many Germans in the capital in the days following the Allies' amphibious Operation Shingle at Anzio. Or he may have used the confusion caused by the landings as an excuse to cover up what indeed was theft on a grand scale. The artworks concealed in the missing boxes had been appropriated as a surprise fiftieth birthday present to Hermann Göring from some of the officers of the division that bore his name. A tribute to a collector who regarded himself as a connoisseur, they had presumably been selected by Göring's art adviser, Walter Andreas Hofer, who had been dispatched to Spoleto for the purpose. They were the best art that Naples could offer: exquisite bronzes from Pompeian houses, fine Roman jewelry, and several spectacular paintings. Among them was Titian's voluptuous *Danae*: "a naked woman that would put the devil into a prelate's body" is how the apostolic nuncio Giovanni Della Casa had described her to Cardinal Alessandro Farnese upon first viewing the canvas in the master's workshop in Venice in 1544. "Compared to this one, the Venus that Your Most Reverend Lordship saw in the Duke of Urbino's chambers looks like a nun," the nuncio had argued in his missive to Cardinal Alessandro, who bought the painting and would hang it in his bedroom.

"I have to give up my inspection of the boxes, which we hurriedly close up and send to the Vatican," Lavagnino recorded in his diary on January 22. The extent and the seriousness of the looting would become officially known only after the Allies' liberation of Rome on June 4, 1944. Of the 187 crates that had left Monte Cassino, only 172 were brought back to Rome: 15 boxes had taken the road up north, to an unspecified location within German-occupied territory, and their exact whereabouts would re-

main unknown to both Italian and Allied officials until the end of the war in Europe, in May 1945. Because of the secretiveness, however, with which the Göring Division had conducted its operation at Monte Cassino, the Italian fine arts world had been rife with suspicion since the beginning of 1944. Interviewed by a reporter for *The New York Times*, Amedeo Maiuri, superintendent of archaeology in Naples, denounced the suspected disappearance of the Pompeian bronzes as "wartime rapine."

Against this background of mounting concern for the fate of art, Giovanni Poggi occupied a unique position. When the Ministry of Education issued its June order to transport all movable art "to the north," he received it with alarm. He knew how unequal his resources were to the task. In two round-trips to the Vatican, Lavagnino had transported most of the artworks from the Marches and the Milanese and Venetian masterpieces from Sassocorvaro to the Holy See, whereas it had taken Poggi the better part of a year to empty Florence of its art. He had moved massive statuary, such as Michelangelo's sculptures for the Medici tombs in the sacristy of the Church of San Lorenzo, very large but delicate objects like the fifteenth-century mullioned and rose windows from the Cathedral of Santa Maria del Fiore, and hundreds of precious paintings. In June 1944, he did not have the trucks or the gas to drive all that art back into town. And time was running out, with the war front already within Tuscany's borders. The combination of the number and importance of the artworks in his care and the unfolding of the Italian campaign, which reached its fiercest climax in that very region in the summer of 1944, turned Poggi's responsibilities into an ordeal unlike that of any other superintendent, and the fate of Florence and its endangered artworks into the most dramatic story in the fight to protect Italian art during World War II.

When he first transferred all movable Florentine art out of the city, Poggi had insisted on keeping it within reach. At the time, he could not predict that the war would turn an easy distance into a nearly impassable gulf, and all but isolate Florence from the surrounding countryside. In early 1944, he refused Giulio Carlo Argan's invitation to store his artworks in the

Vatican, out of concern over hazardous conditions of travel. The severe air strike that on January 14, 1944, caught Ugo Procacci as he was driving through the high valley of the river Tiber, on the cusp between Umbria and Tuscany, was the alarming proof that roads had by then become too dangerous to move artworks anywhere. That January day, Procacci, a thirty-nine-year-old inspector with the Florence superintendency, was bringing one of Piero della Francesca's early masterpieces, the *Misericordia Polyptych*, from the village of Sansepolcro, the Renaissance master's birthplace, to Florence. A cargo of some very local saints filled the back of his truck. On some of the twenty-three wooden panels that composed the polyptych, Piero's brush had indelibly rendered the images of Saint Francis of Assisi, Saint Benedict of Norcia, and Saint Bernardino of Siena: all of them saints who, centuries earlier, had lived, preached, prayed, and performed their miracles in that awe-inspiring region of precipitous gorges and solitary peaks. A huge Madonna, the centerpiece of the polyptych, rose above all, spreading her cloak around a kneeling circle of worshippers in a potent image of blessing and protection. As Procacci and the restorer Edo Masini were driving their ancient passengers down the narrow road winding high above the river, they heard the rumble of approaching planes. They jumped out of the truck but could not find it in themselves to leave the artworks and ran back to their vehicle. The raid was devastating and long: the two men lay in the grass and waited it out, while some of the bombs fell as close as thirty yards from the van. When it was finally over, paintings and men had all escaped unharmed. Many years later, Procacci recounted the incident to a student. "What was I to do?" he recalled thinking at the frightful moment. "I could not leave the paintings like that. I said to myself, 'I am going to die. Too bad.'"

The incident confirmed Poggi in his conviction that a plan to transport his city's masterpieces to the Vatican was, at that date, unthinkable. Nonetheless, Giulio Carlo Argan thought him obstinate and reckless in his insistence on keeping everything in the deposits. Both men's judgments were flawed in the absence of a trustworthy higher authority to help them navigate those volatile and dangerous times. Certainly Argan's belief in the Vatican's unassailability would have been less unshakable if he, and Ro-

tondi and Lavagnino, had known of an order that Hitler had issued in the immediate aftermath of Italy's armistice with the Allies. On September 12, 1943, the Führer instructed the SS general Karl Wolff to prepare "to occupy Vatican City as soon as possible, secure its files and art treasures, and take the Pope and the Curia to the North." The alleged motivation of the order was to save Pope Pius XII from falling into Allied hands by spiriting him off to Germany or neutral Liechtenstein. The order was never carried out, and Rome was spared by both armies. Florence, despite Poggi's and a few other officials' tireless efforts, was not.

During the January meeting in Padua, Tuscan superintendents had not only been ordered to keep their artworks within Tuscany but also been encouraged to transfer as many of them as possible into Florence, for the town, the ministry had declared, was to be considered an "open city." Once officially recognized by all belligerent nations, this status bound the opposing armies to spare cities of particular cultural, artistic, or spiritual significance in a theater of war. In Florence's instance, German occupying troops would agree not to defend it and the Allied armies not to attack it. The announcement was comforting, if slightly puzzling, news for Poggi. Since the early days of the war, the city's archbishop, Cardinal Elia Dalla Costa, and the German consul to Florence, Gerhard Wolf, had been his sole allies in championing the cause. The Swiss consul, Florence-born Carlo Steinhauslin, had also played a part by encouraging his government to exercise pressure on the countries at war to spare the lovely city. A Romanian former foreign minister, Nicolae Petrescu-Comnène, would write a letter to Hitler, in March 1944, extolling the city's beauties and invoking his protection. But Poggi had never been aware of any ministerial involvement in the negotiations.

Months earlier, on November 10, 1943, the German ambassador to Italy, Rudolf Rahn, had visited Hitler at his headquarters at Wolfschanze, in East Prussia, to obtain some commitment from the Führer to protect the city from the passage of war. "*Ja, die Stadt ist schön,*" the Führer had pensively murmured during their conversation. Hitler had visited Florence twice, in May 1938 and again on October 28, 1940. The city, although al-

ready shrouded in its wartime protections and through the heavy rain that had fallen incessantly during the Führer's second visit, had made an impression on the dictator with thwarted artistic inclinations. At the conclusion of his meeting with Rahn, Hitler had given the ambassador his *unofficial* permission to consider Florence an "open city." Conversely, Mussolini, whose lack of interest in art was notorious, told Rahn that "if Florence were to be declared an open city, then every Italian city would claim the same status!" Between a ministry that articulated in an order what, to the best of Poggi's knowledge, Hitler had only expressed in an informal conversation and the Italian dictator who openly contradicted his own ministry, the superintendent had plenty of reasons for perplexity. Still, Poggi complied with its order to keep everything where it was, despite pressure from colleagues to consign everything to the Vatican.

The superintendent's relationship with German authorities went back to an earlier time in the war when not every German in Italy was a Nazi. He had an ally in Gerhard Wolf, the German consul to Florence, whose love of the city and respect for its people were well-known. He regarded Ludwig Heydenreich, head of the Florence office of the Kunstschutz, the German bureau for the protection of European art in wartime, a "tried-and-true friend." Heydenreich, an art historian, had assisted Poggi in the artworks' evacuation during the winter of 1942–1943 by providing German trucks and personnel. The superintendent had no reason to doubt the German scholar's agenda, or suspect that an art historian of integrity would not act in the best interest of Tuscan art.

In January 1944, Poggi was still confident that Florence would eventually be recognized as an open city, relinquished by the Germans without a fight, and bypassed by the Allies in their northward push. The German occupation, in its initial months, was not particularly hostile. The population, while keeping a cold distance from the ally turned enemy, was able to maintain a normal existence, the only instances of violence having occurred in isolated clashes between Italian Fascists and anti-Fascists. As the winter months of 1944 wore on, though, things in Florence started deteriorating

quickly. Despite reassurances to the contrary, the German military presence in the city, far from diminishing, became more oppressive. A belated reply to Ambassador Petrescu-Comnène, dated May 12, 1944, and signed by Hitler's chief of staff, Alfred Jodl, promised "the evacuation of all unnecessary military offices from Florence." Instead, artillery batteries and mortars were installed in two city gardens and in the San Marco and San Firenze squares, and were never removed. When, later that spring, Poggi decided to bring artworks back to Florence from the northern hills of Mugello, now dangerously close to the fortifications of the Gothic Line, he realized that German help would not be forthcoming. Pressed by the Allied advance, the German forces stationed in the city were no longer lending but requisitioning vehicles, any kind, from private cars and buses to ambulances, hearses, and fire trucks, in preparation for their own imminent retreat. In late April, Poggi managed to transport the baptistery's bronze doors back into Florence from the Incisa railway tunnel, which Gen. Albert Kesselring wanted to put back into use for military operations. It was to be his last transfer of artworks conducted with Heydenreich's assistance. By then, Heydenreich had been joined at the Kunstschutz by Alexander Langsdorff, an art historian as well as an SS colonel. When Heydenreich himself was recalled to the northern city of Verona in July 1944, Langsdorff alone remained in Florence. Consul Wolf, who was also summoned back to Germany at that time, warned his Florentine friends of the cruelty of the SS and the ruthlessness of the airborne divisions who were pouring in from Germany to replace them. Col. Adolf Fuchs, Florence's new *Platz Kommandant*, was, in Wolf's opinion, an uneducated man, "unapproachable except on strictly military matters."

In the light of these experiences, by June 1944 Poggi's notion of German help was tinged with suspicion. So, when, on June 15, 1944, the Fascist Ministry of Education ordered superintendents to take all movable art to northern Italy, whence it might eventually be taken to Germany "for protection," Poggi felt compelled to disobey that order. Having refused the Vatican's hospitality, he now declined a German invitation to safety: for the

second time in six months, the superintendent decided that Tuscan art would not be moved. This time, however, his decision ran counter to the ministry's instruction, and there were consequences to be faced.

On a visit to Florence in early July 1944, Alessandro Pavolini, the secretary of Mussolini's reconstituted Fascist Party and a former minister of cultural affairs, confronted Poggi on his determination not to place Tuscan treasures under the wing of the Fascist government in northern Italy. As Mussolini's second-in-command, Pavolini was a dangerous man coming to enforce a potentially ruinous order. His presence in Florence at that time, however, had an unofficial and more sinister reason: the man who would be executed with the dictator by partisans at Dongo a scant year later was in town to organize bands of snipers who, for weeks after the city's liberation by Allied forces, would terrorize the population and assassinate hundreds of civilians from their hideouts on rooftops and in attics.

Poggi's meeting with the secretary was predictably tense. In the midst of it, though, the superintendent had an epiphany of sorts that presently freed him from his predicament. "I was suddenly reminded of the 'Family Pact,'" he wrote in his June 1945 report. "Il Patto di Famiglia, of course!" Pavolini instantly replied, although it is debatable whether he knew what that meant. But the Fascist secretary was evidently relieved, at a time when the outcome of the Italian campaign was looking gloomier by the day for Axis forces, to be offered a means, and one with such a historic ring, to save face while unburdening Il Duce's government of the responsibility of saving Florentine art.

The little-known treaty of some three centuries before that so fortuitously floated to the surface of Poggi's mind can't in fact have been far from his thoughts in those difficult days. Anna Maria Luisa, the Medici's last descendant, was the childless heiress to the fabulous collections of paintings, drawings, statues, libraries, furniture, silver, and jewels that the family had amassed over the centuries. The favorite child of Grand Duke Cosimo III, the talented and music-loving Anna Maria Luisa had married the palatine elector of the Rhine, Johann Wilhelm of Saxony, and returned to her beloved Florence only upon her husband's death, after nearly three decades

of absence. On the death of her brother, the debauched and bedridden Gian Gastone, in 1737, Anna Maria Luisa became the last scion of the family that had ruled Florence for three centuries. With her successors, the Grand Dukes of Lorraine, she concluded the Family Pact that specified that the Medici collections "could not be taken away from the city of Florence, nor out of the borders of the old Medici Duchy, so that the Florentines would never be deprived of their enjoyment."

Once explained, the pact's powerful legacy was not lost on Alessandro Pavolini, who, himself a Florentine, ultimately bowed to the last Medici's wish. The artworks, he declared, would remain in Tuscany, placed under the spiritual protection of the Holy See. As for Giovanni Poggi, defending that birthright of the Florentines in the summer of 1944 was turning from an ordeal into a gamble. He had barely sidestepped the danger of a "trip to the North," and the ominous ramifications that the phrase implied at the time. Temporary storage of the artworks in Padua or Verona—lovely cities that the circumstances of the war had turned into the seats of the last Fascist redoubt—would likely lead to a transfer across the border into Austria. Germany, their final destination, would irretrievably link Italian art to the Reich's ultimate fate as spoils or fatalities of war. But as the superintendent turned his glance south, he could see the mighty force of the Allied armies already advancing within Tuscan borders. Whether or not Poggi bought into the racist hysteria of Fascist propaganda that for almost a year had denounced the Allies as barbarian pilferers and destroyers, they were indeed an unknown quantity: a composite body, the likes of which had never been seen, of Americans, British, French, Poles, Brazilians, Canadians, New Zealanders, South Africans, Australians, Indians, Moroccans, Tunisians, and Algerians.

In late July, the Allies were twenty miles away from Florence. "That is when our tragic days began, and all communications with our deposits were cut off," Cesare Fasola, the Uffizi librarian, later recalled. The castles of Montegufoni and Poppiano and the villa of Montagnana were now on the front line. With help from the art historian and poet Carlo Ludovico Ragghianti, who headed the Tuscan cell of anti-Fascist combatants, Poggi

smuggled a signal across enemy lines to the Allies indicating the artworks' whereabouts. Whether he thought of them as friend or foe, he knew that the fate of hundreds of Tuscan treasures depended on their conduct. As for his own loyalty, that staunchly remained with the artworks. As he wrote during those terrible days, "I managed to deal with the Germans, I'll find a way to work with the Allies."

"MEN MUST MANOEUVRE"

If the winners will respect the gods and the temples of the conquered land, their victory will not turn into defeat.

—Aeschylus, *Agamemnon*

We were told," the librarian of the Uffizi Gallery, Cesare Fasola, wrote after the war, "that when the 'negroes' and 'Moroccans' came, they would chop off our heads. Which didn't happen, after all." Following the Allies' landings in Italy in the summer of 1943, Fascist propaganda against the "invaders" had been relentless and effective. The Allied armies, with their diverse ethnicities, were an almost-ideal target for the attacks of the Fascist media and its well-tested arsenal of xenophobia, racial hatred, and Italian cultural supremacy. Newscasts and newspaper columns spread rumors that dug deep into the oppressed population's fear of the unknown. The United States, a young nation that Fascist information insisted had no culture of its own, was the natural enemy of Italy, a country directly descended from the Roman Empire, whose glory Mussolini's leadership had resurrected. The Fascist press seized on every instance that would emphasize this beloved motif. British soldiers who had established a makeshift office in the cool shade of the columns of one of Paestum's ancient Greek temples were proof that the Allies were to modern Italy what the Huns, the Goths, and the Vandals had been to ancient Rome. "What can Ravenna mean to the Americans, the negroes, the Canadians, the Australians, the New Zealanders, the Scots?" Fascist Radio intoned in one

broadcast. The beauty that the Allies could not understand they would trample and destroy. Or steal. And this is where, even for men of Giovanni Poggi's and Cesare Fasola's education, it became difficult to sift truth from hyperbole. Italian newspapers reported ships sailing daily from the port of Palermo loaded with treasures headed for the New York art market; a bunch of Jewish dealers, posing as "monuments officers," were supposedly scouting the theater of war in search of prized pieces to send overseas.

What made this false news almost seductively intriguing was the merging of two actual facts. Looting *was* taking place in Europe, but it was systematic and Nazi orchestrated. As for the monuments officers, they did exist within the Allied armies, though they were not "thieves" and "gangsters," as Radio Berlin characterized them, distributing maps "to U.S. soldiers to enable them to trace artistic treasures easily." These men were creditable art historians, artists, architects, and archaeologists, in uniform. They were the officers of the Allied Subcommission for the Protection and Salvage of Artistic and Historic Monuments in War Areas. And although in the beginning there were far more words to their outfit's title than men in its ranks, one of this small posse's jobs was to try to prevent Italian art from being spirited away and across the country's northern borders.

While in 1940 Italian art officials were hastily walling off their monuments behind piles of sandbags and brick, several cultural institutions in the United States had begun to express their concern over the threat to European art. What started as discussions and a vague offer of help quickly matured into action, its timing closely following the events that led to the launching of the Allied Italian campaign. In Cambridge, a group of Harvard professors and students created the American Defense, Harvard Group to assist in the war effort by providing information on cultural matters. Paul Sachs, associate director of Harvard's renowned Fogg Art Museum, served as its chairman. The American Council of Learned Societies, founded in New York in 1919 for the promotion of the humanities, later created its own committee on the protection of European cultural matter. With William Bell Dinsmoor, president of the Archaeological Institute of America, as its chairman, the committee counted among its members

Francis Henry Taylor, the director of the Metropolitan Museum of Art in New York, and David Finley, who headed the National Gallery of Art in Washington.

By the end of 1942, concern over Europe's cultural heritage, which had been the subject of conversations and memorandums during the war's early years, had gained urgency once the devastation that Allied and German bombings were wreaking on European monuments became known and persistent rumors of looting spread. The image of Coventry Cathedral, only its tower and outer walls standing after incendiary bombs hit the fourteenth-century shrine on November 14, 1940, was a particular shock. "Those harmless ancient cathedrals," mourned Elizabeth Bowen in her postwar novel *The Heat of the Day*, set during the tragic days of the London blitz. The imminent opening of a second front in Europe, which President Franklin Delano Roosevelt announced in the summer of that year, convinced art historians and scholars to take their ideas beyond the confines of museums and academia and press for action at a higher level. In November 1942, Paul Sachs and George Stout, chief of conservation at the Fogg and one of the country's leading experts on the protection of monuments during wartime, held talks with Francis Henry Taylor in Cambridge. They sought the creation of a small governmental agency that would offer expert advice, channel information, and help the army in whichever way a civilian body could, to prevent or at least limit wartime ravages to European art and monuments. Although none of them would see active duty, they proved bellicose on the home front.

Their request for prompt action did not go unheeded. Taylor, with Finley and Dinsmoor, met with the chief justice of the Supreme Court, Harlan Stone, who sat on the board of Washington's National Gallery of Art, as did the secretaries of state and the Treasury. Justice Stone was sympathetic to their idea and agreed to discuss it with President Roosevelt; in a letter to the president dated December 8, 1942, he suggested the establishment of an organization "to function under the auspices of the Government for the protection and conservation of works of art and artistic or historic monuments and records in Europe." In a strictly advisory role, the organization

would also "aid in salvaging and returning to the lawful owners such objects as have been appropriated by Axis powers or by individuals acting under their authority."

The president's response wasn't long in coming. On December 28, a couple of weeks before the Casablanca Conference, where with Prime Minister Churchill and Premier Stalin he would commit to the invasion of Italy, Roosevelt approved the initiative. About two weeks before the Allied armies were to begin their ground operations in Europe with the Sicilian landings of July 10, 1943, Secretary of State Cordell Hull submitted a draft proposal for the creation of a commission to the president. On June 23, Roosevelt established the American Commission for the Protection and Salvage of Artistic and Historic Monuments in War Areas. Owen J. Roberts, justice of the Supreme Court, was chosen to be its chairman. Finley would serve as its vice chairman, and Huntington Cairns, secretary treasurer of the National Gallery, was appointed its secretary treasurer. Taylor, Dinsmoor, and Sachs were joined by Archibald MacLeish and Herbert Lehman, director of foreign relief and rehabilitation operations, to form the rest of its members.

The agency quickly earned the reputation of being "the Commission with the longest name and the smallest budget in Washington." At a time when the United States was gearing up for war, it is remarkable that it was created at all. From a pragmatic standpoint, its establishment was one effective means for the War Department to counter the incessant pummeling of Nazi and Fascist propaganda. The playwright and three-time Pulitzer Prize winner Robert Sherwood, who served as director of overseas operations, declared at an early meeting of the commission that his office would welcome "all possible publicity or every move . . . made by this Government toward the protection of the art and historic monuments." Sherwood, a friend, confidant, and sometime speechwriter for President Roosevelt, was almost apologetic about what he characterized as his "completely materialistic" remark; yet, he insisted, it was "of tremendous importance that the whole world be reassured on that point." That worldwide anxiety evidently had resonated with President Roosevelt, as it would, a few months later,

with Winston Churchill. With their blessing of the "Roberts Commission," as it became known, the American president and his cabinet were taking up their share of a huge responsibility. As the United States prepared to join the war in Europe, it would strive to defeat Fascism without sacrificing the old continent's cultural heritage. As the poet and librarian of Congress Archibald MacLeish phrased it, "To win this war under terms and conditions which make our victory harmful to ourselves would hardly be to win it."

The initiative, in Gen. John Hilldring's words, was "without historical precedence in any military campaign." In its novelty, the general added, it might prove a tough sell to the army. A soldier and statesman, Hilldring had been instrumental in the creation of the unified Civil Affairs Division within the War Department. Under his direction, the division coordinated the work of all agencies responsible for the rehabilitation of the civilian population of liberated countries. As the main liaison between the fledgling commission and the army, the World War I veteran alerted Taylor, Finley, and their colleagues to the army's general resistance to anything not entirely pertaining to military operations. With delicate diplomacy, the general with the gentle face also introduced the notion to the eager commissioners that the fight for monuments would not be as civilized as a conversation inside a Washington museum, nor as orderly as preparing a series of maps of Italian towns with monuments neatly highlighted to prevent their destruction. However well thought-out, their cause would ultimately play out on the battlefields of Europe, and would be as messy and harsh as the war within which it was to be waged.

Still, it was with maps, as well as handbooks and pamphlets, that the collaboration between the Roberts Commission and the Allied armies began. If damage to monuments was to be avoided, detailed intelligence was needed, and that was what the Roberts Commission could provide. Bombing crews could avoid striking religious and historic sites if these were clearly marked on their charts; once alerted as to the location of monumental areas, commanders could plan their operations so as to spare them. "Soldiers," General Hilldring observed, were not "the vandalistic people folk

think they are"; their commanders, however, could use some guidance on artistic and cultural matters in order to keep their troops in line. Information, the general tirelessly repeated in the early days of the commission, was sensitive—"if we said we wouldn't bomb art objects, we would give the enemy a great advantage," he explained—and must travel exclusively through military channels. But as long as the commission kept to its advisory role, he fully backed its activities. "What we are trying to do with Dr. Dinsmoor is to get every bit of information to General Eisenhower," he announced at an October 1943 meeting in the National Gallery. "It started in Sicily," he continued, "and . . . we will apply it to any area where we have information to give to the General." At the time of the Sicilian invasion, Eisenhower himself had expressed his concern for artistic and historic monuments in Italy. "It is my policy," he wrote to Gen. George Marshall, "in so far as possible without handicapping military operations, to avoid the destruction of immovable works of art."

By the end of the summer of 1943, the Roberts Commission had already forwarded to the War Department photostatic copies of 168 maps that covered the entire Italian territory, including Sicily, Sardinia, and Dalmatia. Working at record speed, it would produce maps for France, Greece, Bulgaria, Albania, Belgium, the Netherlands, and Denmark, and ultimately supply the Allied armed forces with over 700 maps of European and Asian cities and towns that would come into Allied control, accompanying them with as many lists of their monuments, art collections, libraries, and archives.

These maps and handbooks were the joint effort of the Harvard Group and the American Council of Learned Societies. With offices at Harvard and Dumbarton Oaks, the Harvard Group devoted itself to the compilation of lists of monuments and works of art, beginning with every Italian town and city. The "Harvard Lists," as they were called, described Italian churches, their facades as well as their interiors, from chapel to altarpiece, stained-glass windows, baptismal fonts, and marble tombs. A system of stars identified the artistic or historic importance of monuments and artworks, three stars indicating the most precious. With meticulous exhaustiveness, the lists surveyed palaces, old towers, historic houses, and gardens; they

numbered the volumes, old manuscripts, and codices in libraries and archives; every fountain, statue, or column that adorned an Italian square found its mention in their pages. A Herculean feat of art historical survey, the work of the "Boston group" was the result of the patient assembling and collating of data by hundreds of volunteers. The lists were daunting in size, sometimes uneven in their contents, decidedly too accurate for their purpose; even with recourse to the star system, it would be difficult for commanders, among such abundance of monuments, to judge which were the ones to spare in an air raid or declare off-limits for the billeting of troops.

Fifty-five churches, for instance, were listed for Genoa, a dizzying ninety-eight for Venice, which also had fifty-seven of its palazzi mentioned along the Grand Canal alone. The description of the Lombardy city of Bergamo and its province occupied six pages; Brescia seven, while Mantua was dealt only one. Compiled at great speed to be made available to the armed forces before the invasion of Italy, the lists inevitably contained discrepancies and the occasional oddity. Curiously, for example, the Teatro Comunale of Bologna, a much-restored eighteenth-century opera house of good lyric tradition but lesser artistic merit, was given one star, while the gilded and glittery Teatro La Fenice, a gem of eighteenth-century Venetian architecture, had none. The description of towns in the Harvard Lists was sometimes prefaced by a brief history of the place; occasionally, mention of a religious festival or a snippet of local folklore found its way under the heading of a church or a shrine. One of the many anonymous compilers of the lists gave the Cathedral of Naples two stars, and added the following paragraph: "Dedicated to San Gennaro (St. Januarius), patron saint of Naples. Three times a year there takes place a ceremony at which the Saint's blood liquefies: the first Saturday in May at the Church of Santa Chiara, and September 19th and December 16th at the Cathedral. These ceremonies draw enormous crowds. In popular belief rapid liquification of the blood is a good omen for Naples, while slow liquification, or none at all, is a bad one." Though of dubious tactical significance, the notation was a fleeting glimpse into the extraordinary mix of faith and superstition, millennia-old tradi-

tions, dazzling art, and destitution that would meet the Allies on the liberation of the southern city, their first major European capital, in only a few months.

To plot all these monuments onto maps for the use of the Allied armed forces was the job of the American Council of Learned Societies and its committee for the protection of European art. Helen Frick offered the committee the use of the Frick Art Reference Library in New York, which remained closed to the public from July 15, 1943, to January 4, 1944. The committee had access to the library's art reference materials, as well as Miss Frick's own collection of guidebooks, and was assisted by the library's staff. A grid was superimposed on maps that were provided by the Army Map Service, the National Geographic Society, and the Library of Congress, and the exact location of an important building was highlighted. The little white circles that identified a monument, or a cluster of them, on the Frick Maps were the result of thousands of questionnaires on monuments and art collections and their whereabouts that the committee sent to art historians, archaeologists, and architects around the country. Among these were a number of Italian refugees, a handful among the many victims of Mussolini's dictatorship, who supplied information on places and art that they loved and knew very well. The art historian Lionello Venturi and the Orientalist Giorgio Levi Della Vida, who with other college professors had refused to swear allegiance to the Fascist regime, had gone into exile in the United States; and Teodoro "Doro" Levi, who was forced to flee Italy by the 1938 Fascist racial laws, found a haven at the Institute for Advanced Study in Princeton.

While preparation of the Frick Maps and Harvard Lists was set in motion, Francis Taylor and William Dinsmoor pushed their efforts one big, inspired step further. In the spring of 1943, while promoting their plan for the creation of a presidential commission, they had also suggested that qualified men could take up the fight for art in the theaters of war. "There are today more than fifty museum directors, curators, archaeologists and historians of distinction and competence who hold commissions in the armed forces," Taylor wrote in a memorandum to War Secretary Henry L. Stimson on March 15, 1943. In his opinion, the presence of these uniformed art men

in the field could do much more than simply enhance the usefulness of lists and maps. Being archaeologists and art historians, these officers were likely to speak the local language and might well have firsthand knowledge of the regions that the Allied armies were to occupy. They could advise commanders and talk to the troops. And when and if damage was indeed inflicted on a monument, these conservators and architects would know what to do, and would be right there at the scene, ready to bring first aid.

There was a timeliness to this proposal that made it instantly appealing to Secretary Stimson. These men's military training and familiarity with the army's ways and rules would be sufficient guarantee against their getting in the way of fighting operations; they would be an ideal link between scholarly concerns and military goals. Better still, the combination of military practice and their civilian backgrounds matched the profile of the civil affairs officer as it was being outlined in those very days. Since 1942, the army and the government had engaged in a debate on the size and the powers of the temporary government that would administer newly occupied enemy territory. Given the vastness of the theaters that the war was going to reach, and the complexity of the problems it would generate in its wake, it was fairly obvious that the scope of this government would be unprecedented. In April 1942, the School of Military Government was founded at Charlottesville, Virginia, under the direction of Gen. Cornelius Wickersham. At the school, officers who had a background in all areas of civil administration would be trained to become the governors of the countries liberated by the Allied armies, as well as soldiers. American universities and other civilian institutions were to assist the War Department with their expertise as well as with the recruitment of as many competent and experienced civilians as the army could absorb. The plan was ambitious, as the Allied government that was to exercise temporary rule over occupied Italy would have to engage in every kind of relief operation. In addition to the traditional task of assisting invading troops by securing law and order in the rear of the fight, this government would have to provide food, housing, and health services for the civilian population. It would reopen schools and courts, reactivate the country's banking system and postal services, advance

funds for the payment of salaries and for reconstruction plans, and assist displaced people and refugees.

At the insistence of Francis Taylor and his colleagues, in the spring of 1943 the school at Charlottesville included a program on the protection of monuments in its curriculum. Many in the art community could scarcely believe they pulled off such a coup. Theodore Sizer, director of the Yale University Art Gallery, was among the first art historians to teach the course on monument protection at Charlottesville. A veteran of World War I, fifty-year-old Tubby Sizer wrote to Charles Sawyer, a Yale alumnus and the director of the Worcester Art Museum who would become assistant secretary treasurer of the Roberts Commission in 1945: "Apparently the Secretary of War is interested in this art program which General Wickersham, the head and founder of this school, is so keen about (it was Francis who put him on to it)." Sizer continued: "They don't know just how to tackle the problem as yet, but it is the sort of thing that the likes of us should be concerned with if Uncle Sam is to use our services to the utmost . . . They will need all of us as they can lay their hands on. As you can well imagine every half-baked 'art lover' is trying to get in. Let's hope for the best."

The Allied Military Government of Occupied Territories, or AMGOT, was established on May 1, 1943. Plans for Husky, the code name for the invasion of Sicily, which would be the opening salvo of the Italian offensive, provided for four hundred AMGOT officers to be deployed on the island beginning in July 1943. With a British chief civil affairs officer, General Lord Rennell of Rodd, and an American brigadier general, F. J. McSherry, as his deputy, AMGOT was a completely integrated Anglo-American operation, its sections being composed of Britons and Americans in almost equal numbers. This also applied to the advisers on fine arts and education to the chief civil affairs officer, a team of two, initially. The British, however, had taken a different route to setting up their arts protection program. While in the United States museum directors and curators had been rallying the support of the government and the army, among their British allies the cry for help had come straight from the battlefield, and their initiative sprouted

from the resolute action of one impetuous archaeologist amid ancient Roman ruins half-buried in the sands of North Africa.

At the time of World War II, Mortimer Wheeler was arguably one of the most influential archaeologists of his day. The director of the London Museum, Rik Wheeler, as he was known, was a pioneer of new excavating techniques, an eloquent lecturer, and a brilliant popularizer of his subject who would be knighted in 1952 for his services to archaeology. A Glaswegian by birth, Sir Mortimer possessed a fiery personality, a mass of wavy hair, and a thick handlebar mustache. He had fought with valor in World War I and, as a lieutenant colonel, led the Forty-second Mobile Light Anti-aircraft Regiment in World War II. Since 1941, the fifty-three-year-old Wheeler had been fighting with the British Eighth Army in North Africa. Among his men was his friend and colleague John Ward-Perkins, who had been on the staff of the London Museum and, at the outbreak of the war, held the chair of archaeology at the University of Malta. The Oxford-educated Ward-Perkins had joined the army in August 1939 and trained with Wheeler at Enfield, in the northern outskirts of London. In the fall of 1942, he had been wounded in a motorcycle accident near the northern Egyptian town of Ismailia, on the Suez Canal; while hospitalized in Alexandria, he had missed the battle of El Alamein, but met instead the woman who was to become his wife, Margaret Long, who was serving as a nurse at the hospital.

On the evening of January 19, 1943, as the British Eighth Army was closing in on Tripoli, Lieutenant Colonel Wheeler was struck by an epiphany. After a long war and a series of defeats, the victorious battle of El Alamein in northern Egypt, fought over eleven days between the end of October and the beginning of November 1942, had marked a change in the fortunes of the British army in North Africa. Tripoli would surrender on January 23, 1943, and the Axis forces would be pushed to retreat farther to the west and into Tunisia. During a pause in the fighting, it suddenly occurred to Wheeler that the majestic ruins of three ancient sites, in fact the three cities that had given the Roman province of Tripolitania its name, lay only a few miles away along the Libyan coast. Ancient Oea (current-day Tripoli), Lep-

tis Magna, and Sabratha, early Phoenician trading posts and later flourishing Roman commercial centers, stood right in the path of the Allied armies. In a matter of days, those three major vestiges of the Roman Empire in North Africa would be turned into battlefields and become, as Sir Mortimer would vividly remark, "easy meat for any dog that came along."

Sir Mortimer was frankly surprised at himself, "a professing archaeologist," for not having envisaged the threat until a few hours before the battle. The British government and its secretary of state for war hadn't given it much thought either. "At the time of our advance into Cyrenaica and Tripolitania in 1942–43 no steps of any kind had been taken by our military authorities to safeguard museums, records, works of art, 'monuments,' whether during the active process of occupation or during the subsequent military administration," Wheeler wrote ten years after those events. Back in January 1943, however, there was no time for finger-pointing or brooding over unfulfilled responsibilities, and that wouldn't have been Wheeler's style anyway.

Instead, during a lull in the battle, he got in a jeep with John Ward-Perkins, recovered and fresh from his honeymoon at Luxor, and drove to newly liberated Tripoli and Leptis Magna. As Sir Mortimer was to recall later, the two archaeologists approached the spectacular ruins of Leptis with "a combined sense of anticipation and anxiety." Leptis Magna had been a magnificent Roman city. The birthplace of the emperor Septimius Severus, Leptis had been lavishly expanded in the third century A.D. by its illustrious son, a Romanized African emperor who wished to celebrate his family's influence through the architectural splendor of his city. In 1920, an Italian excavation had reclaimed the remains of the temples and the avenues of Leptis Magna from the sands that had buried it for centuries. Through the resurrected beauty of Leptis, Italy's dictator, Mussolini, who had funded the expedition despite his lack of aesthetic interest, had intended to emphasize the continuity between Rome's ancient glory and his own rising power.

Sir Mortimer thought the results of the Italian excavation a debatable success—the work, he thought, partly "sprang from the established Italian

tradition of spectacular if superficial research"—but was nevertheless astounded by the beauty of the architecture and the statuary that had been brought back to light from under the African sand. He was more troubled, though, by the presence inside the ruins of the Royal Air Force seeking a suitable spot to set up a radar station. Undaunted by the notion that neither he nor Ward-Perkins had any authority to talk senior officers out of the plan, he tackled the situation with a mix of scholarship and resolve. "We bluffed our way through a number of fairly effective measures," he wrote later.

The two archaeologists improvised with what they had at hand, placing large OUT OF BOUNDS signs around the ruins and extemporizing lectures to troops. A savvy communicator, Sir Mortimer knew instinctively how to make himself heard by the soldiers. He may have encouraged their respect for those broken columns and old slabs of stone by telling them of Septimius, the soldier-emperor who had fortified and restored Hadrian's Wall to protect Britannia from Scottish invasions and died at York in A.D. 211. What the two archaeologist-officers did at Leptis Magna would become standard procedure for the protection of monuments at later stages of the war: they secured the site, educated troops, and hoped for the best. Together they visited Sabratha when the city fell into Allied hands; and there, in the westernmost corner of Libya, they found the entire personnel of the Italian superintendency for Libya that had been retreating with Axis forces to the border with Tunisia. Through their cursory Italian, Sir Mortimer and Ward-Perkins learned from the Italian chief inspector of antiquities, Gennaro Pesce, that his staff had hidden the best sculpture from the site in an olive grove nearby. Whether this was done out of generic mistrust or fear of their ally, Pesce didn't explain, or was lost in translation. He produced a list of the statuary, though, and the two British officers placed responsibility for safeguarding the three sites back in the hands of Italian inspectors; Arab custodians were placed at all three archaeological areas, and regular reports were requested of the chief inspector on the progress of his work.

As Lieutenant Colonel Wheeler was moving with his regiment into Tunisia, he left Ward-Perkins in charge of reorganizing the Italian archaeo-

logical superintendency of Libya. Thanks to the sympathetic support of Maj. Gen. R. R. Hone, head of the civil affairs branch of the Eighth Army, Ward-Perkins was released from combatant duties for three months. Wheeler, who recognized the qualities that recommended his younger colleague for the job, made him a monuments officer, in effect if not officially, before the role or even an office had been created. In Wheeler's opinion, Ward-Perkins was "the rare combination of a practical scholar and a combatant soldier [which] qualified him alike to appreciate the technical problem and to deal with uniform in its own idiom." And if the appointment had the slightly feudal flavor of an investiture in the field for Major Ward-Perkins, it conferred on him an unofficial degree of seniority over the monuments officers who were to join him at a later stage in Italy.

Since the moment it had "stuck itself starkly on his consciousness," the drive to safeguard monuments was never very far from Wheeler's thoughts. While fighting in Tunisia and following Ward-Perkins's efforts at a distance, the British archaeologist realized that in the absence of a directive or, as he called it, a "blessing" from the top, any sustained action to protect art from wartime destruction was bound to be crippled. He knew of plans for the invasion of Sicily—"a top secret to which I happened to be a party"—and as a result of that intelligence "the archaeologist in me was filled with anxiety." He decided to pull other strings and in June 1943 flew from Tunis to Cairo and to Gen. Bernard Montgomery's secret headquarters. There he met with Lord Gerald Wellesley, who was to be part of the AMGOT deployment to Sicily as senior civil affairs officer for the city of Catania. Lord Wellesley, who would become the 7th Duke of Wellington upon his nephew's death from wounds received at Salerno, promised to do all he could for the art of Sicily; unfortunately, Wellesley had visited the island many years before, and his recollections of places and monuments were old and blurred. If only he could have at least a Baedeker, Sir Mortimer thought, to dust off his memories. As luck would have it, the Baedeker guide *Southern Italy and Sicily* materialized, just a few hours later, its unmistakable red leather cover calling out from the shelves of Professor Archie Creswell, whom Sir Mortimer visited that afternoon at his apartment in the heart of Cairo. An old

friend of Wheeler's, Creswell taught Muslim art and architecture at Fouad University; while he brewed tea for his colleague, Sir Mortimer rapidly pocketed the little red guidebook, a petty theft for a good cause, and put it in Lord Wellesley's hands a few hours later. He would return it, though, to a surprised Creswell as the two of them dined at a club in London eight years later; Creswell, apparently, had not missed the booklet from his library.

While Sir Mortimer was sipping tea with Creswell, a cable had come through from Allied headquarters in Algiers in reply to the archaeologist and Lord Wellesley's inquiry on what, if anything, had been planned for the protection of monuments in Sicily. "It appeared," Wheeler recounted, "that two Americans, whose names meant nothing to us, were, somewhat vaguely it seemed, going to keep an eye upon the churches, temples and collections of Sicily. We glanced skeptically at one another, admitting however that the Americans were at any rate half a move ahead of us." Piqued, perhaps, but certainly encouraged into taking further action by the unexpected American initiative, Sir Mortimer wrote to "the titular head of all archaeology," Sir Alfred Clapham, the president of the Society of Antiquaries of London. In his letter, he suggested a "small but properly-thought-out organization" and the appointment of "a qualified archaeological official." All of this, he insisted, should be directed from the highest levels of the War Office. "Grigg, even the P.M. should be got hold of," he concluded, "the matter is URGENT."

Wheeler's soldierly duties were calling him back into battle and away from the fight for monuments. His message, however, did reach Prime Minister Churchill and the secretary of state for war, Sir P. J. Grigg, who quickly acted upon it. As they searched for the "qualified archaeological official" to pick up where Wheeler had left off, it seemed only natural to both that an initiative that was started from within the armed forces should firmly remain in the hands of the War Office and its civil affairs branch. On November 1, 1943, the premier appointed the eminent archaeologist Sir Leonard Woolley, a decorated veteran of World War I, as adviser for archaeology to the War Office.

Woolley was probably the man Wheeler had had in mind all along to head the arts and monuments protection initiative at the War Office; in fact, the two had been corresponding, and Wheeler had kept Woolley informed of the steps he had taken for the safeguard of the North African archaeological sites. For his part, Woolley described his own appointment with deceiving self-effacement: "Since I happened to be in the War Office . . . I was asked to give advice." By 1943, sixty-three-year-old Sir Charles Leonard Woolley had been serving in the Intelligence Division of the War Office for four years. In 1942, he had worked in the public relations section of the same office, and was well-known to Sir Grigg, then the undersecretary of war. During World War I, Sir Leonard had shared a desk and an office with his friend T. E. Lawrence in Cairo, in 1915; intelligence had been his assignment in that conflict also, a job for which he seemed to have an affinity. "Woolley sits all day doing précis and writing windy concealers of truth for the press," Lawrence wrote. Woolley was discreet and courteous, "sweet to callers in many tongues," as Lawrence recalled. He had been captured by the Turks in 1916 and imprisoned for two years. At the end of the war, he had been released with the rank of major, and had been awarded the Croix de Guerre by the French government.

Sir Leonard's fame as an archaeologist was linked to his excavation of the Sumerian city of Ur, in ancient Mesopotamia. Built in the third millennium B.C. close to the coast of the Persian Gulf, in current-day Iraq, Ur had a powerful biblical resonance to its name: Ur of the Chaldeans, the birthplace of Abraham. Beginning in 1922, Woolley had led a major expedition promoted by the British Museum and the University of Pennsylvania; for over a decade, he had been unearthing spectacular artifacts from the ancient capital. His digging, for which he would be knighted in 1934, made news. "I had just been reading in *The Illustrated London News* about Leonard Woolley's marvelous finds at Ur," Agatha Christie wrote in her autobiography. In fact, the novelist had been so intrigued by the story that she decided to travel to the Middle East to visit the excavation, where she fell in love with Ur, and with Woolley's assistant, Max Mallowan, whom she married in 1930.

With her keen eye for character, Christie captured the visionary quality that made Sir Leonard such an enticing figure, and modeled Eric Leidner, the archaeologist at the center of *Murder in Mesopotamia*, after him. As she remarked years later, "Leonard Woolley saw with the eye of the imagination: the place was as real to him as if it had been 1500 B.C., or a few thousand years earlier. Wherever we happened to be, he could make it come alive . . . It was his reconstruction of the past and he believed it, and anyone who listened believed in it also." As the writer aptly recognized, Woolley could make the remote past relevant to his contemporaries, and that talent, at a time when archaeology was still much the domain of an antiquarian elite, made him a brilliant popularizer of his discoveries.

Physically, Woolley was a short man of slight build, "but presence, yes!" a friend of his once wrote, "even a blind man would know what manner of man he was." Sir Leonard had stature as well as military experience, and these were the requisites that the War Office thought would keep him in good stead when offering his advice to commanders on matters that might well be deemed marginal to the conduct of military operations. Behind the modest appearance and affable manners, Sir Leonard's temperament was authoritative; having observed him on his excavation, Christie said he could be "extremely autocratic." The months following his appointment as adviser for archaeology to the War Office would reveal just how determined he could be in the pursuit of his goals, a thin layer of diplomacy barely disguising his fierceness. The object of his doggedness, however, was not the military at first, but an opposition of a very civilian nature.

If Woolley was an insider at the War Office, he was pretty much the opposite in the London world of antiquarians and art historians. He had the support of the prime minister, who had installed him in a well-appointed apartment on Park Lane where he and his wife, Lady Katharine, entertained elegantly; yet his many years spent excavating in faraway places made him something of an unknown quantity to museum directors and academics. Some among them doubted the appropriateness of entrusting an archaeologist with problems of art protection and conservation that an art historian or an architect would be better equipped to handle. The reserva-

tions and skepticism were mutual: not the scholarly type, Sir Leonard did not sit on museum boards, and his aversion to committees was notorious.

Opposition to Woolley began to mount as soon as news of his imminent appointment spread. On October 23, 1943, Lord Crawford, a trustee of the British Museum, expressed his pessimistic view of Woolley's mission in a letter to the conservative MP Edward Herbert Keeling—"some in the War Office will support him: others equally high up will ridicule the whole affair"—and suggested instead the art historian Kenneth Clark, the director, at that time, of the National Gallery in London and the surveyor of the king's pictures. "He is the best known public figure in the official Art world," he wrote to Keeling, "has courage, good organizing capacity, and a brilliant brain—would get on with and impress people on the spot." Sir Kenneth Clark, who had only a lukewarm interest in Woolley's job, nonetheless expressed his dismissive opinion of the archaeologist. On October 13, 1944, upon hearing a rumor—a false rumor, in fact—that the Uffizi collection of drawings had been pulped by Nazi soldiers, he wrote to the keeper of the Wallace Collection, Sir James Mann, "Woolley does not care about works of art, and cannot understand the anxiety with which many people are filled by reports of this kind."

"Oh, Clark was a great putdowner of people!" exclaimed Craig Hugh Smyth years later, who had himself been a monuments officer in Germany, in the later stages of the war. In the circumstances, however, Sir Kenneth's blunt assumption that an archaeologist could not know art sounded like a thinly veiled attempt to reclaim control of an initiative that had bypassed British art historians and antiquarians entirely. Their American colleagues had organized themselves in a commission that was collaborating effectively with the War Department, while in Britain one man was operating as a committee unto himself and had every intention to continue to do so. "Woolley," Lord Crawford had written to Keeling, "definitely does not want a committee."

When, in the opening months of 1944, the Roberts Commission lent its support to the creation of a parallel body of art experts in Britain, Woolley went on the attack. In a March 1944 letter to the Roberts Commission's William Dinsmoor, he began by defending his work up to that date for the

safeguarding of art. "Of course they do not compare with the lists supplied by Harvard and Washington," he wrote of the inventories he had been compiling in preparation for the Italian campaign; yet it was the "brevity" of his own lists, he insisted, that recommended them for use by commanders. When it came to the understanding of military needs, Woolley pressed on, his judgment was far superior to that of a civilian committee. He offered his views on what type of monuments officer should be sent to the theater of operations at that stage of the war. "The architects are needed at the front . . . the architects," he reiterated, "are really the most essential members of our staff." In his closing paragraph, he felt he should not leave his reader in any doubt as to who was in charge of selecting those officers. "I recommend the personnel to be employed in the field," he declared. "I am personally and solely responsible for the advice I give."

In March 1944, Woolley knew that the establishment of a British committee could not be avoided, yet the tone of his letter to Dinsmoor reaffirmed his resolve not to give up control of art operations in the theater of war. Since the time of his own appointment as adviser on archaeology to the War Office in the fall of 1943, the Reverend Lord Lang of Lambeth, archbishop of Canterbury, had championed the idea of a committee and subsequently had offered to find "a number of people who might form a Commission for certain useful purposes." The prime minister and his cabinet had expressed their sympathy for the cause. But Woolley enjoyed Churchill's support also, and had the respect of the War Office. He knew that the British government did not look favorably on the presence of civilians near the front line. In February, in the House of Lords, the lord chancellor warned: "The idea that we should leave the most eminent experts who have high artistic or archaeological qualifications to walk about the battlefields for this purpose is really one which I think would not be accepted as at all suitable." If a committee was inescapable, Sir Leonard wanted one whose competence would be restricted to issues of art restitution after the end of hostilities. And that was precisely what happened.

On May 8, 1944, Prime Minister Churchill appointed the British Committee on the Preservation and Restitution of Works of Art with Lord

Harold Macmillan as its chairman and a distinguished roster of scholars and art experts that included Sir Kenneth Clark and Vincent Massey in representation of the National Gallery, the Duke of Wellington, Sir Eric Maclagan for the Victoria and Albert Museum, and the keeper of the Wallace Collection, James Mann. It was a victory for Woolley, who presented it as such to Dinsmoor: "The War Office, rightly, in my opinion, set its face against any such [body] being organized to deal with problems in the war areas." Angrily, Francis Taylor characterized the limited scope of the British committee as the result of Lt. Col. Sir Leonard Woolley's "successful sabotage."

With the British "Macmillan Committee" relegated to handling the restitution of misplaced artworks after the war, while hostilities lasted, Woolley was the British counterpart of the Roberts Commission. There was no love lost between the two. Having successfully stressed the strictly military nature of the Allied art protection operation, Woolley, with his army rank and experience, was free to move around a theater of war and could have access to generals and perhaps influence their strategic planning. The Roberts Commission was stuck in Washington, and any attempt by one of its members to visit an operational zone—and there were a few—was stymied by the army. As the Italian campaign got under way, the gap between the commission and its men in the field began to widen as the complexity of the problems the latter were grappling with in a bitter war became harder and harder to grasp at thousands of miles' distance. Initially, every party complained: the monuments officers of not receiving enough support from Washington, the commissioners of not being adequately informed of the work carried out in the field. As the campaign progressed, and the officers became engaged in the salvaging of hundreds of monuments in scores of Italian cities battered by the war, they seemed to be operating entirely on their own, their contacts with Washington reduced to a minimum.

Yet it was the vision of the Roberts Commission that set an unprecedented initiative in motion. And it was Woolley who, indirectly, recognized its significance. On his office door, in the Victoria Hotel on Northumberland Road in London, he pasted a quotation from Thucydides; the words came from Pericles' eulogy for the fallen during the first year of the thirty-

year Peloponnesian War, in 431 B.C. Praise for the valorous dead was for Pericles an occasion to celebrate Athenian civilization and the values those men had sacrificed their lives to defend. "We love beauty without extravagance," Pericles said to the gathered citizens of Athens, "nor do our intellectual pursuits make us soft." The connections between ancient Athens and the Allied nations poised for war to defend Europe were obvious enough. But Woolley took some liberties in his translation of the ancient Greek text to stress what was so specific and unique about the Allied efforts to protect art, and coined an unofficial motto of sorts for the small outfit: "We protect the arts at the lowest possible cost."

SICILIAN PRELUDE

At Wimbledon College
They stuffed him with knowledge
Of Amgot essential hygiene:
He took sanitation
And crops in rotation
With law and fine arts in between.
—Edward Croft-Murray,
Lionel Fielden, and Fred Bennington,
AMGOT anthem

We wanted the Mediterranean. The only way to open the Mediterranean was to conquer Sicily. Sicily was near . . . It was the rational thing to do," the British author and war correspondent Alan Moorehead wrote. D-day for the Allies' landings on the island was set for July 10, 1943. "There was no moon and it seemed a good night for the invasion," the war correspondent Richard Tregaskis recorded. A massive armada of three thousand Allied ships sailed from several Egyptian, Tunisian, and Algerian harbors for the southern shores of the island; a severe Mediterranean storm caught the fleet, which "filled commanding officers with a sudden anxiety while many of the soldiers in the smaller craft were emptied, as suddenly, of their physical burdens," the Scottish novelist and chronicler of the Italian campaign Eric Linklater wrote. The gusting winds and rough sea did not halt the landings, but fooled sentries along the coast who thought that nobody would ever attempt an invasion in such

weather, and the enemy was caught by surprise. The Third Infantry Division of the American Seventh Army went ashore at Licata, in the south of Sicily, while some twenty miles to the east the British Eighth Army landed at the Pachino peninsula, the southernmost tip of the island, and by nightfall its Fifth Division had entered Syracuse, on the eastern coast. In the following days, the Americans made rapid progress to the west, encountering little or no opposition from Italian forces. Undernourished and underpaid, often barefoot and equipped with antiquated weapons, the Italian army, as the supreme commander, General Eisenhower, put it, had "no stomach for fighting." American troops took Agrigento on July 17 and on the evening of July 22 liberated Palermo, Sicily's most populous city, on the northwest shore. The Eighth Army's advance to the east was made slower and bloodier by tough German resistance. While carefully orchestrating their retreat to the mainland, the two German divisions fighting in Sicily concentrated their strength to the north and northeast of the island and fiercely defended the city of Catania, at the foot of Mount Etna. Finally, on August 17, thirty-nine days after they landed in Sicily, the Allies captured Messina, which a two-mile-wide strait separates from continental Italy, and the entire island was conquered.

To many Allied soldiers who first set foot in Sicily, the island initially looked just like North Africa. The heat of summer is as scorching and the glare of its sun as intense as in the North African regions; the torrid sirocco wind that blows from the Sahara has not lost any of its enervating and limb-palsying vigor by the time it sweeps Sicily. If, however, its light-tinted fishermen's houses and the lateen sails in its port made Licata look like a small harbor in Libya or Tunisia, a different scenery opened up to the soldiers as they began to make their way through the interior: "a mountainous island, stormily beautiful and harshly patterned," in Linklater's description. Sicily's long history of wars and violence is written in its landscape. Walled hill towns dot the countryside, where for centuries people have sought refuge from invading enemies or from the threat of malaria. Sicily's tall and craggy mountains, the emerald green of citrus orchards, and the deep blue of the glimmering sea in the distance blend arrestingly with the marks of its an-

cient civilization. In his early days on the island, Tregaskis was awed by the sudden appearance of an ancient shrine. "We saw a beautiful silhouetted Greek temple atop a ridge," he recalled, "and we knew we were nearing Agrigento."

The relatively fast pace of the ground war across Sicily caused little damage to the countryside and the small towns and villages scattered around it. The island's larger cities fared much worse. In preparation for the landings, Allied air forces had been targeting Sicilian seaports for months. On the eve of the invasion, the air strikes increased in intensity and continued throughout it in support of the ground war. All major Sicilian centers, Catania, Messina, Trapani, Augusta, and Palermo, were badly hit. "We reached the water-front district of Palermo," Tregaskis remembered, "where buildings were smashed into the street as far as one could see. Facades and pieces of roof and splintered lumber dripped from the structures like sad veils." The contrast between Palermo's magnificent situation and its present misery was striking. Built between the sea and the squatting mass of Mount Pellegrino, and surrounded by the orange groves that give the Conca d'Oro, "the Golden Bowl," its name, Palermo is an ancient city: a Phoenician settlement that became a thriving Roman and later Byzantine center and that the Arabs turned into the splendid capital of their kingdom. The churches and palaces of the city's old quarters reveal the many strands of Palermo's rich artistic mix: Byzantine, Norman, Islamic, and Baroque. Clustered around the port, they had shared in its fate.

Mario Guiotto had been appointed superintendent of monuments for Palermo in December 1942, too late a date to shield the city's many historic buildings against air raids. Guiotto had hidden movable artworks in the Benedictine convent of San Martino delle Scale in Monreale, four miles west of Palermo, and hastily shielded with sandbags the mosaics, stuccos, and frescoes adorning the interior of churches and chapels. The bombs that started falling on Sicily in January, however, had made his more ambitious plans of protecting churches' facades, windows, and apses with wooden scaffoldings and brick walls impossible. For months, all the thirty-nine-year-old Guiotto could do was to rush out as soon as sirens signaled the end

of a bombardment and search the rubble of damaged buildings for frag-
ments of their decoration before rescuers began to clear the site of debris.
With the help of the superintendency's small staff, he buttressed teetering
walls and temporarily tarpaulined smashed roofs. The relentlessness of the
raids made man power scarce as fear of the bombings drove most of the
population out of the city. Day and night, looters roamed the burning ruins
of the devastated neighborhoods, often inflicting as much injury as the
bombs themselves. "Palermo showed all the appearance of a dead city,"
Guiotto wrote at the time. After six months of air attacks, fifteen monu-
ments were entirely destroyed, and one hundred were damaged, sixty of
which were churches. "The devastation," the superintendent wrote in a re-
port, "was huge and discouraging."

In its randomness, the fury of the bombs had wiped out some layers of
the city's artistic history and spared others. The Royal Palace, a Phoenician
and later Arab fortress that the Norman kings had turned into their sprawl-
ing residence, had not suffered a scratch. The precious marbles and the
dazzling mosaics of the adjacent Cappella Palatina, the chapel that Roger II
commissioned in 1132 shortly after being crowned the first Norman king of
Sicily, were also intact. The rich Islamic tradition of ornamentation, which
still blossomed well after the Arab rule had ended over the island, happily
coexisted on the curved arches and painted wooden ceiling of the chapel
with the stories from the Old and the New Testaments narrated in the mo-
saics on the walls below. The Norman abbey of Monreale and its exquisite
cloister, a forest of slender, multicolored columns, and the superb Norman
Cathedral of Cefalù, high on a promontory a few miles east of Palermo,
were both safe. The Baroque churches on the other hand, "which," Guiotto
remarked, "give old Palermo its most distinctive character," had all suf-
fered badly. The Church of San Giuseppe dei Teatini, one of the best exam-
ples of Sicilian Baroque, had been hit repeatedly. The dome of the Chiesa
del Gesù, also known as Casa Professa, had been smashed, its central nave
ruined, and now a swath of the blue Sicilian sky shone on the church's
sumptuous interior of multicolored marble intarsia.

Among the mounds of rubble that choked chapels and naves, some ex-

traordinary survivors occasionally emerged. The two oratories of Santa Zita and San Lorenzo, for instance, were both hit, but Giacomo Serpotta's exquisite statues inside them were mostly unharmed. Molded in stucco, that most fragile of materials, they were the masterpieces of the eighteenth-century Sicilian who elevated his craft to the status of art and gave his opaque medium the luster of marble. Their unexpected survival, almost miraculous amid such devastation, came like a whispered message to Guiotto not to lose hope. Serpotta's delicate stucco figures seemed to have defied the violence of the bombs; and there was indeed something serenely triumphant in the 250-year-old statue of a young boy, still sitting high up on a cornice inside Santa Zita after the bombs had fallen, his legs dangling in the air, one knee sticking out of his baggy, rolled-up pants, his grace unruffled.

News of the Allied landings in Sicily reached Guiotto as he was surveying the restoration of the former Abbey of Santa Maria del Bosco near the town of Contessa Entellina. Surrounded by mountains, Contessa Entellina was founded in the late 1460s by Albanian soldiers after the fall of their kingdom to Ottoman rule; fifty miles to the south of Palermo, the town remains to this day an enclave of Albanian traditions, a community of roughly two thousand people still speaking a dialect from their motherland. Upon hearing of the invasion, Guiotto headed back to Palermo. He crossed the mountains on foot, since, owing to the emergency, all public transportation had been suspended. The war that the regime had declared impossible was being brought to Italy; it would cut Sicily off from the rest of the country.

Once he was back in Palermo, there began for Guiotto what he called the time of his "solitude." Faced with the many difficulties involved in the rehabilitation of scores of shattered monuments, the young superintendent was seized by frequent doubts; he reeled under the responsibility of having to make decisions that would affect the future of buildings of high artistic importance under such strained circumstances. Forced to act alone, and to act fast, he keenly felt his own and the island's isolation. "It became impossible at that time to talk to friends and scholars on continental Italy, nor could I count on the support or rely on the advice of my colleagues at the ministry," he wrote in the aftermath of Mussolini's deposition on July 25. In six

weeks' time, the king would flee Rome, and the capital would be all but abandoned; by the end of the year, most of his colleagues would be "retired," and the new Fascist ministry relocated a thousand miles north of Sicily in Padua.

Lack of guidance wasn't the only consequence of the power vacuum created by the Fascist government's dissolution. Guiotto's salary and those of his colleagues and staff were months overdue, and the superintendency's funds were depleted. As he gloomily contemplated an unpromising future, the Allies' invasion compounded his fears. The Sicilian population enthusiastically saluted the Allies as liberators. The correspondent for *The Saturday Evening Post* reported that thousands of people who had fled Palermo during the air raids eagerly followed the Allied soldiers back into the city; wherever they went, officers and soldiers were surrounded by children. "Probably," he wrote, "no conquered people ever have greeted their conquerors as the Sicilians welcomed us." Yet the British and the Americans were still the enemy in July 1943. As Guiotto tried to divine whether this enormous army might respect or trample over his island's cultural heritage, the Italian language's predilection for vagueness and love of the passive voice perfectly suited his trepidations. "In those days," he wrote, "the situation at the Superintendency of Monuments was one of uncertainty."

As soon as the Allies entered Palermo, Guiotto resolved to visit their command. Of his meeting, he wrote: "The Allied Military Government, once informed of the historical and educational importance of our artistic patrimony, immediately established a special office for the care of art and monuments." The superintendent apparently never realized that the fine arts section, which, with touching naïveté, he thought had sprung out of his one conversation at Allied regional headquarters, was in fact the result of months of preparation at the highest levels. What mattered most, at that crucial time, was that when he met Mason Hammond, the adviser for arts and education, the American officer appeared to embody all the traits that could allay Guiotto's or any of his colleagues' fears of the "enemy." Cultivated and charming, Mason Hammond had a handsome face, a good sense of humor, and a warm, reassuring smile. It is no surprise that back in Cairo, Mor-

timer Wheeler had had no idea who he was, as Hammond was not an archaeologist or an art historian, but a classicist who taught Latin at Harvard for most of his long and full life. The circumstances of his appointment as adviser, in May 1943, had been somewhat hurried. At that time, the Roberts Commission had not yet officially been established; plans for Operation Husky, however, were being finalized, and an American art expert was slated to sail with an early contingent of AMGOT officers. Hammond, a member of the American Defense, Harvard Group since 1940, was serving as an intelligence officer at air force headquarters in Washington. With the rank of captain, he was dispatched to North Africa in June. Once in Algiers, much to his surprise, he discovered that it wasn't the Roman ruins of Tripolitania that he was to tend to, but the ancient monuments of Sicily. He traveled to Syracuse on July 27, and on August 3 he joined military government headquarters at Palermo.

The choice of Hammond to start the Allied monuments and fine arts work in Italy may have been hasty but was a wise one. Hammond spoke Italian, and in a Catholic country where Mass was still celebrated in Latin, he had that ancient rich language to fall back on in an emergency. His knowledge of the country was thorough and deep. As a scholar of ancient Roman civilization, he had spent extended stays in the capital as a fellow of the American Academy in Rome, and these, in their turn, had given him firsthand experience of life in modern-day Italy. Behind the open smile and what a colleague once called his "senatorial" voice, Hammond had a lucid mind and a level and antiheroic sense of self. In the summer of 1940, on the eve of events that would dramatically affect the lives of millions, Hammond had written to his friend of many years the art critic and connoisseur Bernard Berenson: "Most people appear to me to be much like myself, neither stupid nor brilliant, not wholly ignorant, but narrowly educated. The majority of us want to be left alone to pursue our own little concerns . . . Yet I think that most of us are capable of great thoughts and of great sacrifices if our imagination—in the end, Christianity, or any religion, and democracy—make demands on the ordinary individual which can easily be

lost sight of in times of material ease and tranquillity—the demands of self-discipline, self-sacrifice, and even more, deliberate choice."

While he had no specific experience in conserving art, Hammond's character and skills were desirable traits in an AMGOT officer at that early stage of the occupation. As it assumed control of liberated areas, the Allied government was beginning to address the thorny issue of ridding the Italian public administration of Fascist civil servants. By the fall, 450 pro-Fascists in governmental positions were to be expelled, while the rest, or two-thirds of all state employees, were retained at their posts. In an early report from Sicily, Captain Hammond noted that adherence to Fascism among persons holding government jobs had been mandatory, but added that in the cultural departments, sympathy for the regime had been "to a considerable degree lukewarm." Conversely, mistrust of Italians was to be expected among Allied troops fighting in the country. This is where a scholar whose knowledge of the country extended well beyond the infamous last twenty years of its history could fill the role of cultural interpreter for his own army, and perhaps help to redress a soldier's or a division commander's perspective. In a series of notes written for the officers who were being trained at the Charlottesville School of Military Government, Hammond observed that the monuments officer "must above all . . . have endless sympathy and understanding for the Italians, who are likely to be distrusted and looked down on by his fellow Allied officers." Appreciation of the artistic beauties of Italy was a good place to start rebuilding respect for the defeated and prostrated country. Art and architecture, as the *Soldier's Guide to Italy*—the pocket-size booklet distributed to Allied troops—pragmatically and somewhat condescendingly emphasized, were after all "what Italians were good at in their best moments."

The collaboration between the Sicilian superintendents and their Allied counterparts was smooth and amicable from the start. As the British captain F. H. J. Maxse joined Hammond as his deputy in early September, a division of labor of sorts naturally developed between Sicilians and Allies that was determined in part by AMGOT policy, in part by common sense. As

Col. E. Erskine Hume, who was to head the Fifth Army's military govern-
ment in Naples, explained, "We're not trying to govern Italy; we're trying
to get the Italians to run their country so that we can pursue our principal
objective, to beat Germany." Within the confines of his small section, Ham-
mond had no desire to interfere with artistic and technical decisions that
were better left in the hands of local experts. When Guiotto later thanked
Hammond and Maxse for their "great sensibility and understanding," the
superintendent implicitly acknowledged the ample leeway he was given on
artistic matters by the Allied advisers. They, in their turn, relieved him and
his colleagues of the financial burdens and practical issues that had be-
sieged them until the eve of the liberation. As Hammond remarked early on
from Sicily, "A certain knowledge of the history of art or a refined sense of
criticism are of far less value than the ability to cope with people and prob-
lems and to put in long hours on salary lists, estimates and reports."

From explaining the role of Italian superintendents—there were six in
Sicily and around fifty in the country, with authority over galleries, monu-
ments, and antiquities—to giving instructions on how to submit an estimate
for repairs, to which offices and in how many copies, Hammond exhaus-
tively covered all the information that, if a little dull to read, was the neces-
sary technical background of every monuments officer. His well-organized
descriptions and the smooth and slightly professorial tone of his prose
painted a picture from the field that was perhaps deceivingly orderly; as
later experiences would show, statements couched like precepts often con-
tained actual warnings. "It is unwise to be too accessible to the Italian officials,
who will then refer all decisions to the Advisor," Hammond recommended.
In a private letter, Deane Keller, who was to be appointed monuments offi-
cer for western Tuscany some months later, would return to the topic, with
a passion: "Italian Museum people . . . they are NEVER done asking for
things. When will I ever be through doing favors for these people?" In one
other instance at least, Hammond's terse prescriptions were vividly echoed
by Captain Keller's later tribulations. "Here caution and personal inspec-
tion are advisable," Hammond wrote on the subject of the Italian clergy.
"The demands of the church are insistent and exaggerated. Priests want

their churches repaired and reopened at once. Bishops want their palaces made habitable." After months of hard work in Italy, Keller concluded: "I do not like Bishops."

To the impoverished and demoralized Sicilian superintendents, the Allied advisers were an answer to all their prayers, for funds, transportation, and materials for repairs. Hammond and Maxse had their own woes, though, which were largely shared by most AMGOT officers who sailed to Sicily in the summer of 1943. These men were now experiencing in the field the substance of General Hilldring's warnings to the Roberts Commission in Washington. Army commanders, in general, did not look kindly on officers doing work of a civilian nature while a war was being fought. Army headquarters had refused to include AMGOT officers in the assault quotas for the invasion of Sicily; thirty officers had hastily been embarked with regular troops on the ships departing from North Africa by Group Capt. C. E. Benson within three days of the first landings. The initial confusion prompted Lord Rennell of Rodd, director of AMGOT, to declare to General Eisenhower, "I am frank enough to think that we shall get away with things here more by good luck than by good management." Once on Italian ground, AMGOT officers were promptly and rather unkindly renamed "Aged Military Gentlemen On Tour." Most of them picked up dysentery, and there weren't enough vehicles for them to travel and do their work around the island. "Why can't they get cracking on a bicycle?" a frustrated General Montgomery was reported to have exclaimed at the time.

Hammond was aware that art protection was at the bottom of the list of AMGOT priorities. "This work," he wrote, "is at best a luxury." For himself and his newly appointed clerk, Cpl. Nick Delfino, he managed, however, a bit better than a bike, although a far cry from the "sturdy and dependable transportation" he had hoped to requisition. He handled a succession of temperamental vehicles with unflinching bonhomie. "The *Balilla* 'Hammond's Peril,'" he wrote in a report signed with Fred Maxse, "sheered the bolts of a front wheel, endangering the life of Corp. Delfino, and has since been inoperative. For a brief period, a *Lancia*, model about 1927, of stately elegance and abundant room, was requisitioned for the use of the Advisors.

However, the owner showed such attachment to this Ancient Monument, and the question of maintenance was so problematical, that the Advisors felt that their official position required its return for conservation before it suffered 'war damage.'"

Perhaps it wasn't entirely facetious of Hammond to call his elderly Lancia a monument. Much that was ancient in Italy seemed beautiful to some, but antiquated and malfunctioning to many, just like a superannuated vehicle: broken, moss-covered column drums scattered around the ruins of a temple where only darting Mediterranean lizards seemed at home, or frescoes that couldn't tell their stories anymore because candle smoke, soot, and the passage of time had blurred faces and erased gestures. Ancient, inanimate beauty that stood, sometimes literally, in the path of battling armies was a difficult cause to defend within a conflict of such magnitude and complexity. To future monuments officers, then, Hammond recommended a low profile, and moderation in their requests for funds and materials. Any excessive show of enthusiasm on their part or exaggerated demands, he suggested, might make them look more like amateurs, a bunch of busybodies telling the army what not to hit, or, worse, gentlemen on the grand tour.

Despite its low military rank and mixed credibility, the job still held unexpected rewards. Once they were reenergized by some much-needed American "can-do" spirit and AMGOT funds and resources, most superintendents proved knowledgeable, dedicated, and indefatigable at their work. As monuments officers and superintendents drove together on surveys to villages, hamlets, abbeys, fortresses, and castles, they traveled across luscious countryside where the war was already beginning to feel like a bad dream that morning dispelled. They saw paintings that they had studied or admired before; sometimes they discovered art they didn't know existed. "I learned far more about the internal structure of the Baroque," Tubby Sizer wrote after the war, "by somewhat foolhardily climbing up over the sides of the half-blown-away domes than I ever did from the books." An altarpiece might appear from behind a makeshift wall that a village priest had built for fear of German looting. In more than one case, peasants had taken the sin-

gle masterpiece in their village to a hideaway in the hills known only to themselves. In one instance, the bombs that had ripped through the over-ornate eighteenth-century decoration of the Church of San Francesco of Assisi in Palermo had revealed a much earlier structure underneath that made the church the only medieval example remaining in the city.

For all its bureaucratic demands, the job beckoned the advisers away from their desks. As the monuments officers were all to learn quickly, upon entering a liberated town or village, and even before they met the superintendents, they needed to find themselves a local who would lead them to the sites. Even on the subject of materials, so hard to find after bombings had caused the wholesale destruction of Italian factories, the monuments officers realized that the locals, somehow, often seemed to know best where and how to find them. Nosing about, talking to people, putting their rusty or tentative Italian to the test, often led to discoveries:

Ref. Palermo-Archivio di Stato
Subject: Misuse of Historical Documents
To Whom It May Concern
20 January 1944

Today, 20 January 1944, shortly after 2:00 in the afternoon, the under-signed, visiting a hardware shop in Via Cassari (N.62), saw there some old MS. Documents loose on the counter and apparently about to be used as wrapping paper. Upon showing an interest in the documents he was allowed to examine them and, afterwards, a larger number which apparently had been removed from the same bound volume and com-prised some sheets of parchment, one with heading in gold. Upon offer-ing to buy the smaller batch of documents, he was told that he might have them as a gift. He accepted the offer and left two or three ciga-rettes in return. Upon his arrival at the office of the Monuments, Fine Arts and Archives Sub-Commission he reported the matter to Lieut. Cott and turned over to him the documents which had been given him. The batch proved to comprise sixteen leaves consecutively numbered

from 416 to 431 (fol. 418 a large document of Phillip V, with seal,
dated in 1713). A second visit to the neighborhood to determine the
precise location of the shop found it closed but revealed that several
shops in the Via Argenteria were using similar old MSS. (along with
other documents of more recent date) to wrap fish and other edibles.

 The hardware in question shows no owner's sign; as you proceed on
Via Cassari from Piazza Garraffello towards the port, it is the third
shop on the right, the first bearing the sign LA MONICA.

Bernard M. Peebles
Staff Sergeant
Clerk, MFAA Sub-Comm.

Peebles, the "discoverer of manuscripts," had joined the monuments offi-
cers in the fall; by that date, a few changes had occurred and the outfit had
expanded. As Italy turned from enemy to co-belligerent country, AMGOT,
the Allied Military Government of Occupied Territories, was renamed the
Allied Military Government, or AMG. Within its machinery, the small ad-
visers' office was now called the Subcommission for Monuments, Fine Arts,
and Archives, or MFAA. As the Allied Control Commission, or ACC, was
introduced to ensure that the terms of the armistice signed by Italy with the
Allies were respected, a few more men filled the MFAA ranks. In early No-
vember, Tubby Sizer, Bancel La Farge, and Norman Newton arrived from
North Africa. Perry Cott, an assistant curator at the Worcester Art Museum
in civilian life, was reassigned from his post as an intelligence officer in the
navy to the subcommission on grounds of his "outstanding authority on Si-
cilian art treasures." While Sicily was only to mark a brief passage through
Italy for La Farge, a New York architect who would later serve as a monu-
ments officer in the French theater, Cott and Newton, a professor of land-
scape architecture at Harvard, were about to begin a two-year wartime
journey across the Italian peninsula. At the end of November, they were
joined by Edward "Teddy" Croft-Murray. A curator of prints and drawings
at the British Museum of London, the Mozart-humming Croft-Murray

couldn't wait to be a monuments officer. He loved the Baroque, and on account of his passion for the florid civilization of the seventeenth century, and of his generous girth, once in Sicily he took to calling himself "il Baroccone" or, alternatively, "the Ancient Monument."

Planned and conceived in Washington, the MFAA program was beginning to take form in Sicily, its personality shaped by the officers' individual contributions: Hammond's good mind, Croft-Murray's passionate connoisseurship, Cott's scholarship, and Peebles's searching eyes and walkabout ways. Patient, meticulous work combined with an ounce or two of creativity, it was an unusual mix for a very unconventional outfit within the military government, but it bore fruit. By the time the last monuments officer was withdrawn from Sicily in March 1944, repair had been completed on forty churches in Palermo alone, and the MFAA declared the situation of monuments all over the island "under control."

The timeliness of the officers' intervention was key. War passed through Sicily relatively quickly, but would drag across the Italian peninsula for twenty-one more months; a new Italian government, which would apportion funds for the restoration of war-damaged monuments, would not be formed until May 1945. By rushing to their rescue, a few Allied officers and their Italian counterparts had salvaged the shattered churches and palazzi of Sicily from the threats of weather, vandalism, and looting—saved them, as Frederick Hartt wrote later, "from slipping from history into oblivion." Based on the Italian superintendents' enthusiastic response to the Allies' unexpected help, it is safe to say that a cultural mission had been launched whose significance went beyond the protection of historic buildings. It is no coincidence that General Montgomery chose the Greek theater of Taormina to harangue his troops; a spectacular setting for the very popular Monty, the ancient tall columns silhouetted against the Sicilian sea were also powerfully suggestive of an uninterrupted connection between the past and the present. The theme was bound to gain momentum as war left Sicily and moved onto the mainland and toward Rome. The monuments officers' task, though, after a deceivingly promising beginning, was going to get a lot tougher before it got better in the months to come.

THE BIRTH OF THE VENUS FIXERS

*It was that time when Naples lights up and swells like a jellyfish, its wounds glisten-
ing, its rags all covered with flowers, its population staggering.*
—Anna Maria Ortese, *Il mare non bagna Napoli* ("The Sea Does Not Reach Naples")

On September 3, two divisions of the British Eighth Army reached
the coast of Calabria, on the toe of the Italian peninsula. As the
British writer Alan Moorehead recorded, "There were no Ger-
mans to hit . . . no gun fired back at the British." Having conquered that
first foothold in Europe and despite the enemy's initial lack of opposition in
southern Italy, General Eisenhower was cautious in predicting a fast con-
clusion of the campaign. "The end will not come next month, but some
time next year," he told the press at the time. By delaying the Allies' ad-
vance through eastern Sicily with their strong resistance, the Germans had
secured the orderly evacuation of most of their forces to mainland Italy.
These General Kesselring had decided not to deploy in the southernmost
regions of the country, but to concentrate instead farther north along the
Tyrrhenian coast, where he expected the Allies were likely to land. On Sep-
tember 9, he relinquished Taranto, Bari, and Brindisi, three major Apulian
cities on the east coast. On the same day, however, when the American Fifth
Army entered the Gulf of Salerno, twenty miles south of Naples, Kessel-
ring's divisions were waiting for it. The battle at Salerno—its code name
was Avalanche—was long and hard fought. Although the Germans could
not ultimately push the Allies back into the sea, their forceful counter-

attacks engaged them in strenuous combat for days. Only on September 16 did General Kesselring order his troops to retreat to the north, destroying bridges and mining roads along their path. One week later, once the Salerno beachhead was secured, the Allies began their pursuit of the Germans toward Naples.

Neapolitans cheered when the British king's dragoons first rolled into their city on October 1, 1943. After four final days of furious street battle with the local population, the Germans had left the city, and Neapolitans were giddy at the sight of the Allied liberators smiling from their jeeps. A short-lived state of euphoria transported the population: they were waking up from the nightmare of battle, and the experience had the long-forgotten flavor of soft white bread, baked with flour that the Allies were beginning to bring into town, or the aroma of real coffee, at long last, and a fizzy new drink, Coca-Cola, which seemed to fill their forlorn bodies with bubbly new energy. What Allied troops and generals saw, as they entered the first major European city that they had captured from Axis control, was a stunned population reeling in an urban landscape of utter destruction. The smiling faces of the Neapolitans could barely hide the signs of physical deprivations that three years of war had visited upon them. After the cheering and the waving of flags, the southern capital welcomed its liberators by unfolding a range of problems that, in the initial months of the occupation, would seriously challenge the preparedness of their military government.

A pallid shadow of its sunny prewar self, Naples in the fall of 1943 was a place of hunger, gloom, and disease. The target of more than one hundred Allied air raids since June 1940, the city, as Colonel Hume, chief of the Allied Military Government for the region, remarked, "was largely in ruins." Its liberation did not signal the end of air strikes, which were resumed on October 1, 1943, by Axis airpower and continued into the spring of 1944. Naples, as the British writer Norman Lewis remembered, "smelled of charred wood." One-third of the city's buildings were damaged and most of them uninhabitable. The bombs had opened craters that made many city streets impassable. Dead bodies lay abandoned along the sidewalks, while the harbor was strewn with the wrecks of two hundred ships. A hundred barrage

balloons, looking bizarrely festive, hung over the port to protect it from low-flying planes. From 1942, the ferocity of the bombings had been such that Neapolitans had come to dread even a full moon, rising over Mount Vesuvius and bathing the bay with its radiance, because they feared that its light would expose the city to the bombardiers. *"Ce distruggeno!"* a character in Eduardo De Filippo's wartime play *Napoli milionaria!* cries out during one of these furious strikes: "They're destroying us!"

Those who could had fled, and only 600,000 out of the city's 1 million inhabitants were still living in Naples in October 1943. For those who stayed, the city had opened a whole underworld of unused underground stations and galleries as a refuge from the bombs. The nineteenth-century tunnels that connected the city center to Posillipo, a hill whose climate was so salubrious the ancient Greeks called it Pausilypon, a Pause to All Grief, and to the neighborhood of Fuorigrotta, Out of the Grotto, were turned into shelters. Subterranean caves, which had been dug since antiquity for tufa, the porous volcanic rock on which Naples is built, were filled with Neapolitans fleeing the bombs. At the sound of sirens, thousands of residents of the "Spanish Quarters," the neighborhood that the Spanish king's viceroy, Pedro de Toledo, created in the early sixteenth century for the housing of Spanish troops, climbed down ladders and hid in the ancient Roman aqueduct that lay ninety feet below street level. In the Sanità district, Neapolitans had turned the caverns under the Fontanelle cemetery into their bomb shelter, huddling amid the bones and skulls of thousands of the dead from past epidemics of cholera and plague. The frequency of the strikes had forced thousands of Neapolitans to turn the city's underbelly into their unsanitary and overcrowded wartime living quarters. When the Allies entered Naples, several cases of typhoid and cholera were confirmed, and the city's lower classes were reported to be on the verge of starvation. Water was in very short supply. German anger at its ally turned enemy had dealt one additional and violent blow to the moribund city: before leaving, German troops had sabotaged the city's aqueducts, its sewage system, and all major factories; electricity had been cut off in the last week of September, and streetcar rails had been torn up. Time-delayed bombs were planted

in several public buildings, and mines laid in the city's port. Just before flee-ing Naples, the Germans had flung open the gates of all twelve metropoli-tan jails, releasing hundreds of criminals and, with them, the contagious diseases many of them carried.

War, as one historian remarked, seemed to have thrust living conditions in Naples back into the Middle Ages. As a result of three very long years of death, hunger, and disease, the city's social fabric had begun to tear. Against extreme poverty and malnutrition, lack of clothes and sanitation, the strug-gle for survival had blurred all ethical boundaries. The black market flour-ished, and prostitution was rampant: in the fall of 1943 there were more than forty thousand prostitutes in Naples, the equivalent of one-quarter of the unmarried female population of the city. Just about anything and any-one could be had for as little as a pack of cigarettes or a pair of stockings. Worse than typhoid, and as virulent as hepatitis and malaria, venereal dis-eases were spreading among the local population, and three out of four Al-lied soldiers were reported to be infected. "What we were witnessing in fact," Alan Moorehead wrote, "was the moral collapse of the people."

The Allied Military Government's response to such emergencies was swift and resolute. "To bury the dead and to feed the living," the grim motto of Lt. Col. Lord Gerald Wellesley, senior civil affairs officer for the Sicilian city of Catania, summed up the AMG's absolute priorities. Food supplies remained critical all over the region of Naples throughout 1943. Within a week of the liberation, however, army engineers had swept the port of mines and cleared it of wreckage, making possible regular ship-ments of flour from the United States. One month into the occupation, sew-ers and water mains were fixed, and the system of pumps that brought water to neighborhoods high up on the hill overlooking the bay was func-tioning again. A small supply of electricity was reintroduced, as well as soap, which had almost disappeared from the city before the occupation. Piles of garbage were removed from the streets, and for months sappers would be busy disarming time-delayed bombs and mines. DDT, which had first been tested in North Africa, was extensively employed in Naples to ex-terminate the species of lice that caused skin typhus. Hundreds of thou-

sands of Neapolitans were sprayed with the pesticide, and for months men and women walking on the city's streets looked as if they had been dipped in flour. The entire neighborhood of Fontanelle, where the disease had spread with particular virulence, was evacuated, and by February 1944 the epidemic had been declared under control by Allied medical authorities.

In the massive effort to bring some measure of normalcy to a war-stricken city, any concern not directly related to that purpose could easily have appeared marginal, a misappropriation of man power and resources. The protection of monuments and works of art in the occupied country, arguably a low-ranking endeavor on the list of the AMG's duties, was at risk of sliding off its agenda entirely. The initiative had been tolerated in Sicily, where post-invasion conditions were nowhere so extreme, and the advisers for art and monuments had even enjoyed some degree of collaboration from other branches of the army. Not so in Naples, where the dramatic challenges posed by the ruined city were putting the army's resources, as well as its attitudes, to the test. Patching up churches and villas could seem frivolous next to looking after starving Neapolitans, or treating the Allied wounded soldiers who were being brought back by the thousands from the war front at Cassino. And that is exactly how the first, inevitable clash between monuments officers and other branches of the AMG took crude shape: a case of medicines versus mosaics.

The National Archaeological Museum of Naples, home to one of the most important archaeological collections in the world, was one of the few very large buildings still standing in the devastated city. It was created in the 1770s by the Bourbon king Ferdinand IV, who wished all the royal collections to be gathered in one place. Housed in what had been the seventeenth-century seat of the city's university, the museum was one of the oldest in Europe and boasted the celebrated Farnese collection of Roman statuary, gems, and coins that Ferdinand's father, Charles of Bourbon, had inherited from his mother, Elisabetta Farnese. Mosaics and bronzes as well as pottery and glass vessels found in Pompeii and Herculaneum were brought to the museum from the royal villa at Portici, where they had been displayed since the Bourbon-promoted excavations at Herculaneum had

first begun in 1738. Given its significance, the museum was precisely the kind of historic building that should have been put out of bounds by the AMG, with guards posted at its entrance. From the occupying army's point of view, though, the museum's location, smack in the center of town yet at a safe distance from the port, was, as Sir Leonard Woolley later described it, "temptingly convenient."

One week after the city's liberation, three British officers surveyed the museum's halls with the intention to requisition it for the quartering of troops. Amedeo Maiuri, superintendent of antiquities for Naples and its region, was incensed. Any military use of the gallery, he protested, would expose it to the risk of becoming a target of German air raids. How could the city's liberators jeopardize the museum's safety after this venerable institution, against the odds, had survived three years of bombings? The attitude of British officers on the subject of billeting was in general somewhat cavalier: many historic homes in Britain had been made available for army use, so why the fuss over the monuments of their former enemy? Maiuri, however, had every reason to be alarmed by the prospect of a requisition. Three weeks prior to the Allies' entry into Naples, he had cached the choicest Pompeian bronzes and Roman jewels in the Abbey of Monte Cassino. The mosaics and large sculptures, though, could not be moved, and the museum staff had protected them as best they could: On the ground floor, the massive statue known as the Farnese Hercules was partially walled in by sandbags. On the first floor of the museum, the huge mosaic from the first century B.C. of the Battle of Alexander—more than a million tesserae representing Alexander the Great on his horse Bucephalus defeating the Persian king Darius III at the Battle of Issus, in Syria, in 333 B.C.—still occupied one entire wall; in a strange twist of historical irony, the same thick gray ash that had buried it for sixteen centuries inside the House of the Faun at Pompeii now filled the bags that shielded it against bombs.

The superintendent himself had been a guest of the museum since a bomb had destroyed his apartment in April. With his family, he had found accommodation in a room called the Cabinet of the Venuses. During the day he had watched his wife and other women boil maccheroni over a

makeshift stove in the museum courtyard, or roast chestnuts on the balcony next to the Battle of Alexander. Like the passionate classicist he was, he had read Petronius's *Trimalchio's Dinner* to quell his hunger when food was scarce; at night, he had spread their mattress at the foot of a menacing Roman statue known as the Dying Barbarian. Professor Maiuri was well aware that the open plan of the museum galleries did not allow for the closing off of any of its sections. Its basement was filled with cases of Greek and Etruscan vases, and although its entrance was kept locked, he knew of soldiers' notorious knack for breaking open closed doors. And he had a secret. Not all the prize objects from the collections had been taken to Monte Cassino: the Blue Vase, a delicate amphora of deep blue glass with fine cameo inlays from Pompeii, and the Farnese Cup, an agate bowl from 150 B.C. known as one of the largest cameos in the world, were too precious and too fragile to be exposed to the perilous trip to the abbey. At night and in great secrecy, "as if it were the treasure of a Pharaoh's tomb," Maiuri had stashed them away in a hollowed-out corner of a museum wall. Only the three assistants who had helped him conceal the objects shared his secret.

After a month's silence that had raised Maiuri's hopes, the British Medical Corps did indeed requisition a large part of the museum for use as a pharmaceutical depot. The plan also provided for the billeting of forty men in some of the rooms occupied by the collections, and the installation of a kitchen in the courtyard. Within days, the statues on the ground floor disappeared behind stacks of Red Cross first aid kits. Crates stuffed with alcohol, ether, and other flammable substances were piled high next to frescoes and mosaics, while a constant flow of trucks rolled over the stones of the old courtyard loading and unloading supplies for all metropolitan and field hospitals. Sitting on column drums or leaning against the marble limbs of Greek athletes, Allied soldiers consumed their C rations, and soon over the portraits, the mosaics, and the marble busts of fierce Roman emperors there hovered a faint chemical smell. Maj. Paul Gardner, who had been appointed monuments officer for Naples and its region in early October, was not informed of the requisition of the museum by either the medical corps of the

British Eighth Army or the billeting officer of the AMG, but learned of its occupation, after the fact, from Superintendent Maiuri.

The two men had met one month earlier, when the newly arrived Gardner had visited a bedridden Maiuri at the museum. The superintendent was recovering from a wound suffered during an Allied air strike that had caught him while he was bicycling back to Naples after a survey at Pompeii: he had been hit by strafing fire, and his foot was shattered by a bullet. As Major Gardner stood by his bedside, Maiuri took in what Neapolitans call *"una faccia del buon augurio"*—"a promising face." He thought him "the most peaceful uniformed man in the world," and felt that he had finally found a sympathetic soul within the Allied government. The Harvard-educated Gardner, who had been the director of the Nelson-Atkins Museum of Art in Kansas City since 1933, became the Neapolitan superintendent's natural ally against his own fellow army officers, and despite Maiuri's Fascist record. This was a well-known fact to Gardner and his colleagues, who, however, had opted to handle it following Mason Hammond's pragmatic approach to the issue. "If possible," Hammond had recommended from Sicily, "it is best to let sleeping dogs lie and not to lose an experienced official." Consequently, Maiuri, a capable and undoubtedly dedicated superintendent, would not be formally investigated by the Allied Counterintelligence Service until June 1944, two months prior to the closing down of the MFAA subcommission's office in Naples and after he had rendered months of valuable service to the monuments officers.

Maiuri's hopes that Gardner's intervention would lead to the museum's prompt derequisition were dashed when, in late November, the two met with the British medical colonel responsible for the billet. As Maiuri watched Gardner and the British officer clash over the building's destiny, he observed a "strange reversal of roles," with "the American calm and composed, the British impetuous and aggressive." What made the colonel brazenly confident was his knowledge that Gardner could plead in the name of civilization but had no authority to back his request. Maiuri couldn't possibly know that when the AMG headquarters had moved to

Naples from Sicily, the MFAA and its director had been left behind in
Palermo. To use army language, at that date, in Naples, the subcommission
had not yet been "activated." The British major Paul Baillie Reynolds, who
had succeeded Hammond, called it "a most unfortunate arrangement." To
the layperson, it would have seemed just a bureaucratic glitch. Yet with no
official status, Major Gardner could only accept the National Archaeologi-
cal Museum's requisition as a fait accompli, and concede his and his team's
first resounding defeat of the campaign.

What little steam the small fine arts organization had gathered in Sicily
seemed to have evaporated during the crossing of the straits of Messina. To
make matters worse, a complete set of Harvard Lists for the area of Naples
was lost when the officer entrusted with them ran into German lines near
Palermo and, in Tubby Sizer's words, "he, his motorcycle, and maps disap-
peared." As a result, billeting officers could claim with a clear conscience
that they knew of no such thing as "protected" historic buildings that could
not be appropriated. When the Royal Palace of Caserta, the "Italian Ver-
sailles," was turned into the Allied armies' headquarters, Paul Baillie
Reynolds could only vent his frustration. "While damage is being done by
one section of the army," he wrote to Gardner, "another section created to
prevent such damage is powerless to intervene." British, American, and
French officers and soldiers were quartered in the Royal Palace of Naples,
and more troops were camped in the park of the palace of Capodimonte.
Soldiers helped themselves to the royal palace's antique chairs to furnish
their tents. Others stole rare stuffed birds from the university museum to
decorate their billets, but having grown tired of looking at them, they left
them dangling from tree branches in the university garden. The MFAA sub-
commission further reported that a group of GIs had broken into the crypt
of the Chapel of Santa Barbara in the Castel Nuovo, shaken the bodies of
the monks from their centuries-long rest, and danced about with their skulls.

The incidents, however minor, threatened to taint the entire Allied pres-
ence in Naples with the dreaded term "barbarian," and they did not go un-
noticed. News of soldiers' misdemeanors reached Leonard Woolley, the
archaeology and art adviser to the British War Office, who traveled to

Naples in early December to personally survey the situation. As was his wont, Woolley did not consign his own findings to paper, but back at Allied forces headquarters in Algiers he stressed the issue of negative propaganda that would inevitably result from those vandalistic episodes and got the immediate attention of generals. Once he gained that, he tackled the far more consequential matter of the actual role of the monuments officers in the field.

If lack of authority, he argued in a conversation with Lord Rennell, was what was crippling these officers' action in Naples, a general order should be issued to commanders and troops to regularize the protection of historic buildings. As the experience of Naples revealed, Woolley pointed out to Gen. Alfred Gruenther, Gen. Mark Clark's chief of staff, instances of damage caused by troops were most likely to occur in the confusion of the early days of the occupation, hence the necessity to have one or two monuments officers attached to the forward echelons of both the Fifth and the Eighth armies. As Sir Leonard reminded Gruenther, there had been no such officers present at the Fifth Army landings at Salerno, or when the British Eighth Army had reached the shores of Calabria in September 1943. Most generals were responsive to Woolley's appeal for greater respect of Italy's civilization, yet it was key that all commanders be made aware that no damage caused to its cultural heritage, whether due to negligence, ignorance, or malice, would be tolerated for the duration of the Allied armies' occupation. As Tubby Sizer later revealed, it was Woolley who drafted the letter that General Eisenhower addressed to all commanders and that was to redress the Allied armies' attitude on the subject. On December 29, 1943, the general wrote:

> *Today we are fighting in a country which has contributed a great deal to our cultural inheritance, a country rich in monuments which by their creation helped and now in their old age illustrate the growth of the civilization which is ours. We are bound to respect those monuments so far as war allows.*
>
> *If we have to choose between destroying a famous building and sacrificing our own men, then our men's lives count infinitely more and*

the building must go. But the choice is not always so clear-cut as that. In many cases the monuments can be spared without any detriment to operational needs. Nothing can stand against the argument of military necessity. That is an accepted principle. But the phrase "military necessity" is sometimes used where it would be more truthful to speak of military convenience or even of personal convenience. I do not want it to cloak slackness or indifference.

It is a responsibility of higher commanders to determine through AMG Officers the locations of historical monuments whether they be immediately ahead of our front lines or in areas occupied by us. This information passed to lower echelons through normal channels places the responsibility on all Commanders of complying with the spirit of this letter.

Dwight D. Eisenhower
General, U.S. Army
Commander-in-Chief

Sir Leonard, who had an affinity for the stage and a penchant for histrionics in his lectures, may have relished dashing to the aid of the traumatized Italian city like the deus ex machina of ancient Greek theater. He accomplished a lot during his four days in Naples. While there wasn't much he could do for the immediate de-requisition of the National Archaeological Museum, he would use it as an example never to be repeated. To that purpose, he made sure that the "spirit" of General Eisenhower's letter would inform the army's Administrative Instruction No. 10, issued in March 1944. Drafted jointly by the staff of Allied armies headquarters and the monuments officers, the document detailed the army's responsibilities in respect to Italy's cultural monuments and established a machinery to control indiscriminate requisitions. The AMG had "a staff of officers with expert knowledge of such matters who should be consulted," the instruction stated. While the use of the conditional still left some room for interpretation, the document put the monuments officers in the picture for those commanders

and their troops who until that moment had chosen to ignore their presence. In its final report, the MFAA described Sir Leonard's visit to Naples as "an event of great importance," and Administrative Instruction No. 10 "a turning point for the Subcommission's fortunes."

Woolley's blitz trip was the first of only three visits he paid to Italy during the Allied campaign. While gathering intelligence on Nazi art looting was to be the main focus of his activity throughout the war, he never showed much curiosity for the nuts and bolts of the day-to-day work of rehabilitation of damaged historic buildings that the monuments officers had begun in Sicily and which was to represent the specific nature of their service in Italy. But he avidly scoured their detailed monthly reports from the field for their "news value," the information they contained providing him with ample copy for the articles he compiled for the British press. He wasn't always accurate, and his frequent misspellings of Italian names and places infuriated the monuments officers and his closest collaborators in London. "Sir Leonard Woolley will soon begin to loathe me," the secretary of the British committee, Edith Clay, would write to James Mann in December 1944, "I keep finding discrepancies in his reports . . . I have been wondering whether there is some more lovely individual like myself in his office with whom I could speak on the phone to clear up points like these." John Ward-Perkins described Woolley's *Works of Art in Italy: Losses and Survivals in the War* as a "pastiche of unnecessary error." Still, such was the interest in the topic that Woolley himself had nurtured with his articles that the book sold out within four days of its publication in London in the fall of 1945.

Strategy, rather than attention to detail, was what Sir Leonard was after, and this he pursued with a single-mindedness that bordered on ruthlessness. His tactical sense of how to get things done in the army effectively straightened the course of the art protection program that was at serious risk of being derailed in the early, convulsive months of the Allied liberation of Naples. He alone, a World War I veteran, pushed for the activation of plans that, although carefully drawn up in the United States months before the Italian campaign, might otherwise have remained a dead letter. He

strengthened the status of the monuments officers, and he considered that a personal victory against the Roberts Commission. If Woolley wanted to prove that what the monuments officers needed to survive was a man of his rank, experience, and caliber, and not a commission, to guide them, he could not have been more persuasive. He showed he could get access to the army's top brass and knew how to move around a theater of operations. In contrast, when the Roberts Commission member Francis Henry Taylor, the director of the Metropolitan Museum of Art in New York, traveled to Paris in the summer of 1944, his unauthorized visit resulted in an awkward diplomatic accident. As he wrote in a personal letter to General Hilldring, Gen. Julius C. Holmes, chief of the Allied government section at the Allied forces headquarters, "pinched" Taylor in the capital's Hôtel de Crillon. "How he got there I do not know, but . . . in any event he had no business there as Paris is still an operational area. For your private ear," the general continued, "I realize that this is a touchy business and that there is great interest in it in high places. General Eisenhower knows that, too, and has impressed this fact on his commanders. He, of course, knows nothing of the importuning that has occurred in this field as he has enough on his mind whaling the hell out of the Germans."

When, a few months later, Woolley called the Roberts Commission "a failure, in practice," his old grudge against the American body that had pushed the creation of a British committee he did not want likely dictated his dismissive remark. However abrasive, Woolley's censuring carried a bit of truth. During the early months of operations, no steady flow of communication had been established between Washington and the Italian theater; Mason Hammond and Ernest De Wald, who was to become the monuments officers' director in February 1944, did not learn of the commission's creation until months later. With lack of clear guidance from home, and no authority, as yet, within the military government, it is little surprise that the monuments officers' work seemed unfocused at first and Reynolds and Gardner's performance somewhat disappointing. They were at risk of becoming the servants of two masters, not pleasing either. Even General Hilldring, who had supported their section from the start, was puzzled by

their early timidity. He called them "the scholarly mouse type . . . rambling noiselessly around the Mediterranean Theater."

For one thing, no one, within the chorus of their critics, seemed to have dwelled on the fact that the monuments officers' low army rank—a couple of them were majors, and the others captains and lieutenants—did not count for much and automatically excluded them from high-level planning and decisions. The officers did, sometimes bitterly so. "It's no fun to have to go to a Col. & tell him to be careful what he & his troops do in an occupied building," Deane Keller wrote. The combination of their low rank and superior education made them singularly, and uncomfortably, conspicuous to the troops. Soldiers were often amused by these officers, all past the fighting age. The British radio broadcaster and AMG officer Lionel Fielden could not blame them. "A less military-looking lot can hardly ever have been seen," he reflected as he cast a cold glance around his companions on the ship that took them from England to North Africa for their early training. "We were all, it seemed, middle-aged or more than middle-aged." To complicate things further, in the eyes of the regular GI, these particular officers fussed about old broken statues while bullets were flying. Even their name, the monuments, fine arts, and archives officers of the Allied Military Government, was too long, and slightly pompous. It called for a nickname. Whoever came up with the moniker—and, as with most good jokes, its circumstances, date, and paternity are unknown—thought of something dismissive, but impishly teasing, too. Whatever it was that they did was mixed with that most unmilitary of icons, the goddess of love. "Oh God, they called us the 'Venus Fixers,'" recalled the art historian Thomas Howe, a monuments officer in Austria and Germany in 1945 and 1946.

Of the more than eighty monuments officers deployed in Europe during World War II, twenty-seven served in the Italian theater. The Roberts Commission member Paul Sachs was responsible for selecting the American contingent of the subcommission, culled from long lists of navy and army officers. "A great deal of time and thought have gone into the preparation of this list," Sachs wrote to his colleague Huntington Cairns upon submitting an early roster of names in October 1943, "and, with fallible human

judgment, I am confident that this is a really satisfactory one." Among Sachs's early recommendations was Ernest De Wald, a professor of art and archaeology at Princeton: "thoroughly acquainted with the peninsula and . . . a linguist . . . eminently qualified to head up the work in Italy and be attached to headquarters." Accordingly, Major, later Lieutenant Colonel, De Wald, a veteran of World War I, was appointed director of the MFAA on February 28, 1944. A fifty-three-year-old tall and distinguished man, De Wald was the son of a Lutheran pastor of Swiss and Alsatian descent. He was endowed with a good baritone voice and could have been a sensitive interpreter of lieder and opera arias, but had instead opted for an academic life, preferring "the monastic spirit and the deep religious and scholastic atmosphere of Princeton" to the lure of a musical career. His deputy was also an archaeologist: John Ward-Perkins, the British man Rik Wheeler had named a monuments officer in North Africa before the role was even created. Together, they would spend most of their time at headquarters, first at Salerno, and later in Rome. The capital suited De Wald, who had a weak spot for the high clergy and old aristocracy. And while some of his colleagues in Italy thought him elusive and detached—"frankly, I find him the most difficult person to deal with," wrote the British archivist Humphrey Brooke—the scholarly and organized Ward-Perkins worked in good harmony with his director for nearly three years. Given time, Frederick Hartt also saw past his reserve, and found him amiable. "He is a charming and lovable person to whom I grow daily more devoted," Hartt wrote to Bernard Berenson in October 1945 from Salzburg, after he and De Wald had been working together in Austria for some months.

Knowledge of Italian was a guiding criterion for Sachs's selected candidates; a good understanding of the language, while an indispensable tool in itself, was often an indication of a deeper affinity with a country whose remote past was as luminous as its present was troubling and complex. Deane Keller, a professor of painting and drawing at Yale, the classicist Bernard Peebles, and Norman Newton, who taught landscape architecture at Harvard, had all been fellows of the American Academy in Rome and, as the recipients of a Prix de Rome, had lived in the capital for extended periods of

time. And then there was Frederick Hartt, an art historian with an impressive résumé for his relatively young age. A Boston native, Hartt had received a fine arts honors degree from Columbia University; as a graduate student, he had been instructed by the renowned art historian Erwin Panofsky at Princeton's Institute for Advanced Study. Hartt had written his master's thesis on the classical and medieval sources of Michelangelo, and his dissertation on the Mannerist artist Giulio Romano. As a colleague jokingly said of him later in the campaign, Hartt "breathed and lived Tuscan art for the U.S. Army."

The Venus Fixers' Italian contingent was made up of an assortment of archaeologists and art historians, artists, architects, and archivists, as befit a civilization that spanned fifteen centuries. The British element was mostly composed of architects, as Woolley had intended it to be. Architects, Woolley maintained, were badly needed while the war was still raging, since most of the monuments officers' activities would consist of first aid work brought to bomb-ravaged or artillery-pocked monuments; after the cessation of hostilities, art historians and conservators would be called upon to identify displaced paintings and examine their condition, but at the present stage of the campaign, architects alone, with their solid knowledge of building techniques and materials, could decide the fate of a badly shaken medieval wall or a Renaissance facade that was threatening to collapse, or how best to salvage an ancient Roman bridge whose structure had emerged from underneath the ruin of a modern one. The fury of the fight that swept through scores of Italian towns sadly proved the wisdom of his choice. Woolley picked his architects with care. He sought out Cecil Pinsent, who had flourished as a builder and restorer of Tuscan villas for decades and had only recently returned to England; he recruited the Italophile Roderick Enthoven, born of an Italian mother, and Basil Marriott, an elegant reviewer of art and architectural subjects for *The Builder* magazine.

A smattering of archivists completed the group. President Roosevelt himself had expressed to General Eisenhower his interest in the written records of more than a thousand years of Italian history, and concern for the extreme vulnerability of paper in wartime. In this area, too, Woolley

took the initiative and secured the advice of Hilary Jenkinson, since 1938 the principal assistant keeper of the Public Record Office in London. A thorough scholar, Jenkinson assured him that "with little trouble" the splendid Italian archives could be protected alongside the country's art and monuments. At Jenkinson's suggestion, the War Office dispatched three superbly trained British archivists in succession—Capt. Roger Ellis, Capt. Humphrey Brooke, and Maj. H. E. Bell—and armed them with Jenkinson's detailed lists of the ancient and the modern, and the public, private, and ecclesiastical archives of Italy. At the insistence of Fred Shipman, the director of the Franklin D. Roosevelt Library in Hyde Park, New York, and adviser on archives to the War Department, the imbalance between British and Americans was redressed, and Maj. William McCain was assigned to the MFAA subcommission in the fall of 1944.

Knowledgeable, scholarly, passionate about their calling, and thoroughly committed to their very unmilitary mission, the monuments officers were an unusual outfit within the Allied armies. A "*rarissimo* group," the American journalist Janet Flanner called them, of "mostly heroes who received little attention, and very highly civilized." A series of photographs from the Neapolitan days of the Italian campaign conveys the spirit that made their peculiar fight a quiet success, while capturing the looks and the sophistication that color their curious nickname with intriguing nuance. They were taken by one of the two artists among them, Capt. Albert Sheldon Pennoyer, a painter of landscapes with a predilection for railways and locomotives. A native of California, Pennoyer had studied architecture and art in London, Rome, and Paris, his thick mustache possibly a souvenir of his days at the Académie Julian, the most popular school in his time for American art students in Paris. The photographs he took of his colleagues were his humble nod to the art of portraiture.

Basil Marriott, holding a cigarette in his hand, turns a sidelong glance at the camera, the look of a ladies' man. Tall, notably handsome, he was "an amusing talker," in his nephew's recollection; "a dandy," he added, "as far as his varying fortunes allowed," who wore tailor-made military uniforms and grew a thin mustache as a wartime flourish. Pennoyer's lens captures

the supple line of the body that was lithe on the dance floor and the long hands that could draw with delicacy and precision.

Self-possessed and urbane, Marriott is photographed while leafing through the pages of an art book: one hand tilts the image of a large column-shaped woman enough for the viewer to see, an invitation to look and attempt a guess. As in the old painted images of saints, whom contemporary viewers and worshippers would instantly recognize by the instruments of their martyrdom or some other hint of their "area of expertise," every object is a clue or a prop in Pennoyer's photographs of the Venus Fixers. Rather than Saint Lawrence with his gridiron, though, their portraits seem to be pointing at Saint Jerome for their model, surrounded by all that the intellect wants for its work: books, maps, paper, ink, and a good source of light. A length of the Tyrrhenian coast on a wall map of Italy is the background of John Ward-Perkins's portrait, the many tortuous roads that carried the Venus Fixers on innumerable trips across the peninsula radiating, as it were, from his head. Teddy Croft-Murray, a map spread on his desk, with an eraser and a ream of lists of artworks, runs his pencil-holding hand through his hair in mock despair: so many monuments, so little time, and no jeep!

As their portraits discreetly suggest, the Venus Fixers, while proudly wearing their uniforms, were not going to renounce their identity as "art men." A scarf tied loosely around the neck, horn-rimmed glasses, or a slanting beret, these small but telling details declare that in their fight to protect Italian art, their connoisseurship, idiosyncrasies, and mild eccentricities were going to war, too. Striking Renaissance poses in modern military garb, their portraits breathe a tacit determination to be promoted from pain in the neck to thorn in the side of the Allied armies.

THE CONFLICT OF
THE PRESENT AND THE PAST

The war raged and destroyed, men expired, buildings fell. It was overpowering, at times, to follow in its wake and see silent desolation where civilization was once vibrant.

—Albert Sheldon Pennoyer

With their skills still largely untested and their personalities only slowly coming into focus, the Venus Fixers gathered at the bleak scene of wartime Naples. Ernest De Wald arrived in the city within weeks of its liberation. More officers joined him during the winter and through the spring months of 1944. By the time Frederick Hartt reached Naples as a newly minted monuments officer, his colleagues were all still stationed in the southern capital, locked behind a front that for months had remained ominously near yet seemingly impassable. After relinquishing Naples, the Germans furiously battled the Allies along the banks of the tortuous Volturno, twenty miles north of the city. Once they victoriously crossed the river, General Clark's men were faced with the massive range of the Apennines, which run like a backbone across Italy from Campania to the Po valley, and, laced through its peaks, ridges, and gorges, the mighty fortifications of the German Winter Line. By mid-October, the German general Albert Kesselring, with his clever tactics of counterattack and gradual retreat, had bought his army enough time to look forward to the autumn rains and the chill of the approaching winter as powerful allies

in its strenuous defense of that most hostile territory. The Allies' breakthrough would not come until May 1944.

Naples, that winter, was blighted and inhospitable. "I've never been so cold in my entire life," the monuments officer Deane Keller wrote to his wife on reaching the city in February 1944, "perhaps because I've never lived in unheated places before." In the devastated city, the Venus Fixers' accommodation, in De Wald's understated words, was "rather bare," AMG officers having got what was left over by forward troops. Teddy Croft-Murray shared "a rather ramshackle flat near the docks" with Christopher Lumby of *The Times* of London and Cecil Sprigge, Reuters' chief correspondent from Italy. "No electricity tonight, so I'm writing on my table by candlelight," Keller reported from his room in the half-destroyed Hotel Volturno on the historic and bustling Via Toledo. De Wald's nights in his elegant but abandoned apartment on the hill of Vomero were "a grim and spooky affair"; with sweeping views of the city and its bay, under the shadow of the massive Castle Sant'Elmo, he "played solitaire by candlelight to while away the time before retiring, interrupted on occasion by air raid warnings and the raids themselves."

The MFAA had its office in the Palazzo delle Poste, the main post office, a modern building that a German time-delayed bomb had partially destroyed, killing thirty people, one week after the liberation. Through its broken windows the sounds of the city reached the Venus Fixers as they sat at their desks: carts rolling over the cobbles, a hand organ being played in the street, the voice of a boy who sold copies of the Allied armies newspaper, *The Stars and Stripes*, chanting "*Starsa e Streeps.*" "By looking out of my window," Keller wrote on February 19, "I can see broken glass and plaster stripped from walls, a little woman all wrapped up in a shawl, no stockings, is sitting behind a box on which are two trays of nuts to sell, a pot of ashes— now cold—by her side. Sun is going down. Over her is a sign—'Istituto di Danze' [Dance School]."

Naples, ever a study in contrasts, which its wartime agony had heightened, held a fascination for the American and British Venus Fixers that was alternately bewitching and lurid; its mysterious beauty surprised them, its

misery stoked their nostalgia. "I have seen the destruction of war in material and human life. Have seen works of art which I never saw before," Keller wrote within days of his arrival. Claustrophobic, suffocating, and harsh, Naples was a tough school for them, a protracted lesson in loneliness, frustration, patience, and resilience. While its streets and alleys teemed with "that eternal Neapolitan crowd," as the novelist Anna Maria Ortese described it, "that keeps on moving like a snake scorched by the sun but not yet killed," the city was isolated from all other liberated southern centers by the German destruction of railroads, and cut off by the front from Rome and the north. For months, no one was allowed to travel beyond five miles of the city. With little or no transportation available, the Venus Fixers spent long hours at their desks poring over guidebooks and compiling lists of monuments they hoped still to find standing in the cities they would be assigned to once the Allies finally advanced to the north. At no other stage of the Italian campaign did they all share one office. They worked knee to knee and had ample time to study one another at close quarters; highly individualistic men that they all were, they slowly learned how to function as a team.

Paradoxically, given its current drama, Naples was an ideal city for the Venus Fixers to start their Italian journey. Though not as rich in celebrated monuments as Florence and Rome, Naples was vibrant proof that there is more to the beauty of a place than the sum of its masterpieces. Its rich and ragged fabric told the city's complex history, the very tears in that cloth often revealing the many layers of its ancient civilization. The bombs of August 1943 that nearly destroyed the beautiful Church of Santa Chiara, stripping it of its eighteenth-century marble and stucco decorations, had brought to the surface the stark simplicity of its original Gothic structure. Alluring and challenging, Naples rewarded the curious, the patient, and the enterprising. "I enjoy walking along its narrow old streets and under its tall roofs; I find comfort in the deep shadow of its old memories," the philosopher Benedetto Croce wrote of his birthplace. For those who climbed its hills, the city opened up breathtaking vistas; and if they dared to venture through its narrow and slightly threatening alleys, their eyes might be daz-

zled by a sumptuous Baroque church concealed behind an inconspicuous facade, or catch a glimpse of the soaring sweep of a rococo staircase from behind the gate of an inner courtyard. Their spirits would be soothed by the unexpected peace of a cloister hidden at the heart of an overcrowded neighborhood, or cheered by the glossy majolicas of a church floor.

Naples was for connoisseurs. And with time on their hands, the Venus Fixers used their knowledge to fill in the dots of vague directions from Washington, let their passion define their job, and allowed their inquisitive minds and insatiable eyes to guide their first steps. One morning in early May, Edward Croft-Murray made his way up to the palace of Capodimonte, built by King Charles of Bourbon in 1734 to take advantage of its wooded hills' good hunting terrain. The ascent to Capodimonte, the Top of the Mountain, is long and somewhat steep, yet it would have been well within the strength of a good pair of war-toughened legs. It climbs in a straight line from the Via Toledo, leaves the rusty red walls of the National Archaeological Museum behind, and runs past the Rione Sanità, the neighborhood with the auspicious name Health, huddling around the Baroque Church of Santa Maria della Sanità, and the bright sight of its colorful majolica dome. Once one reaches the top of the hill, Naples comes into view just like Norman Lewis saw it in the days of the occupation, "an antique map, on which the artist had drawn with almost exaggerated care the many gardens, the castles, the towers and the cupolas." Seen from above, Lewis remarked, the city seemed "cleansed of its wartime tegument of grime," and it simply looked magnificent.

The purpose of Croft-Murray's visit to Capodimonte was to check on its collections; yet it was also in the spirit of a pilgrimage that he climbed the hill, following in the steps of the neoclassical sculptor Antonio Canova, Goethe, and the Marquis de Sade, who before him had admired the paintings, drawings, and precious objects, the rich library, and the armor that the Neapolitan sovereigns had gathered in the palace. As Croft-Murray walked around the deserted rooms, the rows of gleaming Italian swords, the Bourbon suits of armor, and a sixteenth-century tournament helmet, among the finest ever crafted by a Milanese workshop, brought to mind his friend

James Mann in London. Mann was the keeper of the Wallace Collection of eighteenth-century paintings, furniture, and porcelain, a member of the British Committee for the Preservation and Restitution of Works of Art, and the master of the armories at the Tower of London. The armory at Capodimonte was in a poor state, Croft-Murray realized, God only knew when it had last been cleaned. He thought the Italians could use some expert help—like that of Mann, for instance, who had spent several summers in the late 1920s, in the sweltering heat of Mantua, cleaning a set of suits of armor that had belonged to the Gonzaga family and that had erroneously been believed to be made of papier-mâché. "Dear Mann," Croft-Murray wrote later in his beautiful penmanship—modeled, as he relished explaining, on the Carolingian uncial script:

> I have recently been up to see Capodimonte and (which I know you will be interested to hear) went round the armory there. Everything there is untouched—in fact too untouched. The windows were blown out of the rooms & the damp air has unfortunately got in and affected many of the suits which have become surface rusted in consequence. We have protested very strongly about this, but unfortunately I rather gather that the old Duchess of Aosta, who lives there, has been one of the difficulties as she bullied the Italian authorities into letting her have the prior claim of having her own windows put in before the Museum could be dealt with.

The term "minor," often employed to describe the decorative arts, did not belong in Croft-Murray's lexicon, nor did it have much currency with his fellow Venus Fixers either. Even if emptied of its masterpieces—its superb collection of paintings, and its magnificent Titians among them, had been cached in the Vatican for months—Capodimonte had ornate marble floors and frescoed ceilings and was lavishly furnished. Its collection of china was a rarity. In 1743, King Charles of Bourbon had started a workshop of fine porcelain in the woods of Capodimonte to rival the celebrated

Meissen and Sevres manufactures. Upon becoming Charles III, king of Spain, in 1759, the monarch left the entire collection of paintings, statuary, and objects in Naples, but brought the china manufacture—craftsmen, materials, and formulas—to Madrid, where he renamed it the "Buen Retiro." The Capodimonte production of china had spanned only seventeen years. As for the armory, the wearers of those iron suits Croft-Murray had found all rusty and dusty in the palace's galleries were often the same men who had commissioned chapels and altarpieces, palaces and *studioli*, their taste no less refined when it came to the etching on a helmet or the embossing of a cuirass that protected them from the blows of battle. God was, literally, in the details for Croft-Murray, as had been the case for the medieval and Renaissance rulers and clerics and the scores of artists and craftsmen who worked in their service. And details would be given due attention by the Venus Fixers, no village being too small not to justify an inspection, no church, monastery, or museum too "minor" to be worthy of a survey.

A couple of guards posted at the palace gates were all that was needed; a minimum demand on the overextended AMG ranks, they made all the difference between a looted collection and one that, when the war was over, was virtually intact. *"L'occasione fa l'uomo ladro"* goes an Italian saying: "opportunity makes the thief," as was well-known to General Hilldring, who, back in 1943, had warned the Roberts Commission that soldiers are not vandals but need a little watching. The posting of OUT OF BOUNDS signs on monuments, in itself a rather prosaic endeavor and hardly requiring a team of experts to perform it, nonetheless declared that someone within the Allied armies cared for those vestiges of an old civilization; and that was in most cases a sufficient disincentive for trespassers and souvenir hunters. As for the indoctrination of troops and their commanders, there, too, the Venus Fixers took the low-key approach, the only one that their low rank allowed. As they could not sit around a table with generals strategizing the next operation, they wrote memos to colonels emphasizing the particular artistic relevance of a town about to be entered and a constant stream of letters to regional commanding officers protesting, for instance, the requisi-

tion of a section of the San Carlo opera house for use as an officers' club, or the unconscionable whitewashing of a frescoed wall in the Royal Palace by overzealous and ill-advised soldiers.

Though delivered in the humdrum tone of army communications, their message of respect for the civilization of the liberated country was unrelentingly tenacious. A far cry from the rhetorical flourish of a Rik Wheeler stumping amid the ruins of Leptis Magna, it nevertheless seeped through army ranks. Ernest De Wald authored the *Soldiers' Guide to Rome* and its companion guide to Florence; in the booklets he devised sightseeing walks for the GIs and filled them with curious details. On the Church of Saint Cecilia in the neighborhood of Trastevere, for instance, he went to some length to describe the death of the saint, the protector of music who was martyred for her Christian faith in A.D. 230. Cecilia did not perish after having been plunged in a scalding bath for three days, "and three strokes of the sword—all," De Wald specified, "that Roman law allowed—failed to sever her head from her body." According to the legend, the saint survived two more days and is buried in the catacombs of Saint Calixtus. Arrestingly gruesome, it was the kind of story that once heard is never forgotten; De Wald, undoubtedly a subscriber to the belief that the stones will talk to those who know, matter-of-factly passed it on to soldiers, to mull over on a stroll around Rome. "The European grew up with these monuments," he later wrote. "They were woven into the very woof of his existence from the days of his earliest childhood and were the visible bridge leading from his cultural past into the present."

Sadly, no indoctrination, however impassioned, could always prevent destruction. When a monument was torn apart by bombs, the spectacle was a shock for the Venus Fixers, and the amount of destruction often disheartening. "TO CENSOR: if this is beyond limits please throw it out," Deane Keller wrote in a letter to his wife on March 27. "I went to a church a while ago, a beauty, just as a sightseer. I went to the same church a few days ago and there was little left. Went on business: that drove the lesson of this war as solidly as anything . . . It is very terrible, utterly destructive." Two weeks before Keller's letter, the Church of Sant'Anna dei Lombardi had been hit

during one of the most devastating German air strikes, which left three hundred dead in Naples. Its beautiful coffered ceiling was smashed and the portico destroyed. As De Wald cautiously waded through the rubble that smothered the naves, he saw "great cracks . . . in the walls of the two chapels flanking the entrance from which the disordered pipes of the old 18th century organ were dangling like the entrails of a disemboweled horse in a bull-ring." Also known as Monteoliveto, Sant'Anna is a Renaissance church of elegant proportions. The marble reliefs and sculptures by the renowned Tuscan artists Benedetto da Maiano and Antonio Rossellino grace its walls and chapels. This was a rarity in Naples, for the Aragon king Alfonso II, who had good political relationships with the rest of Italy, encouraged "foreign" masters to come and work in the city and decorate the church where he loved to attend Mass. It was thanks to his sister Eleonora, who married Ercole d'Este, that Guido Mazzoni, a sculptor at the Este court in Ferrara, realized one of his masterpieces for Sant'Anna, *The Lament over the Dead Christ*, in 1492. Buttressed in sandbags, the stunning group of eight life-size terra-cotta figures, two of which were said to represent the Aragon royal couple, had survived the force of the blast. Maiano's relief of the Nativity and Rossellino's tomb of Mary of Aragon also emerged unharmed from underneath the seaweed-stuffed mattresses that had covered them, "and what good fortune they had had," De Wald remarked as he recalled his and his colleagues' trepidation in unveiling the sculptures from their protection: "The emotion of an archaeologist bringing forth from the dust of antiquity some masterpiece of the past could not have surpassed our own."

The ancient bronze doors of the Cathedral of Benevento had not been so fortunate. On September 19, 1943, an Allied air strike killed one thousand civilians and almost completely destroyed the town's Romanesque shrine. Since the attack, wild rumors had been circulating about the thirteenth-century bronze doors, among the masterpieces of medieval art. The local population believed that the seventy-two panels representing scenes from the Old and the New Testaments had been taken away on trucks by the Germans. Major De Wald decided to investigate the alleged disappearance

and asked for special permission to travel to the small town to the northwest of Naples. "I had a personal interest in the fate of the bronze doors of Benevento," he wrote later, "because I had had many occasions to use them as material in my studies in medieval art." When he found them, heaped in the dormitory of the Benevento seminary, where the clergy had sheltered them after the attack, he could barely recognize them. "The archbishop being absent," De Wald recounted,

> on the day of my first visit I called on the rector of the seminary . . . He received me most graciously, we chatted of mutual interests and of friends in America. I stated my mission and my concern for the bronze doors. He smiled and told me that I had come to the right place . . . With difficulty I restrained my excitement and impatience. Eventually we ascended the stairs to the long narrow dormitory, at one end of which was a large disordered heap of metal which represented the bronze doors of Benevento! Rosettes, bits of molding, jagged fragments of broken panels made up the heap, a pathetic witness to the force of the blast and the fire which must have ensued. For the metal which formerly had a beautiful patina was now the color of terra-cotta and was friable to an extreme.

As De Wald set to work rearranging the charred panels, he found that four were in fragments and only six missing—five, in fact, at a later tally, as a GI had taken one as a souvenir back home to the Midwest, but thought better of it and returned it when he learned what it was. It was a labor of love on his part, patient, inconspicuous, and necessarily incomplete, for the monuments officers' job was to be limited to the first aid stage of the intervention; only in their role as emergency room doctors, who could handle the acute phase of a crisis or stabilize an injured patient, would their presence be justified within the Allied armies, while restoration proper would be the Italians' peacetime responsibility. "Artistic restoration," as Bruno Molajoli, the Neapolitan superintendent of monuments, explained, required a patient examination of the damaged structure, experienced crafts-

it came at a time when, after months of hard work in Naples, the Venus Fixers were reeling from a blow made all the more devastating by its having been inflicted by their very own army.

On February 15, 1944, 450 tons of Allied bombs hit and destroyed the Abbey of Monte Cassino. Square, massive, and very white, Monte Cassino sits starkly on a steep hill that dominates the confluence of the Liri and Rapido rivers; all around, the peaks of the southern Apennines encircle it like an amphitheater. To the north of the abbey stands Monte Cairo, towering at five thousand feet; to the west lies the Liri valley and the ancient Via Casilina, which, running along it, leads to Rome, eighty miles to the north. Remote, solitary, and awe-inspiring, Monte Cassino has been a sacred place since antiquity. The remains of a Roman temple to Apollo were still standing on the hill when Saint Benedict chose the site to found his monastery, in 529. At Monte Cassino the saint wrote the Rule of Benedict, a series of precepts that regulates the community life of monks and that was to be adopted by most Western monasteries. Vowed to a life of prayer and manual work, during the Dark Ages the Benedictine monks preserved literary works that had been passed down from antiquity, copying and ornamenting them with magnificent illuminations on parchment codices. The abbey became renowned for its Gregorian chant. The secluded Benedictine rule, however, could not protect the abbey from the passage of history. Before the Allied air strike of February 1944, Monte Cassino had been destroyed by Zotto, Duke of Benevento, who led the Lombards in 581; the Saracens had laid waste to it in 884, and an earthquake had demolished it in 1348.

Since the Allies had reached the foothills of the Apennines in late October, their advance on either side of the peninsula had been slow and difficult. German defense lines cut across Italy from the Tyrrhenian to the Adriatic coast, and the mountainous terrain couldn't have been more favorable to their purpose. By enlarging mountain caves and building underground chambers, flooding plains, stretching barbed wire, and planting mines, General Kesselring's army erected a rampart of defense that proved as formidable an opponent as the natural obstacles of rivers, hills, moun-

men, and special materials, which were virtually impossible to find in wartime. While hostilities lasted, and bricks, tiles, and wood were earmarked for rebuilding homes, hospitals, and schools, all the Venus Fixers could do was search for fragments through the heap of blackened stone and crushed timber of demolished monuments; they picked up the pieces that made the postwar process of regeneration possible. Two thousand cubic feet of rubble were searched and removed from the Cathedral of Benevento alone.

The significance of the Venus Fixers' seemingly modest intervention was not lost on Molajoli. "The clearing of rubble, the shoring up of walls, and the patching of tiles on a church roof may look like work of a rudimentary nature and quite simple to perform," he wrote in 1944. "When it comes to ancient monuments, though, one has to be able to read their old structure, interpret their history, and be quite familiar with the events of their often intricate past. Monuments are like venerable seniors, and more often than not, they are venerable as well as chronically ill . . . As it happens, however, a timely and well-calibrated treatment in response to a sudden crisis may result in curing the new complaint as well as the old, and restore these patients to a state of health that would simply have been undreamed of before." Only a year earlier, at his city's darkest hour, Molajoli had felt discouragement and resignation prevail. "To seek help for the safety of our old monuments," he had written then, "would have been deemed naive, indeed delusional at a time when all spiritual values were being crushed by living conditions that were so harsh they resembled mere survival." To his grateful surprise, the Allied armies showed a preparedness that filled the superintendent with newfound energy and even some optimism. "Trapped" in Naples for months, half a dozen monuments officers, who would later be spread across the peninsula, were able to focus their attention and resources on the wounded monuments of Naples. In June 1944, all sixty-five Neapolitan churches that had suffered war damage were being repaired; by midsummer, work was so advanced that the superintendent described it as "the greatest first aid program that was being carried out in Europe at the time for the conservation of the artistic heritage of a country." The tribute was as heartfelt as the boost it offered was most needed and gratefully received, for

tains, and gorges. The narrowness of the valleys proved impassable for the Allies' heavy artillery. Rain, cold, and mud numbed their soldiers' strength and gradually crushed their morale. Between mid-November and mid-January, the Allied Fifth Army battled for every peak under the constant fire of German artillery and, while suffering heavy losses, managed to advance a mere seven or eight miles closer to Rome. As General Clark recalled in his memoir, "The Fifth Army took one strong point after another, only to see, through the rain and the mud, still another mountainside on which the enemy was entrenched in pillboxes and well-protected artillery emplacements." So well protected, in fact, were the enemy's positions that a group of German officers, as General Clark would later recount, was known to have been playing cards inside a bunker dug into the mountain during a particularly intense Allied air raid and artillery attack. When Allied forces finally broke through the Camino hills, three miles south of Cassino, in early December, they were faced by the Gustav Line, the last bastion of German defense before Rome: stretching from the foot of the Majella massif to the east, to the Rapido River toward the west, the line ran right behind the town of Cassino.

"The battle of Cassino," General Clark wrote, "was the most grueling, the most harrowing, and in one aspect perhaps the most tragic of any phase of the war in Italy." The fight to win control over Cassino, a town of twenty thousand people ensconced at the foot of the hill, began on January 17, 1944; by February 10, very little progress had been made, and the troops, some of whom had been fighting uninterruptedly since September, were exhausted and demoralized. On February 12, the British general Bernard Freyberg, who was to lead the New Zealand Corps in a renewed attack on Cassino, requested full air support. He asked that the abbey be bombed. Although German artillery positions and observation points were scattered all around the area, there were no German soldiers inside Monte Cassino. The abbot, Gregorio Diamare, a small group of monks who had refused to leave the monastery, and between one and three hundred refugees from the town of Cassino were the only inhabitants left in the abbey at the time. Yet the solitary shrine had seemingly come to represent for Allied soldiers the

impregnability of the place. Its four rows of tall windows felt like eyes whose hard gaze was fixed on their suffering; its massive walls, blindingly white against the mud and the blood of the battle below, stood like the defiant symbol of an unattainable victory.

The abbey was on a list of forbidden targets, and Allied generals were all aware of the efforts that had been made up to that moment in the campaign to avoid unnecessary damage to monuments and religious shrines. General Freyberg, however, called its destruction a military necessity, and Gen. Harold Alexander backed his request. General Clark held the opposite opinion, that the bombing of the monastery was not only of little or no strategic significance, but would come to represent a psychological as well as a tactical mistake; the general knew from experience that the ruins of a building could usefully be turned by the enemy into an observation point, or a sniper's den. Since the operation was being led by a British commander, though, the American general acquiesced to General Alexander's decision.

And so at 9:30 on the morning of February 15, over two hundred heavy and medium bombers flew over the Abbey of Monte Cassino. By the time the raid ended, at 1:30 in the afternoon, only sections of the seventeenth-century external wall of the monastery, the main staircase, and the tombs where Saint Benedict and his sister Saint Scholastica were buried had survived. The abbot and his monks were escorted to safety by German soldiers after the end of the savage strike, but some 150 refugees were believed to have perished in the explosion. Monte Cassino, however, was not captured on February 15 or in the following days. Indeed, German troops made excellent use of its rubble, and the abbey only fell into the hands of the Polish Third Carpathian Division of Allied armies three months later, on May 18. Once the road to the capital was finally opened, Rome was liberated on June 4, on the eve of the Allied invasion of Normandy. The Battle of Cassino had cost the lives of fifty thousand Allied and twenty thousand German officers and soldiers.

General Clark called the destruction of the abbey "a tragic mistake." Years later, in his memoirs, General Alexander defended it: "When soldiers

are fighting for a just cause and are prepared to suffer death and mutilation in the process, bricks and mortar, no matter how venerable, cannot be allowed to weigh against human lives." The fate of Monte Cassino, the first major building of both religious and cultural significance to stand in the path of the two battling armies, had put General Eisenhower's message to commanders to the test of war. However opposite, the two generals' views fell well within the terms of Eisenhower's letter. The first great cultural casualty of the war, Monte Cassino was also the victim of a conflict of a different order, whose nature a poet had comprehended, with stark clarity, eighty years before the events that would fell the abbey.

In the 1870s, Henry Wadsworth Longfellow had climbed to the monastery and listened to its bells chime for vespers. The profound quietness of the place at break of day seemed to him to resonate with the echo of the many centuries of its history:

> *From the high window I beheld the scene*
> * On which Saint Benedict so oft had gazed,—*
> *The mountains and the valley in the sheen*
> * Of the bright sun,—and stood as one amazed . . .*

> *The conflict of the Present and the Past,*
> * The ideal and the actual in our life,*
> *As on a field of battle held me fast,*
> * Where this world and the next world were at strife.*

> *For, as the valley from its sleep awoke,*
> * I saw the iron horses of the steam*
> *Toss to the morning air their plumes of Smoke,*
> * And woke, as one awaketh from a dream.*

Military necessity or tactical blunder and a senseless blow to civilization, the destruction of Monte Cassino caused furor, shock, and disbelief, as well as a short-lived sense of relief among Allied troops fighting in the region.

Disconcertingly, among the clamor of media reports, official statements, and individual reactions, some of the most dissonant notes came from the ranks of those who should have lamented the loss of the monastery. "The German press of the last few days is devoted to Monte Cassino and its destruction by those barbarians, those air gangsters, those terrorists, the Anglo-Saxon aviators," Bernard Berenson wrote in his diary on February 27. Seemingly blind to the fact that even if couched in overblown language, the enemy's coverage of the tragedy perhaps had a point, the art critic found comfort in the thought that the three-time-rebuilt Monte Cassino wasn't a monument of such artistic import. "I wonder how many of the writers, let alone readers," he continued a little further in his entry, "of such stuff had ever heard of Monte Cassino; and of those who had heard of it what percentage had any notion of what the place was worth artistically." It escaped Berenson that the relative newness of the abbey—such a flaw in his eyes—could be considered an implicit tribute to the inextinguishable holiness of the place. "The buildings and decorations were no earlier than of the seventeenth century and in no way remarkable for that period," he wrote. "There are in Catholic countries hundreds of structures far more valuable. What connoisseur would dream of placing it beside the Escorial or Sankt Florian or Melk!" In its ferocious artistic elitism, Berenson's tirade had an object, but its name was not Monte Cassino. The sad fate of the monastery was rather the occasion that had once again rekindled the critic's contempt for the vainglorious artistic policies of a boorish dictator: "A Mussolini is free to demolish and disfigure whatever he pleases in a city like Rome, to make hideous gashes, to bottle up spaces, to furbish up and even to forge ruins, and to receive nothing but prayer and praise except from a few soreheads; while the accidental destruction of this or that bit of ancient building by Allied bombardment is a crime against civilization, against humanity."

Jarring and provocative, Berenson's reaction pales in comparison with the response that the destroyed monastery elicited in Sidney Waugh, a sculptor, a former Prix de Rome recipient, and, of all things, a Venus Fixer. Forty-year-old Capt. Sidney Biehler Waugh, whose designs for Steuben

Glass remain to this day among the most distinctive of the American firm, had been the first Venus Fixer to join Ernest De Wald in Naples in the fall of 1943. Although he found him a bit of a prima donna, Deane Keller appreciated his talent and enjoyed his company. The sympathy was not reciprocated. As he revealed in his correspondence with his brother and in the pages of his diary, Captain Waugh intensely disliked his army assignment as a monuments officer and harbored a deep distrust of Italians. He called his colleagues "sentimental criminals," or "sentimentalists in uniform," who would not hesitate to hold up war operations to save a little piece of antiquity. More radical than the most obstinate of army oppositions, he thought that the true purpose of their war service was "to make up lecture notes for the first five years after their return to Princeton." On the day that Monte Cassino was destroyed, Waugh wrote the following in his diary: "I can't remember anything I have seen or done that made me as happy as the sight of the abbey being blown off the top of the hill . . . I loved to see the symbolic breakdown of the church and monument tradition."

Captain Waugh wrote that the ban on hitting Monte Cassino had been lifted "partly through my efforts," a rather boastful claim. Like the monuments officer Norman Newton, who was with him that day, he was nothing more than a spectator while the abbey burned. He could no more congratulate himself over its destruction than the Venus Fixers could be blamed for not having been able to stop it. No document from that date indicates that their opinion was solicited, or indeed that they were aware of plans to destroy the abbey. Still, the tragedy was a blow to their credibility. Herbert Matthews, who was covering the battle for *The New York Times*, did little to improve their standing. He took it upon himself to talk to the troops about the monastery's history, and months later told the Roberts Commission that soldiers and commanders ignored what the abbey was or meant. If by saying this he implied that he had been doing what should have been the Venus Fixers' job, the timing of his impromptu lecture on the battlefield, twenty-four hours prior to the air attack, indicates that he, too, had no idea of what was coming.

The Allied air strike that razed Mantegna's Ovetari Chapel in Padua fol-

lowed the Monte Cassino disaster by one month. In that case, no military necessity was invoked to justify the destruction, which was rather the result of negligence, or ignorance of the importance of the site. The pulverization of the Ovetari prompted one more bizarrely offhand reaction from Berenson, who felt that he should not "weep his eyes out," since Mantegna's celebrated frescoes in the chapel "were not oversuitable for the space they covered, their coloring was not harmonious," and they could be better appreciated in photographs. For the Venus Fixers, however, the loss of the chapel was the cause of much alarm. The Allied campaign was now in its eighth month, and there was no end in sight. The enemy had proven its tactical excellence and sheer determination to continue to contest every inch of the country. As the battle was about to advance toward Rome and then Umbria and Tuscany, the Venus Fixers had reason to fear that more monuments might suffer as the result of the fight growing more furious and desperate. Months before, in Washington, Robert Sherwood had warned the Roberts Commission of the danger of the "Germans maneuvring us into a position where Rome or Florence will be battlefield."

The monuments officers seized on the Ovetari tragedy, and their action resulted in a turnaround in their relationships with the rest of the Allied armed and air forces. In the aftermath of the Mantegna chapel's destruction, De Wald obtained permission to personally visit with Brig. Gen. Lauris Norstad, director of operations of Mediterranean Allied air forces. As a result of their meeting, simplified maps—known as Shinnie Maps, after Peter Shinnie, an archaeologist in civilian life, who prepared them—replaced the overcrowded Frick Maps for the use of bombing crews. As the MFAA's final report later remarked: "The Subcommission assisted informally in the final stages of preparation of these volumes, but the credit for their production rests with the Air Forces themselves." Thanks to De Wald's talk with Norstad, the subcommission could now receive, on demand, from the Mediterranean Photographic Intelligence Center, up-to-date photographs of targets, which would enable the monuments officers to keep a record of damage and check the claims of enemy propaganda. The Harvard Lists also were streamlined, their copious information edited down to manageable

booklets organized by Italian regions and distributed down to battalion level. Finally, in the spring of 1944, Leonard Woolley's earlier recommendation that monuments officers be put in closer contact with combat troops came to fruition. For months, the War Department had resisted the request, arguing that officers without tactical training might be killed when assigned to forward echelons. The subcommission countered that men, in a war, were killed anyway, and the risk was outweighed by the importance of posting some of their officers near commanders and troops.

In May, Deane Keller was attached to the Fifth Army in its fight across Tuscany. Norman Newton and Roger Ellis joined the Eighth Army in its ascent along the Adriatic coast. The three officers could now enter towns within hours of their liberation, survey damaged sites, and quickly organize first aid repairs that second-echelon monuments officers would follow up on; their very presence among forward troops would prevent looting and vandalism, and avoid the billeting of historic palaces for officers and soldiers. Henry Newton, an army general and an architect in civilian life, was to act as a link between the monuments officers and the War Department.

After months of feeling trapped far behind the front line, the Venus Fixers were energized by the more efficient organization of their ranks. As they gained more self-confidence, they seemed eager to detect any wisp of a breeze that might be blowing more auspiciously in their direction. For De Wald, the symbolic turning point was the story of the army engineer who believed in the new and detested the old when it came to buildings; but then he discovered an old Roman bridge that had emerged intact from underneath a new one blasted by a bomb on the old Appian Way, and the experience changed him forever. "A father of a new-born child could not have been prouder," De Wald wrote years later. "He insisted that the old structure would have to be preserved at all cost; he therefore drew up plans making it possible for archaeologists visiting the site later to study these Roman remains . . . He was on fire for further discoveries." The Princeton professor excitedly felt that they had made a "convert." It was either that or the gradual acceptance, on the part of Allied soldiers, that war in Italy was to be fought, as General Clark put it, "in a goddam art museum."

TREASURE HUNT

Sebastian, idly turning the page of Clive Bell's *Art*, read: "Does anyone feel the same kind of emotion for a butterfly or a flower that he feels for a cathedral or a picture?" Yes. *I* do.

—Evelyn Waugh, *Brideshead Revisited*

W e are having a shattering time around Florence with Giottos and Botticellis peeping from every country house," John Ward-Perkins excitedly wrote to Paul Gardner on August 7, 1944. While Major Gardner was still in Naples, finishing up the subcommission's work in the city, Major Ward-Perkins had just returned to headquarters in Rome from a brief visit to some of the art repositories in Tuscany, within a few miles of the war front.

After liberating Rome in early June, the Allied armies had been pressing northward in pursuit of the retreating German forces. Riding on the tactical advantage offered by the enemy's temporary disarray around Rome, General Alexander pushed to advance across the central Apennines, aiming to reach the open plains of the river Po by mid-August. Orders, in early June, were for the Eighth Army to advance "with all possible speed" toward Arezzo and Florence, while to the west, and closer to the Tyrrhenian coast, the Fifth Army would move along a northbound line toward Pistoia and Lucca, and reach the river Arno at Pisa. Both armies were to take "extreme risks to secure the vital strategic areas mentioned above before the enemy can reorganize or be reinforced."

Haste guided General Alexander's strategy, but General Kesselring's tactics to make his enemies' ascent up the peninsula as arduous as possible remained unchanged. After the Allies' breakthrough at Cassino and their swift march up the Liri valley toward Rome, the general had not contested the city and, in an effort to save his troops, had withdrawn. By the middle of June, he had regrouped and was organizing his army's slow retreat. The Gothic Line of defense, stretching from the port of La Spezia on the western coast to Rimini on the Adriatic Sea, was not yet completed; in fact, the Germans would never finish it, but in the summer of 1944 they needed all the time they could buy to try to erect that last and formidable barrier against the Allied armies' advance into northern Italy. Once again, the hills and mountains of Umbria and Tuscany and the many rivers that score central-eastern Italy from the foothills of the Apennines to the Adriatic coast were to play in the Germans' favor.

Despite the loss of seven divisions that were moved from the Italian front to take part in an assault on the French Riviera slated for mid-August, the Fifth Army conquered the medieval walled town of Viterbo, between Rome and Orvieto, in northern Lazio, and the port of Civitavecchia in early June. Led by Gen. Oliver Leese, who had taken up command from General Montgomery on December 31, 1943, the Eighth Army captured Perugia in mid-June, but on its northward advance toward Arezzo was met by stiff opposition on either shore of Lake Trasimeno, on the cusp between Umbria and Tuscany. The ancient city of Arezzo fell to the Eighth Army on July 16, while on the twenty-third General Clark's Fifth Army entered the southern sector of Pisa, near the estuary of the river Arno. Farther inland, the Second New Zealand and the Eighth Indian divisions of the Eighth Army had been engaged since July 20 in heavy battling along the Chianti valley toward the Val di Pesa and the middle valley of the Arno, a few miles west of Florence.

After having let go of Rome without a fight, the Germans were strenuously defending Florence. The city was heavily protected around its outskirts by three defensive lines, the Olga, the Paula, and the Mädchen. "Modern Valkyries and thickly muscled Rhine Maidens had been imaginatively mobilized for the guarding of Florence," the Scottish novelist Eric

Linklater remarked on the incongruously romantic names. During the last days of July, as war was closing in on Florence, the villages and hamlets of the Val di Pesa and the Val d'Elsa were engulfed by its tide. On July 26, the New Zealanders furiously fought around the medieval hamlet of Poppiano; on the twenty-seventh, the Punjabis of the Eighth Indian Division occupied the village of Montespertoli. Three miles south of Poppiano, on the Volterrana road, lay the castle of Montegufoni and, between Poppiano and Montegufoni, the villa of Montagnana. The two castles and the villa were the repositories of more than six hundred paintings that had been taken out of Florentine museums to the "safety" of their sturdy walls in the winter of 1942, and were now caught in the middle of the battlefield.

As late as 1942, Giovanni Poggi, who had committed those hundreds of artworks to their protection, could not have imagined that that quiet corner of Tuscany could be turned into a theater of the bloodiest of wars: the gentle rhythm of its valleys, rolling hills, and winding roads shattered by artillery fire, the dancing geometry of olive groves and vineyards crushed by the passage of tanks and pocked by the explosions of mines, bombs, and grenades. The two castles of Poppiano and Montegufoni, standing within sight of each other, had long forgotten their original function as bastions of defense against the threat of an advancing enemy. Poppiano, the seat of the Florentine Guicciardini family since the eleventh century, comes into view after a turn in the road like a shepherd guarding the little flock of houses huddling at its feet. Built on a low hill above a wide and open valley, Montegufoni and its slender tower may remind one of a large ship that has drifted ashore to anchor itself in the landscape, lovely and slightly mysterious. In the sixteenth century, the castle's medieval ramparts were turned into stone terraces, where lemons and wild capers grew, the Renaissance having added a touch of architectural grace to the solid mass of its medieval structure.

Montegufoni's "air of forlorn grandeur" struck Sir George Sitwell when his car broke down right before it in 1909. Or that is what his travel companions, Miss Fingelstone, an English friend, and the Italian baron Pavelino, who was probably an estate agent in disguise, wished him to be-

lieve. A former MP, a polymath, and a true eccentric, Sir George Sitwell was the father of the notorious intellectuals and aesthetes Osbert, Edith, and Sacheverell. His love of the Middle Ages, combined with a passion for ambitious building plans, elevated his encounter with Montegufoni from the slightly common notion of an arranged match to the inevitability of a *coup de foudre*.

Montegufoni had been the property of the Acciaioli family since the 1280s. In the fourteenth century, members of the prominent family had left Florence and gone on to conquer Malta and Corinth and had become the Dukes of Athens. Upon returning to Italy a century later, they had established a literary court of great sophistication at the castle. Their wealth was built on steel—the name Acciaioli, "Accheeyawly," as Sir George instructed his son Osbert to pronounce it, comes from the word *acciaio*, "steel," in Italian—and so was the Sitwells' fortune, founded on trade and on the manufacture of ironworks in the eighteenth century.

Sir George Sitwell bought the castle in his son Osbert's name, with some hundred villagers living in it. In the letter with which he informed Osbert of the purchase, Sir George described the beautiful tower, a copy of the one standing in the Palazzo Vecchio in Florence, the picture gallery full of the Acciaioli family portraits, a pebble-work grotto, a chapel full of the relics of saints, and a courtyard "where one could take one's meals in the hot weather." The castle, he was convinced, was a smart buy. "We shall be able to grow our own fruit, wine, oil—even champagne!" he wrote. "I have actually bought half the Castle for £2200: the other half belongs to the village usurer, whom we are endeavouring to get out . . . The purchase, apart from the romantic interest, is a good one, as it returns five per cent. The roof is in splendid order, and the drains can't be wrong, as there aren't any. I shall have to find the money in your name, and I do hope, dear Osbert, that you will prove worthy of what I am trying to do for you, and will not pursue that miserable career of extravagance and selfishness which has already once ruined the family. Ever your loving father, George R. Sitwell."

While protesting that he wasn't the spendthrift in the family who bought Tuscan castles large enough to house hundreds, Osbert Sitwell

came to love Montegufoni, if for slightly different reasons from his father. On his first visit to the castle, in 1912, he fell for the atmosphere of the place and for the garden, which was a tumult of verbena, lemons, and plumbago, all growing more riotously than in England. While wandering around the house, Osbert discovered sacks full of delicate, translucent shells, likely the leftovers from the decoration of the grotto in the 1650s; and the chapel was, as promised, the repository of "a remarkable concentration of holiness, the finest collection of Saints' relics in Tuscany." The cool, deep cellars of the castle were fragrant with the sweet smell of wine vats. The harmonies of the Società Filarmonica di Montegufoni, the village ensemble of which Osbert was a patron and the president, lingered under its vaulted ceilings; even if the music, as performed by the village's tailor, butcher, cobbler, and baker, was not of the highest standard, "I would sometimes," Osbert wrote in his memoirs, "of an afternoon or evening, attend a rehearsal, and it must be admitted that those hours offered some of the strongest and strangest physical sensations of a lifetime."

Osbert Sitwell inherited Montegufoni upon his father's death in 1943. At that time, owing to Sir George's extended illness and Osbert's service in the army, the castle had been abandoned for a few years. Even in its fallow season, though, the historic house had been far from deserted. In the winter of 1942, at the behest of Poggi, it had opened its doors to 265 paintings from the Uffizi, Pitti, and Accademia galleries and from the Museum of San Marco in Florence. Of the hundreds of canvases that were hidden at Poppiano, Montagnana, and Montegufoni, the latter sheltered some of the largest in its vast rooms: Botticelli's *Primavera* measured six feet in height and nine in width, and Giotto's *Madonna d'Ognissanti* towered over all, at nine by six. The local farmers Masti and Meoli had been charged by the Florence superintendency with the care of the artworks, and had moved their families into the castle. In a little over a year, the threat of the advancing war front had pushed more families from the nearby village of Bacchiano and other neighboring hamlets to join the Meolis and the Mastis inside Montegufoni. In a curious case of historical entropy, the same villagers that the Sitwells had managed to evict over the span of thirty years, or their di-

rect descendants, were back in their hundreds, living in the courtyard, the cellars, and some of the rooms of hospitable and versatile Montegufoni. On being informed of the presence of the paintings in the castle, Osbert was delighted. "What a house party!" he exclaimed. "Surely they will leave, in gratitude, something of themselves in the house."

Despite the crowds sheltering there and the occasional burst of artillery fire all around it, the castle of Montegufoni was quiet when Eric Linklater and Wynford Vaughan-Thomas walked through its gate on the afternoon of July 30, 1944. Linklater, a major with the Eighth Army chronicling its Italian campaign, and Vaughan-Thomas, a BBC war correspondent, had last seen each other near Rome, at its liberation, an overjoyed Vaughan-Thomas, who had spent the last four months on the beachhead at Anzio, dancing in the street. On that July day, Linklater had no transportation, but knew the way to the Eighth Army's press camp at San Donato in Poggio, while Vaughan-Thomas had a jeep but no idea of how to get there. As the two traveled together, Linklater persuaded Vaughan-Thomas to stop along the way to check in on the Mahratta Light Infantry Division, which had established its headquarters at the castle of Montegufoni.

On that hot and sunny day, the roads that wind around the Tuscan countryside were overloaded with military traffic and very dusty—Vaughan-Thomas had looked "as white as flour" when Linklater had first seen him atop his jeep that morning. Occasionally, a spectacular view suddenly opened up at the summit of a ridge or at a turning in the road. One such sighting was Montegufoni, as Capt. Unni Nayar of the Mahrattas pointed it out to Major Linklater and Vaughan-Thomas from across the valley. "In recent years," Linklater later wrote, recalling that moment, "incongruities have been as common as violent death, but unless the mind has been numbed by too much exposure, the latter still dismays and the former continue to excite curious pleasure."

In the course of the Italian campaign, the Mahrattas had earned a reputation as fierce fighters, yet they looked quite tame in their repose, silently standing to attention in their impeccable uniforms. While their colonel, after days of uninterrupted battle, was resting, Linklater and Vaughan-Thomas

wandered around the sprawling castle. As he stepped away from the dazzling afternoon light of the courtyard into the semidarkness of a large vaulted room, Major Linklater noticed several paintings stacked two and three deep against the walls; a few more were leaning against a rack in the center of the room. He knew the place to be the property of the Sitwell family and expected to find it elegantly furnished and tastefully decorated. There seemed, however, to be very little furniture around, whereas the paintings, now that his eyes were beginning to adjust to the shuttered dimness of the room, looked like good copies, indeed very good copies, of old masters. They were remarkably good . . . As the thought was slowly dawning on Linklater that he might be in the actual presence of some authentic masterpieces of Italian art, Vaughan-Thomas burst into the room screaming, "There are hundreds of pictures, Giottos and Botticellis, the whole house is teeming with them!"

Presently, the Scottish writer and the Welsh journalist launched into a game of name guessing and memory raking: Could that be Filippo Lippi? And that other one, oh, it was on the tip of their tongues! Linklater later recounted that he had furtively run his fingers over the three Graces that lightly tread the grass in their dance in Botticelli's *Primavera*: he knew that when they would meet again, it would be in the formal surroundings of a museum, this wartime encounter at Montegufoni a treasured secret. Meanwhile, a little crowd of refugees had been gathering around the two British men, and they were timidly nodding and saying, "Yes, yes, Botticelli, and Giotto, no copy." And then they all had turned and announced, with hushed anticipation, that the "Professore" was coming.

A spirited man of diminutive size, wearing plus fours, appeared and greeted the two British writers warmly. It was Cesare Fasola, the Uffizi librarian and, for those last dramatic days of July, the emissary of the Florence superintendency to the art deposits of the Val di Pesa. Fasola was relieved and elated as he finally found himself face-to-face with two representatives of the Allied press who seemed to show such appreciation of Italian art. He spoke no English, but after ten days of dealing with Germans

and roaming refugees, drunken soldiers, pilfering troops, and stray bullets and shells, the fearless professor did not consider a foreign language an intimidating obstacle.

Fasola had been dispatched to Montegufoni as the Florence superintendency's desperate measure to supervise its deposits. In Florence, on July 4, Superintendent Poggi was summoned to the German *Kommandantur*. Counselor Metzner—the name, recorded by Poggi, may not be the correct one, as it does not appear in the Wehrmacht lists—confronted him with a command to transport the artworks stored in the villa of Montagnana to northern Italy. In the course of the very tense meeting, Poggi had firmly countered Metzner's claim that the nearly three hundred artworks at Montagnana would be abducted by the advancing Allied troops, and refused to put them in German hands. "You then refuse our offer to transport your paintings away from the front," an irate Metzner had declared at the end of his talk with the superintendent. "This is not a refusal," Poggi had calmly replied, "and we are actually very grateful for your offer. But all Florentine authorities believe that given the risks of the approaching war, it is better to leave the artworks where they are." After the meeting, an alarmed Poggi had informed his friend the German consul Gerhard Wolf of Metzner's intentions. After a quick investigation, Wolf discovered that on July 2, two days before Poggi's conversation with Metzner, the deposit of Montagnana had been emptied by German troops.

The German "salvaging" of Florentine art continued. On July 16, a detachment of airborne troops, the *Dienstelle L. 5837*, led by a Colonel von Hofmann, most likely Adolf Raegner von Hofmann, and a Captain Tweer, filled three trucks with the paintings cached in the villa of Oliveto, near Castelfiorentino, southwest of Florence, and, claiming that the area was now under Allied fire, brought them back to the city. The next morning, while the artworks were being unloaded in the Piazza San Marco in Florence, the custodian Augusto Conti, who had followed the convoy, took Poggi aside and told him that there was no fighting at Castelfiorentino, and that two panels belonging to the Uffizi, Lucas Cranach's *Adam* and *Eve*,

had been separately put in an ambulance that had never reached Florence. A couple of nights later, Colonel von Hofmann was heard boasting, at a Florentine family's house, that the two Cranachs were destined for Göring.

With Florence besieged and isolated from the surrounding countryside, and with Poggi forced to remain in town to counter German officials who were becoming daily more aggressive, Cesare Fasola volunteered to traverse the front to get to the deposits located south of the city, by then a no-man's-land between clashing armies. A member of the anti-Fascist Partito d'Azione, his name on the Fascist blacklists, Fasola may have been fleeing Fascist prosecution, and possible death, while watching over the artworks repositories. But he felt a genuine Florentine pride for the art of his hometown and later cited as a model for his conduct Tommaso Puccini, director of the Uffizi at the time of the Napoleonic Wars, who had firmly opposed the French request to take the celebrated Greek statue of the Medici Venus to Paris.

On July 20, Fasola set out on foot for the Val di Pesa. Already around Galluzzo, three miles south of Florence, the landscape was one of utter devastation. Terrified at the looting and killing by retreating Germans, the population of entire villages had fled. The hamlet of Cerbaia was deserted. Men between the ages of fifteen and sixty were hiding in woods, attics, cellars, and even wine barrels, to avoid deportation to German labor camps; women, the elderly, and children carried the shock of war on their faces. As lawlessness reigned, pillaging bands roamed the villages; Italian Fascists ruthlessly carried out personal vendettas. The German soldiers took everything on their flight to the north, vehicles and bicycles, food, wine, oil, horses, and cattle. Countess Giulia Guicciardini recorded in her diary the killing by the SS of all the farmers, laborers, and the local priest on the estate of Meleto in the Val di Pesa, one of many similarly horrific instances reported in the area.

Fasola went first to Montagnana. The Renaissance villa, the property of the counts Bossi-Pucci, was abandoned. The gardener told Fasola that the German troops that had first been billeted there had behaved with respect. The paratroopers, however, who had replaced them, had terrorized ser-

vants and farmers and sent them fleeing. They had retreated only two days before Fasola's visit. The trail of wanton destruction they left behind spoke of enraged and despairing soldiers fighting a war that was becoming for them daily more senseless. Everything around the eerily quiet rooms of Montagnana was in a state of complete disarray: furniture, windows, and doors had been shattered; books had been swept off the shelves in the library, and a thick coat of filth lay over all. Fasola, who had not expected to find any paintings in the house, was puzzled to see a few, thrown on the floor, among glass shards, rotten food, and smashed chairs. They were masterpieces, such as Perugino's *Crucifixion* and the *Presentation in the Temple* by the Sienese master Ambrogio Lorenzetti. The theft, Fasola realized as he looked in dismay at the discarded frames that had been ripped off their canvases, had likely been carried out by troops who had no idea what these artworks were, soldiers who had a truck to fill and hastily stuffed it with what was at hand: approximately one-eighth—in Fred Hartt's later estimate—of the Pitti and Uffizi treasures, uncrated and unprotected. This would explain why Counselor Metzner, at the start of his meeting with Poggi, had bluntly asked the superintendent whether the paintings at Montagnana had any value. "Of course they're valuable," Poggi had replied, barely containing himself, "they are from Pitti and Uffizi, of course they are masterpieces!"

All alone and with little time before dark, Fasola feverishly tried to clear up at least some of the mess: he picked up the frames, shook the dust and debris off the pictures, and neatly stacked them against the wall. At dusk he headed for Montegufoni. After the desolation of Montagnana, the librarian was relieved to find the castle populated, indeed overcrowded, and in relatively good condition. The refugees had camped out in the cellars while the Germans still occupied almost every room of the castle, and the custodians, Meoli and Masti, had guarded the paintings with a gun and a prayer. Meoli, the braver of the two in Fasola's opinion, had taken frequent rounds of inspection of the artworks, while Masti was convinced that if they were all eventually to escape death and extinction—his own family, the refugees, the pictures, and the castle—it would be thanks to the protection of those

saints and Madonnas who had taken temporary residence at Montegufoni. *"Santini, aiutateci voi!"* he would repeat like a mantra. "Little saints, do please protect us!"

Because of the importance of the paintings sheltered in the castle and the hazards posed to them by the war, as well as the considerable number of people bivouacking around them, Fasola decided to settle, for the time being, at Montegufoni. The stories he heard from the refugees rang a familiar tone: the first German troops had behaved, and life at the castle had been "possible"; but the subsequent arrival of the paratroopers and the SS had signaled a turn for the worse for both the manor and those sheltering in it. The paintings, on first inspection, looked unharmed, although most of them had been taken out of their crates and, inexplicably, many of their labels had been removed. The canvases had been moved around, to no apparent purpose, and Fasola would never cease to be mystified as to why the soldiers did that. Locked doors were all pried open, and it didn't matter how many times the indefatigable librarian would close them again, they would all be reopened in a matter of minutes. Before his arrival, German soldiers apparently had slept and cooked around the artworks; they had stacked pots and pans on altarpieces, and on one occasion they had used Ghirlandaio's *Adoration of the Magi*, a tondo or round picture, for a tabletop.

Because potential disaster lurked at every corner of Montegufoni, Fasola resolved on being "everywhere, all the time." Unobtrusively, almost furtively, he began to cache all small paintings, the easiest for the soldiers to steal, behind the locked door of the chapel. At night, he went to bed fully dressed. As he recounted after the war, he had developed his own strategic routine: "Whenever I see a group of soldiers wandering aimlessly, I walk right up to them and, in my broken German, I offer myself as their guide: I lead them through the paintings, I explain, I make up stories; I encourage them not to detach their labels, and not to leave doors open, because of the danger of drafts. With any luck, I manage to lead them all the way to the exit." Fasola staunchly believed in the civilizing effect of art; besides, there was no other strategy he could think of in the circumstances. Whether the soldiers were amused, startled, or annoyed by this skinny, middle-aged

blabberer, they knew they were being watched, and whatever they had intended to do with or to the paintings, they were deflected from it.

In the early days of his stay at Montegufoni, Fasola walked daily to Poppiano and Montagnana. Fearing depredations, the Guicciardinis had remained at Poppiano until mid-July: Count Lorenzo and his wife, Giulia, lived at the villa while their young and widowed daughter-in-law, Giuliana, stayed at the castle with her three small children. Since January 1942, the castle and the villa had played host to hundreds of pictures from the Mostra del Cinquecento, the ill-fated exhibition of sixteenth-century painting that had opened in Florence in June 1940, only to close a few days later upon Italy's entry into the war. At the time, the Guicciardinis had interpreted the superintendency's decision to store the paintings at Poppiano as a promising indication that the war would not pass through tranquil Val di Pesa. Later, armed with a letter signed by General Kesselring that declared the villa and the castle out of bounds, they had felt protected by their inanimate guests. Since early July, with seemingly unquenchable courtesy and impeccable manners, Count Lorenzo had wined and dined a succession of German officers who had set up their quarters in his home; his wife, Giulia, was less sanguine at the spectacle of German soldiers stealing cattle and raiding cellars and orchards while her family, the village of Poppiano, and the entire area had been reduced to a strictly vegetarian diet. "May every potato they steal explode, every pear become a bum-bum bullet!" she wrote in an outburst of fury in her diary.

Like everywhere else in the region, conditions at Poppiano had quickly deteriorated with the advance of the front. The place was becoming almost completely isolated; as Giulia wrote, "We do not know what is going on a mile from us, and if someone happens to stop by the village, people run and gather around him for news ... just like in the fourteenth century, when a wandering merchant, roaming the world on his horse, would wind up at this little feudal hamlet of Poppiano." On July 3, the ground floor of the villa was turned into a German field hospital, with the dining room serving as the operating room. Increasingly worried by the worsening situation, the Guicciardinis sent a message to Giovanni Poggi in Florence to inform

him that they could not guarantee the safety of the artworks any longer. On July 16, deeming living conditions at Poppiano too dangerous, Count Lorenzo returned with his family to Florence. "I wonder whether I shall ever see those beautiful painted ladies again," Giulia wrote at that date, "with their pearls, their stiff gowns, and their lace collars, fleeting acquaintances of those memorable days!"

The area had indeed become too perilous even for fearless Fasola. "Last night two German soldiers stabbed a girl in the neck, farmer Roselli's daughter," he wrote on July 22. On July 27, Poppiano was in the line of fire; on that afternoon, the New Zealanders were at Montegufoni. "We all ran down to the cellars," Fasola recalled. "We heard the noise of artillery approaching, devastatingly loud and pelting against the door of our shelter. Then the New Zealand Unit appeared: a moment of surprise followed, as they looked around at all those people; then, from all these men, women and children, the sick and the elderly there came a round of applause for the newcomers and it was as if a huge cloud of oppression had lifted from our hearts."

As if he could not yet believe that after weeks of anxiety, the worst danger might indeed be over, Fasola was cautious, at first, in his appreciation of the new soldiers. "The Indians are curious, but at least they don't smash doors," he wrote. A day later, he happened upon a group of New Zealanders intent on a mighty cleaning at Montagnana, while the villa was still under German artillery fire. The shirtless soldiers were sweeping and singing while they worked. "I could have hugged them all," Fasola exclaimed. Linklater and Vaughan-Thomas's subsequent visit to Montegufoni confirmed to the exhausted librarian that his nightmare was over. After anxiously protecting the artworks from soldiers itching to steal them, deface them, or dine off them, he was surrounded at last by people who were exhilarated to be in the presence of some luminous tokens of human achievement amid that landscape of ruin.

Since their first encounter with the paintings at Montegufoni, Vaughan-Thomas and Linklater had been sneaking daily visits to the castle's extraor-

dinary cache. On August 1, they brought a special visitor with them: 2nd Lt. Frederick Hartt. Linklater, who met him that day for the first time, found the young American officer "highly agitated." Tall, eager, bespectacled, Hartt was impetuous and somewhat excitable. That day, however, he had plenty of reason for concern. After his service in Naples, Hartt had had "the good fortune," in his own words, to be appointed regional monuments officer for Tuscany and, since late June, had been stationed at regional headquarters in Orvieto. The lovely hill town, untouched by war, had been a respite at first after the ravages Hartt had witnessed in Naples; still, his forced inactivity had soon become a source of anxiety. While Deane Keller, attached to the Fifth Army, was surveying town after liberated town in the west and north of Tuscany, Hartt occupied his time with checking and editing lists of monuments in Tuscan towns yet to be freed. The eastern provinces of Tuscany were the theater of heavy fighting; yet he was trapped in the rear at Orvieto and could not intervene as promptly as he wanted upon their liberation. He began by procuring a jeep for himself, "Lucky 13," a battered veteran of the North African and Sicilian campaigns, and a driver, Franco Ruggenini, a friend from Mantua he had found again in Naples during the last weeks of his stay. Lucky 13, as its proud owner recorded after the war, went on to acquire some measure of celebrity in Tuscany, carrying bishops and peasants, superintendents and princesses, a U.S. senator and the assistant secretary of war, as well as chickens, lambs, turkeys, pigs, cheeses, flour, cement, and a few priceless artworks.

At the suggestion of the monuments officer Norman Newton, toward the middle of July, Hartt was temporarily attached to the Eighth Army, so that with Newton he could be among the first AMG officers to enter liberated Florence. The battle for the city still raging, however, he had to spend more days impatiently waiting and compiling lists, this time under a tree, in front of Major Newton's tent at Castiglione del Lago, between Perugia and Arezzo. It was while at Castiglione, the Eighth Army's headquarters, that, on the morning of July 31, Hartt heard Vaughan-Thomas's BBC broadcast on the discovery of the Tuscan paintings at Montegufoni. Barely able to

contain his excitement, he immediately drove to the Eighth Army press camp to hear more from the journalist himself. The next day he was riding in his jeep to Montegufoni.

Bumping along the Via Cassia at an average speed of thirty miles per hour, Hartt had plenty of time to let his mind dwell on the amazing events of the last twenty-four hours. As the lusciously green landscape of high summer rolled by, wild anticipation gave way to apprehension and a dozen unanswered questions and doubts. The news that hundreds of world-famous paintings were found stored in a castle right in the middle of a battlefield had, predictably, caused quite a sensation. "There's a million bucks wortha nice pictures in there," a sergeant from Bensonhurst, Brooklyn, was quoted as saying in *The New Yorker*; "a million and a half bucks," a comrade had corrected. Spectacular as the news was, Radio Berlin had still tried to one-up the British Broadcasting Corporation by announcing that a German art historian had been parachuted into Montegufoni to snatch the Botticellis and the Giottos from the rapacious hands of the Allies.

The German report was so preposterous it was almost amusing. The BBC broadcast, on the other hand, which presented the story as a chance discovery, was annoying to the Venus Fixers. Sheldon Pennoyer, among the most even tempered of the group, recorded his irritation at Vaughan-Thomas's excitement, "as if he had made a world important personal discovery." Linklater and Vaughan-Thomas's happening onto the pictures at Montegufoni was not, technically speaking, a "discovery," and that irked the monuments officers. They had known about the Tuscan art deposits since entering Rome in early June; Emilio Lavagnino and Giorgio Castelfranco had provided them with complete inventories of the Florentine artworks and the castles and villas where they had been sheltered. At that time, however, both the Allied monuments officers and the Italian art authorities in Rome were convinced that Florence had been recognized as an open city by both belligerents; as a result, they believed that all paintings and statues had been brought back into the city's walls. Because the front cut Florence off from southern Tuscany, the monuments officers had not as yet entered into direct communication with Giovanni Poggi, and would

not until the city's liberation. Whether the superintendent's message indicating that most artworks were still outside Florence had ever been delivered by partisans to Allied headquarters, it evidently had not been repeated to the Venus Fixers. Hence their surprise at hearing from the BBC that the artworks were still in the countryside, and their relief to learn they were safe.

Fred Hartt's war experience until the date of his first trip to Montegufoni had been intensely emotional. If devastated Naples had been a shock, in Tuscany he had witnessed how cruelly and capriciously the war could spare and destroy. High on a hill in the Val di Chiana, he had visited Cortona, which he considered "the quintessential medieval hill-town," and found it peaceful and untouched. Twenty miles to the north, Arezzo, the arena of furious battling, had suffered bitter destruction. A trip across the stark clay hills of the Val d'Orcia, where the little towns of San Quirico and Castiglione d'Orcia had been only slightly damaged, had culminated in Siena, lovely and intact. While the Germans had not defended Siena, war had raged to the north around San Gimignano. Summoned to the small town in the Val d'Elsa by an alarming report from Captain Keller, Hartt had found that San Gimignano's fifteen celebrated medieval towers had withstood the assaults of artillery fire, but two of its Romanesque churches, their frescoes and statues, were badly hit. He had waded ankle-deep in the rubble of the Collegiata, the cathedral of San Gimignano, which had suffered from its proximity to an enemy's observation post in the nearby Palazzo del Podestà. The roof had been smashed in at several points, and a cycle of frescoed scenes from the New Testament by the fourteenth-century painter Barna da Siena had been repeatedly pierced by shells. Surrounded by dangling roof beams and the gaping holes that shells had opened in the church walls, Hartt had found the sight "terrifying."

This was Tuscany for Hartt in those days: a rapid-fire succession of despair and relief, the sight of a disemboweled church quickly pushed out of his mind by the sudden appearance of a glorious natural landscape. The beauty of the scenery was almost inseparable in his eyes from his beloved Tuscan masters' interpretation of it in their paintings. As he approached

Montegufoni, the exquisite, rippling silhouettes of the hills and the trees and the blue summer sky put him in mind of the Renaissance painter Benozzo Gozzoli, a pupil of Fra Angelico's, who created his masterpiece, the *Procession of the Magi*, on the walls of the very small chapel of the Medici Palace in Florence. Amid the festive pageant, Benozzo painted the prominent members of the Medici family: richly attired atop their fine horses, Cosimo, Lorenzo, and Giuliano proudly parade across a fabulous landscape. Hartt's mood was the appropriate one for the circumstance.

Briskly striding across the weatherworn stones of the courtyard at Montegufoni, he followed the castle custodian through the heavy Baroque door and into the spacious vaulted room where the larger pictures were stored. And there was *Primavera*, leaning against a wall right by the entrance, as if to greet him. "I unwrapped *Primavera* entirely," Fasola had said, "because it always makes a good first impression." Standing at eye level, in the room's penumbra, was one of the most celebrated images in the history of Western art. Beautifully startling in the singular domesticity of the circumstances, it could have been a picture just unloaded by movers and waiting to be hung on a wall, or a living woman, surprised in the privacy of her inner chambers.

Charged with symbols, the painting is enchantingly elusive. It was commissioned by Lorenzo di Pierfrancesco de' Medici, a cousin of Lorenzo the Magnificent's, for his palace in Florence. Lorenzo was younger and, having lost his father at the age of fourteen, was also wealthier than the Magnificent, who, for his part, was a far more avid collector of books and miniatures than a patron of the arts. The Magnificent preferred the conversation of poets, scholars, scientists, and historians to the company of artists, whom he generally found lacking in intellect and learning. Sandro Botticelli was the exception. The son of a cooper, Botticelli had a restless, inquisitive mind that earned him admission to the circle of men of letters and science who were Lorenzo's closest friends. The philosopher and polymath Pico della Mirandola spent hours watching the painter at work in his study. Since his childhood, Sandro had been a friend of Amerigo Vespucci's. A couple of years his junior, Vespucci loved math and would become a navigator, cartographer, and a discoverer of new continents. Scholars have suggested that

in creating *Primavera*, Botticelli was inspired by *Le stanze*, the poem that Angelo Poliziano composed for Lorenzo's brother Giuliano and interrupted upon Giuliano's murder at the hands of members of the rival Pazzi family in 1478. Others have traced his sources to the works of Ovid, Seneca, Horace, and Lucretius, the Latin poets and philosophers that Lorenzo and his friends read and admired. The literary references to the mythical kingdom of Venus that are laced through the narrative of the canvas and the moral allegories that its nine large figures represent would have been readily legible to Botticelli's contemporaries, though its intricate pattern of meaning is mostly obscured for the modern viewer. The painting itself was neglected and almost forgotten in the Medici Villa of Castello, and only brought to the Uffizi in 1815, where toward the end of that century the Pre-Raphaelites' enthusiasm rescued the canvas and the whole of Botticelli's work from centuries of oblivion. At the heart of the painting, Primavera's smile, faint, noble, melancholic, remains an enigma. It would have been hard, however, on that August morning of 1944, not to see in her face, as she emerges tall and pale from a dark wood of ilexes, the image of Florence, whose fate was on everybody's mind.

As one by one the windows were opened in the large room, the late morning light fell on a series of crucifixions from various Florentine churches that leaned on one another like exhausted soldiers at the end of a long day of fighting. Hartt's eyes ran to all those old acquaintances and rested on the images so familiar from books and slides and museum visits, all of them so close and exposed now. Stacked at random, all considerations of chronology and provenance forgotten, some were odd companions: Giotto's solid, architectural Madonna sat next to Velázquez's massive allegorical portrait of Philip IV riding on horseback in a plumed hat, cherubs fluttering in the sky above. At the far end of the room, among annunciations, crucifixions, and depositions, saints, angels, and Madonnas, the spears and the helmets of Paolo Uccello's *Battle of San Romano* gleamed in the light streaming in from outside.

Large, colorful, and gallant, *The Battle of San Romano* celebrated a 1432 battle in which the Florentines, led by Niccolò Maruzi da Tolentino, de-

feated the Sienese and their captain, Bernardino della Ciarda. It was an in-
conclusive victory, for the Sienese had retreated rather than concede a tri-
umph to their enemy, yet one that the founder of the Medici dynasty,
Cosimo the Elder, who had financed the campaign, wanted remembered, as
it had marked the beginning of his family's political influence in Florence.
Cosimo commissioned Paolo Uccello, an artist he loved, to paint the phases
of the battle on three different canvases. When the three paintings were
first displayed in the old Medici Palace in the Via Larga in Florence, the ser-
vants giggled at them, for they had never seen pink and blue horses before
or soldiers wearing bizarre checkered hats for their helmets. Lorenzo the
Magnificent kept the three enormous scenes in his bedroom until his death.

An odd and solitary man, so poor he could not afford to buy a bird for
his daughter but had to paint one for her—hence the nickname *uccello*,
"bird"—Paolo Uccello was enamored of the use of perspective in the art of
painting, which the ancient Romans had developed and the Renaissance
was rediscovering. Giorgio Vasari chastised him for his constant experi-
menting with the technique. "By wasting his time in these doodlings, he
achieved poverty rather than celebrity in his lifetime," he wrote in his *Lives
of the Painters*. Yet by his recourse to perspective, by organizing horses and
men along symmetrical lines and planes as if they were the knights and
pawns on a chessboard, Paolo had brought order and sense to his *Battle of
San Romano*. He moved away from a reality of horror and cruelty and into
a fabled world where a battle becomes a story, the suffering is muted, and
only chivalry and valor are remembered. The background of the painting, a
swath of hilly countryside where hares, hounds, and a fox leap across neatly
tilled fields, could easily have been seen as the continuation of the land-
scape outside the windows of Montegufoni. So, too, could the substance of
the canvas, for only a few miles to the west the Fifth Army's Eighty-eighth
Division was engaged in furious fighting near the village of San Romano, in
the Arno valley. The connection was not too far-fetched, not for an art lover
like Fasola at least. His improvised tours to German soldiers before, and
now to Indian, New Zealander, and South African men, were his own way
to protect the artworks from the vandalism of ignorance and, perhaps, to

spark an interest in the art of his country. When, in early August, General Alexander paid his respects to the paintings, Fasola was moved. During a pause in the battle, Alexander, an amateur painter himself, spent three hours walking among them. To the Uffizi librarian, the British general, sitting in the castle courtyard after his visit, looked like a "Homeric hero at rest."

With Hartt's arrival at Montegufoni, Fasola's tenure at the castle came to a close. He had now seen with his own eyes that the Allies were not savages or greedy looters, and with great respect for the young art historian and the Allied outfit he represented, the librarian relinquished responsibility for the artworks to him. "In place of the insignificant German Office," Fasola later wrote, "the Allies have set up a complex organization which has its seat in Rome, under the command of Colonel De Wald." They would work in collaboration with the superintendency as soon as the military circumstances permitted it; they would replace his own individual efforts to protect the paintings with proper military guards. Fasola could finally, as he wrote, breathe a sigh of relief.

As for Hartt, he quickly realized that the fast turnover of Allied divisions passing through the castle was a potential hazard for the paintings, and that the only way to ensure round-the-clock protection for them was military shifts of guards that could be authorized only from high up. He wrote a secret letter to the aide-de-camp of Gen. Oliver Leese, the Eighth Army's commander, and asked Vaughan-Thomas to deliver it. This was the first but certainly not the last instance in which Lieutenant Hartt decided to skip military channels to get what he needed fast. He often got in trouble as a result, and always thought it was well worth it. Hartt knew there were many more deposits in the area that would soon be liberated and wanted to make certain that those, too, would receive protection without delay; he wasn't sure of their exact location, but included approximate maps in his letter to Leese. In the next days, he would think of all other matters of organization, coordination with De Wald at headquarters, and liaison with the superintendency. On the night of August 3, 1944, Hartt decided to settle at Montegufoni and use the castle as the base for his future surveys. He chose a

room with a large canopied bed and a window overlooking the valley. The moon was almost full, and in the distance the sky over Florence was aglow with what looked like the flashes of artillery fire. The Germans called it *Feuerzauber*, "fire magic."

From the opposite side of town, on the hills to the north of Florence, the nocturnal scene of leaping flames and smoke enveloping the city was mesmerizing. Sitting on the terrace of the Villa Le Fontanelle, which faced the heights ranged around Florence to the south and the west like an amphitheater, Bernard Berenson found the spectacle grandiose and theatrical, though "fraught with tragic possibilities." He called it "Neronian."

Located in the vicinity of Lorenzo the Magnificent's beloved Villa of Careggi, Le Fontanelle was the home of Marchese Filippo Serlupi Crescenzi, ambassador of the small and independent Republic of San Marino, in central Italy, to the Holy See. As the residence of an active diplomat, the house enjoyed extraterritorial status, and for nearly a year it had been Berenson's wartime hideaway. The art critic's own Villa I Tatti, at Ponte a Mensola, lay only one mile to the west as the crow flies. Bernard and his wife, Mary, had bought the villa in 1905 and, over time, had filled it with the critic's remarkable collection of paintings and Oriental objects and a library rich in twenty thousand books on art history. As early as the second decade of the twentieth century, the art historian had been thinking of eventually bequeathing I Tatti and its collections to Harvard University, his alma mater, as a center for the study of Renaissance Italy.

In 1944, Berenson was seventy-nine years old and had spent fifty-six of those years living in Italy. An influential art critic and connoisseur on both sides of the Atlantic, Berenson enjoyed some notoriety in Italy and was considered one of the most eminent residents of Florence. Yet as a Lithuanian and naturalized American, his presence on Italian ground had increasingly been imperiled since the United States' entry into the war. "I begin the New Year of 1942 as a civilian prisoner," he wrote in his diary. Later that year, he was bewildered and dismayed by the development of the conflict: "Of all

the improbabilities that could have been suggested when I first trod this earth in September, 1888, none would have seemed more fantastic than that in my lifetime Italy would be at war with the United States."

Against their friends' advice, and their own government's orders, Bernard and Mary Berenson decided not to leave their adopted country. "We have not blundered into remaining here," he emphasized in his diary on the opening page of 1942. On the contrary, Berenson could list plenty of reasons for staying—simple reasons, and quite noble ones. In the first place, he felt a profound affinity with Italians—"I mean the so deeply humanized majority of Italians"—and refused to consider himself their enemy, as his returning to America would almost inevitably force him to do in some capacity. For decades, Italy had been, in his own words, his "happy hunting ground: the scene of numberless motoring trips to visit a remote medieval hamlet or peer at an altarpiece in the dim light of a small village church." The worst hazards, in those days, had been a flat tire or a custodian who had locked a museum and left for the neighboring village with the keys in his pocket. "Few were the towns and villages, monasteries and churches I did not study. It was an enchanting adventure," Berenson reminisced in the early days of July 1944. He was not, therefore, going to war against a country he often described as an earthly paradise. As for the Italians, he would not fight "against these people who will have to pay the piper no matter who called the tune."

Loyalty mixed with curiosity in determining Berenson's decision to remain in Florence. His understanding of the Italian people would be incomplete, he felt, if he did not live through the war among them. Curiosity put him, a Jew by birth, in harm's way. The Fascist racial laws of 1938 and 1939, which banned Jews from serving in public institutions and teaching in schools and universities, forbade "mixed" marriages between Jewish and non-Jewish Italians, and called for separate schools for Jewish children, had not affected him. Convinced as he was of the basic decency of most Italians, he was long reluctant to believe that bigotry would take root in the country, or that the Fascist regime would push racial hatred to its extreme conse-

quences. When that did indeed happen, he recorded his disbelief in his diary. "Yesterday morning," he wrote on December 2, 1943, "to the surprise and consternation of almost everybody, the government radio came out with the following police orders: 'Jews, whether Italian subjects or foreigners, were all to be treated as strangers and alien enemies, to be segregated in concentration camps, and their property to be confiscated for the benefit of the poor who have suffered from air raids.'" A little later, Berenson remarked, "I cannot believe that Mussolini and his counselors would have given out such an order. They know too well what the reactions would be on the part of every Italian except possibly some anti-Semites."

As a prominent American citizen, Berenson had enjoyed the protection of powerful friends in the early years of the war. On leaving Italy after Mussolini's declaration of war on the United States in December 1941, the American ambassador William Phillips had asked Galeazzo Ciano, the dictator's son-in-law, to look after the Berensons. This request, while ensuring the Berensons' safety for a while, had contributed to the rumor that Berenson was some sort of agent of "international Jewry," or a spy for the U.S. government. In early 1942, however, his collections seemed to attract more attention than the critic himself. In March of that year, Friedrich Kriegbaum, the director of the German Institute in Florence, received a visit from someone Berenson later described as "a member of Göring's gang," who sought information about a villa and its collections of art and books belonging to an American. Kriegbaum, a good friend of Florence's who would perish in the Allied air raid over the city in September 1943, deflected the man's eager interest by declaring that the artworks in the collection were all based on Catholic subjects and the books of merely local interest.

At that stage, it was not exclusively Nazi predation and Göring's notorious greed for art that hovered threateningly over Berenson's possessions. At about the same time as the visit of Göring's emissary to Florence, the Fascist minister for national education, Giuseppe Bottai, addressed a memorandum to Mussolini on the subject of the art historian. Dated February 2, 1942, the minister's note reminded the dictator that Berenson, "an Ameri-

can art critic of Polish [*sic*] Jewish origin and the owner of an outstanding collection of artworks and a rich library," had intended to donate his villa and collections to Harvard University since the 1930s. At that time, the bequest had received Mussolini's preliminary approval. The outbreak of the war, however, by causing a temporary halt in the negotiations, seemed to open up, in the minister's view, new possibilities. "It is to be noted," Bottai wrote, "that the importance of the collections—consisting of some hundred Oriental, Classical, and Renaissance paintings and sculptures and an extremely rich library of books and photographs—is such that it ought to be examined whether from the present situation a different solution may result that will prevent them from becoming the property of a foreign institution after the end of the conflict."

What the minister meant by the "present situation" becomes frighteningly explicit in one example taken from the press of those days. In an article titled "The Berenson Affair" that appeared in the December 1941 issue of the magazine *La Vita Italiana*, the journalist and inspector general for race, Giovanni Preziosi, wrote, "Although he [Berenson] owes his wealth and reputation to Italy, he has been persistently and poisonously slandering our country and our people . . . After the advent of Fascism, and well before approval of the measures against Judaism, this Jew's hatred for Italy was ferocious and has been steadily growing . . . Many in Florence believe his activities to be confined to the field of art criticism and he poses as an objective and impartial observer." The journalist concluded: "Many foreigners have been expelled from Italy for a variety of reasons; many others, in these harsh days of war, have been interned in concentration camps. Berenson is untouched, yet nobody has waged a more nefarious and heinous action against Italy than this Russian Jew, who became an American citizen and thrives in Florence."

The time was ripe for Minister Bottai's suggestion to Mussolini. In his memorandum he wrote, "Berenson, as the press has recently reported, was instrumental, through his activity, in the transfer abroad of many Italian works of art, and earned a considerable fortune as a result of his dealings, and . . . his lack of loyalty toward the country of which he is a guest is out-

standing . . . Unless you, Duce, will confirm your previous decision, the legal means by recourse to which we could secure his collections for Italy and for the city of Florence are sequestration, as authorized by the 'War Law,' or expropriation according to the law on the protection of the national artistic heritage." While sequestration was only effective for the duration of the war, Bottai explained, expropriation, which was applicable to what would preserve or increase the national patrimony, would allow the permanent acquisition of Berenson's collection, "which," the minister concluded, "must be considered as belonging in spirit to the Italian civilization."

Perhaps because of Galeazzo Ciano's intercession in Berenson's favor, in March 1942, Mussolini, against his minister's advice, took the lesser step of ordering the sequestration of the art historian's house and collection as enemy property. At the suggestion of Giovanni Poggi, Villa I Tatti and its contents were entrusted to the care of Marchese Serlupi. Eighteen months later, after Mussolini's fall and the September 1943 armistice between Italy and the Allies, Ciano was no longer in a position to help the Berensons. Count Ciano, who had voted in favor of Mussolini's deposition at the Fascist Grand Council of July 25, 1943, would be tried by a Fascist tribunal and executed in February 1944. Marchese Serlupi, deeming it too dangerous for Berenson to continue to inhabit I Tatti amid the German occupation of Florence, took him to live at Le Fontanelle, which flew the Vatican flag and was respected as neutral territory by both armies. Elisabetta "Nicky" Mariano, Berenson's secretary, accompanied him during his stay at the Serlupis'; Mary Berenson, too ill to be moved, remained at I Tatti in the care of Mariano's sister and brother-in-law, Baroness and Baron Anrep. At the suggestion of Kriegbaum and the German consul, Gerhard Wolf, the art historian took the choicest pieces of his collection with him to Le Fontanelle; he hid another thirty-two paintings in an apartment he owned in the Borgo San Jacopo in Florence, while his books and photographs were stored in the villa of Quarto, the residence of Marchesa Serlupi's mother. To the Gestapo, who inquired about Berenson's whereabouts,

Consul Wolf replied that he had gone to Portugal; Marchese Serlupi spread the rumor that the art historian was the illegitimate son of a Russian duke, thus wrapping him in the protective cloak of Aryanism for good measure.

To further conceal Berenson's identity, the Serlupis took to calling him "the Baron," a generically aristocratic term that befit, in the locals' eyes, an elderly gentleman of distinguished looks and affable manner who spoke fluent Italian with a thick foreign accent. Berenson's love of long daily walks, however, and his tendency to stop and chat with farmers threatened to undermine his hosts' efforts to protect his anonymity. The art critic, sharing in most Italians' belief that the Allied armies, once on the mainland, would sweep across the peninsula, had expected his stay at the Serlupis' to be a short one; instead, he would spend a year at Le Fontanelle. His "captivity," in the early months at least, was relatively pleasant. He loved the house, which stood on the site where the Renaissance scholar Marsilio Ficino, a protégé of Cosimo the Elder's, had lived. He took increasing material limitations and growing danger in philosophical stride, as a rather salutary reminder of earlier times, when "modern" comforts, such as electricity and running water, were not taken for granted. "I have already settled down to short commons in the way of baths and to the light of one candle or oil lamp," he wrote on August 2. All of this, in his eyes, seemed vastly compensated by the beauty of the land, and by its generosity: "Only fresh meat is at an end. Who cares in this season when one has all the homemade *pasta* and home-baked bread one wants, plenty of green vegetables, luscious pears, huge succulent plums, and honey-sweet figs!"

As the front approached, Berenson seemed unconcerned about his personal safety. His mind, engaged in rereading the classics, kept at a distance what was in fact dangerously near. Since the end of June, he and his hosts had been hearing the rumble of German trucks driving along the Via Bolognese, which runs right above Careggi and Le Fontanelle. The night traffic on the road that leads from Florence to Bologna and to the north had intensified over the summer. Berenson was lucidly aware of the situation.

"They must defend the hillside as it commands an important line of retreat," he wrote in his diary. In early August he noted, "We are at the heart of the German rear-guard action, and seriously exposed."

Rather than the fast-approaching war front, though, it was the increasing isolation of the villa and the complete lack of information, through telephone, radio, or newspapers, that vexed the critic most. Private telephone lines in Florence were cut off at the end of June, while the Fascist-controlled newspaper *La Nazione* ceased publication on July 31. Florence, which lay so close at the foot of the hill, had become a remote place now. "The cathedral, Giotto's campanile, the tower of the Palazzo Vecchio appear romantically silhouetted, and at times startlingly near," Berenson had written in the early months of his stay at Le Fontanelle. Six months later, on August 7, he remarked, "We look over Florence yet we know nothing of what goes on."

Since June, only rumors, of a vague, contradictory, but alarming nature, had reached the inhabitants of the villa. "It was gossiped that . . . the Germans would blow up all the bridges," Berenson recorded in his diary on June 23. "Then a commission went to Hitler imploring that they be spared . . . now it seems that the Ponte Vecchio and the S. Trinita bridge will not be touched. The last is the most elegant and artistic thing of its kind in Europe, and its destruction would indeed be a loss, more than a dozen Monte Cassinos." On July 3 he recorded, "The Germans, on the plea of saving them from Judaeo-American predatoriness, want to take along with them as they leave all the valuable and admired masterpieces of art to be found in Florence. They must be aware that . . . these masterpieces run serious risks of destruction on their way to the north." By the end of July, even rumors had ceased, and the city was eerily quiet. "It is the silence of an abandoned city," Berenson wrote. "Not a sound comes up from Florence, nor of traffic on the roads."

The information blackout was briefly broken on August 3 by a group of German officers who were stationed for a few days at the villa of Quarto. Nicky Mariano, whose mother tongue was German, interpreted for her hosts. "They had been at Montegufoni," Berenson entered in his diary on that day, "where they had enjoyed the company of beautiful pictures—

particularly a portrait by Rubens. Unfortunately, they could not save them from the rapacity of the Americans, who would carry them off and sell them at fabulous prices." If Berenson seemed puzzled rather than distressed by the news, the explanation lay a little further down the page. "The owners," he wrote, "are the well-known triad of Sitwells. To my knowledge they had no old masters that I would have given a hundred dollars for." Rather surprisingly, to that date he had not known that many masterpieces from the Florentine galleries had found refuge at Montegufoni.

"Meanwhile," the critic remarked, "nothing can surpass the visual beauty of these days, and the delightfulness of the weather." As if cruelly oblivious to the ominous signs of the impending battle, the weather in Florence was glorious in the opening days of August 1944. "It is fresh yet radiant, and a pleasure to remain in the sun even at noon," Berenson wrote. At night a cool breeze lured him and the Serlupis to sit on the terrace: under the moonlight, they looked over to Florence and tried to divine where the fire came from, and whether it was Allied or German shells that lit the sky. The explosion they heard on the night of August 3, though, was like no other before. It was loud and seemed, in Berenson's words, "to burst from the heart of Florence. We fear," he wrote, "that the sound was of a bridge dynamited by the Germans."

"Carissimo Anti"—"My dear Anti"—Giovanni Poggi wrote to the Fascist director general of fine arts, Carlo Anti, in the last days of July, "the situation here is deteriorating by the minute." Whether or not he still believed he could get any help from the weak fine arts director of Mussolini's discredited government, Poggi reported the abduction of the Montagnana artworks and of the two Cranachs to Anti and asked that no effort be spared to locate them. On July 28, an SS colonel Baumann visited Poggi at the superintendency. Poggi later recorded his name simply as Baumann, and one strong possibility is Col. Hans Baumann, who was involved in the liquidation of the Warsaw ghetto and had been a member of the right-wing paramilitary group Freikorps von Epp with Heinrich Himmler. In Florence, Colonel Baumann carried an order that came directly from Heinrich

Himmler, the new head of the Wehrmacht after the failed conspiracy to assassinate Hitler on July 20, 1944. As Poggi later recorded, Baumann claimed that following an agreement between Hitler and Mussolini, Himmler had ordered that all major Florentine works of art be taken to northern Italy to protect them from Allied rapine. Determined to "face each and every danger as they arose, one by one," Poggi countered the SS colonel's request with his own government's orders and Alessandro Pavolini's directive to leave everything in Florence. With well-rehearsed arguments, he stressed the difficulty, indeed the near impossibility of transporting so many precious artworks when there were virtually no trucks or gasoline left for such a task in Florence. He was startled to hear that, on the contrary, the colonel had all the transportation he needed for the job and that his orders were to carry out that transfer regardless of cost. The German persisted in his demands and, Poggi added, interspersed them with threats; but the superintendent did not budge. Annoyed by the Florentine's immovability, Baumann asked to inspect the artworks, and on the following day Poggi showed him around the Bargello Museum and the inner portico of the Pitti Palace, where the largest statuary and heaviest bronzes had been stored. Were there not, Baumann asked, any private collections that might need salvaging to the north? To the best of his knowledge, Poggi replied, all masterpieces in private hands had long been moved away from Florence. He omitted to mention that the Piero della Francesca panels, which Ugo Procacci had risked his life to drive from Sansepolcro, were hidden in town, and so was the entire collection of drawings from the Uffizi Gallery. Despite his promise to discuss matters further with Poggi and Consul Wolf, on the next day Colonel Baumann left Florence. A few hours later, Col. Alexander Langsdorff of the Kunstschutz paid a surprise visit to Poggi: during what would be his last conversation with the superintendent, he claimed total ignorance of Baumann's rescuing mission, but assured Poggi that news about the two missing Cranachs was good: the two paintings were safely held at a location he was not at liberty to disclose.

No sooner did Poggi bid Langsdorff farewell than the field of his duels with the German authorities suddenly broadened beyond Florence's mas-

terpieces to encompass the city in its entirety. Colonel Baumann had been gone a few hours when the superintendent was informed by the engineer Alessandro Giuntoli, head of the technical office of the City of Florence, that the German command had requested a detailed map of the area of the city that surrounds its bridges. As the two ran to confer with Cardinal Dalla Costa, archbishop of Florence, a rumor that for weeks had haunted many Florentines was rapidly becoming hideously real. As all knew, the German army had refrained from blowing up the bridges of Rome at the time of its retreat from the capital, out of respect for the ancient and holy city. As a result of the enemy's decision, the Allied armies had crossed the city at great speed and caught up with the German army's rear guard, routing it. General Kesselring was convinced that sparing the Roman bridges had cost him ten thousand men and was determined not to repeat the same mistake in Florence.

Consul Gerhard Wolf had been aware of a German plan to mine all Florentine bridges for some weeks, and had pleaded with Ambassador Rudolf Rahn to have it revoked. On July 28, however, the consul was summoned from Florence to northern Italy; to the Swiss consul Carlo Steinhauslin, who had been begging him to stay, Wolf explained that he thought he could help Florence better by being near Rahn in the north. The anti-Fascist lawyer Gaetano Casoni took the news of Consul Wolf's removal for what it in fact meant: "Wolf's departure is a sign that things are collapsing in Florence." As the natural successor to Wolf's indefatigable good work for Florence, Steinhauslin became the ally of Poggi, Casoni, and Cardinal Dalla Costa during the last dramatic days of July 1944. In his native German tongue, he tirelessly interceded with the military authorities to try to save the city's bridges from destruction. "I realize that perhaps my behavior hasn't been 100 percent 'neutral,'" he remarked after the city's liberation.

In the afternoon of July 29, a proclamation was posted all over town that ordered the evacuation of all neighborhoods bordering the river Arno by noon of the following day, Sunday, July 30. The area extended for about a mile in length and was around 150 yards deep on either side of the river. From the San Nicolò Bridge in the eastern part of town to the Park of the

Cascine to the west, it ran along the *lungarni*, the avenues that flank the Arno, with their elegant Renaissance palaces. At its center was the medieval heart of the city, the web of narrow streets and small squares that had been the scene of Florence's nascent greatness, where trade had flourished and talent bloomed, the stage of the city's violent passions and fierce fights. The area included the Borgo Ognissanti, on the north side of the Arno, where the wool trade that gave the city its wealth had been founded by the Lombard monk order of the Umiliati, the "Humiliated." Also to be evacuated was Por Santa Maria, one of the most ancient of Florentine streets, which connected the Ponte Vecchio to the Piazza del Mercato Nuovo; in the Middle Ages, it had been the bustling center of the silk trade, and some of the most powerful families had built their palaces and towers there. All Florentine bridges lay within the section indicated by the German military authorities, the oldest of which—Ponte Vecchio, Ponte alla Carraia, Ponte alle Grazie, and Ponte Santa Trinita—were as charged with the history of the city as its squares, churches, palaces, and galleries. The thirteenth-century Ponte alla Carraia had been at the center of the wool industry, allowing the carts that gave it its name to shuttle between the Borgo Ognissanti and the wool-manufacturing shops in the San Frediano neighborhood on the opposite bank of the Arno. The bridge, which had partially collapsed during a city festival in 1304, had twice been destroyed by rains, and twice rebuilt; Giotto supervised its fourteenth-century reconstruction, Bartolomeo Ammannati its late-Renaissance edition. And by commission of Cosimo I, Ammannati had redesigned the Ponte Santa Trinita; Michelangelo had also had a hand in creating the perfect curvature that, in the eyes of the Florentine intellectual Piero Calamandrei, sprang across the Arno "like a slingshot."

To Carlo Steinhauslin, who rushed to his headquarters to plead for the safety of Florence, Platz Kommandant Fuchs replied that the evacuation was a purely precautionary measure, in case of an Allied direct attack on the city. Fuchs, whom Casoni described as "tall and squarish, not yet fifty, and with a hard face that killed all hope," insisted that all depended on the behavior of the Allies, who were by then less than five miles south of Florence. As proof

of his words, he reminded Steinhauslin that the evacuated population had been told to leave all belongings and furniture behind and to take only the strict necessities for a few days' absence. As he listened to him speak, Steinhauslin was reminded of a remark that Gerhard Wolf had once confided to him: "To Colonel Fuchs, Florence or Smolensk are exactly the same thing."

All around town, evidence seemed to contradict the Platz Kommandant's reassurance. In the afternoon of July 30, the superintendency received a call from an unknown German office inquiring after the possibility of moving the four statues representing the four seasons that stand in couples at either access of the Ponte Santa Trinita. The seventeenth-century sculptures, the superintendency replied, were too heavy to be moved. As he drove by the Ponte alla Carraia on July 31, Consul Steinhauslin glimpsed several neatly arranged rows of wooden boxes, presumably stuffed with explosives. "Reason tells me that the bridges are doomed, and yet I still hope . . . in a miracle," he wrote. A proclamation from General Alexander's headquarters that was dropped by Allied airplanes on July 30 only made matters worse. The flyers encouraged the population of Florence to protect its bridges and monuments from destruction, so that the Allied armies could liberate the city and continue with dispatch their pursuit of the enemy to the north. The proclamation confirmed the Germans' claim that the Allies had not recognized Florence as an open city; it justified their recourse to "precautionary" measures and ultimately gave military justification to their defense of the city.

In one last, desperate attempt to save Florence, on Sunday, July 30, Cardinal Dalla Costa, Giovanni Poggi, and the dean of the university, Mario Marsili Libelli, submitted a memorandum to Kommandant Fuchs that listed the stages of the German commitment to consider Florence an open city, from Ambassador Rahn's and Consul Wolf's repeated efforts to the Führer's unofficial promise. The document emphasized how the few Allied air raids over the city had carefully avoided its monuments. Finally, it asked of the German authorities a safe-conduct for the archbishop to cross over to Allied headquarters to inform them of the gravity of the situation inside

the city, so that "the responsibility for acts which could bring grave harm to a city of such importance, not only for the Florentines but for the Italians and for the whole civilized world, should remain clearly determined before the judgment of history." Colonel Fuchs approved of the contents of the memorandum. He declared, however, that he did not have the authority to grant the archbishop a safe-conduct, as such permission required General Kesselring's approval.

On that Sunday, at noon, thousands of Florentines began to leave their homes. The streets that had increasingly become deserted and quiet during the waning days of July were suddenly filled with men, women, and children, carrying their mattresses and what little food they had and their pots, pans, and pets. Since motorized vehicles had long disappeared from Florence and tramlines had been sabotaged by the Germans, the elderly and the sick were pushed in carts and wheelbarrows. Hundreds of patients were evacuated from the San Giovanni di Dio Hospital in the Borgo Ognissanti. On the way to their meeting at the German *Kommandantur*, Giovanni Poggi and Gaetano Casoni stopped to look at that human flood that moved hurriedly, yet in good order, toward the house of a friend or a relative, and a very uncertain future. They saw the silent resignation and solidarity, youth relieving older men of the burden of a heavy suitcase, or an elegant lady helping a *popolana*, a "woman of the people," with her baby. The architect Nello Baroni remarked, "This is not the time to indulge in bickering, which, under normal circumstances, is so dear to the Florentines." Mixed among the crowds streaming from Oltrarno—the neighborhood "beyond the Arno" that was included in the city by the second circle of walls erected by Arnolfo di Cambio in 1284—were the Guicciardinis, who had to leave their palace on the *lungarno*: eleven of them, plus five chickens. Among the bustle of people and vehicles, Giulia Guicciardini noticed a woman addressing a friend in the street from her window: *"Indo' tu vaite?"*—"Where are you headed?"—she chirped in her crisp vernacular. *"Ma, e s'anderà a' Pitti,"* the woman in the street replied—"I guess we'll go to Pitti." *"Sicché tu vai da irre!"* the first woman shot back—"So, you are going to live with the kings!"

Massively rising at the top of an ascending square along the Via Guicciardini, the Palazzo Pitti was the great house that Luca Pitti, a thriving Florentine merchant, commissioned Filippo Brunelleschi to build for his family. A friend of Cosimo the Elder's, Luca had turned into an enemy of Cosimo's son Piero de' Medici and conspired to murder him. The plot failed, but the Medicis, Piero and his son Lorenzo, decided to spare Luca's life; in time, however, they wrecked his business and reduced him to bankruptcy. As a result of his financial ruin, Luca's projected palazzo, whose windows were to be larger than the main door of the Medicis' own palace on the Via Larga, was left incomplete during his lifetime. Eleonora of Toledo, wife of Cosimo I, bought it from Luca's descendants in 1556 and entrusted the architect Bartolomeo Ammannati with its renovation and expansion. The renowned architect Niccolò Pericoli, known as Il Tribolo, turned the hill behind the palace into the magnificent Boboli Gardens. The Medicis by then had become the grand dukes of Tuscany, and their home and gardens were worthy of the most splendid courts of Europe.

An estimated four to six thousand people found shelter at the Palazzo Pitti, a state-owned museum since 1919, in the last days of July 1944. The princely home opened its gate to the populace of Oltrarno as well as to aristocrats, intellectuals, and professionals: anybody who lived within 150 yards of the river and had nowhere else to go. Reeling under the weight of old suitcases, laden with cardboard boxes and baskets, they gathered under the porticoes that line the main courtyard on three sides, two large Roman statues of Hercules watching over them. Within hours of the refugees' arrival, ballrooms and state rooms were strewn with sheets and towels as each family tried to carve out a little privacy for itself under the crystal beads of resplendent chandeliers, their humble domesticity reflected by large, gilded mirrors. From the ground floor to the attic, through secret passages, grand staircases, back stairs, and narrow corridors, the palace teemed with humanity: men and women carrying on with the business of daily life as best they could. There were pots bobbing over a makeshift stove behind the altar in the chapel; in the Boboli Gardens, people washed and did laundry in the fountains, sought respite from the scorching August sun in the cool

shade of the seventeenth-century grottoes, and used the many paths and hedges as their open-air lavatories. "Each conifer protects, under its long extended branches, a little camp," Giulia Guicciardini wrote.

"Oh, we were lucky," Giuliana Guicciardini recalled in 2004, at ninety-one years of age. "We were allowed to stay in a few rooms of the apartment of the Count of Torino." Vittorio Emanuele of Savoia-Carignano, Count of Turin, had not lived for years in the Palazzina della Meridiana, an eighteenth-century addition to the palace that had been the residence of some members of the Italian royal family since Florence's short spell as the nation's capital in the 1860s. The count's apartment, however, was pristine and richly decorated with draperies, objects, tapestries, and the occasional bearskin rug: elegant if ornate, and a nightmare to clean, Giulia Guicciardini reflected as she prepared to occupy the library and one bedroom overlooking the Piazza San Felice. In the evenings, from their balcony, the Guicciardinis chatted across to the Frescobaldis, who had found refuge in the observatory tower of the Boboli Gardens; from a distance, Giulia and her family watched with envy the trays of roasted potatoes that were being served at the table of their friends, who owned a dozen farms around Tuscany. More families occupied the ground floor of the count's quarters, where Vittorio Emanuele, an enthusiastic huntsman, had housed his museum of trophies. From atop the staircase, the Guicciardinis glimpsed once-ferocious fangs now tamed into coat pegs, and antlers handily lassoed with clotheslines by the people who had taken up residence there.

On July 31, after the Allied artillery severely damaged the electricity plant that supplied the city, Florence was plunged into darkness. Inside the Pitti's walls, "it felt as if the end of the world was coming, yet an almost cheerful calm reigned," the physician, painter, and writer Carlo Levi recorded. The anti-Fascist author of *Christ Stopped at Eboli* had found a last-minute shelter among the crowds at the Pitti. "Everybody was busy with immediate things," he recalled on the tenth anniversary of the city's liberation, "yet nobody could stop wondering what would happen to their besieged city." Nello Baroni recorded in his diary: "At around eleven o'clock at night, we climb up to the *oculi*, round windows high on the top floor." From the *sof-*

fittone, Pitti's cavernous attic, Baroni and a few other men would peep down into the *piazzale*. "From the Via Guicciardini we hear the sound of people at work, the sappers," he wrote. Ugo Procacci, also a resident at the Pitti with his wife and two children, could not bear the anxiety anymore, and started off along the Corridoio Vasariano, the aerial passage that, hardly visible from the street, runs above the Ponte Vecchio and connects the Pitti Palace to the Uffizi. Cosimo I had commissioned his favorite architect, Giorgio Vasari, to build the walkway in 1560. The idea came to the grand duke from Homer's description of King Priam's secret passage at Troy; Cosimo wanted a hallway, away from the public eye and the ever-lurking threat of conspiracies and assassinations, that would lead from the Pitti, his home, to the Palazzo Vecchio, where he conducted the business of the state. As he carved his aerial gallery over rooftops, Vasari ran into opposition from the old and fierce Mannelli family—they proudly traced their ancestry to the old Roman clan of the Manlii—who refused to have their tower destroyed to make room for the corridor and forced Vasari to build *around* it. He completed the corridor that bears his name in six months.

On that Monday, Procacci advanced cautiously, keeping his head below the windowsills and away from the sight of patrolling German soldiers. "I arrived at the arch on the Via de' Bardi and looked toward Borgo San Jacopo," he later wrote in a report for the monuments officers. "Two Germans were battering down the door of a house; as the door resisted, they stepped backward and quickly threw a hand grenade. The entrances to the houses ahead, nearer the Ponte Vecchio, appeared all broken open. At that moment I guessed everything which was to happen: in addition to the bridges, they were mining even the houses; they were going to blow up the ancient quarter of the city." Fearing that one of the German soldiers had spotted him, Procacci quickly retraced his steps: "I returned toward Pitti: I had tears in my eyes and my closed throat almost kept me from breathing."

On August 3, the German authorities declared a state of emergency. Within a large area of town, all windows and doors were to be kept shut, and people were to retreat to their cellars and basements or find shelter inside the city churches. Anybody caught walking in the streets would be

shot. "The thought of the bridges accompanied me that night," Gladys Hutton, a self-described "quiet English lady" who had been living in Florence for years, recalled ten years later. It was a hot night, and Procacci and his wife stepped outside in the garden, among the refugees, to find a breath of air and enjoy the moonlight. A little before ten, they felt a tremendous explosion: dull at first, it grew in intensity and became louder than the rumble of artillery the Florentines had almost grown accustomed to over the last weeks; it seemed to be coming from under the ground and was as terrifying as an earthquake. "For a moment we thought it was the end," Procacci wrote. "It seemed that the earth was trembling and that the great palace would be conquered from one moment to the next; at the same time from every side glass and pieces of window rained on the crowd, and the air became unbreathable. Terror seized the crowd; a few began to cry 'the bridges, the bridges!'" Procacci's brother, who had run to the top of the Boboli Gardens, saw smoke filling the Via Guicciardini.

A second, devastating blast followed in a matter of minutes. As hundreds of people all over town climbed to their rooftops, they saw a thick, dark cloud of dust cloaking the sky and hovering over the Arno and its south bank. Their view obfuscated by the heavy smoke, they tried to determine from the direction of the explosions which of their landmarks might have been destroyed. By the time the clock on the Palazzo Vecchio struck midnight, the sky had gone red, pierced here and there by the pale glimmer of the moon. The ground did not stop shaking in Florence from the force of the explosions until the fiercest blast was heard at five o'clock in the morning. "We knew then," Gaetano Casoni remembered later, "that the ruin was catastrophic."

FLORENCE DIVIDED

But nothing was real till at length we entered the nonpareil City.
—Cecil Day-Lewis, *An Italian Visit*

Morning finally came, and the city lay quiet and unnaturally still. From inside the Palazzo Pitti, Ugo Procacci heard loud voices coming from the square, and for the first time in weeks they were not German but Italian. He opened a window looking over the Piazza San Felice and in the timid light of the summer dawn saw a few young partisans, wearing the tricolor armbands of the Tuscan Committee of National Liberation. "Where are the Germans?" he asked. "There are no more Germans on this side of the Arno," the young men excitedly replied. "And the bridges?" "All gone, except for Ponte Vecchio. Viva l'Italia!" they cried and ran on. "Viva l'Italia," echoed Procacci and closed the window.

The German occupation of Florence was ending and with it the nightmare of twenty years of Fascist dictatorship. That morning Procacci, a member of the anti-Fascist movement Giustizia e Libertà, was no longer a clandestine in his own country; after two decades of secrecy and fear, he could express his ideas freely again. Yet all he could think of at that moment was the Ponte Santa Trinita, whose fate had become an obsession for him over the last weeks. He questioned the truthfulness of what he had just heard. The partisans, after all, may have been wrong, he thought as he ran out into the palace courtyard and breathlessly began to climb the slope of the Boboli Gardens. On that morning, he was not alone in refusing to be-

lieve what he feared to be true but what his eyes had not yet seen. The emergency was not over, and people all over town were still locked in their homes. Sleepless, starved, stunned, many Florentines were simply happy to be alive; many guessed in anguish what they would find of their city at the end of that terrifying night. "Never before had the monuments felt so much like *our own* monuments," the writer Giorgio Querci recalled.

A reeling population struggled to get news and, through their shock, sift what was alarming but false from what was devastating and real. On their terrace at Le Fontanelle, the Serlupi family found dozens of Wehrmacht bulletins left behind by retreating German troops: the typed messages announced that the Allies had blown up the bridges of Florence and destroyed the Tower of Pisa. Marchese Serlupi, Bernard Berenson, and Nicky Mariano rejected the news as malicious and desperate attempts to destroy hope: "these people are stuffed with propaganda like Strasbourg geese" was Mariano's response. In town, but on the north side of the river, Gaetano Casoni heard that the Por Santa Maria road had suffered the worst damage and that the massive fourteenth-century Palazzo di Parte Guelfa was still burning. By mid-morning he could no longer remain in his study, north of the evacuated Borgo Ognissanti. Pretending to be wounded, his arm around the shoulder of a Red Cross nurse and friend, he hobbled toward the Piazza della Signoria. He walked by the fierce scrutiny of several German patrols and reached the archbishopric, where he learned that the nonagenarian priest of the Romanesque Church of Santo Stefano al Ponte, who had refused to leave his parish, had died shortly after the explosions, probably of a heart attack caused by the shock. A huge pile of rubble choked Por Santa Maria, and he could not reach the river. He saw enough, though, to realize that the scale of the destruction was large—too large, in fact, for some to accept it at first. "These are horrible stories that we are hearing, and cannot quite believe them," Giulia Guicciardini wrote from inside the Pitti.

Halfway up the Boboli hill, Procacci reached the Kaffeehaus. The little pavilion was an eighteenth-century addition to the gardens by Peter Leopold of Lorraine, the enlightened Grand Duke of Tuscany who pro-

moted the arts, reformed the educational and the justice systems, and made Tuscany the first state in the world to abolish the death penalty. Pale green against the darker hues of ilex and laurel, the Turkish-style circular Kaffeehaus is cradled by the gentle slope of Boboli; from its tall windows and curved balustrades it offers an enchanting view of Florence. Procacci flew up the stairs of the graceful rococo building, headed for one of its balconies. "Don't look out, the Germans are firing!" a woman shouted at him. He looked, and in the pale morning light saw the ruin of Oltrarno at his feet. He turned to the Arno to his right, where a wide gash had been torn all around the Ponte Vecchio, on both sides of the river. He could not see the Ponte Santa Trinita from where he stood, but his eyes now confirmed what the partisans had told him. As the Florentine writer and actress Elsa de' Giorgi wrote later, "Ponte Santa Trinita is gone, and it is unbelievable. Unbelievable like death on the face of a loved one." It had taken three charges of explosives to destroy it, and only at dawn had the bridge fallen. The Ponte Vecchio alone was untouched, yet the Germans had blocked both its accesses by dynamiting a large area surrounding it.

The art historian could have told at a glance which palazzi and streets were destroyed and which towers had fallen, but his eyes were blurred. In a matter of days he would rally his forces and put all his knowledge, experience, and dedication into salvaging and repairing whatever could be rescued from under the wreckage. Right then, standing by the window of the Boboli Kaffeehaus, he cried. "There was nothing else to do at that moment, really," Giorgio Querci wrote as he recorded his own grief and that of many other Florentines as they first contemplated that vision of horror. "Everything had vanished into a whitish heap of smoking rubble: the old houses, the patchwork of their faded colors, the rhythm of their contours, that most intimate and familiar aspect of our landscape, the face of our city, our childhood, our life, our very soul." A few days after the destruction, casting a sad glance at the bridgeless Arno, Giulia Guicciardini thought that even its waters now had a different voice. "I feel," she wrote, "that from now on I often shall wish to close my eyes and see with my memory."

As Procacci slowly retraced his steps down the hill, the voices of men

and women shouting "The Allies are here!" reached him from the palace courtyard. On her way to the chapel of the Palazzo Pitti, Giulia Guicciardini glimpsed a few of those officers: how well fed and neatly dressed they all looked in their khaki uniforms; how healthy, young, and smiling against the forlorn Florentines that surrounded them, whose mood was shifting rapidly from bewildered to exultant. A strange, long-forgotten feeling of lightness took Procacci as he walked into the courtyard. As if for a moment at least he had left his sorrow up on the hill by the Kaffeehaus, he finally surrendered to the joy of the liberation, transported by the same giddy euphoria that was infecting everyone in that multitude of dirty, malnourished, exhausted refugees of the Pitti Palace.

Among the celebrating crowds of Oltrarno was Gladys Hutton, the self-styled "quiet English lady." At dawn, from the windows of her pension, she had seen five South African soldiers creeping quietly along the walls of the long and dusky Via dei Serragli. As she rushed to the street door, her thoughts ran back to the last year and her many friends who had been deported, tortured, or killed by the Fascist military authority in Florence and its dreaded leader, Maj. Mario Carità. This was the past as she stepped outside to meet *her* people: British, Scots, Irish, South Africans, Australians, Canadians, New Zealanders, and Indians. "*Signorina*, for God's sake, come back inside, it's dangerous," begged a neighbor. "This is not danger," Miss Hutton replied, "I've been waiting for this for four years!"

News of the liberation of Florence's southern neighborhoods spread rapidly by word of mouth. As the first flush of enthusiasm began to recede, however, Florentines south of the river began to ask when they would be reunited with relatives and friends living across the Arno. The evacuees were anxious to go back to their homes. Inhabitants of the northern sections of town, in their turn, wondered why the Allies had not yet reached their neighborhoods. As *The New Yorker*'s Daniel Lang reported, "The Florentines would crowd around the jeeps and inquire ingenuously, 'Are we liberated?'" The question was bound to remain unanswered for days, as an increasingly dismayed population that had been cut off from all sources of information for weeks tried to fathom why the Allies would not advance,

and in fact retreated almost as soon as they entered Florence. "These were military decisions that could not be discussed, or explained, by those among us who were privy to them," the British officer Hubert Howard, of the Psychological Warfare Branch at Allied headquarters, recalled ten years after.

Officer Howard was among the first Allies to enter Florence on August 4. German opposition had suddenly relented that day as a result of that army's gradual retreat toward the north. Early that morning, an Allied convoy started for, indeed rushed toward Florence. Raising a cloud of dust, Allied jeeps and trucks entered the town through the southern gate of the Porta Romana, saluted by Florentines. On approaching the narrower streets of the ancient center of town, Howard proceeded in a jeep protected by two tanks. Driving cautiously along the medieval city walls, they entered the old neighborhood of Borgo San Frediano. Once it reached the river, along the more exposed Lungarno Soderini, the small convoy came under German fire coming from the northern outskirts.

This was expected, whereas German machine guns trained on the city from the southern hill of Bellosguardo were an unwelcome surprise. Contrary to the Allied commanders' belief, the enemy had not yet entirely relinquished the southern quadrant of Florence, and the city was not safe for occupation by regular troops until all German artillery positions had been cleared. The sad fate of Pisa, which was still being contested after weeks of street-by-street battling, dictated General Alexander's decision. The Allied armies were to circle Florence and in a pincer movement chase the Germans from the city's western and eastern outskirts; once reunited to the north of town, they would continue their pursuit of the enemy across the Apennines and to the city of Bologna. Hours after the first Allies entered Florence, Allied headquarters ordered the retreat of regular troops from the city. For the Florentines, hope contracted once more.

For a week, the Arno divided Florence into Allied and German halves. Few Allied officers were allowed into town, and no one was permitted to cross the river. Among those few were Cecil Sprigge and Christopher Lumby, war correspondents for Reuters and *The Times* of London. Although the focus of the military action was shifting away from Florence, the two British

journalists had argued persuasively to headquarters that the news the world was most anxious to hear concerned Florence and its fate. Once inside the beleaguered city, they became rare witnesses of the Florentines' harsh and protracted struggle. They saw the population's terror as patrols of German SS from the north raided the center of town at night for the sole purpose of frightening the Florentines, retreating at dawn; and they shared in its anxiety for the city's art. "Every morning, we climbed up to the top floor at Pitti to make sure that some architectural treasure had not disappeared during the night," Cecil Sprigge wrote. "I learnt to love Florence deeply during that dramatic week."

Armed with excellent directions to the narrow streets from Eric Linklater, who had been to Florence with one of the first convoys, Lumby and Sprigge reached the Pitti Palace. They should make their way through the crowds, Linklater had instructed them, and find a little room with a pleasant painting "in the style of Luini." The two journalists located the room, which was to become their living quarters and working space during their stay, with its pretty sixteenth-century canvas; yet they were far more delighted to discover a faucet that, one droplet at a time, could fill a glass in a quarter of an hour. In a city where the Germans had dynamited all water mains, this was a ducal luxury. During their first hours, Lumby and Sprigge briefly basked in the feverish attention that all Allies received from residents upon their arrival in Florence. The American owner of a pension near the Pitti offered to cook their C rations and fussed over them like a doting old aunt. "I know the uniform makes you look younger," remarked Sprigge, middle-aged like his friend Lumby but flattered nevertheless. An English lady insisted on their having tea on her terrace; as she poured, the two men realized that it was bullets they heard hissing over their heads, to which the Englishwoman, like most residents of Florence, had evidently become somewhat inured. A more disquieting mark of what the war had done to Florence soon caught Sprigge and Lumby's attention: the few civilians who ventured out of doors in search of food or water moved quickly and cast frequent, fretful glances at the roofs and eaves above. On occasion, a black figure could be spotted crawling stealthily over the city's rooftops, or a dark

silhouette behind a curtained window. These were Alessandro Pavolini's snipers, shooting at partisans or training their guns on civilians. The secretary of the Fascist Party was, as Giulia Guicciardini sorrowfully noted in her diary, her own children's age, and had seemed one of the smartest, most serious, and most kindhearted of his generation. "In little time, the Fascist fold has made him bloodthirsty, greedy, and immoral . . . dragged like so many others down the same vertiginous spiral." The scores of young men and women who gunned down hundreds of their fellow citizens before the complete liberation of Florence were the Fascist secretary's legacy to his hometown.

At the Pitti, Lumby and Sprigge met Carlo Levi, and the writer in his turn introduced them to the art historian and poet Carlo Ludovico Ragghianti. Twice jailed by the Fascists, Ragghianti had been the leader since September 1943 of the Tuscan section of the Committee of National Liberation, or CLN, the multiparty political organization that had been leading the underground fight against Fascism since the armistice. Through Levi and Ragghianti, both prominent intellectuals as well as patriots, the British journalists were first acquainted with the Italian partisans, the armed branch of the CLN and a far more diverse organization and complex structure than Allied commanders had generally understood up to that stage of the war. Widespread opposition to Fascism and the German occupation had come together as a cohesive force after the September armistice. While underground cells were yet to be formed during the Allies' liberation of southern Italy, by the time the war reached Tuscany, partisan groups had flanked the Allied armies' fight by providing intelligence and information about places and terrains, receiving arms and ammunition in return. The German army commander, Albert Kesselring, recognized their danger. "Partisan bands," he remembered in his memoir, "began to be a nuisance in and on both sides of the Apennines for the first time in April 1944, being most active in the region of Florence." According to Kesselring, their numbers ranged between 100,000 and 200,000 men at the peak of the fight. The partisans' Arno Division was described by Daniel Lang in *The New Yorker* as "three thousand brave men who provided abundant evidence that Italians could fight when

they feel like it." While acknowledging the partisans' expert conducting of guerrilla warfare and the selfless courage of many in their ranks, Allied commanders had likely pictured their organization as an eleventh-hour band of Italian, Balkan, and German deserters and outlaws. Not surprisingly, then, they were taken aback by their request to meet and discuss the terms of the interim government of Florence. The look of the younger fighters in their ranks, as they first appeared to Allies and their fellow citizens alike after months spent *alla macchia*, or "living in the bush," hiding and fighting in the Tuscan woods and hills, was deceiving. Sporting bandannas, long beards, and an arsenal of assorted weapons, these modern brigands were only the colorful face of a tightly disciplined organization whose members' backgrounds were as varied as their ethnicity and whose political leanings ranged from moderately conservative to Socialist and Communist.

Carlo Levi's assistance proved invaluable to Lumby and Sprigge. He got them a candle—a rare find—which they suspected he stole from some church altar, by whose feeble light they wrote their dispatches. And he turned out to be an excellent source of information. In fact, the two newspapermen soon realized that they knew "too much," the nature of their intelligence being so sensitive that, if published, it would benefit the enemy. So they informed their command, rather than their readers, that there were partisans disguised as Fascists in the tower of the Palazzo Vecchio and that a secret telephone line connected liberated Oltrarno with a room in the superintendency office in the Uffizi. Despite the German-imposed curfew and the Allied order not to cross the Arno, they learned from their partisan sources that a few brave men waded through the sluggish waters of the river every night to gather information on the enemy's moves from the other side of town.

Living conditions north of the Arno were severe. As the actress Elsa de' Giorgi observed, "The deserted and anxious look of the streets of Florence attacked you like a tragic force." Men were still forbidden outdoors and were to be executed if found on the streets. Women only were allowed to leave their homes for a few hours every day to fetch water from the city

wells. As very little food could reach town from the countryside, hunger, for most Florentines, was as devastating as the fear of German arrests, executions, and retaliation. The writer and psychiatrist Corrado Tumiati kept a diary of those days as a way to endure his forced inactivity as an inmate in his own town. Each of his entries ended with a meticulous tally of food: "potato and wheat meal for supper; chickpea soup and leftover rabbit; a little rice and anchovies tonight." By August 10, his sense of humor had not yet entirely surrendered to hunger: "Today I made a golden bargain with a neighbor, I swapped a tin of anchovies for two cans of rabbit and tuna: a food orgy."

While Florence struggled to survive, the Allies were carving a path around the city from southwest and southeast toward the north. The Germans were retreating slowly, fighting bitterly, and relinquishing one neighborhood at a time. The Florentines had by then learned to guess the two armies' movements by the difference in the loudness of their fire; their trained ears could distinguish the far rumblings of Allied artillery from the close crackling of German machine guns. On August 7, German soldiers were still defending the Piazza Beccaria, within the city walls; on the northeastern outskirts, the Allies were fighting for Settignano and Fiesole. "Frankly," an exasperated Steinhauslin asked Fuchs's assistant, Baron Cajus Freiherr von Münchausen, "why don't you leave? What are you waiting for?" General Kesselring's strategy was unchanged: he contested every inch of terrain, buying himself time and pushing the fight to the end of summer and into the fall. By then, he trusted that the Gothic Line of defense would be completed, and the cold weather and the Apennines would help him hold the Allies in check for yet another winter.

On the morning of August 11, the city was awakened by the tolling of the bell of the Palazzo Vecchio: it was a signal prearranged by partisans to indicate that the Germans had withdrawn. The combined voices of men and women, an unthinkable sound for weeks, filled the streets: a low murmur at first that kept growing louder. Upon entering the city for the second time in one week, Hubert Howard felt the stare of hundreds of eyes fixed on him from behind shuttered windows. "We heard the muffled applause

of hidden hands," he wrote on the tenth anniversary of that day. The ancient Volognana bell, by the Bargello Museum, began to toll, as it does only on exceptional occasions, followed by those of many city churches. Florence's whispered welcome to the Allies gained in boldness. The Germans had left the center of town and had retreated behind the Mugnone, a stream flowing along its northern outskirts, leaving signs promising their return all over Florence. The population took a rather optimistic view of the ominous posters, thinking that if the Germans could threaten to return, they must truly be gone. Pavolini's sharpshooters were still terrorizing civilians, yet the city's north and south were reunited, and this was a good reason to celebrate. As Sprigge found himself surrounded by Florentines pouring into the Piazza della Signoria, where the Committee of National Liberation's flag was now flying from the tower of the Palazzo Vecchio, an old lady approached him and asked in her tentative English: "Excuse me, sir, are you the Eighth Army?"

Despite the Florentines' spontaneous joy on August 11, it took the Allies three more weeks to flush all German resistance out of the northernmost areas of the city, until the whole of Florence was finally liberated on September 1, 1944. As long as the military situation remained unsettled and living conditions were critical for the city's population, only a small contingent of Allied medics and public safety officers was allowed into Florence. For the initial phase of the liberation at least, the Allied Military Government's plans for the Tuscan capital could not include monuments officers. Fred Hartt heard of the destruction of the bridges on August 4, his first day at Montegufoni. The news came from the Allied press camp, and it was imprecise and confusing. The destruction was huge, that much he understood, but he could not rush to the city as he wanted and see for himself. He was determined, however, to waste no more time and get to work. The Eighth Army was extending its control over the Arno valley south of Florence, and the art deposits located in that area were now falling into Allied hands. Because of the breakdown in communications between the city and the surrounding countryside due to the passage of the war front, for weeks

no one had known what fate had befallen the hundreds of evacuated Florentine masterpieces. While waiting for permission to enter Florence, Hartt did what Giovanni Poggi, stuck like all Florentines inside the city, wished he could have done, and rushed to survey the art repositories as soon as they were liberated.

He began on August 5 with the Torre del Castellano, a massive eleventh-century castle high on a hill overlooking a gorge on the Arno near the town of Incisa. Technically, the castle had been in Allied territory since the previous day. German and Allied artilleries, however, were still exchanging fire within a hundred yards of it. As they approached the fortress, Hartt and his driver were abruptly plunged into an inferno of exploding shells and thick clouds of smoke. The din was deafening and the road too dangerous to attempt. Inside the turreted château, though, was the Medici collection of Greek, Hellenistic, and Roman statuary from the Uffizi Gallery. The collection was the fruit of centuries of the Medicis' pursuit of beauty and connoisseurship. Cosimo the Elder, the dynasty's founder, and his son Piero, both passionate patrons, had begun it in the mid-fifteenth century. "When it is a matter of acquiring worthy or strange objects he does not look at the price," the sculptor Antonio Averlino said of Piero de' Medici, Lorenzo the Magnificent's father. The collection's ancient marbles later adorned the "*horti medicei*," the long-vanished garden located between the convent of San Marco and the Medici Palace on the Via Larga, where Lorenzo the Magnificent set up a school of fine arts. Among the academy's students was Michelangelo, a youth of such talent that Lorenzo took him to live in his palace, treating him like a son. Michelangelo's early works such as the delicate marble relief of the *Madonna della Scala* and the tumultuous *Battle of the Lapiths and Centaurs* were inspired by the styles of the ancient statuary scattered among the citrus trees and thick hedges of his patron's secluded city garden. All these treasures were now cached at the Torre del Castellano, including the celebrated Medici Venus, a Hellenistic copy of the Greek sculptor Praxiteles' sensuous original. Unearthed at Hadrian's Villa at Tivoli, the naked goddess of love had been purchased in the 1580s by Cardinal Ferdinando de' Medici, an avid collector who exhausted his fortune acquir-

ing sculptures for his splendid Roman villa. All carefully packed and labeled, the cardinal's choicest pieces—the Wrestlers, Dionysus and the Satyr, and the massive, twelve-figure group Niobe and Her Children—were now exposed to an artillery barrage in the besieged castle.

Hartt's impatience to reach the fortress ran ahead of any concern for his own safety that day. He left jeep and driver on the side of the road—in fact it was Roger Ellis's "Georgette" that he was borrowing—and climbed up the hill. Having reached the top, as he later recounted, he "made a dash along the exposed skyline" to reach the safety of the castle walls. Once he was inside, the atmosphere was scarcely any quieter. Shouting to be heard over the furious noise of the battle raging outside, the castle's owner, Signor Pegna, told him that German soldiers had decamped only the day before. They left behind a trail of filth, scattered food, and broken furniture, but the rooms where the artworks were stored had not been tampered with. Relieving as the news was, Hartt had to take Pegna at his word, as the quarters, located on the north side of the building, were still dangerously exposed to German fire. Only once the boxes had been opened could the statues be examined for possible damage; only a careful check with the Florence superintendency's inventories would reveal if some of the pieces had been looted. All Hartt could do at that time was to promise a second visit and a thorough survey as soon as conditions around the castle had been stabilized.

The trip to the Torre del Castellano, Hartt wrote, was "harrowing." A noncombatant officer, Hartt had found himself under fire for the first time and exposed to the serious possibility of being killed. He had acted on impulse, but the experience, in retrospect, had brutally opened his eyes to the volatility of war, and to the crazy challenge of defending art on a war front. The area was a no-man's-land of stray fire, roaming deserters, and feral retreating troops; what could Signor Pegna do, brave though he was, if faced with a squad of vengeful Fascists, or a handful of soldiers in the mood for a little souvenir hunting? The artworks could not be transported back to Florence, not while the city was in a state of near siege. The experience at the Torre del Castellano gave dramatic urgency to what Hartt had already intu-

ited on his first visit to Montegufoni: he needed help, from his army and his colleagues, and a plan. As the Allies were gaining control of an ever-expanding area south of Florence, and more art repositories were likely to be identified, Allied patrols would have to be set up to guard these deposits around the clock.

This had all happened rather spontaneously at Montegufoni, thanks to the cooperation of Capt. Unni Nayar of the Mahratta Light Infantry, whose wife's love of art prompted him to place a couple of his men to watch over the Uffizi paintings. General Alexander's personal interest in the artworks had also greatly helped matters at the castle. "General Alex," as his men called him, was himself an amateur painter known for pitching his private camp, named Caledon, in a charming and scenic spot, no matter what country he found himself in. And he had been a friend of Osbert Sitwell's, the owner of Montegufoni, since the days of their military service at Wellington Barracks in London at the beginning of the century.

What Hartt discovered as he visited newly liberated art deposits in the frantic and exhilarating days of early August was that General Alexander was by no means an exception. The army's mood, he realized with delighted incredulity, had changed since the Venus Fixers' woes in Naples. General Eisenhower's directives on historic monuments and art in a time of war had had time to sink in with commanders, and the Allied counterpropaganda had worked hard to dispel the Nazi- and Fascist-promoted notion of the Allied armies as a horde of savages. And then this was Tuscany, the birthplace of the Renaissance, that the generals and their troops were called to respect and protect. Time and time again, the Venus Fixers were amazed at how many among their superiors loved Italian art, or were simply eager to see more of it in their rare moments of leisure. Hartt loved the story of Brig. Gen. Ralph Tate, for instance, which occurred one month later in the still-operational area of Mugello, north of Florence. As Hartt told it, the general's Thirty-fourth Artillery Division had occupied a castle in the village of Barberino, and accidentally found a number of large cartoons, or preparatory drawings, from the Uffizi collection. Tate offered Hartt his full assistance and let him use civilian workmen, in a war zone, to load the artworks on a

Fifth Army truck that would drive them back to liberated Florence. He also insisted on watching the loading operations and asked Hartt to impart some information on every single piece; never one to shun an opportunity for a little impromptu lecturing, Hartt obliged, against a backdrop of hissing grenades and rattling machine guns.

The liberation of the Torre del Castellano and the anticipated discovery of more art repositories to the south of Florence mobilized the Venus Fixers' ranks. The British monuments officers Roger Ellis and Roddy Enthoven, the latter freshly arrived from England, joined forces with Hartt at Montegufoni. Ernest De Wald and John Ward-Perkins traveled from Rome to the castle with the Italian art officials Giorgio Castelfranco and Emilio Lavagnino. The plan of action called for Hartt to continue his first surveys of liberated repositories, while within a day or two of his visit Pennoyer, Ellis, or Enthoven was to follow up with a careful check of their contents. As the officers prepared to examine the paintings, they did not know in what condition they would find them. Almost two years had passed since they had left their home in the Uffizi, Pitti, and the other Florentine museums. They had been exposed to the risk of travel, by truck, through the countryside; they had been put through what artworks fear most, change, of temperature and humidity. Some of the paintings were crated, some were not; some of the crates had been opened, paintings had been moved around. Castelfranco and Lavagnino, who carried copies of the lists of artworks that the superintendencies had handed to the ministry at the time of their evacuation, would help their Allied counterparts discover if something had been misplaced or stolen.

Since no monuments officer was as yet allowed to be billeted in Florence, they all found accommodation at Montegufoni, which became an unofficial headquarters for the Venus Fixers of Tuscany during that tumultuous August of 1944. Even if war tested, the castle's grandeur was a comfort at the end of hot, trying days spent driving along dust-choked and mine-infested roads. The castle's walls were thick and its halls cool, and there was no dearth of spacious rooms and large beds—with mattresses!— for weary limbs that had been hefting colossally weighty and fragile can-

vases in ornate frames. As Fasola had observed at Montegufoni, soldiers, whether Allied or German, loved shifting paintings around, for no particular reason. Most had no idea of what these things were; and even when no harm was intended, canvases were often stacked one on top of the other or left leaning with their painted surface against a damp wall, a drafty window, or a rickety chair. Consequently, while to some comrades the Venus Fixers may have looked like devoted and thorough housemaids, straightening, dusting, rearranging, they were in fact watching over a civilization's tremendous heritage at a crucial time in its history. In the deceptive domesticity of their work, they acted as swiftly, competently, and lovingly as they knew how.

At night, they soothed their headaches and rinsed off the dust and grime of the day in a giant earthenware planter turned into a tub, the Acciaioli crest emblazoned on its outside. Lunch was mostly C rations eaten by the roadside, but suppertime at the castle, as Hartt recalled, was a "pleasant affair": hearty Tuscan meals cooked by a local peasant with the ripe tomatoes, eggplants, peppers, and wild fennel of high summer and enjoyed by as many as fifteen officers and drivers, Italians and Allies, gathered around the massive dinner table. Chianti flowed, which made the British and Americans chattier, their conversation spilling into the dusk-softened garden overlooking the valley; the wine probably dealt the final blow to the Italians, who, exhausted by a day spent talking a language not their own, often retired early.

By August 7, Hartt had retrieved Lucky 13 from Siena and together with his excellent driver, Franco Ruggenini, was headed for the Villa di Torre a Cona, a seventeenth-century mansion owned by the counts Martini and Rossi. "Vermouth," the monuments officer Henry Newton felt compelled to insert in a report by way of clarification of the family's business. Cached in the house was one of the largest and most important of the Tuscan deposits, whose inventory read like a who's who of masterpieces of Florentine Renaissance sculpture. Hidden in the huge Baroque villa were Michelangelo's massive sculptures for the Medici tombs in the New Sacristy of the Church of San Lorenzo, and Donatello's statues of prophets that had been removed from Giotto's campanile. Also stashed away in the manor was the collection of bronzes and marbles by Donatello, Verrocchio, and Michelan-

gelo from the Bargello, one of the most ancient palazzi of Florence; named after the man who administered justice in the city, the building was for centuries the grim place of trials and torture, until Grand Duke Leopold abolished the death penalty in 1782, burned all instruments of torture in its courtyard, and turned the palace into a museum. In the company of these masterpieces, many other significant artworks that were sheltered at Torre a Cona seemed, in comparison, minor. The glazed terra-cotta reliefs of the evangelists by Luca della Robbia had been detached from the walls of Brunelleschi's Pazzi Chapel in the Church of Santa Croce. From the museum of Casa Buonarroti, the house that Michelangelo had bought in Florence for his nephew Lionardo, came the master's early marble reliefs *Madonna della Scala* and the *Battle of the Lapiths and Centaurs*, as well as hundreds of drawings and the autograph manuscripts of the sonnets and letters that offer such a compelling insight into the artist's soul.

Less than five miles south of Florence, Torre a Cona was, on August 7, on the edge of Allied-controlled territory. According to Allied press information, the villa had been liberated the day before Hartt's visit, but for all he knew, he could still be heading into a pitched battle. The road that led to the manor, narrow, deserted, and snaking through wild countryside, certainly looked ideal to Giovanni Poggi when, back in 1942, he was selecting remote shelters for the Florentine artworks. On this August morning, however, the thunderous noise of artillery, an ominous reminder for Hartt of his previous expedition to the Torre del Castellano, made the villa more unattainable than even Poggi may have wished. But Hartt had a rendezvous with a master who was to figure prominently in his life and deeply engage his work as an art historian, and he drove on. "I decided to continue," he wrote later, "as long as I found recent wheel tracks, asked for information from military units, and watched for signs of disturbance in the surface of the road, for the worst danger was from mines."

The villa, Hartt was relieved to discover, had indeed been released by German troops the previous day and was now occupied by an Irish battalion. Accompanied by the estate's steward, he walked around the house, where every floor and every room and salon were crowded with boxes of

artworks; save for the library, ransacked by German soldiers, apparently nothing had been damaged. The steward then led Hartt to a spacious hall below the villa's ground floor, whose large door opened onto a terrace in the back of the house. A truck could drive right up to it, and for this reason the room had been chosen as a storage space for the largest and heaviest statuary. Because of its accessibility, the occupying German soldiers had insisted on turning it into a garage, despite the steward's vehement protestations. And there, among crowbars and greasy cans of oil, the Venus Fixer found himself face-to-face with Michelangelo's statues for the Medici tombs.

He had encountered them first as a teenager, his sketchbook propped on his knees and his eyes gazing at the full-size plaster casts that the Metropolitan Museum made available to art students in those days. At the time, he later recalled, he had been "speechless with wonder." He had since had many opportunities to admire the real statues, pacing around them and studying their volumes in the New Sacristy at San Lorenzo in Florence. That afternoon at Torre a Cona, though, his reaction to Michelangelo's mighty work was far more physical. But these, as the rumble of artillery coming from not a mile away reminded him, were exceptional circumstances. As the steward opened the door fully and the warm summer light came pouring in from the garden, the marbles were revealed, caged inside wooden crates, and the young monuments officer was climbing over them. He wanted to make sure that the statues were all there and that they were not pitted with bullets, stained with gasoline or grease, or broken by their perilous travels. Yet even from behind their wooden slats, the potency of the artist's work took his breath away. As he peeped down into one crate, he was transfixed by "the agonized face of Michelangelo's *Dawn*."

The Medici pope Leo X and Cardinal Giulio de' Medici had commissioned Michelangelo to decorate the New Sacristy in the Church of San Lorenzo in 1520. The chapel was to contain the tombs of Cardinal Giulio's father, Giuliano, and of his uncle Lorenzo the Magnificent; with them were to be buried Lorenzo's son Giuliano, Duke of Nemours, and grandson Lorenzo, Duke of Urbino. It was Cardinal Giulio's wish that the New Sacristy celebrate the house of Medici at a time when, as Hartt himself wrote a

few years later, "the new dynastic hopes of the Medici family were seriously endangered by the death of both Dukes and their papal power by the menace of Martin Luther." Michelangelo worked "as he could no harder," he wrote to the pope; by 1526, he had completed the statues *Night* and *Dawn*. By that date, the ambitious Leo X, a bon vivant and an arts patron, had died, and Cardinal Giulio had been elected to the Holy See as Pope Clement VII. In 1534, the decoration of the chapel unfinished, Michelangelo left for Rome, never to return to his native Florence.

The artist's chisel gave the marble effigies of Dukes Lorenzo and Giuliano the handsome profile and noble stance of Roman warriors. The statues bore little resemblance to the two deceased Medicis, who are portrayed as bearded in contemporary images; according to the poet Niccolò Martelli, the artist figured that no one would ever know, at a thousand years' distance, what the two men had really looked like. Their ornate armor bespeaks conquest and power, yet the attitude of the two dukes is pensive. Giorgio Vasari was the first to call Michelangelo's Duke of Urbino *Il pensieroso*, "The Brooder," and that has remained the statue's epithet since. The Medici duke, the dedicatee of Machiavelli's *Prince*, was anything but: ambitious, yes, but prone to wrath and lacking political skills and military courage. Tuberculosis killed him at the age of twenty-six, in 1519, three years after his uncle Giuliano died. In the sacristy, both statues turn their heads to gaze at the Madonna nursing her child that sits on the tomb of Lorenzo the Magnificent. At their feet, the artist placed the allegorical statues *Night* and *Day*, *Dawn* and *Twilight*. In a written note, a sketch, probably, for a poem, Michelangelo imagined a dialogue between his sculptures: "The Day and the Night talk to each other and say, 'With our swift course we drove Duca Giuliano to his death.'" While exalting the Medicis' secular greatness, Michelangelo, who called himself "poor, humble and mad" in his correspondence with the Vatican, turned the sacristy at San Lorenzo into a somber meditation on the brevity of human life and the passing of earthly glory. "Fame holds the epitaphs in position," the artist wrote underneath a sketch for the tombs, "it goes neither forward nor backward for they are dead and their work is finished."

At their unveiling in 1534, the statues caused a sensation in Florence. *Night* especially received much praise, as well as some insipid verse by the poet Giovanni Strozzi. Michelangelo, almost as incisive a writer as he was a sculptor, gave his own words to *Night*:

> *Grato m'è 'l sonno e più l'esser di sasso*
> *mentre che 'l danno e la vergogna dura;*
> *non veder, non sentir m'è gran ventura;*
> *però non mi destar, deh!*
> *parla basso.*

> *It is my pleasure to sleep and even more to be stone:*
> *As long as shame and dishonor may last,*
> *My sole desire is to see and to feel no more.*
> *Speak softly, I beg you, do not awaken me.*

Michelangelo, who could spend months at a time in the quarries at Carrara selecting the right piece of marble for his statues, was believed to have voiced his own torment through *Night*'s somber words. The statue should have been grateful not to be awake to the tumultuous events that had plagued the city. Being made of stone, it did not grieve the burning at the stake of Girolamo Savonarola, as did Michelangelo, who was an ardent follower of the Dominican friar's inflaming call for a return to a humbler and more spiritual Church of Rome. Nor did it suffer the shame of the siege laid to Florence in 1529 by the emperor Charles V at the instigation of Pope Clement VII. When, after a ten-month-long resistance, Florence fell, the two exiled heirs to the Medici family, Giuliano's illegitimate son, Ippolito, and Alessandro, whom the pope had probably sired, were reinstated as the city's absolute rulers. Michelangelo, who as the city's governor of fortifications had drawn the defenses for the strategic hill of San Miniato, fled Florence to take shelter in Rome.

The repatriation of Michelangelo's sculptures, once military operations permitted it, promised to be as titanic as their transfer out of Florence had

been. In 1942, the superintendency had shielded the statues in the sacristy of San Lorenzo with piles of sandbags held in place by wooden scaffoldings; the sacristy's foundations had been reinforced to support the weight of the protections, and in the process a few Roman amphorae had been unearthed. In early 1943, Superintendent Poggi had decided to shelter the statues in Torre a Cona, because of the growing risk of air raids over Florence. The transfer, Poggi wrote, was one of the most complicated, involving the lowering of the two dukes from their niches and the lifting of *Night*, *Day*, *Dawn*, and *Twilight* from the marble tombs on which they lay. The following year, as the war front approached, the superintendent had been anxious to bring Michelangelo's masterpieces back to Florence; by the spring of 1944, however, the German requisitions had left the superintendency with only one truck, and a smallish one at that. Still, Poggi was determined to evacuate Torre a Cona, and did bring some artworks back into town, but was almost immediately stopped by the German military authorities who claimed that traveling in and out of Florence had become too dangerous.

Mesmerized by his discovery, Hartt had not realized at first that Michelangelo's sculptures were not the only celebrities sharing quarters with discarded tires and winches. Stacked against a wall of the crammed garage, the biblical stories of flood and destruction that Paolo Uccello frescoed in the Chiostro Verde of the Church of Santa Maria Novella seemed strangely apposite to their present circumstances. Painted in red and the lurid green that gives the cloister its name, they were a fruit of the master's maturity. Vasari thought they were his best work. The frescoes had been detached from the cloister walls by the *strappo*, "stripping," technique: the painted surface had been covered with a facing cloth fixed to the fresco with soluble animal glue; the cloth, and the pigment adhering to it, were then stripped off the plaster and mounted on a new canvas support. The purpose of the operation was restoration, but it had been conducted by the Istituto Centrale del Restauro, the Central Institute of Restoration, against the advice of the Florence superintendency. In the opinion of the respected restorer Leonetto Tintori, the *strappo*, which had successfully been applied elsewhere, had resulted in considerable damage to Uccello's frescoes. At

the time of their removal from Florence, Poggi had stored three panels at Torre a Cona and three more at Montagnana. These the Germans had left behind when they had emptied the deposit. They probably deemed them too large and cumbersome to be driven with the nearly three hundred other works of art they took to the north; or they were spooked by the ashen faces and the livid bodies whipped by gusting winds against Noah's massive ark.

At Torre a Cona, nothing seemed to be missing, and everything looked intact; the Irish battalion's commander was willing to spare a couple of his men to guard the artworks, and in a matter of days Enthoven and Lavagnino would be conducting a thorough check of the statues, frescoes, and paintings. With help from the estate's workmen, Hartt removed some boards that were scratching Uccello's frescoes. And then it was time to launch Lucky 13 back up the Arno valley and on to his next destination.

On August 8, the Eighth Army itself, in the person of Capt. Lawrence Miller, alerted Lieutenant Hartt to the presence of an art deposit that Miller's unit had happened on at the Ugolino Golf Club near the village of Grassina, in the southern outskirts of Florence. "Long and fantastic story later," Hartt announced to Deane Keller in a hasty dispatch. Grassina was very much in the line of fire. As for the artworks, there were plenty of them, all locked in the clubhouse: an interesting modern building, Hartt noted in passing, and his eye, as usual, didn't fail him. While the mid-nineteenth-century club harked back to the early days of the British colony in Florence, the clubhouse had been designed by the renowned Italian architect Gherardo Bosio and was considered one of the best examples of the International Style in Italy. Once inside, Hartt had to crawl through a hole pierced by German soldiers in the partition that had been built to separate the works of art from the rest of the building; and since there was no electricity in and around Florence, he examined them by the flickering light of a candle. The art came from Pisa: mostly altarpieces and crucifixes from the city's churches, they represented some of the best examples of thirteenth- and fourteenth-century Tuscan painting. That was not the entire story, though. The custodian of the golf club told Hartt that the superintendent of Pisa in person had delivered the masterpieces. The date of the transfer, only a few

weeks prior to Hartt's visit, meant that the art official had whisked the paintings out of Pisa right before the beginning of the intense artillery battle and street-by-street fighting that would see large parts of the city leveled. His action had been gutsy and undoubtedly arduous to carry out at a time when Tuscan roads were subjected to constant bombings. The superintendent, on the other hand, had never returned to Pisa. His name was Piero Sanpaolesi, and he was reported to be currently living among the anonymous crowds at the Pitti Palace.

"All of us at Montegufoni took a rather grim view of a superintendent abandoning his post at a time of danger," Hartt remarked. The mysterious circumstances of the superintendent's disappearance, however, seemed to provide Hartt with a good reason to finally wrangle permission from the AMG to travel to Florence. The AMG command rejected his request, but offered to bring the superintendent to Montegufoni instead. He arrived promptly the next day, accompanied by four carabinieri. Such unusual escort, Hartt surmised, was to be attributed to the apparent "belief that he was a dangerous man."

Forty-year-old Piero Sanpaolesi had what Keller and Hartt later described as "an unfortunate Fascist history." Based on early information, Hartt knew him to have been a Fascist sympathizer, at least until the Allies' arrival in Italy. The fact was damning enough, in those early, highly volatile days after the liberation, for the partisans to execute a man in his position, if ever they apprehended him. In that light, the four carabinieri at his side were probably escorting a man in danger, rather than a dangerous man, to Montegufoni. A few days later, Hartt would learn from Sanpaolesi himself that he in fact had been a *squadrista*, a member of the Fascist paramilitary group that supported Mussolini in his rise to power, since the age of eighteen. And, according to Ugo Procacci, his sympathies were quite unchanged.

But Piero Sanpaolesi was also a very good superintendent. As a young graduate with a degree in engineering and an extensive knowledge of chemistry, he had so impressed Giovanni Poggi that the Florentine art historian had hired him at the superintendency of Florence to direct a restoration laboratory annexed to the Uffizi Gallery. Sanpaolesi had been the superin-

tendent of monuments of Pisa since July 1943. An expert on Byzantine, medieval, and Renaissance architecture, he was a scholar of exquisite taste. He had a thorough knowledge of the monuments of Pisa and its territory, as well as great organizational skills. In brief, he was not a man the Venus Fixers could afford to lose at a time when what little news came out of Pisa spoke of enormous devastations. The superintendent's eventual fate, Hartt felt, was a delicate matter for the new Italian government to decide. For now, they would make use of him. As for his relinquishing of his post, Hartt officially accepted Sanpaolesi's written testimony in which the superintendent claimed to have been caught behind enemy lines while inspecting the artworks at the Ugolino Golf Club. He expressed his reservations in a confidential letter to Keller, who was to be heading up the work in Pisa. "For my part," he wrote, "the arguments are very weak indeed." Sanpaolesi first assisted Sheldon Pennoyer in a meticulous check of the artworks at the Ugolino Golf Club. He was then dispatched to aid Keller in the much-devastated ancient town of Volterra. "Inform your Public Security Officer of the situation," Hartt advised his colleague, "obtain permission to use Sanpaolesi as long as he is useful, and then let him face the music. But it is your baby."

Sanpaolesi was the first superintendent Hartt worked with in Tuscany. Despite the awkwardness of an Allied officer cooperating with a Fascist official, and an unrepentant one at that, ever since their first conversation at Montegufoni Hartt realized what a terrific asset the Pisan superintendent was. He held detailed lists that he himself had prepared of the evacuated works of art. And even without an inventory in hand, his knowledge of the artistic patrimony of Pisa and its province was so thorough that he could identify a misplaced artwork or an unlabeled canvas and its provenance at a glance and thus avoid loss by the misidentification, ignorance, or negligence that is unfortunately so common in wartime. Sanpaolesi was familiar with the history of all the monuments in his town, and with their different building techniques and materials. He knew the good restorers from the mediocre and poor ones, could secure a team of tested and trustworthy workmen at short notice, and knew how to navigate the intricacies of Ital-

ian bureaucracy; from specialized moving companies to glass, timber, and brick suppliers, he was a mother lode of expertise and precious information and a man who could make the work of the Venus Fixers, as they were bracing for the devastation of Pisa, Arezzo, and Florence, a whole lot easier. He was in fact one of the secrets of their ultimate success. Hartt's encounter with Sanpaolesi renewed his determination to meet with the Florentine superintendents as soon as the military circumstances allowed it. And the situation in Florence was slowly improving. On August 13, after the Allies secured the center of town, he finally received permission from the Allied Military Government to visit the city for one day to meet the Florentine superintendents at the Pitti Palace.

He left Montegufoni brimming with anticipation, his impatience to get to Florence silencing in his mind the dire reports of the destruction. Nothing could quite prepare him for the misery that assailed him as soon as he drove through the arched gate of the Porta Romana. "The recollection of the sights of that day makes it difficult to write even now," Hartt recorded two years later. Along the road to the Pitti, there were few people on the sidewalks, and they looked wan, ill, and underfed. Once he was inside the palace, the stately residence of the grand dukes of Tuscany appeared to him "like the most crowded slum in Naples." As he stood befuddled at the sight of laundry billowing from Ammannati's balconies, jostled by the crowd cheering at his uniform, his bewilderment presently turned into relief and awed surprise as Procacci and Poggi appeared from amid the stoves, the baby carriages, and the clotheslines and shook his hand.

These men had been just names for him until that moment, the signatures at the bottom of the ministry's inventories. Yet everywhere in the repositories he visited, Hartt had recognized the mark of their commitment to the treasures of the city in the hundreds of wrapped, crated, and meticulously labeled panels and canvases, and in the massive dismounted bronze doors and huge altarpieces that had been transported out of the city in a dozen perilous trips. The events of the last fortnight had shattered these men's morale. Hartt's enthusiasm, on the other hand, was only waiting to be tapped, and the small team of monuments officers was just then getting into

gear. As he sat around a table with them at the Palazzo Pitti, the American lieutenant explained to the superintendents who the monuments officers were and how they intended to help them to reconstruct their city. He outlined a partnership of sorts, Allied Military Government resources and Italian expertise meeting through the conduit of the Venus Fixers. The superintendents would provide surveys of damage and estimates for the reconstruction, and the AMG would help to secure bricks and tiles, glass and timber. He offered a concrete plan that sealed the horror of the last weeks in the past, and a timidly growing sense that they could get to work together began to rekindle a bit of hope.

At the end of their meeting, Procacci offered to walk with Hartt across the river and to the north side of town, and together they set out for the Ponte Vecchio. The length of the Via Guicciardini that from the Pitti Palace leads to the bridge was blocked by a mountain of rubble thirty feet high. The mines had entirely destroyed the western side of the street, while to the east several houses and palaces were badly damaged. The only way to reach the Ponte Vecchio from the Pitti that day was through the Corridoio Vasariano, which in its initial section, south of the Arno, runs along the Boboli outer wall. Procacci and Hartt climbed a ladder up the garden wall and entered the corridor. Both tall and fit, Procacci sporting an unruly forelock of thick black hair, in less dramatic circumstances the two of them could have passed for youthful men on an adventure, seeking a secret passage out of the palace. The last time Procacci had walked down Vasari's aerial gallery, the bridges on the Arno were still standing. He told Hartt of the day in late July when he had crawled along the corridor and peeped out of its windows, narrowly avoiding the Germans' watch. As Procacci narrated the frightful events of the night of August 3, they reached the point where the hallway, having left Boboli, runs above the Church of Santa Felicita, creating a portico over the church facade. They could continue no farther, as the mines had destroyed the section of the "serpentine artery," as Henry James described Vasari's gallery, around the southern approach of the Ponte Vecchio. Through a narrow staircase, the two men descended into the quiet shrine. Tucked in a corner of the small square of the same name, Santa Fe-

licita was the church where the grand dukes of Tuscany, Cosimo I and his successors, attended Mass privately. Its prestige as a ducal shrine made up for its modest proportions, and many prominent Florentine families sought to build chapels inside it. Pontormo, the solitary and visionary artist whose talent Michelangelo much admired, painted some of his most beautiful works for the Capponi Chapel that Brunelleschi had designed. Most of the artworks had long been evacuated, while the church, thanks to its discreet location, was untouched by the explosions.

Once they stepped outside the church, Hartt and Procacci were hit by the full impact of the devastation. The tall granite column that had been standing in the center of the square since the Middle Ages now lay broken in pieces on the ground. All around was a mass of tangled beams, broken mortar, and shattered glass. A narrow passage had been cleared between the wreckage and the damaged buildings. Mindful of the mines that the Germans had laced the rubble with before retreating, people were slowly advancing in a single line toward the river. The Ponte Vecchio was still standing, the only causeway connecting north and south. It was the first bridge to have been built over the Arno in ancient Roman days, twice destroyed by the river's redoubtable floods and twice rebuilt. Its name, the "Old Bridge," dated back to the time when a new span, the Ponte alla Carraia, had been erected in 1218. At 599 years old, the Ponte Vecchio had withstood all the Arno's subsequent assaults since its last reconstruction in 1345. The interrogation of German Kunstschutz officials in May 1945 would confirm what the Florentine superintendents had unofficially known for weeks before their bridges were blown up: the Ponte Vecchio owed its survival to Adolf Hitler, who thought it "the most artistic" of Florentine bridges—a debatable opinion, though its historical significance was immense. In order to save it while still delaying the Allies' progress through town, the Germans had destroyed the area surrounding both its approaches.

In his sorrow and disbelief that the bold curve of Santa Trinita should be sacrificed and the picturesque Ponte Vecchio spared, it occurred to Hartt to think that the German Führer's taste in art was second-rate. It was an errant thought that day, when so much else was on his mind; but it did recur,

when a few more instances during his wartime days in Italy seemed to point to a certain Nazi predilection for quaint themes and cozy domestic subjects over a more classical artistic idiom. Even so, the Ponte Vecchio's charm and popularity may not have been the only reason for its survival. A crucial element of its quirky appeal is the shops that have lined its parapets since medieval times. Butchers and grocers sold their wares there for centuries until Grand Duke Ferdinand I judged them unworthy of such a prime spot and evicted them in 1593. The Medici grand duke, it appears, found the stench of their meats unbearable as it seeped through Vasari's corridor, and allowed only jewelers and goldsmiths to ply their trades under the bridge's porticoes. Even if demolished by mines, the bridge's mass of masonry would not have sunk beneath the river's surface in summertime. Hartt, who was no military strategist, reflected on how low and sluggish the Arno waters were at that time of year. As Hartt stood on the Ponte Vecchio, a few people were cautiously fording the river. A few yards downriver, Allied soldiers were already at work stretching a temporary Bailey bridge over the surviving prow-shaped piers of the demolished Santa Trinita: the lawyer Gaetano Casoni, who like most in Florence had never seen this type of causeway before, described it as "a giant set of Erector pieces brought from across the Ocean that the soldiers were slowly unrolling over the Arno."

The futility of the destruction struck Hartt with particular bitterness. It "may not have held up the war in Italy five minutes, but it paralyzed the city," he wrote later. The horror of it began to sink in as he and Procacci reached the center of the bridge and looked around. All they could see was a sepulchral landscape of truncated facades, disemboweled buildings, and vacant windows. The stench from the dynamited sewers was almost sickening in the hot summer day. As they gazed northward, the skyline from the bridge was horribly distorted: through the smoking desert that was now the Por Santa Maria road, the massive square of the Church of Orsanmichele was now in full view, and so was the Cathedral of Santa Maria del Fiore. Among the ruins of what were once stern palaces of rough stone, only a few medieval towers were still standing, the tottering vestiges of the city's ancient pride. On either side of the river, the explosions had felled the rows of

modest little houses that went back to the days when so much of the city life, festivals, fairs, markets, and processions, took place around the Arno. "Immemorial houses," Henry James called them, "that back on the river, in whose yellow flood they bathe their sore old feet." Their rooftops and sky-lights seemingly climbing one on top of the other, to Hartt they had looked like "a city vaulting the river." All that was left of them now was "a gigantic sandpile slipping into the green Arno."

As Hartt and Procacci painfully took stock of the ruin, they realized that about one square mile of old Florence had been razed. "I do not wish to ex-aggerate," Hartt wrote later, as if putting a brave face to the shock of that day with a measured evaluation of the damage that Florence had suffered to that date. "With the exception of the Ponte Santa Trinita, the best-known monuments of the city were intact or only slightly damaged." No major church or museum had been hit, at least until that moment, since at that time German cannons were still trained on the center of town. But one-third of the city's medieval section was leveled. Hartt called it the "matrix of it all," the hub of dusky streets, severe houses, and tall towers that had both flaunted and jealously defended Florence's earliest wealth. The Via de' Bardi, which ran along the southern embankment of the Arno, was half-demolished. Until the mines of August 3, it had outlived the fortunes of the eponymous family of bankers who had built their palaces on it, and whose empire extended from England to Flanders and France. They lent too much money to the English king Edward III, who defaulted on his loans, and the Hundred Years' War undid them.

Mournfully, Hartt and Procacci left the Ponte Vecchio and, bending their way down the Via Lambertesca, emerged in front of the deep portico and expansive facade of the Uffizi Palace. "I never built anything more dif-ficult, for it has its foundations in the river, as it were, and in the air," Gior-gio Vasari wrote of the palace he designed for Grand Duke Cosimo I, who wished to gather all major city magistracies under one roof, close to the seat of his government in the Palazzo Vecchio. In order to make room for the building, the Medici grand duke did not hesitate to raze to the ground the humble medieval neighborhood of Baldracca, as well as part of the old

Church of San Pier Scheraggio. Vasari, the bold interpreter of Cosimo's urban vision, conceived an office building, the *uffizi*, for his duke in the grand scenic style of the late Renaissance. Potent yet airy, the U-shaped, three-story-high palace sweeps around three sides of the square at its center like the ornate set of a court theater. Gray *pietra serena* defines arches, lintels, and the frames of its tall windows against the simple white of the walls, while, on its short side, three wide arches frame a stunning view of the Arno.

The Uffizi, the final destination and outer limit of Procacci and Hartt's walk on August 13, was now a bleak scene of devastation. Although the museum had not been mined, the violence of the explosions on the nearby *lungarno* had been such that most of its windows were shattered. Shards of glass crunched under Hartt's and Procacci's feet as they crossed the square and headed toward the palace doorway. Broken plaster and more smashed glass covered the grand staircase as the two climbed up to the top floor of the building. Cosimo I had devoted a few rooms in the palace to house the family's collection of paintings and sculpture, but it was his son Francesco I, an avid art lover, who turned over one entire floor of the Uffizi to the display of art in the 1580s. The architect Bernardo Buontalenti, who had succeeded Vasari, covered the originally open top-floor loggia with skylights so that paintings could be hung on its walls. From that time on, the term "gallery" came to be used to describe a museum. Bureaucracy receded under Grand Duke Francesco's wide-ranging interests. The offices now occupied the ground floor of the Uffizi while Francesco, a passionate scientist who dabbled in chemistry, botany, alchemy, and astronomy, opened the first floor to the workshops of goldsmiths and jewelers, painters, sculptors, precious-stone carvers, and tapestry weavers. At his death, his brother Ferdinando I, having "decardinalized" himself in order to become Tuscany's new grand duke, brought to Florence some of the statuary he had acquired for the Medici villa in Rome. Buontalenti designed the "Tribuna," a raised, octagonal room with a mosaic floor and mother-of-pearl-studded ceiling, to house the best pieces of the collection. Down to the last member of the family, the Uffizi was to be the ongoing project of the Medicis, the story of an

ever-growing collection and of its ever-expanding grand home; in 1737, Anna Maria Luisa, last of the Medicis, declared them the property of the Florentine people. And the Lorraine dynasty, who succeeded the Medicis as grand dukes of Tuscany, proved equal to their predecessors and brought the museum into the modern era.

Now, as Hartt and Procacci walked around the gallery, torn pieces of tapestry dangled from the walls. Fragments of the seventeenth-century frescoes that decorated the ceiling now covered the floors. On the walls, squares of lighter paint marked the spots where the pictures had been hanging. On that day, Hartt could only vouchsafe for the paintings he had found, unharmed, at Montegufoni. For the other hundreds of canvases hidden in deposits north of the city, those whitish splotches in the gallery's rooms were a reminder of the artworks' as yet unknown fate. The two men left the Uffizi in a somber mood, and as they came out in the bright light of the summer day, Hartt felt "strangely lonely" standing in his Allied uniform; as a small crowd of Florentines, still getting accustomed to the sight of an Allied officer, gathered around him to greet him, he felt slightly embarrassed. After all, his work was only beginning.

Chapter Eight

A TIME TO REND, A TIME TO SEW

The fire within the stern streets, and among the massive Palaces and Towers, kindled by rays from Heaven, is still burning brightly, when the flickering of war is extinguished.

—Charles Dickens, *Pictures from Italy*

n the words of the American newspaperman Herbert Matthews, Florence in August 1944 was "a terrible story." All its major monuments were spared, but the city had nonetheless been made to pay a very high price for standing in the path of the two armies at the most critical juncture of their struggle. Large sections of its medieval neighborhoods lay in ruins, and damage of a stealthier nature extended well beyond the destruction of the bridges and the devastation of Oltrarno. Florence's loveliest churches were still standing, yet weeks of shelling had pierced their roofs and shattered their windows. Frescoes, mosaics, stucco moldings, wooden ceilings, and marble reliefs were exposed to the double threat of weather and vandalism. An especially cold and rainy winter announced itself early that year. While driving to an art deposit at the beginning of September, Fred Hartt had a "first taste of the drenching rains that were to make the autumn offensive impossible and our own work exceedingly difficult."

Work, at first, was a rush to prevent weather from finishing what war had begun, and it was maddeningly hindered by almost insurmountable odds. The wholesale destruction of Tuscan glassworks, brick factories, and lumberyards by the passage of the war front and by German sabotage made

it extremely hard to obtain building materials for repairs. And prompt intervention was as difficult as it was hazardous. Through the month of August, Florence remained an operational zone, with the two armies engaged in fierce battle around its outskirts. As Allied shells crisscrossed the Florentine sky, German artillery intermittently targeted the center of town. The cathedral, the Uffizi, Brunelleschi's Church of Santo Spirito, and the Gothic Church of Santa Croce all suffered hits. On the morning of August 20, the Church of San Lorenzo was shelled, and twenty people coming out of High Mass were killed on the square outside it. Mines continued to be a threat to rescuers for months; planted in the rubble of destroyed areas, hidden under dead bodies, they were even found by sappers in the Neptune fountain in the Piazza della Signoria.

The situation, Hartt admitted, was almost desperate. For three weeks after his first exploratory mission to Florence, the city was liberated but not quite; "apparently," he explained in his wartime memoir, "the only reason the Germans did not retake the center was to avoid the responsibility of caring for the miserable population." Despite the city's instability, however, and the still-light Allied presence in it until early September, Hartt was allowed to start repair work; for as long as the emergency lasted, he traveled daily the twenty miles that separate Florence from Montegufoni. Undeterred by the danger of working in a war zone, he was determined not to let a whole layer of the city's history disappear in the wreckage. His response to the overwhelming ruin was "prompt action and intensive labor." Others in those frantic early days of the reconstruction shared in his conviction that even the smallest surviving fragment of the destroyed monuments must be salvaged. The young Florentine sculptor Giannetto Mannucci spent weeks in his swimming trunks, diving in the turbid, debris-choked waters of the Arno to fish out pieces of the Ponte Santa Trinita. With a makeshift raft and help from volunteers, he recovered one-sixth of the bridge's original stone, and most fragments of the statues of the four seasons that had stood at its four corners. At one point in his search, a severed human head kept swirling around him, but he could not find the head of *Spring*, the only

piece missing. The fragment was finally given up for stolen, until a sand digger pulled it out of the Arno in 1961.

A sense of urgency charged those early efforts with an intensity that suited Lieutenant Hartt's temperament. Always impatient of army regulations, he felt that the present situation more than justified a certain disregard of military rules. "We could not sit and watch the monuments fall to pieces," he wrote, "while the bureaucracy, Italian and Allied, haggled over the *preventivi*." These were the estimates for first aid repairs that, signed by himself and the superintendents, were submitted in five copies to as many as nine AMG and Italian offices; together with his ceaseless hunt for tiles and other building materials, they became such an exasperating presence in his life as a monuments officer in Florence that their Italian name recurred like a woeful refrain in his letters and dispatches. "Dawn patrols" were more his style, early morning rounds of the streets of Florence to check monuments for damage that might have been inflicted by shelling and the nightly German incursions before vandals or thieves could harvest the broken pieces. With the blessing of the superintendency and in the company of a small contingent of local artists and architects, he recovered small fragments chipped off the polychrome marble walls of the cathedral and Giotto's tower, and the head of a medieval Madonna from a marble relief that graced the nearby late-Gothic Loggia del Bigallo. Though his methods were unorthodox at times, Hartt's ardor won him the sympathy of the thirty-year-old British lieutenant colonel Ralph Rolfe, the youngest Allied provincial commissioner in Italy at the time, as well as the friendship of Captain Roberson, a member of the British military police. Both men's help proved crucial to Hartt: they kept the requisitions of historic buildings for officers and troops to a minimum in the city, and readily granted military policemen to guard a monument; in one instance at least, they tipped him off to a batch of large beams left behind by an army unit that would be used to salvage an otherwise doomed medieval tower.

Personality as well as circumstances turned Hartt into the de facto head of the monuments officers in Florence. As it prepared to launch a surprise

attack on the German army along the eastern coast of Italy, the Eighth Army relinquished control of Florence to the Fifth Army in mid-August. Deane Keller, chief monuments officer for the Fifth Army in Tuscany, agreed to share responsibilities with Hartt, who was more than ten years his junior, on account of the enormous artistic wealth of the region and the extensive damage it had suffered. The decision was taken informally during a conversation between the two men at Montegufoni: Keller was to be in charge of monuments from Pisa and Lucca, the seaport of Livorno, and the ancient Etruscan town of Volterra in the northwest; Hartt was responsible for those from Florence, Arezzo, Pistoia, and the rest of eastern Tuscany. While Keller followed the Fifth Army in its fall push against the German Gothic Line, and in its final offensive in the spring of 1945, Hartt did not leave Florence until the summer of 1945, when he could say with pride that not one leaky church roof was left in the vast region.

Hartt established his office at the superintendency in the Uffizi Palace, with the American private Paul Bleecker as his assistant and an Italian secretary, Ester Sermenghi, whom he described as "a real heroine of the Partisan resistance in Florence." By the end of August, he had bidden goodbye to Montegufoni and sought living quarters in the city. As his regional headquarters was still in Siena and could not billet him, he had to fend for himself: asking for hospitality at the Palazzo Corsini, the massive late-Baroque palace on the *lungarno* between the Santa Trinita and the Carraia bridges, proved an inspired choice. Princess Lucrezia Corsini, the descendant of a long line of art patrons and collectors, as well as cardinals and one pope, was impressed by the young officer's work for the art of her city and gave Hartt a small corner apartment on the top floor of the three-story palazzo. In 2004, her daughter, Donna Anna, at ninety-three years old, could still remember the tall American standing by his jeep in the U-shaped courtyard of her palace "as if it were yesterday." For a year, regardless of how long and trying his days were, Hartt always woke up to an inspiring view of the rust-colored dome of San Frediano against a backdrop of dark hills gently tumbling into town, while the Arno waters drowsily flowed on or furiously

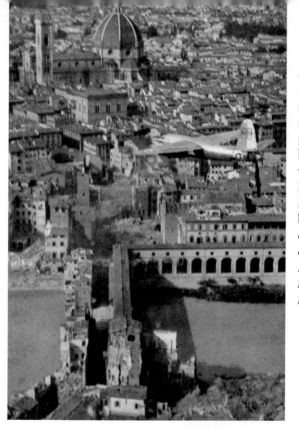

"Smaller than Rome, and more compact, the beautiful city along the Arno presented targets that seemed impossible to attack without causing irreparable damage to things long precious to humanity," the American bombardier Lt. Benjamin McCartney wrote at the time of his mission over Florence, on March 11, 1944. A B-26 Marauder, similar to the one flown by McCartney, surveys the city's devastated area after German mines destroyed five of its bridges on August 3, 1944. *(Pennoyer Archives, Department of Art and Archaeology, Princeton University)*

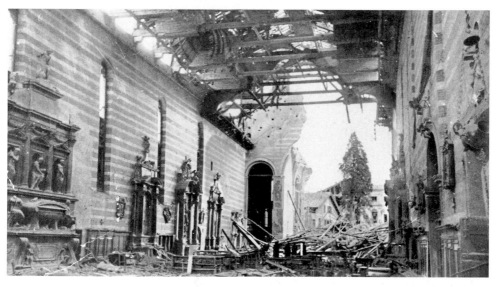

The Gothic Eremitani church in Padua after the Allied air strike of March 11, 1944. "I wonder whether anywhere in the world there is such a constellation of lovely cities, towns, and villages as in the north of Italy into which the devastating tide of war must sooner or later flow," the Archbishop of Canterbury said during a parliamentary debate on February 16, 1944. The bombs destroyed the Ovetari Chapel, to the right, the adjacent Dotto Chapel, and the apse and the right wall of the Cappella Maggiore. *(Venice, Archivio fotografico Soprintendenza per i beni architettonici e per il paesaggio del Veneto orientale)*

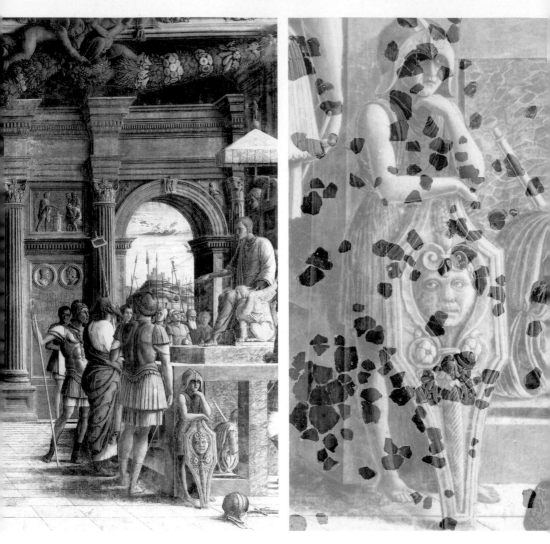

LEFT: A figure in Andrea Mantegna's *The Judgment of St. James* in the Ovetari Chapel particularly intrigued Marcel Proust, one of the Renaissance painter's many literary admirers. He noted in *Swann's Way*, "That purely decorative warrior whom one sees in the most tumultuous of Mantegna's paintings, lost in thought, leaning upon his shield, while the people around him are rushing about slaughtering one another." *(Photo Alinari/Anderson)*

RIGHT: A detail of the same scene after digital recomposition. Two thirds of the Ovetari's painted surface were pulverized by the bombs of March 1944. Eighty thousand fragments of Mantegna's frescoes, roughly corresponding to two hundred square feet of the original decoration, were gathered in boxes and stored at the Istituto Centrale del Restauro in Rome. Returned to Padua on the fiftieth anniversary of the end of World War II, they were the object of a virtual restoration conducted by a team of scientists at the University of Padua between 1995 and 2005. *(Laboratorio Mantegna Padua)*

Workers building a protective wall in the courtyard of the Bargello Museum in Florence in July 1940. June 1940 was a particularly rainy month and the sand that should have filled hundreds of burlap sacks was too wet and heavy for use; brick walls replaced sandbags in shielding statues and monuments. The Florence Superintendency documented its massive protection efforts with more than five thousand photographs. *(Gabinetto fotografico della Soprintendenza per il Patrimonio Storico, Artistico ed Etnoantropologico e per il Polo Museale di Firenze)*

Michelangelo's *David* in the Accademia Gallery was first protected by sandbags in 1940; as further protection against incendiary bombs, it was hidden beneath a brick dome in January 1943, when this photo was taken. Two and a half years later, Deane Keller wrote to his wife, "The bright spot yesterday was seeing Michelangelo's *David* at length divested of its air raid protection. It was dusty and dirty but it was a great thrill." *(Gabinetto fotografico della Soprintendenza per il Patrimonio Storico, Artistico ed Etnoantropologico e per il Polo Museale di Firenze)*

The appropriation of historic sites by soldiers was a major concern of the Roberts Commission, established in August 1943 by President Roosevelt at the insistence of American museum directors, curators, and art historians. "I understand that there is an office, for instance, in the temple of Paestum. That is probably something the high command could avoid if there was someone to call the fact to his attention that it is a Greek temple of importance," the director of the National Gallery in Washington, D.C, David Finley, said during a 1943 meeting of the commission. The soldiers look peacefully at work in the temple of Neptune at Paestum, on the south coast of the gulf of Salerno—yet their presence under the massive fifth-century Dorian columns could have attracted an enemy's air raid and provided juicy material for Fascist and Nazi propaganda. (*The National Archives at College Park*)

The Allied monuments officers mostly employed local craftsmen in the restoration of damaged art and monuments. As they noted, often "the mason who has done the repairs is the great-great-grandson of the man who erected the original building." A *marmorario*, or marble worker, attends to the statue of an angel in the church of Casa Professa in Palermo. The Baroque shrine, which was celebrated for its *marmi misti*, the rich inlaid marble decoration that covered its altars and walls with ornate floral patterns, suffered a direct hit during an air raid in early 1943. (*The National Archives at College Park*)

Monuments officer Frederick Hartt and Father Majone of the Naples Superintendency sorting out fragments of the fifteenth-century tomb of Maria of Aragon, illegitimate daughter of the King of Naples, in the church of Sant'Anna dei Lombardi in Naples. Sant'Anna was badly damaged by one of the last German air strikes over Naples, on the night between March 13 and 14, 1944. *(Imperial War Museum London)*

Captain Albert Sheldon Pennoyer instructing a worker in the church of Sant'Anna dei Lombardi. Through the joint efforts of the Allied monuments officers and the superintendency, first aid work proceeded at a fast clip in Naples. Nine months after the front had moved past the city, roughly 60,000 cubic feet of rubble had been removed and 70,000 square feet of roofing had been restored. "It is evident already," the art historian Emilio Lavagnino wrote of Sant'Anna in 1947, "that once the restoration is completed, the results will surpass the most optimistic expectations, especially in the eyes of those who saw the church immediately after the bombing, when entire sections were reduced to a pile of rubble." *(Imperial War Museum London)*

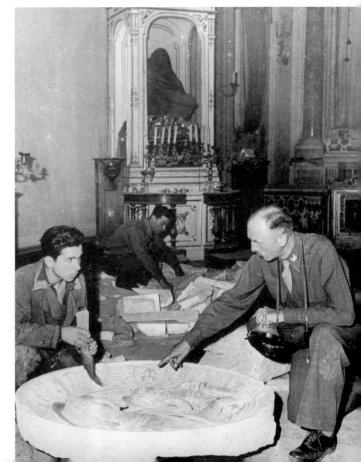

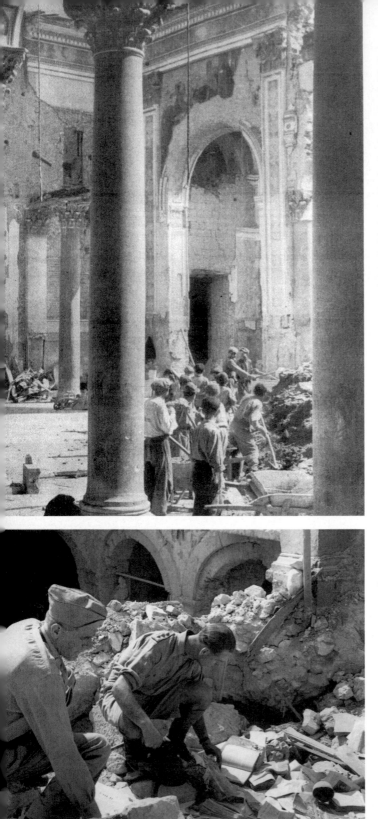

TOP: A victim of the fierce battle around the Volturno River, the town of Capua, twenty miles north of Naples, was hit by an Allied air raid on September 9, 1943. Its cathedral was two-thirds destroyed and deemed by the monuments officers "too damaged for more than clearage." The New Zealander photojournalist George Silk, who took this photograph, was twenty-six at the outbreak of World War II. "The only way I could comfortably go to war was to photograph it," he later said. (Life/*Time Warner*)

BOTTOM: Monuments officers Ernest De Wald and Roger Ellis sort through the rubble of the library at Monte Cassino, "a *very* important monastery of which I could only report that the site of the Archivio (which contained 40,000 parchment rolls alone) was just an immense heap of white dust with no documents visible at all," Ellis wrote in June 1944. As he later learned, however, the vast majority of the abbey's books and documents had been transferred to Rome by the Göring Division in late 1943 as part of a German plan to transport all major Italian archives to northern Italy or Germany. Given the sheer number of Italian historic archives and their widely decentralized locations, the plan was deemed unfeasible in early 1944 and abandoned. (*Imperial War Museum London*)

1. The American monuments officer Deane Keller, in peacetime a professor of painting and drawing at the Yale School of Fine Arts, was often the first among his fellow officers to enter with forward troops the liberated towns of northern Lazio, Tuscany, and, after the Allies' final breakthrough in the spring of 1945, all the major cities of northern Italy. In his eighteen-month service he figured he traveled 60,000 miles and slept in 130 different places, surveying major monuments as well as obscure churches and convents located near or on the front line. *(Pennoyer Archives, Department of Art and Archaeology, Princeton University)*

2. Ernest De Wald was the director of the subcommission for the Protection and Salvage of Artistic and Historic Monuments in War Areas. A professor of art and archaeology at Princeton and a World War I veteran who was fluent in many European languages, De Wald was ideally suited to head an outfit that was hard to sell to the army. In a letter to the editor of the Allied armies' newspaper, *The Stars & Stripes*, Sgt. Robert Wronker objected: "More time, effort and money are being expended on the care and restoration of dead art than on the rehabilitation of live civilians . . . Now, art is a fine thing when you have ample food, clothing and shelter, but as yet no one has offered 13th century tiles to children suffering from malnutrition." *(Pennoyer Archives, Department of Art and Archaeology, Princeton University)*

3. As the monuments officer for the Veneto, Basil Marriott, an architect in civilian life, brought his thorough knowledge of historical styles and building techniques to monuments pocked by artillery fire or felled by air raids. He attended to the restoration of the roof of the great classicist Andrea Palladio's Basilica in Vicenza and to many of the architect's injured palazzi. *(Pennoyer Archives, Department of Art and Archaeology, Princeton University)*

4. At fifty-nine, Cecil Pinsent was the oldest of the monuments officers in Italy. In Florence, the scene of his thriving architect's career for three decades, he surveyed dozens of damaged or demolished villas, many his own creation. The experience was harrowing. A decade after the war ended, he wrote to an Italian acquaintance that he was only just returning to his memories of the war. *(Pennoyer Archives, Department of Art and Archaeology, Princeton University)*

5. The architect Roderick Eustace "Roddy" Enthoven was on the scene in devastated Florence after the German retreat. Later transferred to the north, he took up the thankless job of repairing monuments in Piedmont, Liguria, and Lombardy, the targets of concentrated Allied air raids. Incendiary and explosive bombs gutted Turin's baroque palaces, and nearly all of Genoa's important churches were hit. Enthoven took the extreme scarcity of repair materials and the repeated promise of a car and a typewriter for *"domani"* in humorous stride. *(Pennoyer Archives, Department of Art and Archaeology, Princeton University)*

6. The Allied monuments officers devoted as much attention to Italy's ancient papers as they did to its monuments and works of art. Advancing with the Eighth Army in Lazio, Tuscany, and Umbria, Captain Roger Ellis surveyed major as well as very local archives. Despite their seeming fragility, old books and parchments tended to fare better than the bomb-damaged buildings in which they were housed, and could often be retrieved from under the rubble relatively intact. *(The National Archives at College Park)*

7. The cooperation between the Allied monuments officers and Italian arts officials and scholars was almost everywhere excellent. John Ward-Perkins, who was Ernest De Wald's deputy, is photographed here with De Wald, seated, and with Paola Montuoro Zancani, a professor of Greek archaeology at the University of Naples. As the historian Marcello Barbanera remarked, to pursue Greek archaeology during Mussolini's dictatorship, when all the focus was on Rome and its civilization, was in itself a form of intellectual anti-Fascism. *(Imperial War Museum London)*

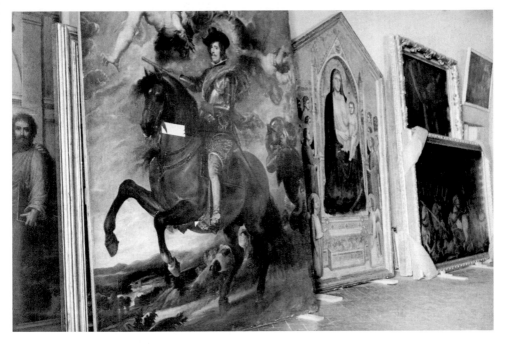

Velázquez's *Allegorical Portrait of Philip IV*, Giotto's *Madonna d'Ognissanti*, and Paolo Uccello's *Battle of San Romano* as the Allied officers first saw them at the castle of Montegufoni in August 1944. In 1942, hundreds of Florentine artworks were moved out of the city for fear of bombings and into old villas and castles in the surrounding countryside. Between the fall of 1943 and May 1945, however, the Allied Italian campaign turned the country into one great battlefield; the passing of the war front through Tuscany in the summer of 1944 isolated these masterpieces in a perilous no-man's-land. *(Pennoyer Archives, Department of Art and Archaeology, Princeton University)*

General Harold Alexander (center), with monuments officer Frederick Hartt (foreground right) and the BBC correspondent Wynford Vaughan-Thomas (second from left), visits Montegufoni on August 3, 1944. The general, himself an amateur painter, was a friend of the writer Osbert Sitwell's, the castle's owner. During a pause in the fierce fighting, he spent a couple hours admiring the rediscovered masterpieces at Montegufoni. *(Imperial War Museum London)*

Following the German authorities' order to evacuate a large section of Florence by July 30, 1944, thousands of the city's inhabitants sought shelter in the massive sixteenth-century Pitti Palace in the heart of town. The writer Carlo Levi recorded: "The Palace when I arrived was already full, in all its salons, hallways and attics; four thousand people were rumored to be living in it . . . Everybody was busy taking care of ordinary things, organizing the few belongings they had taken with them in their flight, getting their children settled, preparing something to eat; . . . in a matter of hours, in those extraordinary circumstances, a society of men and women was formed that was peaceful, harmonious and naturally courageous." *(Imperial War Museum London)*

German sappers planting mines beneath the paving stones of the Ponte Vecchio in preparation for the demolition of six bridges over the Arno and the German retreat from the city. By order of Gen. Albert Kesselring, commander of German forces in Italy, the mines were removed only from the storied Ponte Vecchio on August 1, 1944. The number of unexploded mines and bombs found after the blasts of August 3 that destroyed the remaining five bridges and a significant portion of the city seems to indicate that the German military authorities had intended to destroy an even larger section of Florence. *(Bundesarchiv Bild 101I-480-2227-10A/Bayer)*

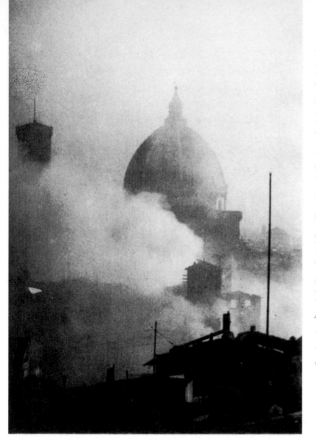

The Florentine architect Nello Baroni, who took this photograph, was among the evacuees at Pitti. On August 4, 1944, he wrote: "We haven't heard any explosions for a while. The sun has risen and a reddish light pierces through an opaque curtain of thick dust . . . Where Por Santa Maria once was thick clouds of black smoke are now hovering, behind which I glimpse Palazzo Vecchio and the Duomo, intact . . . Standing next to me—I didn't hear him coming—a man is watching in silence with his eyes full of tears." *(Gabinetto fotografico della Soprintendenza per il Patrimonio Storico, Artistico ed Etnoantropologico e per il Polo Museale di Firenze)*

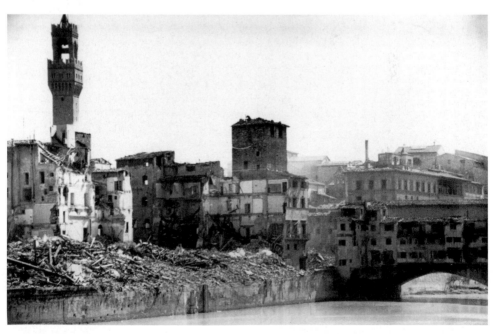

On the north bank of the Arno, the palaces of Lungarno Acciaioli, Baroni wrote, looked like "an immense mass of scree cascading into the Arno." *(Gabinetto fotografico della Soprintendenza per il Patrimonio Storico, Artistico ed Etnoantropologico e per il Polo Museale di Firenze)*

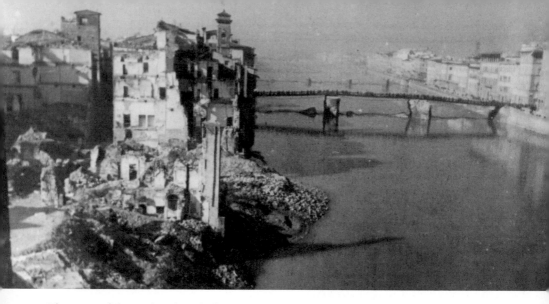

The ruins of the medieval road of Borgo San Jacopo seen from the Torre dei Mannelli. Ugo Procacci, an inspector at the superintendency, recalled that on August 4, 1944, "that day of mourning for the entire city," Giovanni Poggi, superintendent of galleries in Florence, was nowhere to be found. "Only in the evening," Procacci added, "one of our employees told me he had spotted him sitting alone on the ruins of the Via de' Bardi." *(Gabinetto fotografico della Soprintendenza per il Patrimonio Storico, Artistico ed Etnoantropologico e per il Polo Museale di Firenze)*

BOTTOM LEFT: A view of the Ponte Vecchio from the remains of the medieval Palazzo de' Rossi, after the blasts of August 3, 1944. The dome of the Cathedral is visible in the distance; to the right is the smashed section of the sixteenth-century Corridoio Vasariano, the private walkway of the Medici that originally ran around the Mannelli Tower. *(Gabinetto fotografico della Soprintendenza per il Patrimonio Storico, Artistico ed Etnoantropologico e per il Polo Museale di Firenze)*

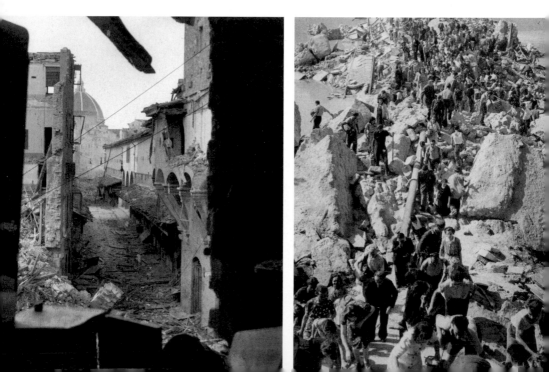

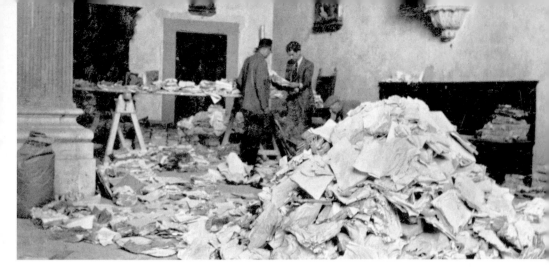

The salvaged books, codices, and manuscripts of the eighteenth-century Colombaria Society gathered in the courtyard of Palazzo Mozzi Bardini. "I still remember with horror the work of a very young soldier, almost a boy, who was operating a bulldozer upriver of the Ponte Vecchio," Ugo Procacci recalled years later. "He chuckled and laughed seeing me and Poggi as we scampered among the rubble trying to salvage precious manuscripts from the Colombaria in the short intervals between the rearing of the machine he was driving and its sudden advance." *(Pennoyer Archives, Department of Art and Archaeology, Princeton University)*

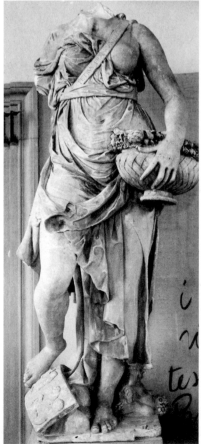

OPPOSITE PAGE, BOTTOM RIGHT: Ponte alle Grazie, the third span to be built across the Arno, in 1237, had withstood the disastrous floods of 1269 and 1333. The first bridge to be destroyed on the night of August 3, 1944, it was rebuilt in 1957. Despite the deadly danger of mines dug in the rubble, people walked across the ruined bridges to bring food or visit friends and family on the opposite side of the river. "Within a relatively few days," remarked the writer R.W.B. Lewis, who was in Florence in August 1944, "the old resiliency began to assert itself; the old energy, even the old combativeness were regained." *(Imperial War Museum London)*

RIGHT: "The Florentines want the head of their Primavera back," reads the handwritten sign behind Pietro Francavilla's reconstituted statue, minus the head, as it was displayed in a 1945 exhibition, "Mostra della Firenze distrutta," at Palazzo Strozzi in Florence. The fragments of the *Primavera* and of the three other statues that had stood at the base of the Ponte Santa Trinita were recovered soon after the bridge's destruction. *Primavera*'s head was found only in 1961 during dredging work on the Arno riverbed. *(Gabinetto fotografico della Soprintendenza per il Patrimonio Storico, Artistico ed Etnoantropologico e per il Polo Museale di Firenze)*

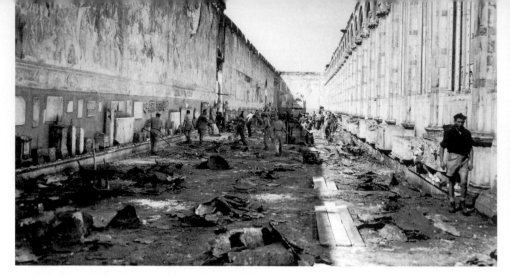

The roofless Camposanto of Pisa after a stray shell hit it on the night of July 27, 1944. The fire that devoured the thirteenth-century cemetery in the celebrated *Campo dei Miracoli* was violent but relatively brief. The medieval and Renaissance frescoes that covered the Camposanto's walls, while gravely damaged by the molten lead of the ceiling dripping down, were spared long exposure to intense heat. The blaze affected the original paints differently, helping experts to distinguish subsequent restorations. As large swaths of the painted surface fell off the walls, they revealed the underlying *sinopie*, monochrome preparatory drawings that offer a unique insight into ancient fresco technique. *(Pennoyer Archives, Department of Art and Architecture, Princeton University)*

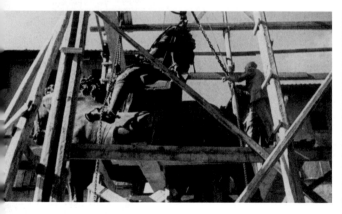

ABOVE: The equestrian statue of Cosimo, first Medici Grand Duke of Tuscany, being put back on its pedestal in the Piazza della Signoria in Florence. The sixteenth-century eight-ton bronze by the Flemish artist Giambologna was evacuated from the city on a cart driven by four oxen in August 1943; in one place the road had to be excavated because the horse's ears could not clear a bridge. Once the threat of bombings was over, a convoy of Allied trucks drove it back to the city in February 1945, amid crowds of Florentines cheering the return of their great ancestor. *(Gabinetto fotografico della Soprintendenza per il Patrimonio Storico, Artistico ed Etnoantropologico e per il Polo Museale di Firenze)*

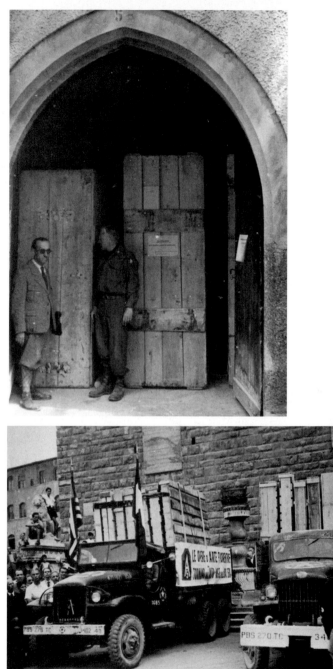

TOP RIGHT: Filippo Rossi, director of galleries for the city of Florence, and Deane Keller amid crated Florentine paintings at San Leonardo in South Tyrol. Nearly six hundred artworks were taken by German officers from their deposits around Florence and driven to German-controlled South Tyrol late in the summer of 1944. They were discovered at San Leonardo and at Neumelans Castle by Allied officers upon the German surrender on May 2, 1945. "This should be the last traveling that this great collection of Italians ever does," Keller wrote as he prepared to repatriate them to Florence. *(Gabinetto fotografico della Soprintendenza per il Patrimonio Storico, Artistico ed Etnoantropologico e per il Polo Museale di Firenze)*

BOTTOM RIGHT: "THE FLORENTINE WORKS OF ART RETURN FROM ALTO ADIGE TO THEIR HOME," reads the sign on the trucks loaded with paintings that entered the Piazza della Signoria in Florence on Sunday, July 22, 1945. The artworks made the two-hundred-mile trip from the north on a freight train, the first to cross the river Po since the retreating German forces had blown up the bridges. "The Florentine trumpeters in their medieval costumes blew us a salute inaudible over the shouts of the crowd, as the huge trucks manoeuvred around to their positions below the bulk of Palazzo Vecchio," Fred Hartt recalled. *(Gabinetto fotografico della Soprintendenza per il Patrimonio Storico, Artistico ed Etnoantropologico e per il Polo Museale di Firenze)*

OPPOSITE PAGE, BOTTOM RIGHT: Deane Keller at work in the Camposanto. One of his many challenges was locating materials, which were extremely scarce and badly needed for the reconstruction of homes, hospitals, and schools; tipped off by local craftsmen, Keller managed to secure mahogany from the nearby port of Livorno and plaster from Volterra for repairs. Keller had the monument cleared of all the rubble and covered by a temporary roof before the start of the torrential rains of the winter of 1944. *(Pennoyer Archives, Department of Art and Archaeology, Princeton University)*

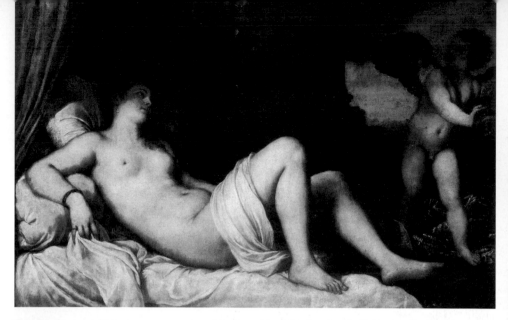

Titian's *Danae*, which the master painted in the mid-1540s for Cardinal Alessandro Farnese, a sophisticated art patron and the grandson of Pope Pius III. In the Greek myth, Danae was a king's daughter seduced by Zeus, disguised as a shower of gold; the canvas apparently bore a strong resemblance to a favorite courtesan of the prelate's. The *Danae* was abducted in the fall of 1943 from the abbey of Monte Cassino by the Göring Division for its Reichsmarschall, whose appetite for art was notorious and who favored sensuous nudes. It was found in South Tyrol in May 1945 and returned to Naples on August 13, 1947. *(Soprintendenza per il Patrimonio Storico, Artistico ed Etnoantropologico e per il Polo Museale di Napoli)*

Frederick Hartt standing by his jeep, "Lucky 13," in the Piazza della Signoria in the summer of 1945. "His jeep, launched on the roads of the Casentino hills and the Arno valley, has entered the realm of legend," wrote Antonio Paolucci, a superintendent of galleries in postwar Florence. "The importance of his timely and often dangerous surveys will never be praised enough." Hartt was made an honorary citizen of Florence for his outstanding wartime contribution and for his help in the aftermath of the catastrophic 1966 flood. His ashes are buried in the city's Porte Sante cemetery on the hill of San Miniato. *(Gabinetto fotografico della Soprintendenza per il Patrimonio Storico, Artistico ed Etnoantropologico e per il Polo Museale di Firenze)*

roared at the embankments, depending on the season. At night, sitting in Princess Lucrezia's parlor with Anna and her brother Filippo, he would recount the events of his day. "I can't remember how many times yet another batch of his hard-earned tiles was stolen," recalled Donna Anna, a frail-looking woman with penetrating blue eyes. As he walked through the door at night, she learned to recognize where he had spent his day from his gait. "If he plodded up the stairs, I knew he had been to war-torn Pisa, but if he came bounding two and three at a time, then he had visited Siena, to which the two battling armies had been merciful."

A man whom an art historian described as "always at war, with someone or something," Hartt found fulfillment and recognition in the context of an actual war. All along his career, some colleagues would resent his litigiousness and often abrasive ways. In 1944 Florence, however, the superintendents liked his hardworking habits and found his dedication a source of renewed energy; if there was a manic edge to it, the febrile atmosphere of war could well absorb it. Excitable and impatient in his work, Hartt found a pause of warmth and calm in his evenings at the Palazzo Corsini. Donna Anna and her family enjoyed his amiable, witty conversation and charming manners. Hartt's Italian was excellent, moving nimbly through the registers, from a workman's saucy vernacular to the highly polished diction of his art historian colleagues and patrician hosts. He was a knowledgeable art historian of sophisticated taste, but there was an abandon to his love of Italy that was endearing even to the notoriously lofty Florentines. He formed friendships during his year in embattled Italy that the passage of time only strengthened. When the Arno flooded Florence in 1966, Hartt rushed to the city two days after the catastrophe to help with the rescue operations. Once back in the United States, he raised money for the restoration of damaged artworks. His support of Florence at yet another tragic time in its history brought great comfort to the Corsinis and to many other Florentines. It reminded them of just what it was that they had all liked so well about Fred Hartt since his wartime days, and Donna Anna summed it up in one sentence: "He cared for our art as if it were his own, and *I loved* that."

. . .

The last pockets of fierce German resistance were flushed out of Florence's northern neighborhoods of Fiesole and Careggi only at the end of August 1944. The city, which the Allies had first entered on August 4, was completely liberated on September 1. "Armored tanks are driving up the Bolognese Way," the writer Corrado Tumiati recorded at that time. "The fight has now moved to the north." With the liberation came the end of fear—of bombs and shells, snipers, arrests, executions, and hunger. The mood shifted almost overnight from anguish to cautious hope and, with it, a desire to rebuild. Living conditions slowly yet steadily improved, with increasing supplies of food, a few daily hours of electricity, and a little running water. The evacuees returned to their homes. More Venus Fixers came to the city to assist Fred Hartt: Teddy Croft-Murray, Sheldon Pennoyer, Roger Ellis, Roddy Enthoven, and Cecil Pinsent. Though older and higher ranking than Hartt, they all recognized a seniority of sorts in their thirty-year-old colleague who had first set foot in the wounded city when it was in shambles. Soon, they took to calling him "Tuscany boy."

With fuller ranks, the monuments officers' work in Florence switched from the frantic salvaging phase of late summer to a more systematic program of repairs. In one year, the superintendency and the Venus Fixers together went from wresting whatever could be rescued from the ruin to taking the first steps toward the restoration of Florence's prewar aspect, while the conflict was still on. By the end of 1944, with the campaign poised to last through yet another winter, they initiated the long process of the city's reconstruction. In early 1945, when the most severely damaged monuments were all but stabilized, they turned their attention to the lesser ones; as if they were reconnecting even the subtlest wires of an ancient civilization, they tended to the street tabernacles and the old villas that together create Florence's unique architectural landscape. Now that Florence was no longer the target of air raids, they began to bring some of the artworks that had been exiled to the surrounding countryside for over two years back into town. By the time they left, Florence was once again full of its stories and bright with color.

• • •

At first, it was a matter of getting to the rubble fast. In late August, the British Royal Engineers were at work clearing the wreckage of the Via de' Bardi along the Arno in search of a water main buried under the debris. Although they had agreed to notify the superintendency whenever their men approached the site of a historic building, the engineers neglected to do so once they reached the old Colombaria Society. The eighteenth-century institution owed its name to the Pazzi family's Colombaria, or dovecote tower, and had its seat in a palace with a lovely arcaded loggia overlooking the river. The society's museum boasted an important collection of Etruscan artifacts dug up at many excavations promoted by the Colombaria all around Tuscany. Its library and archives were rich in codices, incunabula, and manuscripts, and were a trove of documents on the early history of Florence.

The explosions of the night of August 3 destroyed the Colombaria to its foundations. The library and museum were buried under the mortar and stone of the collapsed building, and much of their holdings were carbonized by the ensuing fire. The archive, on the other hand, had not burned down, and there was hope that a thorough search through the building's ruins could yield a substantial portion of its manuscripts. Ugo Procacci, however, got wind that the Royal Engineers were bulldozing the area. What Hartt saw as he rushed to the spot was a Caterpillar slicing off chunks of debris and shoving them into the river. On September 4, 1944, he dispiritedly reported: "MFAA officer made between three and five trips each day, losing about an hour each trip, to the site of the excavations, and each time whatever British authorities on the spot agreed to stop the bulldozer short of the river in order to allow examination of the rubble heap. Each time MFAA officer left the scene, however, the rubble was pushed in directly without examination." When, at around the same time, Lieutenant Colonel Harris, commander of the Royal Engineers, declared rather triumphantly that nothing of interest had been saved from the Colombaria anyway, Hartt could only rejoin, "No wonder."

Exasperation triggered a quick response from the superintendency and Hartt. Removal of the wreckage and art-rescuing operations were not mu-

tually exclusive in their opinion, and Harris's bulldozer-happy ways only precipitated their determination to fight the Royal Engineers. Local history was on their side. Viewed from the angle of the city's centuries-long tradition of discord and strife, their skirmish with the engineers had a genuinely Florentine flavor to it. The curious battle of man versus machine, with the art officials leaping in and out of the way of a jerkingly unpredictable bulldozer, was comically overlaid with the patina of a medieval feud. In 1294, when the city administration had decided to rebuild a bridge across the Arno against the wishes of its proud aristocracy, which refused to bow to its orders, workmen had had to wear helmets and coats of mail as a protection against the arrows shot at them by members of the powerful Alberti family. In the end, Maj. Gen. Norman Coxwell-Rogers, chief engineer at Allied headquarters, backed Lieutenant Colonel Harris, while Brig. Maurice Stanley Lush, representative of the Allied Military Government at General Alexander's headquarters, intervened in favor of the demolished Colombaria. In a letter to Coxwell-Rogers, Lush encouraged him to restrain Harris's "zeal in clearing up Florence." "Forgive me," he added in a closing paragraph, "for bothering you with what may seem a matter of small import, but it is one on which I, among others, feel most strongly." Unheedingly, Coxwell-Rogers retorted: "I think you will agree that we must consider British and American soldiers' lives before ancient monuments of historic and artistic fame." The inflated rhetoric of the argument did not have much traction. Not in Florence, where the liberal bulldozing of the city's historic center into its river was one sure means of exposing the Allies to the accusation of bringing to completion what the Nazis had so meticulously begun.

As the protracted dispute was putting a stranglehold on the monuments officers' massive load of emergency work in Florence, Hartt asked Gen. Edgar Erskine Hume, chief of the Fifth Army AMG, to intervene. The general, who was a medical officer but also a linguist and a scholar and the only American officer to have fought in Italy in both world conflicts, requested that bulldozers bypass the site of the Colombaria entirely, so that the superintendency's officials could freely search its ruins. Working in two shifts under the supervision of Hartt, Teddy Croft-Murray, and the Italian volunteer

Mario Bellini, the superintendency personnel retrieved a surprising number of manuscripts and codices. Before heavy rains started in late September, the salvaged books and parchments were sheltered in the nearby German Protestant church: the archivist Roger Ellis, who also took part in the operation, thought it a case of "poetic justice." Gathered in the church cloister, the heaps of books were a sad spectacle. The fire that had devoured the library had then been banked by the rubble and continued to smolder underneath it: some books were only burned at the edges, but others had been carbonized. Most unbound volumes had been pulped by falling masonry, but bound ones had had their spines damaged while their pages were, in most cases, intact. For two months after they were rescued, Gustavo Bonaventura, director of the Institute of Book Pathology, smoothed their pages, consolidated their bindings, removed dust and fragments of debris, separated pages stuck together by dampness, and inserted dry paper between them to avoid mildew. The final tally vindicated the tenacity of the Venus Fixers and the superintendency: forty-two out of eighty-two historical and scientific manuscripts were salvaged, thirty out of thirty-eight precious codices, and twenty-four out of thirty-six incunabula. And the water main was eventually discovered nowhere near the Colombaria.

"I had a few hours in Florence recently," Roddy Enthoven wrote to John Ward-Perkins in October. "I was glad to have the opportunity of seeing my via Guicciardini-and-Tower-Shoring in place," he continued, "with the streets duly cleared and no dead bodies of bulldozer drivers lying around, as had been prophesied by the Army Engineers." As the letter suggests, by the time Captain Enthoven joined Hartt in Florence, in mid-September, the conflict with the Royal Engineers had far from abated. In fact, as the Venus Fixers' rescuing operations shifted from searching through the rubble to salvaging what little was left standing of medieval Florence, the confrontation had soared to dramatic new heights. The forty-four-year-old British captain, an architect in civilian life, proved a mighty match for the military engineers.

Since joining the ranks of the Venus Fixers in early August, Roderick Eustace Enthoven had been helping Emilio Lavagnino with the painstaking

job of checking inventories in the art deposits of liberated Tuscany. Once he was in Florence, his temperament, as much as his profession, turned out to be an asset for the subcommission. With a thin, slightly mousy face and gentle eyes behind large round horn-rimmed glasses, Enthoven was a natural sidekick to Hartt on the scene of devastated Florence, as quietly tenacious as his American colleague was impetuous. He had the stamina to sustain a protracted dispute, and the sense of humor to defuse exaggerated posturing on the part of his opponent. His eye, so ready to spot the funny side of things, was unforgiving when it came to details. A few colleagues, over his long career as an architect, were tempted, occasionally, to call him pedantic.

Being an architect, Enthoven became the natural ally of the Florence Superintendency of Monuments, and a catalyst for the energies and ideas of a group of young Florentine architects. Led by Carlo Ludovico Ragghianti, these men had formed the Art Commission for Destroyed Florence, quickly and grimly renamed the Rubble Commission. Although Allied rule allowed no Italian outside government to create a commission at that time, Hartt had characteristically disregarded such wartime law and welcomed these local professionals' input. With Enthoven, he passionately shared these Florentines' will to salvage and repair the few surviving medieval buildings. It was on these monuments, they insisted, that the future reconstruction of Florence would be anchored. Captain Enthoven's authority as an architect would serve them well in their dealings with the recalcitrant engineers. His judgment on matters of structure and statics could not be dismissed as easily as his "antiquarian" colleagues' opinion. Sounding suspiciously like shorthand for "amateurs," this term had cropped up in General Coxwell-Rogers's letter to Brigadier Lush in which the general defended the action that had recently led to the demolition of the Guelph Tower.

The sturdy, medieval Torre di Parte Guelfa rose at the junction of the Via Guicciardini with the Via de' Bardi. With the Torre de' Rossi, on the opposite side of the street, it had formed a small, intimate square at the southern foot of the Ponte Vecchio. On the morning of August 4, the Rossi Tower

was a mound of broken stone and shattered bricks while the Guelph Tower, although badly cracked down to about twenty feet from the ground, was still standing. Between the engineers, who feared that its top portion might collapse, and the monuments officers, who strove to save the entire edifice, General Hume brokered a compromise whereby the upper part was to be brought down and the tower's lower section preserved. Once cables were attached to the top of the tower, though, the structure offered such resistance to the bulldozer that the force applied to destroy its upper portion brought the whole building crashing to the ground. "The entire tower was demolished in the presence of Capt. Croft-Murray, who was powerless to stop it," Hartt wrote in his report.

Upon arriving in Florence in the immediate aftermath of the destruction of the ill-fated Guelph Tower, Enthoven recorded his opinion of the incident in no uncertain terms. "Had the time spent on removing the resultant pile of masonry been spent on strutting and shoring the tower, the requirements of both engineers and MFAA would have been met without any delay in the actual work," he wrote. Consequently, his first act as he joined Hartt as a monuments officer for Florence was to obtain a map of the devastated area, on which he marked the historic buildings that his section intended to salvage. "RED INDICATES damaged bldgs. to be retained," he wrote on the margins of the map. "BLUE INDICATES approximate line of remaining built-up area. YELLOW INDICATES temporary street diversion to permit shoring." What Enthoven drew, as he circled towers, palaces, and old houses, was as much a plan of action as a chart of responsibilities. If the engineers claimed that they were not going to risk their men, then the monuments officers would take the responsibility upon themselves to prop up shaky walls and ruined facades, with the superintendency's blessing and the help of Italian man power.

There wasn't much left to be salvaged. Two palace facades on the Via Guicciardini; the roofless Palazzo di Parte Guelfa, a fourteenth-century palace that Brunelleschi and later Vasari had redesigned; and the badly smashed sixteenth-century Palazzo Acciaioli were the dismal count of sur-

vivors around the Ponte Vecchio. And then there were the towers, fewer than a half dozen of them remaining. They were cracked and shaky and dangerous, yet their teetering silhouettes still rose amid the devastation as a haunting metaphor for the city's irresistible rise to prominence and a powerful reminder of its legacy of excellence. Erected between the eleventh and the thirteenth centuries for the purpose of defense, some of them were still robust enough in 1944 to withstand the force of modern warfare. The towers dated back to a time when Florentine bankers and merchants had vied for economic and political dominance over the city. In the fourteenth century, Florence counted about one hundred of them. Built adjoining the great families' houses, they offered protection to the families and their allies, the *consorteria*, against conspiracies, coups, and vendettas. Inside, bedrooms and living rooms were stacked one on each floor, with a well and a stable on the street level and the kitchen at the top. Square and stout, these urban fortresses increasingly became a mark of prestige: the taller the tower, the more powerful its owners. In the thirteenth century, at the height of the internecine fight between the Guelphs, the party of the pope, and the Ghibellines, who supported the Holy Roman Emperor, that divided the Italian peninsula and bloodied the streets of Florence, the winning faction would chop off the top of its enemies' towers as a humiliating sign of their defeat. When the Guelphs victoriously returned to Florence from their exile in 1250, they ordered all towers to be razed to slightly above the level of house roofs. With recourse to a botanical term, the towers were then *scapitozzate*, "pollarded," a lasting image, within the urban landscape, of hubris chastised.

For weeks, the engineers and the monuments officers battled over the fate of the Torre degli Amidei, one of the best examples of thirteenth-century tower building, on the northern side of the Arno. Its north wall collapsed, its south wall partially destroyed and precariously leaning, and only portions remaining of its eastern and western sides, the massive structure was in worse condition than the Guelph Tower. Yet it should be saved, the Venus Fixers and the superintendency argued, as it was virtually the only

building of historical relevance and artistic interest that was left standing on the once-prosperous and now-annihilated thoroughfare of Por Santa Maria. It could be preserved, Enthoven and the superintendency's architect Guido Morozzi insisted, if its fragile walls were propped up and its cracks anchored with steel clamps while the rubble around it was searched for fragments and all remaining blocks of ancient stone sorted. Their plan for intervention included a new concrete foundation; the remaining sections of the walls would be reworked above it, while their missing parts were to be replaced with rough brick. At a later stage, the retrieved old stones would cover the restored tower. A little luck helped the Venus Fixers in the form of a batch of sixty-foot-long beams left behind by an Allied unit on the hill by the Piazzale Michelangelo, which Hartt immediately appropriated to shore the tower. Enthoven's perseverance did the rest. He fought his battle out with the engineers and eventually persuaded them that the plan only required method and a little more attention than the blunt thrust of a bulldozer. With minimal inconvenience, military and pedestrian traffic could be diverted and the tower cordoned off to allow rescuers to sift the debris for missing pieces. And the rubble yielded two Etruscan lion heads of white stone, which to this day decorate the tower facade like a symbolic badge of the successful salvage.

Emboldened by the Venus Fixers' advocacy and AMG funds, the superintendency soon set to work on the Romanesque Church of Santo Stefano al Ponte, which the mines of August 3 had gravely damaged. A large portion of the church facade was dismantled, its stones painstakingly numbered and stored like the pieces of a gigantic puzzle; within months of the explosion, its roof was repaired, its walls were strengthened, and the old blocks were put back in their original place. Similarly, when, late in the fall, the swollen waters of the Arno were threatening to sweep away the remains of the Ponte Santa Trinita, the superintendency was allowed to disassemble the surviving but weakened piers, against the engineers' wish to replace them with modern ones. Numbered and stored, the recovered stonework would become the foundation for the reconstruction of the bridge in post-

war days, while more stone would be quarried from the Boboli hill, the original source of Ammannati's blocks.

The Venus Fixers' support this time was of the scholarly kind. The Italian architect Riccardo Gizdulich, who was commissioned by the superintendency to draw elevations of the bridge, asked Ernest De Wald to help him locate old prints and measurements of the sixteenth-century span. "After some scurrying in New York we found a large thin folio by Lewis Vulliamy from which we have had photostats made of three plates," the architect Rensselaer Lee, a member of the American Council of Learned Societies, wrote to De Wald. Lee did not stop, however, at Vulliamy's 1822 publication, *The Bridge of the SS Trinita over the Arno at Florence*. In the Avery library at Columbia University, he found a nineteenth-century English translation of *The Lives of Celebrated Architects, Ancient and Modern* by the eighteenth-century Italian architect Francesco Milizia. "Following dimensions given," he quoted from a footnote in volume 2, "middle arch, 96 ft. span, each other arch, 86 ft. span; width of piers 26 ft. 9 in.; clear dimension of the carriage and footways between the parapets, 33 ft." "Some day Florence will see," the *New York Times* correspondent Herbert Matthews wrote after having watched a team of stonemasons at work, "as close a likeness as possible of its beautiful Santa Trinita. If Florentines can't get that exactly subtle curvature that has so baffled architects through all these centuries, only the experts will know the difference."

Four months had elapsed since Matthews's first, dramatic reportage from the devastated city, and the results of the early intervention were becoming visible. By the end of October, a dozen churches had been repaired. The progress had buoyed the Venus Fixers' confidence. "On the whole October has been a month of unexpectedly concrete accomplishment," Hartt wrote in his monthly report. "The future looks very much brighter for this Region than it did at the end of September, although the unsolved problems still remain large and numerous." The buttressed walls, shored-up towers, and reconstituted facades were the result of an increased number of foot soldiers in the MFAA outfit and their efficient teamwork, each man bringing his specific competence to an injured sector of the city. With the

arrival of the British officer Cecil Pinsent, the Venus Fixers' work extended beyond the heart of the city to its surrounding hills and to the vernacular architecture of its old villas. "I am glad," Pinsent wrote to John Ward-Perkins on reaching Florence in late September, "to be doing something for Florence, which did so much for me."

Cecil Pinsent and Florence went back a long way. At sixty years old, the British captain was, even by AMG standards, an officer of "venerable age." A wartime photograph shows a tall, bespectacled man of distinguished bearing whose fine features, though whittled by the passing of time to the translucency of parchment, still show a trace of the look that, at the beginning of the century, had prompted Mary Berenson to describe him as handsome "in a frail sort of way." The Berensons had been instrumental in launching Pinsent on a career as an architect in Florence that, after a blundering apprenticeship, had flourished. As the oldest of the Venus Fixers in Italy, Pinsent brought to his wartime team the tremendous experience of three decades of life in Italy; Hartt repeatedly praised him for his "diplomacy," a natural trait as well as the result, no doubt, of having learned not to resist the bureaucracy or fume at the delays, understanding that patience and a large reserve of charm could open doors that irritability and indignation could forever lock. Pinsent also had the distinction of being the only one of his colleagues who had contributed to the making of the architectural landscape they were now struggling to protect—a bittersweet lot, as many of the ancient villas ravaged by the protracted fight around Florence had been lovingly restored by Pinsent, and a few were, sadly, his own creation.

Pinsent first visited Italy in 1906 as a young graduate of the Royal Academy School of Architecture in London. A couple of friends, Edmund and Mary Houghton, aesthetes and insatiable travelers, needed a driver for their excursions around the country; Pinsent, an avid motorist and as skilled a mechanic as he was a draftsman and a photographer, fixed the often-broken car and, in the pauses, recorded his first impressions of Italy—hilltop villages, medieval towns, an alpine landscape, or a Venetian canal—in pencil

or pen-and-ink sketches and watercolors. The Houghtons introduced him to Florence, and to the Berensons, who had recently bought Villa I Tatti. "An unassuming, well-proportioned Tuscan house," in Nicky Mariano's description, I Tatti, in 1907, had no electricity and no telephone and needed extensive renovations. Pinsent and his new professional partner, Geoffrey Scott, a promising classicist who, however, had done disappointingly at the Oxford Greats exams and had opted for architecture as an alternative, needed a start in their career. Mary Berenson was eager to give Pinsent, and especially the dashing Scott, an opportunity; the two were, however, long on grand ideas, but terribly inexperienced. Nicky Mariano, Berenson's secretary and later partner, remembered the "Settecento room," where the two architects had tried their hand at stucco decoration in the Venetian style, as "a rather unfortunate experiment."

Mary was protective of her fumbling architects, whom she alternately called "the Artichokes" or "the Boys," and their firm, which she nicknamed "the Infirm," on account of Scott's frequent ailments. Berenson, initially, was less enchanted with Pinsent, his amateurish experiments in design, and his cavalier attitude toward expenses. "That insolent, unbearable Cecil," he once called him in an outburst of irritation, yet their relationship improved with time; as five decades of almost uninterrupted correspondence confirm, the two men became quite close. Over the years, Pinsent designed for his patron and friend rooms of elegant proportions, a loggia that gracefully framed the countryside, and a beautiful library that Edith Wharton declared a "bookworm's heaven." When Pinsent, with Scott's help, set about turning the fifty acres of fields and vineyards that surrounded the house into a garden, it was the aesthetic of the Renaissance, mixed with his own love of geometry, that guided his hand. Terraced along the slope, the garden was a formal solution to a difficult terrain, and a "theorem clipped in box," as the garden historian Giorgio Galletti described it. A tamed, orderly, and elegant nature came lapping at the house, inviting the scholar to leave his writing for a while and rearrange his thoughts while walking down the avenue of ilexes, where his eyes could idly follow pattern on rhythmic pattern

of green. The garden, which had originally been Mary's idea, captured the very essence of the Renaissance and put a man at the center of his universe. When it was finished, the critic was well pleased. "I now feel," he wrote, "all the beauty I need is my own garden."

I Tatti's garden prompted Sir Harold Acton to coin the adjective "Anglo-Florentine," a term that aptly describes both Pinsent's original vision and the particular atmosphere of blue bloods, blue stockings, and wealthy expats that gathered around Berenson in Tuscany, and for whom he became the inspired interpreter of a local idiom. Pinsent built houses and gardens in the Tuscan tradition but infused them with a modern British sensibility. For a quarter of a century, he anglicized with gusto and secularized with discretion. The radical change in the political climate of Italy in the late 1930s brought his intense activity to an abrupt close. By 1937, Fascism had fully revealed its grimmest face, and Pinsent's fellow Britons and patrons were leaving Italy. He, too, felt it was time to go. "What I have offered is not congenial to the time and what the times want is not congenial to me," he wrote to Mary Berenson in October 1938, "or perhaps it's all just simple laziness."

When Leonard Woolley sought out Pinsent and brought him back to Italy, he readily accepted a commission, glad to be offered the unexpected chance to return to the country he thought he had bidden farewell to forever. The excitement of revisiting Florence seemed to offset the shock of its devastation. "Being here," he wrote to John Ward-Perkins, "in the heart of things and among familiar sights and friends has brought me to life again." He threw himself into completing the shoring and clearing of Por Santa Maria and the Via Guicciardini that Enthoven and Hartt had initiated. Among his responsibilities, he was handed a list compiled by the superintendency of the Florentine villas that had suffered damage and needed inspection. "The list contained every blessed house that had an antique stone in it," Pinsent good-humoredly commented to Ward-Perkins. For days he patiently listened to the procession of gardeners, butlers, and maids, for the most part old acquaintances of his, as they filed through his office to tell their stories.

The worst casualties of the fierce fighting around Florence in the weeks

leading up to its liberation were the villas of Fiesole, a hill that Pinsent, by the garden historian Giorgio Galletti's account, had "partly redesigned" during his Italian years. His duty as a monuments officer was bringing him back to the scene of his most creative season. "It was sad to see Villa Medici at Fiesole, and Villa Le Balze (my work) next door, both of them sort of second homes to me, so badly knocked about and the inside in such a wanton mess" was all a somber Pinsent allowed himself to reveal on closing his letter to Ward-Perkins.

In the warm light of a late summer day, Pinsent walked around the devastated Villa Le Balze accompanied by its gardener, Dino Rigacci. Le Balze was the first house he had built in Florence, in 1913. His experience did not amount to much at that date, but Charles Augustus Strong, a philosopher and a man of considerable means, was a friend of Berenson's and had admired Pinsent's good work at I Tatti. Strong commissioned Pinsent to build his own Tuscan villa to fit in right next to the exquisitely Renaissance Villa Medici. The result was an elongated and simple two-story house that Pinsent designed to naturally follow the contour of the hill. Strong loved his house, and when diagnosed with a terminal illness, he refused to return for treatment to the United States, and chose to die there, in 1940, with the sole assistance and comfort of his manservant. For the duration of the occupation, the empty house had been turned into the headquarters of the German transportation corps. During the battle for Florence, it was caught in the two armies' cross fire: the Allies, believing it to be a German defense post, trained their guns on it, while German artillery responded to their fire from a nearby hill. Shell fire had pierced the ceiling in several places and destroyed both loggias. The rooms that had been redolent with the scent of lavender and roses wafting in from the garden now stank of charred wood and human excrement. A bomb lay unexploded on the library floor. This had been Strong's favorite room, deep and book lined, of an almost severe elegance. Pinsent had opened a narrow slit along one of its walls through which the valley could be glimpsed, and a large window framing a tranquil, enclosed garden that the philosopher could contemplate from behind his desk.

The garden was a particularly bitter sight that September day. Pinsent had met the challenge of designing it along a slope by creating seven small terraced enclosures at various levels around the house. A breathtaking view of the Arno valley below was the reward of building on a precipitous incline. This vista Pinsent had used knowingly, and sparingly, by alternately obscuring it with the tall parapets of a walled-in garden and suddenly revealing it through the slender arches of a loggia. With clipped box and cypress hedges, he had re-created the symmetries of an Italianate garden but then softened their lines with an abundance of flowers and a walkway shaded by the thick curls of a wisteria vine. Now Pinsent, with Rigacci at his side, carefully stepped amid smashed urns and trampled plants; all around them, trees and parapets were pocked by machine-gun fire. The stone statues of Socrates, Aristotle, and Zeno, which ornamented the garden in the Renaissance and Baroque tradition and were the architect's flattering nod to his philosopher patron, were toppled off their pedestals and broken.

Half a mile to the southwest of Le Balze, in the village of Settignano, Pinsent found the Villa Gamberaia a gutted shell in September 1944. This particular house—an exquisite seventeenth-century Tuscan villa sitting on the brow of a low hill overlooking Florence and surrounded, in Harold Acton's words, by "the most poetical garden"—had been a favorite model for Pinsent's own design. At the turn of the century, its mysterious owner, the Romanian princess Catherine Jeanne Ghyka, an art student and a beauty in her youth, had poured her artistic talent into restoring the villa and its garden. As a child growing up in Florence, the writer Iris Origo remembered having heard that after her looks faded, Princess Ghyka never showed her unveiled face to anyone, but paced her garden at night and bathed at dawn in its magnificent pools. Financial constraints forced Princess Ghyka to sell the house in 1925; its subsequent owner, Baroness von Ketteler, vacated it on the eve of World War II. In 1944, the villa was turned into the Geographic Institute of the Italian army. Retreating German troops, rather than moving the mass of documents and maps stacked in the villa, set fire to the house, which burned for three days, from August 24 to August 26. While the garden survived, only the external walls of the villa remained. A thick

layer of ash covered the inside of the house when Pinsent visited it; scattered all over were German propaganda booklets decrying the damage to artworks perpetrated by the Allies.

For a month, Pinsent's long and lanky figure tirelessly paced the hills of Fiesole and Arcetri. By late October, he had surveyed fifty villas in the environs of Florence. With his gentle manner, he rallied the help of custodians and handymen and directed the work of carpenters and stonecutters. No one better than he could advise on how to reconstruct what he himself had built, altered, or renovated: which craftsmen to employ to rework a pavement's colored pebbles, rebuild a rusticated wall, or restore a cracked balustrade. He literally knew some of the houses from the foundations up: among the Origos, he had fondly been known as "the passionate plumber," such was his zest for modernizing a house's sewers and getting, as Mary Berenson once wrote, "thoroughly dirty." For some of the villas he had even designed the large earthenware planters for orange and lemon trees that now lay smashed on terraces and flower beds; he could advise on how to obtain the perfect cream wash for a wall, or how to clip a cypress hedge in topiary shapes. As for his own melancholy at witnessing the destruction and senseless defilement of a world of fragile sophistication whose end he had intuited before the outbreak of the war, he let it surface only fleetingly in a letter he would write to Berenson on his return to England at the end of 1945. "Though I wouldn't have missed this experience for anything," he told his old friend, "I'm glad it *is* over." But in the fall of 1944, he did his best Venus Fixer's job to restore Florence to its prewar self, and that would remain his lasting memory of his service. To Alfredo Barbacci, superintendent of monuments of Bologna, who was to be his colleague at a later stage in the campaign, he wrote, in Italian, ten years after the end of the war: "I had one good fortune in the war, to have been assigned a constructive rather than a destructive role."

Holding a large sheet of paper folded several times over, Roddy Enthoven walked intently along the gray flagstones of Florence's narrow sidewalks.

His eyes traveled from the typed names on his list to the rusticated stone of the palazzi. "Donatello (?), via di Pietra Piana," read one line of his inventory; "Rossellino, via della Spada," followed right below. Brightening street corners or ensconced between a portal and a corniced window, these were the tabernacles, "street art" from medieval times, some thousand images of Madonnas and saints that traced their origins to the gloomy days of the plague of 1348. As the pestilence ravaged the city, eventually killing three-quarters of its 125,000 inhabitants, the Florentines forsook churches for fear of the contagion, attending Mass around improvised altars in the streets. When the epidemic ended, the tabernacles, which took their name from the Hebrew word for "tent," remained as a memorial of that time of suffering. As the Middle Ages drew to a close, people took to gathering around these small street shrines at the end of a day's work. Crafts guilds and religious confraternities commissioned the best masters of their day to paint or sculpt the tabernacles, and the practice was still alive at the dawn of the twentieth century.

Since the beginning of the war, more than fifty tabernacles had been sealed up behind brick walls. At the bottom of his list Enthoven penciled, "Forty-seven inspected." He supervised the removal of their wartime protection, and of shattered glass, birds' nests, and tattered old posters. And while at that, he advised on the restoration of stone canopies damaged by the concussion of the mines, and recommended to oil metal cases and replace old wooden frames and sooty glass. And if it might have looked a little trifling, a skinny, bespectacled man dusting off old images of saints while people were trying to rebuild their lives, Enthoven and his colleagues' divesting Florentine art of its bandages was as good for their morale as Allied flour supplies were for their bodies. The battle for Florence had ended, but the war was not over. The Allied generals probably never doubted the ultimate success of the Italian campaign, but their fight across the country was lasting far longer than expected. The German Luftwaffe, though, had been defeated for months; that meant that the threat of bombs and the horror of air strikes were over. Unwrapping monuments, putting statues back on

their pedestals and inside their niches, was one eloquent way of telling the population that the end was in sight.

It was Deane Keller's idea initially, enthusiastically backed by Hartt, for a few significant sculptures and paintings to be brought back to town as a boost to the morale of the long-suffering Florentines as well as "a fitting reward to the men who have fought in the campaign." One of the first works of art to be returned to Florence, in February 1945, was the ponderous bronze monument of Cosimo I, which for the last year and a half had been lying under a wooden shelter in the garden of the villa of Poggio a Caiano, a few miles northwest of Florence. At Poggio a Caiano, Enthoven and the superintendency architect did not see eye to eye as to how best to move the heavy monument. "Signor Bearzi insisted on the adoption of his methods, i.e. those of the pyramids," the Venus Fixer recorded. In the interest of peace, however, and the speedy repatriation of the bronze effigy of the great Medici, the British captain opted to stand back and let Bruno Bearzi "conduct operations," as he could not help remarking, "orchestra wise." Hours later, and after having "demolished a few feet of park wall, negotiated two sharp corners and cut two military lighting cables," the convoy got under way. Enthoven and Keller, both actors in as well as spectators of the curious pageant, followed the trailer that transported the horse, and the truck that carried the duke, "his legs in the air and water in his eyes." To the piercing sound of sirens and with red lights flashing, the convoy made its slow progress toward Florence along roads rutted with shell holes and lined with wrecked army vehicles and equipment. A soldier, riding astride the neck of the bronze animal, lifted overhead wires, as if he were drawing arabesques against the wintry sky. His nickname, Smokey, is penciled on the back of a snapshot taken that day; the same hand also recorded that he was killed one week later at the front. As the grand duke was slowly driven through the Tuscan villages, people immediately recognized their formidable ancestor; as his face and arms proceeded at eye level with the upper stories of their homes as if gazing into their private lives, men and

women leaned out of their windows and cheered. For them, Enthoven wrote, "the return of Cosimo was a symbol for the return of peace." As the bronze grand duke emerged in the Piazza della Signoria in Florence, a coachman doffed his hat and cheered, *"Bentornato, Cosimo!"* "Welcome home!"

Chapter Nine

THE DUELISTS

To the devil with painters, to the devil with their daubs, one little angel in the Cathedral is worth all the daubers in the world. Always in love with Pisa. Even after having seen the Parthenon and Pompeii.

—Le Corbusier

This is truly a most beautiful land. But dealing with Italians in a business way is a lot different from being a tourist," Deane Keller wrote to his wife from Tuscany, one sentence summing up his experience as a monuments officer during the summer of 1944. Blond, stocky, with wide shoulders developed, as the caricaturist Willis Birchman remarked, "by his constant swinging of the paint brush," forty-three-year-old Deane Keller was an assistant professor of painting and drawing at Yale at the time of his enlistment. Years later, a colleague remembered him as being "at times quite gruff, partially a carry over from the time he had spent with the Fifth Army in Italy during World War II." Yet there was also "kindness and an unusual sensibility toward art," the same colleague observed, underneath Keller's rough exterior. After having sailed to North Africa from the United States, Keller had started his service as a monuments officer in Naples. In May, following the Monte Cassino disaster and the Ovetari Chapel's destruction, he was attached to the Fifth Army's forward echelons, while the British captain Roger Ellis and the American major Norman Newton, who had been with him in Naples, were assigned to the Eighth Army. After months of sharing an office with his colleagues, Keller couldn't wait to leave

Naples for his new posting and its promise of a more active and independent role. "I'll be glad to be out of here even if it will mean bathing in my helmet if there is no water," he wrote to his wife. While Fred Hartt stayed headquartered in Florence, Keller followed the Fifth Army as it swept across Tuscany in pursuit of the retreating enemy, from the southern border with Lazio to the Arno valley and along the Tyrrhenian coast all the way to Liguria.

The Eighth Army launched its assault to the northeast of Florence on August 25, while the Fifth Army held the enemy's attention in the west, with orders to seize every opportunity to gain new territory. Such was the Eighth Army's northward push, toward Bologna and the Po valley, that General Kesselring concentrated the bulk of his German forces north of Florence, leaving only two divisions in the west. On September 1, the Fifth Army crossed the Arno and moved close to medieval Pistoia, in the southern foothills of the Tuscan Apennines, and to the walled-in town of Lucca; by mid-September, it had reached the western defenses of the Gothic Line along the border between Tuscany and Liguria. On September 22, General Clark attacked on either side of the Serchio valley but was soon stopped by the enemy's strong opposition and its potent defenses and by torrential downpours. "The rains and the floods," Eric Linklater remarked, "were as useful to Kesselring as a couple of fresh divisions." As General Kesselring would write in his memoir, he had promised Hitler "to delay the Allies' advance appreciably, to halt it at the latest in the Apennines and thereby to create the conditions for the prosecution of the war in 1945." The Allied armies had suffered heavy losses as they entered the second winter of their Italian campaign; their troops were exhausted, the mountainous terrain made the transport of food and medicines extremely difficult, and ammunition was in short supply. By mid-October, it had become clear to Allied command that the final defeat of the German army was not in its immediate grasp. At a conference in Malta, on January 30, 1945, Roosevelt, Churchill, and the Allied chiefs of staff decided that operations would be resumed in the spring.

"This was the dusty dirty rapid advance," Keller wrote a few months

later, as he looked back to his summer of 1944 with the Fifth Army. "Every day was a day near the front—guns & military movements, Moroccan troops, French, English, Poles etc., flat tires, K rations, begging gas wherever we could get it." He reckoned he visited "at least 200 towns in the last 5 months." The reward of such a feverish pace was the thrill of entering a newly taken town: "You sense it in the air even if you hear nothing and see nothing too unusual outside the tangled wires, new bypasses, fresh mine clearance signs left by the engineers, rubble fresh in the roadway." The excitement outweighed the discomfort of life near the front. "Am on the road 12 hrs. a day," he wrote to his wife at the time. Months later he recalled, "If I spent two consecutive days in camp during June July August September, it seemed strange." With no top and no springs, his driver Charlie Bernholz's jeep, called *"Me ne frego"*—I don't give a damn—offered little protection from the blaze of the summer sun or the relentless fall rains. The caption below one of the many drawings that Keller sent his little son, Deane junior, read, "Daddy reading a letter from Deane. Mosquito reading too." A couple of months later, another cartoon showed a drenched Keller disconsolately declaring, "It always rains where daddy is." As winter approached, he would suffer from chilblains—"sort of a woman's trouble, I guess," he wrote to his wife, "but can't help it." After months of subsisting on C rations, though, he announced rather proudly, "I at last have a waist."

The harsh reality of war hit Keller more bluntly than it did his colleagues in the rear of army operations; the scenes he witnessed on first entering newly conquered cities often stunned him. "I saw one town 90% destroyed—done, gone, people, everything," he wrote. "I can get used to full days in rubble heaps but people are another thing and they haunt you. There are groups who stand and wave . . . Others are too weak to do anything but look." Work, on the other hand, was different from anything he had foreseen, more complex and challenging but also more varied. Before he could survey damaged monuments, and rally local man power, secure estimates, and locate repair materials, the preliminaries were often harrowing, as

Keller described in rapid dispatch-from-the-field style from hotly contested Pisa to his friend Tubby Sizer:

> I . . . go in when the small arms fire stops. The shells still fly often, go in with bed roll and food, . . . then to my own work with some partisans who know the town. This involving trying to find keys to buildings, breaking glass doors (to look for booby traps), breaking windows to enter. Often no one is around, waking up priests or at least finding them. Once I found a pile of 17 century books in the street. All operations stopped until they were put in a nearby house, locked or barred up door . . . Traps and mines are located and proper warnings and people notified. Damages accounted for, histories of atrocities and German activities taken down and listened to. Then it is lunch time, C rations or K opened and eaten on curbstone—chairs taken from nearby houses to sit on. If there is an Englishman near—petrol cans are produced, C Ration cans emptied and filled with gas, a pot of tea soon brewing. Then more inspections . . . One comes to a palace, doors blown, and a piano leaning out the window—tapestries, books, pictures askew, statues in pieces on the ankle deep carpet, no windows, raining, no one around, try to put a little in order. Now it is 5 or 6 in the evening . . . if Carabinieri's good, they will have found an empty house near, if not one look. Go in—see if there is a toilet (never functions) if no toilet there is always the shovel, we bring our own water find a broom . . . If no furniture we tour the streets and collect from other houses . . . Now it's dark . . . Sit around the street in pilfered chairs and eat and wonder if will get shelled. Around 9:30 nothing to do, pooped, go to bed . . . We learn where to walk and how to put the foot down on a staircase or a step. There may be a trip wire under the tread. No doors that are locked are broken open until carefully inspected with flash light— No one with any sense enters a shop, door blown in with enticing souvenirs on the shelves, one boy and his companions were blown to

bits in a music shop—saxophone lying innocently atop the piano and one picked it up . . . The stench of dead bodies, offal, seeing starving kids, wailing over lost homes, the horrible conditions of refugees. It's not all aesthetic.

Keller visited Chiusi, Pienza, Siena, Volterra, and San Gimignano, but the full list extended to dozens of villages and hamlets; perhaps only Bernard Berenson, in the motoring trips that he had taken around Italy to study yet another medieval triptych or reexamine an Annunciation of doubtful attribution, had covered as much ground. Keller could not help remarking, amid bursts of artillery fire at Colle Val d'Elsa, that the hilltop village between Siena and San Gimignano was the birthplace of Cennino Cennini, the artist and author of *The Craftsman's Handbook* on Renaissance painting techniques, and that Arnolfo di Cambio, the architect who designed the Florence cathedral, was also born there. Sightseeing and connoisseurship were not, however, what drove Keller to inspect these storied and evocative Tuscan places in rapid-fire succession. In preservation, time was of the essence, for, as the war correspondent Herbert Matthews pointed out, "how can we expect a Frenchman from North Africa with his Moroccan gun crew to appreciate the importance of Pienza's cathedral?" Aside from Matthews's veiled racism, it truly could not be assumed that a soldier would know that the little town in the Val d'Orcia was an architectural gem, a small-scale, exquisite Renaissance "ideal city" that the architect Bernardo Rossellino designed for Pope Pius II, a native of that land. What Keller was trying to prevent as he rushed along in his bouncing, roofless jeep was a liberating soldier's "first flush of enthusiasm," as Mason Hammond had described it early on in Sicily, when an ancient marble column or a statue might become the prop for a rowdy celebration and the temptation of looting, viewed as a victor's booty, was at its highest. While everybody knew and was expected to respect Rome and Florence, these were lesser-known and often humble-looking towns lying quite defenseless in the middle of the battlefield. As Keller recorded on July 20, we "went into a completely deserted town recently. No one. Most eerie feeling. Shops, pri-

vate dwellings, nothing in them at all ... Streets full of debris, a library open to air, the cathedral in utter ruin. When will it cease?" When he got to Pienza, he found that the roof of its little marble cathedral, whose apse juts out on the valley like the prow of a small ship, had been shattered by shell fire; thanks to the AMG's intervention, the roof was repaired before the destructive winter rains could render the damage inflicted by war irreparable.

Driving along the coastal Via Aurelia, or the Cassia, which runs almost parallel to it in the interior, Keller traveled across the ancient land of Etruria, visiting D. H. Lawrence's "Etruscan Places" one by one. Of that pre-Roman civilization, whose country of origin is wrapped in mystery and whose language is to this day undeciphered, no name of political leader, poet, or historian survives—as Robert Hughes noted, "No English schoolboy was ever flogged for misconstruing an Etruscan text." The Romans defeated the Etruscans, and their temples, made of wood or clay, no longer exist. And yet the Etruscan ancestry lingers in Tuscany; in Osbert Sitwell's opinion, it explained "the strangeness" of Florence, which, the novelist wrote, "passing itself off as one of the many European cities, is yet in its being as remote from them as would be medieval Timbuktu or Aleppo ... The universality of the Renaissance itself never succeeded in banishing this alien element that had accompanied the inheritance of Etruscan blood." What survives of the Etruscan civilization are its celebrated frescoed tombs. As for its superb metal crafts—bronze statuettes and exquisite ornaments of granulated gold—and its pottery—Greek-inspired vases and the glossy black clay pots known as *buccheri*—these are the riches of the small, modest-looking museums of Tarquinia, Chiusi, and wall-encircled Volterra. Once the thriving centers of the Etruscan league, in 1944 these were backwater towns that the passage of war made quite vulnerable. Keller swiftly posted OFF BOUNDS signs on their monuments, and AMG guards by their museums: simple measures—as much as he could organize with little time and few resources—that, however, prevented the precious objects of Italy's most ancient civilization from being carried away under cover of the chaos of war.

As he moved from town to town, Keller perfected his routine, and improved his rough-and-ready Italian: in each new place, he found himself a guide, typically a local partisan, to lead him to the places of historical or artistic significance; he sought out the local carabinieri, whose corps since the armistice had consistently shown that their loyalty lay with the country rather than with Fascism, to stand guard at monuments until Allied soldiers could be seconded for the job; he surveyed damages, filed a report with the MFAA director, De Wald, and started repairs that the second echelon would follow up on. All the while, he was surrounded by a swarm of malnourished children asking for *caramelle* or, as they quickly learned to say, candy. As he endeavored to rally laborers, locate safe and dry locales for the temporary storage of the rescued fragments of a monument, or secure materials, he came in contact with all kinds of Italians, from the town's mayor to the farmer who helped him rescue his jeep from a riverbed by hitching his bullocks to it—"Ercole Settembre, I want to remember him," he wrote. He encouraged his wife to read *A Bell for Adano*, John Hersey's Pulitzer Prize–winning novel of 1944, in which the American major Victor Joppolo (the real-life lieutenant colonel Frank Toscani) endeavors to penetrate the somewhat mysterious ways of a tight-knit and initially diffident Sicilian community at the start of the Italian campaign. Keller communed with peasants, smelling of garlic for days after having shared a meal with them. He liked nuns—overall a smart and helpful lot, he thought—but was uncomfortable around bishops: "I can't bring myself to bend my knee and kiss their ring as some do. But I try a bow which reminds me of the one that Deane learned at school. I guess it is all right."

An incident at the medieval hill town Cortona, where priestly imbecility proved as harmful as Hermann Göring's rapaciousness, may have crystallized his impatience with the clergy. In 1942, Göring, through an Italian dealer, had expressed his interest in acquiring Fra Angelico's *Annunciation* in the city museum. The archbishop of Cortona replied that the work was not for sale, whatever the price; but he did not trust Göring and his notorious appetite for art, and promptly hid the *Annunciation*, together with more paintings and the Etruscan artifacts from the local museum, in four

secret, walled-in caches in the cathedral and the bishopric. The parish priest of the Church of San Domenico, however, refused to let go of another early Fra Angelico masterpiece, a triptych representing the Virgin Mary and four saints; he claimed that he was too attached to *his* artworks and insisted on concealing it with another triptych by the Sienese painter Sassetta in a hideout of his choice in the church. War spared Cortona, and once the front had moved on, its treasures were brought out of their refuges, all intact except for the triptychs. "Among things seen," Keller wrote to his wife, "a Fra Angelico knee deep in mould. The priest would not tell us about it in a church . . . and left it bricked up in a damp place." The clergyman's obstinacy finally vanquished, the two gravely damaged paintings were rescued and brought to Florence for restoration. As it turned out, the priest's ill-chosen hiding place had dealt a severe blow to the two canvases that had been exposed to humidity for centuries; as a result, the painted surface was peeling off, while the paintings' wooden supports had been tunneled by woodworm. Work on the triptychs was given priority over all other damaged artworks in the Uffizi restoration laboratory. It took four restorers—Gaetano Lo Vullo, Arnaldo Lumini, Gilberto Bisi, and Vittorio Granchi—a whole year to salvage them: the painted layer of the canvases was transferred onto a new surface and the color was strengthened with the application of small strips of extremely fine gauze. Poggi described the endeavor as "most arduous." Both triptychs were subsequently displayed in the Museo Diocesano, the Church Museum, built with AMG funds and opened a few months after the end of the war.

In the Adriatic sector, Roger Ellis, monuments officer with the Eighth Army, was fighting a parallel war to Keller's across eastern Tuscany. A captain with the Royal Northumberland Fusiliers, the British archivist Ellis had been detailed to the Subcommission for Monuments, Fine Arts, and Archives to fight for the preservation of the very fragile medium of paper. Given the scanty number of men in the MFAA's ranks, though, in the early phase of the campaign he had doubled up as a fine arts officer as well as an archivist and performed, in his words, as "a jack-of-all-trades." He wel-

comed the opportunity. After earning a degree in classics from Cambridge, Ellis had wished to pursue a career in a museum or a gallery, but as there were no openings in that field at the time, he had joined the staff of the Public Record Office in London. As soon as he reached Italy, Ellis bought himself an Italian grammar and art books to broaden his knowledge of the old masters. On August 12, he was the first monuments officer to enter Florence, when only the city's southern section was liberated; after a few hours' stay, he could report that the cathedral was intact and so was the Church of Santa Maria del Carmine, although Masaccio's superb frescoes in its Brancacci Chapel were hidden behind a wall of sandbags and their condition could not be checked. Weeks later, Ellis took part in the efforts to salvage the Colombaria library. With Ernest De Wald, he visited Monte Cassino, where "the destruction," he wrote, "was terribly complete." Around Tuscany he surveyed churches and chapels, "but I do *not* forget that I am an Archivist first," he declared to Hilary Jenkinson on June 3.

Jenkinson, who would be knighted in 1949, was the principal assistant keeper of the Public Record Office and the consultant on Italian, and later French and German, archives to Woolley and the War Office. He had provided Ellis and the other British archivist to join the MFAA, Humphrey Brooke, with inventories of both historical and modern Italian archives, and both officers regularly reported to him on their activities with unofficial and very detailed letters. "Archives are regarded as a kind of younger brother," Ellis told Jenkinson, referring to the low priority they were at first accorded within the MFAA's efforts. In some instances, archives had also been treated very poorly earlier in the campaign. The most egregious incident had been the deliberate burning of some of the most precious documents from the State Archive of Naples by German soldiers the day before the city was liberated. A squad of German pilferers had broken into their wartime repository, the Villa Montesano at San Paolo Bel Sito, fifteen miles due east of Naples, looking for livestock to steal; having found none, the soldiers had set fire to 866 boxes containing thirty thousand volumes and fifty thousand parchments that had been stored in the villa. Among the lost documents were the deeds of the Angevin chancery, one of the most impor-

tant sources for the history of the Middle Ages, and of the Aragon chancery, the original treaties of the Kingdom of Naples, and most of the archives of the Bourbon dynasty and the ancient and powerful Farnese family. In addition to vandalism and retaliation, the many humble ways in which people, often uneducated and illiterate, used paper—to wrap fish or cheese, for instance—made the written records of the country's history extremely vulnerable in wartime. Early in the conflict, the same measures that Italian superintendents had taken for the protection of artworks had been applied to archives, the most valuable of which had been packed in boxes and evacuated to castles and villas in the countryside. By the time the Allies arrived in Tuscany, the chaos of war had dispersed some archives, and a few archivists had bolted.

A trim thirty-four-year-old man with bushy eyebrows and large observant eyes, Roger Ellis tackled the daunting job of locating and restoring archives and archivists to their proper seats with a disciplined mind. "My shadow plan was to visit each Archivio di Stato or sezione [section] thereof, do any necessary first aid work, set the Director on to preparing lists of his most important private and semi-public archives, and also plans for any long-term work on the Archivio; and then call up Brooke as 2nd echelon to do things in more detail from the information I had obtained for him," Ellis wrote to Jenkinson on September 30. "It has not worked out quite like that," he added a few lines further. Remote and rather obscure villages such as Massa e Cozzile and Montalto, between Florence and Pistoia, turned out to have important fifteenth- and sixteenth-century archives. Of the latter, Ellis wrote that it was "a torpid and unsatisfactory place . . . much time wasted hunting up sleepy officials . . . Archives finally seen with the Prosindaco [deputy mayor], the village idiot, and a young woman who was found inside one of the rooms when it was unlocked." Pisa, badly destroyed and full of mines, was a headache with, in Ellis's words, "*Archivio*, Archives and Archivist in three different places." "Archivist discovered 80 miles away," he announced in early October, having found the director of the Archivio di Stato, Professor Achille De Rubertis, at Impruneta, to the south of Florence, where he had sought refuge since June. He showed the director a let-

ter from the Ministry of the Interior inviting him to return to his post and offered him Allied transportation for the trip. "Loud were his lamentations," Ellis noted in his report, "but he went." Livorno and Pistoia presented him with similar difficulties, but the archives at Lucca were undamaged. This, he confessed to Jenkinson, was a slight disappointment, for in the lovely Tuscan town he would "gladly have stayed indefinitely, had there been reason."

His advance with the Eighth Army, however, continued throughout the fall of 1944. On December 4, Ravenna was the last important center on the Adriatic coast to be reached by the Allied forces before hostilities temporarily ceased. Maj. Norman Newton was the first monuments officer to visit the town. Despite the intense fighting in that corner of the Adriatic, both armies had respected the city that had been the capital of the western Roman Empire after the fall of Rome, and an island of Byzantine civilization and art in the West. Ravenna's major churches—San Vitale, Sant'Apollinare Nuovo, and Sant'Apollinare in Classe—and the Mausoleum of Galla Placidia, as well as their resplendent mosaics, had all had "narrow escapes," as John Ward-Perkins, the MFAA deputy director, wrote in a report, but were nonetheless intact. In the west, the Fifth Army had chased the enemy to their defensive line along the foothills of the Apuan Alps.

With hostilities all but halted in late December, a brief but intense battle flared up in the Serchio valley and around the little town of Barga in northern Tuscany. The area, which the Allies had first reached in mid-September, was briefly recaptured by German forces at Christmastime and reconquered by the Eighth Indian Division shortly after. Keller witnessed that winter fighting and wrote excitedly about it to his wife: "Charlie and I went up there and watched a German counter attack from the summit of the hill where the Cathedral is. We saw the artillery duel and aircraft bursts fall all around us. We hid down under a wall." Huddled around its Romanesque cathedral, Barga sits on a hill some twenty miles north of Lucca, where the Apennines bend to the northwest to meet the Apuan Alps of Liguria. The poet Giovanni Pascoli, who was seeking a peaceful retreat in the 1890s, was

struck by the beauty of the place, a wood-covered hill gently sloping to the river valley and surrounded by a range of tall peaks that protect it from the northern winds, "so that the sun caresses it and the cold doesn't bite it . . . Except for the mountains, which look like huge blue diamonds," Pascoli wrote, "everything else is green here . . . the poplars, willows, alders, chestnuts, oaks, fruit trees, and even the occasional slender and dark cypress, all billowing and murmuring in the breeze." "Sometime I want to tell you about Barga," Keller wrote to his wife in early January, wistfully imagining the town in peacetime, its grace restored and the front that had cut across it simply a memory.

For all the excitement of being close to the actual fighting and ahead of his colleagues in bringing first aid to damaged monuments, Keller found that the strain of war near the front was beginning to take its toll on him. By the winter of 1944, he had been in uniform for a full year. "I am sick of broken homes & monuments . . . I am tired of Italian ways of doing things," he wrote. He missed the gentleness of civilian life, the comfort of its domestic details, and he missed his wife. "How often do you have your hair frizzed?" he asked her. "I was just thinking what sort of clothes you are buying . . . I hope nice & fluffy + lots of silk and full skirts & all." While he was facing a rough winter in the Apennines, most of the other Venus Fixers were settling more comfortably in liberated cities and hitting their stride at their postings. Ernest De Wald and John Ward-Perkins, who had been in Rome with headquarters since early July, were joined by Teddy Croft-Murray, Perry Cott, and Humphrey Brooke over the course of the summer. As the British radio broadcaster Lionel Fielden remembered it, "Rome in 1944–46 was a Paradise for an Allied officer. The Allied officer was run after, petted, flattered, and entertained; and the Roman aristocracy was, after all, an old hand at entertaining magnificently."

Away from the front, and in more comfortable circumstances, the Venus Fixers were feeling upbeat and in an almost celebratory mood. In August, three months after the liberation of Rome, Cott curated a successful exhibit at the Palazzo Venezia of forty-eight masterpieces selected from the hundreds of artworks that had been sheltered in the Vatican. Palma Bucarelli,

director of the National Gallery of Modern Art in Rome, and Emilio La-vagnino assisted him. "Cott splendid, with his round childlike face and white Navy uniform," Bucarelli noted in her diary on the day of the open-ing, August 25. "They hung some dreadful velvet draperies, though, a gaudy yellow and blue, behind Raphael's *Marriage of the Virgin* and Correg-gio's *Danae*: truly vile." But the exhibition, she declared, was spectacular. Lavagnino took his own personal satisfaction by placing a sixteenth-century canvas, Dosso Dossi's *Circe Turning Ulysses' Companions into Pigs*, above what had been Mussolini's desk. Meant as a reward to the troops for their long fighting, and a feast for the eyes of the Italians, who had not seen those paintings for years, the show attracted more than 150,000 civilians and troops, and income from ticket sales went to fund the restoration of damaged Italian monuments. In the liberated capital, the Venus Fixers now had a chance to display what they had been endeavoring to salvage all along.

The tone of their correspondence from that time is companionable. Ital-ianisms seeped into their dispatches: Hartt saluted De Wald with a *"Caro Ernesto"* and *"Caro colonnello."* Linguistic false friends slipped into their prose as if they felt so at ease in this foreign country that they were unaware of Italian quietly gnawing at their English. In a monthly report, Hartt re-gretted that some work had been "retarded" by loss of time, a straight im-port from the Italian *ritardato*, "delayed." Having survived the harsh criticism and self-doubt of the early stage of the campaign, and Naples's gloom, the Venus Fixers now regarded the risks and inconveniences of life in a war zone as good storytelling material. As the Italian saying goes, *"Un mal comune è mezzo gaudio"*—"A shared evil is half a pleasure." "We are comfortably settled after a not uneventful journey including the bogging-down of the entire convoy at a river crossing in a cloudburst," Basil Mar-riott wrote to Ward-Perkins from the spa town of Chianciano, in southern Tuscany, on July 12, 1944. "We are at present in stygian gloom from dinner onwards, but magnificent views and sunsets (and -rises) in full Technicolor compensate. The Spachitecture is a drôle hangover of the art nouveau pe-riod, and a fairly regular 24hr. obbligato of detonations is a salutary re-

minder to keep to the main roads. Goat therefore features fairly frequently in the mess of the committee of which I have the uneasy honor to be a member!"

Early during his time in Naples, Keller had realized that he would have none of the dry humor, the bantering, and the camaraderie that seemed to be the currency of his colleagues' relationships with one another. He felt oddly out of place and, occasionally, rejected: "The majors & a lt. go to a wine shop often; I have never been invited to go." In one instance, their behavior caused a violent outburst of homophobia on his part. "Two of my British Capt. companions discussed some God Damn draperies like a couple of fairies in my office today. It was all I could do to hold my tongue . . . I have worked hard all day and I'm just about fed up all the way through. I don't like that sort of thing and never did," he wrote to his wife in April 1944. As a result, he sought a more soldierly life near combat formations and away from his Venus Fixer companions, even if this came at the price of his increasing isolation. For all the pristine beauty of the Apennines, winter in the mountains was brutal, and the fighting, even if temporarily confined to local skirmishes, kept inflicting horrible wounds and claiming lives. Keller missed his family bitterly. "I am so lonely I am almost out of my head," he wrote to his wife in early December. Distance magnified his perception of his colleagues' shortcomings, which at times peaked into savage antipathy.

Of all his colleagues, Fred Hartt, who shared the responsibility for Tuscany with him, was the last person with whom Keller wanted to be associated. Herbert Matthews's reporting for *The New York Times* on salvaging efforts in Florence in December 1944 triggered his anger. The drama of wartime Florence was being "happily colored," the journalist wrote, "by the progress in repairs, thanks to the unselfish and indefatigable work of one American and many Italians." That one American was Hartt. In Matthews's story, he had "valiantly" fought for the Torre di Parte Guelfa and "vigorously" intervened to save the remnants of the Ponte Santa Trinita. While he considered Matthews an untrustworthy correspondent guilty in "several instances of gross error," Keller felt that Hartt was courting media

attention, a behavior deplored by army code. But there was more that Keller found objectionable about Hartt's conduct and personality. He knew him from Yale, where Hartt had been an assistant curator in the art gallery for a time before the war, and had met him again in Naples. His first impression of the younger colleague in wartime was unflattering. "Have seen a lot of Fred Hartt," he wrote on October 18, 1944, "bores me to death. Lectures all the time as I happen to walk down a street with him." Ardent and extroverted, Hartt had a feeling for art that ran opposite to Keller's quiet, almost modest appreciation. Eve Borsook, a longtime friend of the art historian's, called his attitude flamboyant and admitted that some American colleagues did not take kindly to it. Keller found it irksome, and perhaps a little intimidating. He did try to give Hartt his due. "He has done a good job and that is all that counts," he continued in the course of the same October letter. "But he is a bore," he reiterated a little further, "knows infinitely more than I do about it all. Frankly, I don't take the interest the historians do. I enjoy it, but I don't take it down & then regurgitate like a cow."

While most Venus Fixers took Hartt's abrasiveness in stride, a forgivable flaw in a knowledgeable and very hardworking young colleague, one dissonant voice was that of Sheldon Pennoyer, the group's only other artist besides Keller. Pennoyer was the Venus Fixer who first got word of Bernard Berenson's whereabouts after they had all been worrying about the elderly critic's fate for weeks. Tucked away in his written narrative of the final installment of Berenson's wartime saga is a rather bilious opinion of Hartt.

Back in mid-August, while standing in the lobby of the Excelsior Hotel in Florence, Pennoyer had run into Professor Giovanni Colacicchi, the director of the Academy of Fine Arts, who was anxious to inform the Allies of Berenson's hideout. Colacicchi was at his wit's end, as no officer in the Excelsior seemed to know who Berenson was, until Pennoyer approached him. "I have known of him for years," he said, "he is one of the most famous connoisseurs in the world: where is he?" He learned of how Berenson had taken refuge at the Serlupis' villa, which, at the time of his conversation with Colacicchi, was still behind German lines. As a result of this intelli-

gence, on September 2, upon the Germans' retreat from northern Florence, Allied officers visited the seventy-nine-year-old Berenson, whom they found frail and shaken by the experience of the last several weeks, when the villa had been exposed to intense artillery fire, but otherwise unharmed. At the Excelsior, Colacicchi had asked the Venus Fixers to check on Berenson's Florence apartment, which lay in the devastated area of the Borgo San Jacopo. With Hartt, Pennoyer visited the medieval house, which had withstood the German mines, although its front door had been blown away, leaving some of the critic's precious paintings exposed to the risk of looting. Policemen, or carabinieri, were in short supply in the city. Would Communists do as guards? the British civil affairs officer had inquired. As Pennoyer recorded later, his "thoughts crowded as to their reliability," as he had had no previous experience with Communists. Despite his initial apprehension, he recognized that the "reds" had done a good job of guarding the place, and in early September the critic's thirty-one paintings, six of which had been damaged, were handed to Giannino Marchig, Berenson's trusted conservator, for restoration.

Weeks later, Pennoyer, Keller, and Hartt visited Berenson, living once again at I Tatti. "After all the humanity that one rubs up against in the army, to say nothing of the surroundings that go with its day after day grind, the refreshment of stepping into a completely civilized and tastefully furnished home of an American was like a cool beverage after a seemingly unending thirst," Pennoyer remarked. The son of a wealthy California family, Pennoyer had spent several years studying fine arts in Europe, and felt torn between the desire to absorb the atmosphere of the place at his leisure and the obligation to conform to the social conventions of a formal visit. They spoke of mutual acquaintances at the Century Club in New York—"Royal Cortissoz! How is he? How is he really?" Berenson asked—and the three officers were treated to a "personally conducted tour" of the collection. Pennoyer found Berenson intriguing, with a cordiality and alertness that belied his age. "Here was a person," he noted, "whose existence had concentrated on the amenities of life embracing particularly the trends of the old world civilization and above all those making the greatest painters what

they were. Every word he said reflected all this and I concluded smiling, 'so this type of person still exists!'" During his few hours at I Tatti, Pennoyer could not help noticing, and later recorded, "Hartt's purring . . . as he viewed the little kingdom of the man whose position and accomplishments he so completely envied and was doing all he could to emulate."

Hartt, who called his weekly visits at I Tatti "the happiest hours spent in all that year of ceaseless work," would probably have been mortified and wounded by Pennoyer's remark. As for Keller's feelings, a relatively marginal episode gave the young lieutenant a sense of his fellow officer's animus toward him, and he was dismayed. Hartt wanted to issue a protest against soldiers who had violated OUT OF BOUNDS signs in a Tuscan villa. Keller informed General Hume in rather blunt terms that he did not intend to compromise his good relationship with the troops over what he considered a minor infraction. On January 23, 1945, Hartt wrote to Keller: "I must frankly say that I was a little surprised at your letter to the Gen. about the violation of the Out-of-Bounds signs. I didn't have any idea you wouldn't support me in the matter, which I had talked with you about ahead of time, and your letter was quite a slap in the face . . . We always got along fine up till now," he concluded, "and I really feel a bit hurt and let down by this incident, the first of its kind."

Hartt rightly perceived that Keller's instinct to censor him went beyond this small incident. The young art historian, his closest colleague, stirred Keller's ambivalence toward the team he belonged to in the army. In more than once instance, Keller took his distance from the rest of them. "Many have told me after seeing the other fine arts men that I was the only one who could have lasted 14 months in a great campaign handling a thing like Fine Arts," he boasted in July 1945. It was the taint of the objectionable more than the marginal that Keller feared. On the occasion of being denied a Bronze Star, a decoration he had much hoped to receive, he revealed to his wife, "I shall *always* regret way down deep in me that my citation did not go through . . . My department is still a queer one in the Army . . . It is not as real as Public Safety, or food for starving people, or handling refugees and partisans. That's the trouble." Credibility, always a thorny issue for the

Venus Fixers, got tangled up with respectability. Homosexuality, Hartt's and De Wald's, was not a subject that a man of Keller's generation and upbringing would feel comfortable discussing, least of all in writing. In neither officer's case was it even openly acknowledged. Yet De Wald's personality was reserved, and his behavior quite guarded. Hartt, on the contrary, was at times almost reckless in his personal life, an adolescent romanticism stridently mixing with a potent sexual drive. In Keller's eyes, Hartt's behavior justified the lingering suspicion, among troops and some officers, that his and his colleagues' work was unmanly. In addition, they were sharing the stage of Tuscany, and Hartt, Keller felt, was stealing the show. After reading another, much longer article on art salvaging in Italy that Matthews wrote for *Harper's Magazine* in May, Keller declared, "He could have gotten just as good a story from me about Pisa."

Florence and Pisa, historic archenemies, were the apposite backdrop for Keller's and Hartt's activities in Tuscany. The savage wartime losses of Pisa, scene of Keller's most important work, were overshadowed by Florence's ordeal much as its fortunes over the centuries had been subjected to Florence's power. One of four powerful Italian "maritime republics," Pisa in the Middle Ages reaped the profits of its participation in the First Crusade and established trading posts all over the Mediterranean. In 1284, the Genoese put an end to its primacy in the naval battle by the rock of the Meloria, off the coast of Livorno. By the dawn of the fifteenth century, the river Arno having to a large degree silted up, the city was under Florentine rule. "The Republic of Pisa fought with the Republic of Florence, through the ages, so ferociously," Henry James wrote, "and all but invincibly that what is so pale and languid in her to-day may well be the aspect of any civil or, still more, military creature bled and bled and bled at the 'critical' time of its life." Byron, Shelley, and the Italian poet Giacomo Leopardi were all attracted to what felt like the nineteenth-century reflection of Pisa's past fortunes, a tranquil gravity. The city, in their days, had the stately atmosphere of the seat of an ancient and illustrious university; indeed Leigh Hunt, journalist and friend of Byron, felt that along the streets of the city where Galileo taught mathematics, one "ought to walk gowned." When the war

engulfed it in the last week of July 1944, Pisa had been for centuries a quiet, provincial Italian town, the banks of the Arno lined by magnificent Renaissance palaces, its storied past embodied in a cluster of ancient monuments arranged with striking grace on a broad green lawn: the baptistery, the Camposanto, and the cathedral and its tower.

"I have dreamed of such buildings, but little thought they existed," the British novelist and essayist William Beckford wrote in 1780 in his *Travel-Diaries*. The poet, aesthete, and dramatist Gabriele D'Annunzio called the monumental area "Campo dei Miracoli," the Field of Miracles. Such was the beauty of the cathedral, with its distinctive white, yellow, and gray marble exterior, and the celebrity of its tower that the superintendency of Pisa thought these monuments would never become the targets of air raids; indeed, Superintendent Piero Sanpaolesi and his colleagues hoped that they would shield the entire city from bombardments. Pisa, however, was a hub of railroad communications and the seat of sizable glass- and engine-making factories and lay close to the important harbor of Livorno on the Tyrrhenian Sea. The first of many devastating Allied air strikes, aimed at disrupting northern Italian industries and lines of communication with the Reich, hit on August 31, 1943, destroying one-fourth of the city. By June 1944, half of the population had fled. In July, Pisa became the site of the German army's last stand on the Arno. In its pursuit of the enemy, the Allied Fifth Army reached the left bank of the river at Pisa on July 23. Kesselring's troops, entrenched on the opposite side, furiously countered the Allies' attack. For forty days, the city's streets became the two artilleries' battlefield.

"This is September 3 as I write and I have had one of the experiences of my wartime activities. All I can say is read the papers," Keller told his wife on the day after he entered Pisa with the first troops. The city was devastated and ghostly. "On the south side of the river only two civilians were seen this day," Keller wrote in a September 7 report. Piles of rubble and wreckage filled the streets, and entire neighborhoods were made impassable by the presence of mines and booby traps. Four of the city's bridges, including the medieval Ponte della Fortezza and the seventeenth-century

Ponte di Mezzo, had been damaged by Allied bombardments and mined by the retreating Germans. To Hartt, who visited the city two weeks later, Pisa had "the appearance of a landscape on the moon." Shells—American shells, Hartt would emphasize—had repeatedly hit the roof of the cathedral and the baptistery. The Germans had established an observation post inside the tower, thereby attracting Allied fire on the monumental area. Shells or shrapnel had pierced the bottom and the top tiers of the eight-story marble tower. "We hit the cathedral fifteen times, the baptistery five times," Herbert Matthews reported, "but in no case," he added consolingly, "did the damage amount to anything." The injury to the two monuments was indeed minimal, while by far the worst victim of the artilleries' cross fire was the Camposanto, the long rectangular building of white marble that closes the Piazza dei Miracoli on its northern side.

One month before Keller entered the city, on the evening of July 27, an intense Allied cannonade had been directed at the cathedral and its neighboring monuments. Seeing smoke rising from the roof of the Camposanto, Bruno Farnesi, a technician with the Opera Primaziale del Duomo, the association that has been looking after the monuments since the Middle Ages, ran to the site. With the building custodian and a few workmen and volunteers, armed with "picks, shovels, clubs and poles," Farnesi climbed to the top of the building only to realize, once on the roof, how unequal their resources were to the force of the fire. "With a few jets of water," Farnesi mourned, it would have been easy to extinguish the fire, but the aqueduct had been sabotaged, and for many days Pisa had been without running water. A 1942 plan to build a water tank near the monuments to be used in a fire emergency had, inexplicably, never been carried out. Farnesi rushed back to the ground and sent word of the disaster to the archbishop; he sought the fire department's intervention and even enlisted the help of a German private who happened to pass by, but there simply wasn't enough water in the city to stop the blaze. He climbed once more to the top of the Camposanto, where the flames, fanned by the summer breeze, were advancing at furious speed, devouring more than a yard of the roof every one and a half minutes. As he and his companions were smashing the wooden

beams to try to isolate the fire, they were caught by a new artillery attack and forced to find shelter in the cathedral. By nightfall, when the shelling was over, Farnesi returned to the Camposanto: "As we gazed upon the destroying flames, I saw swiftly but clearly the long time spent there, and my thoughts went to the many labors completed with care and love . . . I saw again the visitors who, dazzled by all this harmony . . . remained rapt and astonished by such luminous beauty."

The last of the monuments to be built in the Piazza dei Miracoli, in 1277 at the peak of the city's power, the Camposanto, a spacious cloister of white marble, serves as both cemetery and museum. A porticoed gallery with delicate Gothic arches runs around the courtyard, where handfuls of the sacred earth of Golgotha, which Archbishop Lanfranchi had brought back from the Third Crusade as a relic, were spread. The Camposanto owed its name, Sacred Field, to this portentous soil that, according to legend, dissolved the bodies of those who were buried in it in a few hours. The burial place of all notable citizens and aristocratic families of Pisa, the Camposanto's corridors were ranged with marble Roman sarcophagi. The nineteenth century's love of the Middle Ages and its taste for the morbid and the sepulchral turned it into one of the most celebrated monuments in Europe. "The place is neither sad nor solemn," Beckford wrote. "The arches are airy, the pillars light, and there is so much caprice, such an exotic look in the whole scene, that without any violent effort of fancy one might imagine one's self in fairy land." But what the romantic century found most enticing about the large, oblong cloister was the medieval and Renaissance frescoes that covered its forty-foot walls from floor to ceiling. "The best idea, perhaps, which I can give an Englishman of the general character of these paintings," Leigh Hunt wrote, "is by referring him to the . . . serious parts of Chaucer." The Pisan artist Francesco Traini's *Crucifixion* was followed by *The Stories of the Hermits* and the *Triumph of Death* by Buffalmacco, a painter better known, as Vasari remarked, as a practical joker, who often appears in Boccaccio's *Decameron*. "All the characters of the medieval man and all aspects of medieval life," the art historian Enrico Castelnuovo wrote, "from its joyous festivities to its horror of death, were

depicted in the frescoes." "Briefly," John Ruskin observed in 1845, "the entire doctrine of Christianity, painted so that a child could understand it (and what a child cannot understand of Christianity, no one need try to)."

But all that was left after the cannonade of July 27 were "pitiful rags of frescoed plaster peeled and sagged from the walls," as Hartt described the scene on first visiting the Camposanto in mid-September. It had taken just five hours, from seven to midnight, for the fire to destroy the entire roof. The dry roof timbers had burned quickly, and the heat melted the underlying lead sheets that covered a large section of the gallery. The molten metal fell "like scorching raindrops," as the superintendent Piero Sanpaolesi later wrote in his report, "and blanketed sarcophagi, tombs, sculptures, frescoes, and the floor with a spongy coat half an inch thick." As the rescuers soon discovered, the medieval frescoes had been painted on plaster fastened to the walls by wicker matting; the latter, made fragile by the passing of time, had detached and crumbled during the fire, and large portions of the frescoes had fallen off the walls. The heat had "baked" the marble and altered the colors of the paintings; what was left, in Sanpaolesi's words, looked like "grayish shadows only lightly dipped into their original colors." To make matters worse, for thirty-eight days until the Allies' entry into the all-but-abandoned city, the damaged frescoes of the roofless Camposanto were exposed to the glare of the summer sun.

"Organizing repairs, this is complicated," Keller wrote to his wife on September 12. Indeed, the proportion of the destruction in the Camposanto and the difficulties it presented to rescuers were staggering. "No civilian agency could have coped with the situation," Hartt remarked later. Keller's six months as a monuments officer paid off in Pisa. "I have gotten a good deal of the Army down by now," he wrote in those days. "At least I know where to go + what I want + where to get it as far as my job is concerned." In Pisa, he went straight to General Hume, chief of civil affairs for the AMG Fifth Army, who, at his request, visited the Camposanto on September 4. Pisa was ravaged, starved, and without water. As Hartt wrote later, "The conditions that made Florence hell for two months lasted in Pisa half a year." Yet General Hume informed General Clark of the emergency, and

in a matter of days the latter ordered an engineering officer to assist Keller in his work. The commander of the Thirty-third Engineers led a team of eighty-two Italian infantrymen in the construction of a temporary cover for the monument: "a lean-to roof some eight to twelve feet wide," as Hartt later described it in his wartime memoir, "running around the top of the walls, and supported from the ground by a system of struts, the roof to be covered with tarpaper." Superintendent Sanpaolesi supervised Italian workers as they cleared the rubble covering the floor of the Camposanto, labeling and sorting all fragments according to the place where they had been found for later restoration. "Despite his lurid past," Keller recorded later, "Sanpaolesi has done an A1 job in Pisa." Yet another crew of Italians patiently shaved the skin of hardened lead off every surface of the monument, the tombs and sarcophagi, the floor, the statues, and the pillars.

Three restorers were dispatched from Florence to work on the frescoes, although the city could hardly spare any at that time, and on September 11 the MFAA deputy director, John Ward-Perkins, accompanied Cesare Brandi, director of the Istituto Centrale del Restauro in Rome, to Pisa. Work began in earnest on September 12. Large sections of the Camposanto's painted decoration were discolored, blistered, and scaled; portions of the frescoes kept falling off the walls until the night before the restorers' arrival at Pisa. The twenty-four stories from the Old and New Testaments that Benozzo Gozzoli had frescoed from 1469 until almost the last days of his life in 1497 were most gravely damaged. The colorful biblical episodes that earned the artist a tomb in the Camposanto were barely recognizable when the restorers, Brandi and the father-son team of Amedeo and Cesare Benini, set to work. Like a modern scourge, the roof's molten metal had mixed with the rain of fire and brimstone in Benozzo's *Destruction of Sodom* and doused the floods that Noah fled on his ark. As the plaster was peeled off for restoration, though, vibrant, life-size line drawings in red earth appeared on the bared walls. Richly detailed and charged with an energy that, in Hartt's opinion, Benozzo's frescoes sometimes lacked, these were the artist's sinopias, his preparatory sketches. Their discovery was extraordinary, as it

offered what remains to this day a unique insight into Renaissance drawing techniques. It was met with awe, and to one person at least it offered the welcome opportunity to switch the focus from the fact that the Allies had been responsible for the artistic disaster that had revealed the centuries-old cartoons: in a press communiqué in early 1945, the master publicist Leonard Woolley called the Camposanto "one of the greatest laboratories in Italy for the study of fresco painting."

"Up to ears in work," Keller wrote in a letter home on September 26. "A host of minor problems and a few big ones," he expanded in his first extended report from Pisa; "pay, rations, permits, policy, the line of demarcation between protection and restoration, expenses . . . ordering materials are some of these." The sum of these rather prosaic pursuits amounted to a heroic feat. Despite severe living conditions in Pisa, work in the Camposanto proceeded at a fast clip. "Materials for repairs have been consistently difficult to get," Keller wrote, sounding a familiar note. "However," he continued, "through channels and outside channels, by devious routes, usually best known by the Italians themselves, a remarkable amount of repair work has been done." On October 11, the temporary roof was completed before the onset of winter rains. "The frescoes were as dry as a 15th century tibia in the last downpour," Keller wrote on October 12. One month later, the monument was entirely cleared of debris; by the end of the year, all frescoes were stabilized. All along, Keller had been pressing for an early reopening of the university to jump-start the lagging economy of the beleaguered city. Classes resumed on November 25, 1944. "This is the biggest job I have had of it, and it has been interesting all through, though fraught with unforeseen troubles," Keller wrote to his wife as he was preparing to leave Pisa in early October for the cities of Livorno and Viareggio, the seaside town where Shelley had drowned. "I wonder if this whole story will ever come out for people to know about it . . . I doubt it."

Fred Hartt told it, in great detail, in his wartime memoir, juxtaposed with his own work in the eastern provinces of Tuscany. Through the fall and winter, the two officers' efforts proceeded in parallel, with Keller as energetic

in and around Pisa as Hartt was unstoppable in Florence, Arezzo, and the many surrounding villages and hamlets. Hartt waded through the rubble of the eleventh-century Basilica of Santa Maria at Impruneta, inexplicably hit by an Allied air raid after the Germans had already retreated, and organized repairs in badly damaged Arezzo. Aboard Lucky 13, he wound his way up a mule path to reach impervious La Verna, the remote sanctuary in the Casentino hills where Saint Francis received the stigmata and which Andrea della Robbia decorated with some of his best terra-cotta reliefs. In early September, after the Fifth Army had pushed the enemy across the Arno, he could finally inspect the deposits of Florentine art located north of the river.

On September 5, he traveled with Filippo Rossi of the Florence super-intendency to the Medici Villa of Poggio a Caiano, ten miles due west of Florence. The Germans had retreated two days before, and the inhabitants of the small village greeted the American officer as a liberator. Since the end of July, the villa had sheltered one thousand people, as the entire population of Poggio a Caiano and refugees from nearby villages had sought protection in the massive vaults of its cellars. Wheat had been brought by volunteers to be threshed and ground with rudimentary tools, and bread had been baked twice daily in the villa's kitchens, though the villa had come under intense shell fire. The Sisters of the nearby convent of the Sacred Heart had tended to the sick and treated the wounded in the house's eighteenth-century theater; nine people died, and three babies were born during that time. Hartt was the first Allied officer the villagers saw as they emerged from their monthlong siege. The villa's steward, Aldo De Luca, met him with relief, but had bad news to convey.

De Luca, who had been watching over the refugees during those dramatic days, had also been a vigilant custodian of sculptures from the Bargello Museum, stored in a separate section of the villa's cellars since 1943. For more than a year, he had reassured Superintendent Poggi on their condition with frequent written updates. On August 23, however, he received a visit from a high-ranking Nazi officer accompanied by two subordinates who requested the inventory of all artworks cached in the house.

The officer told De Luca that his orders were to take all works in Poggio a Caiano across the Apennines to Bologna, some fifty miles behind German lines, for safety. With responsibility for more than one thousand unarmed civilians, some of whom were men hiding in the villa for fear of deportation to German labor camps, De Luca could do little to oppose the officer's will; nor could he inform Poggi, since communications with the city had long been cut off by the front line. His protestations that the sculptures had been put under the protection of the Holy See were ignored, and all he could obtain from the German officers was a receipt for the works they were taking away. The transfer of the artworks, the document declared, was carried out under the auspices of the second-in-command of the German Kunstschutz in Italy, Professor Leopold Reidemeister, and by order of the supreme SS and police leader in Italy, Gen. Karl Wolff.

"Here's what they stole," a shocked Fred Hartt wrote to Ernest De Wald on the night of his visit. He enclosed a copy of De Luca's inventory of the contents of fifty-eight crates that the Germans had loaded onto a truck at Poggio a Caiano. At the top of the list was Donatello's celebrated bronze statue *David*. The sculpture had originally belonged to Cosimo de' Medici and was the first freestanding statue of a nude male since antiquity. Michelangelo's *Bacchus* had also been removed, and Donatello's earlier marble effigy of Saint George, the patron saint of the armorers and swordsmiths who had commissioned the work for their guild. Unlike the abduction of artworks from Montagnana in the Val di Pesa one month earlier, ostensibly the work of retreating troops grabbing whatever they found, here the sculptures had been carefully selected. They all were masterpieces, and their choice seemed to point to a particular affinity for the sensual and the languorous. Naked except for his large-brimmed, three-cornered hat and boots, Donatello's enigmatic *David* caused a stir when it was first unveiled; Michelangelo's epicene, tipsy *Bacchus*, the sculptor's homage to ancient Greek and Roman statuary, is so different in mood from the potent and fraught work of his maturity that, as the art historian Umberto Baldini suggested, were it discovered today, it would hardly be attributed to the great master. A ruse surrounded the operation at Poggio a Caiano, as Hartt and De Wald

quickly realized. Around August 20, the German Foreign Office, via Bern, Switzerland, had informed AMG headquarters in Rome of the presence of artworks in the Villa of Poggio a Caiano—"a fact long known to MFAA," De Wald somewhat impatiently emphasized. Between August 23 and August 25, while the sculptures were being moved to the north by Reidemeister, several German broadcasts had repeated that there were no Germans in the villa, and that any damage to the artworks resulting from military operations would be the entire responsibility of the Allied forces. It appeared clear to De Wald and Hartt that while the Allies were temporarily restraining from shelling the area as a response to the broadcasts, the Germans had emptied the villa. This left the monuments officers in little doubt that the "salvage" was in fact a theft, and the news boded ill for the other, still unvisited deposits.

Of the repositories left to be surveyed, the Castle of Poppi in the Casentino was the most crucial. Hartt first attempted to reach it on September 7. The inhospitable area, surrounded by the mountains of the Pratomagno and the Alpe di Catenaia, was still held by pockets of German resistance that continued to loot and destroy when the Allies had already advanced thirty miles north of the region. Hartt tried again on September 12 by a different route through the Consuma pass, only to encounter, in the village of Consuma, a sign that announced THIS IS THE FRONT. On September 25, he finally visited the massive castle that had been the medieval residence of the powerful Guidi family and, by the flickering light of a candle, could ascertain that Botticelli's *Birth of Venus* and Leonardo da Vinci's *Adoration of the Magi* were untouched. Several witnesses, however, told him that a German truck had made away with a box full of artworks during the last days of August. On a second visit, this time with Rossi, he took down the full story. The time of the operation coincided with the abduction from Poggio a Caiano: the last days of August, when the Allies were furiously battling to wrench control of the areas to the east and northeast of Florence from the Germans. The circumstances in which it had been conducted, though, were far more dramatic. Three Nazi officers had confronted the mayor and charged that the little village was teeming with spies.

They insisted on searching the castle for arms; once inside, revolvers in hands, they forced the carabinieri who had accompanied them to load boxes full of paintings onto trucks parked in the back of the castle. The officers worked all night selecting the artworks and stripping them of their frames. Once outside, they fired their guns to frighten the distraught population and discourage it from trying to stop the convoy. At dawn, they laced the village streets with mines that were timed to detonate after they left and that demolished the town gate. Here, too, the transfer had been ordered by the German high command, and the motivation that the officers in charge of it offered was once again the need to protect Italian art from the rapacious Allies, with little regard for the terrible danger of air strikes on the way to the north. While the pattern was almost monotonously similar, Hartt found one aspect of the operation puzzling. The Nazis had spent one whole night choosing their loot: they had neglected Botticelli and Michelangelo, and chosen Cranach and Memling instead. They had taken Titian's *Concerto* from the Pitti and three Raphaels, but mostly they had opted for northern or specifically German artists. So much the better for Florentine art; Hartt, however, found the notion bizarre. The taste seemed second-rate, but there was method to it. The Germans had removed, Hartt noted with clerk-like precision, "five Dürers, seven Cranachs, one Breughel, one Holbein, four Memlings, and works by Ruysdael, Steen, Joos van Cleve, Terborck, Teniers." All these riches didn't amount, in his eyes, to Michelangelo's *Doni Tondo* or Botticelli's *Venus* alone.

As the tally of vanished artworks grew with every new inspection, more disturbing details were added to the picture. Dicomano, a village in the Mugello hills near the Gothic Line, lay in ruins when Hartt visited it in late September. Several witnesses reported that a German captain had been seen walking around carrying a list of deposits a few days before Dicomano was destroyed. From the village's small Oratory of Saint Onofrio twenty-six cases were stolen containing classical sculptures from the Uffizi collection. The entire contents of the repository at the Villa Bocci at Soci, near the village of Bibbiena, had been carried away; its sculptures, mostly from the Bargello Museum, were not of the greatest importance, but, as Hartt noted,

"there were many fine things." By early fall, as he completed his surveys, Hartt was beginning to draw some grim conclusions. While the works of art from other Tuscan towns, Pisa, Siena, Arezzo, and Pistoia, had not been touched, Florence, he wrote, "had suffered robbery . . . on a scale to dwarf the depredations of Napoleon." By his early estimate, in a little more than a month, between early July and the third week of August 1944, 735 objects, the equivalent of roughly one-fourth of Florentine artworks, had ended up in German hands. Half of them were of major importance.

As he continued to analyze the circumstances surrounding the abduction of the Florentine artworks—from Poppi, Poggio, Montagnana, Dicomano, and Soci—Hartt noted that most had been sanctioned by German high authorities, and all had been taken without the permission of the Florence superintendency or the knowledge of the Italian fine arts authorities. They had allegedly been removed to protect them from the risk of shell fire only to be exposed to the far graver danger of the Allied air raids relentlessly battering northern Italy. This large-scale transfer had taken place when the German army had hardly any transportation and fuel left for its own troops, yet could spare enough vehicles to move the artworks to the unspecified "north"; finally, Hartt reflected, Germany was losing the war, and the Allied armies knew that its defeat was now a matter of months. Hartt's inevitable question then was, "why did they do it?" The whole operation had such a character of desperation about it that any educated answer to his question had to be very scary indeed.

rounding their temporary stay in the Apennines. "A partisan from Bologna, a friend of superintendent Gnudi's," Cesare Fasola wrote in a note to Hartt on November 20, "came to see me this morning"; according to the patriot, the paintings, accompanied by "a foolhardy German lieutenant," had traveled uncrated and had been badly jostled during the trip. Once at Marano, they were unloaded at Villa Taroni; the villa's owners had given a ball in early August where some of the guests were well-known to the partisans as Nazi sympathizers. "One Titian," the patriot added, "was used to decorate the ballroom, which was suggestively lit by candles and torches."

Carlo Anti does not seem to have replied, in writing at least, to Poggi's letter. From his seat at the Fascist government in Padua, the fine arts director could not officially correspond with Poggi in Allied-liberated Florence. Instead, Anti relied on assistance from several superintendents in northern Italy. He instructed Pietro Zampetti, superintendent of Modena, to inspect the precious paintings at Marano and make all the necessary arrangements for their transfer to an art deposit in the Isola Bella, one of the three Borromean Islands on Lake Maggiore, where a large number of artworks from northern Italy had been sheltered in the seventeenth-century Palazzo Borromeo in recent months. Anti informed the Kunstschutz director, the SS colonel Alexander Langsdorff, of this plan. Langsdorff promised the fine arts director his full cooperation. But on August 9, without prior notification to Anti, he personally supervised the loading of the pictures on army trucks and on the following day set out with them for Verona, at that time the headquarters of the SS.

"They inform me," a rattled-sounding Anti wrote to Langsdorff on August 25, "that the paintings from Montagnana were transferred to San Leonardo in the Passeier Valley and the sculptures from Dicomano to Campo Tures." His source was most certainly Dr. Otto Lehmann-Brockhaus, formerly of the Hertziana Library for art history in Rome and, since July, the Kunstschutz liaison with the Fascist Fine Arts Directorate in Padua. To mention Lehmann-Brockhaus's name in writing, however, would have exposed the German scholar to the possible accusation of favoring Italian interests over his own government's decisions. Anti found the news of the

Chapter Ten

ALPINE LOOT

There's a lot of nonsense talked about the fragility of the "old masters." By and large, they are a sturdy lot. Otherwise they wouldn't have lasted this long.

— George Stout, head of the Department of Conservation, Fogg Museum of Art, 1933–1947

No sooner had these hundreds of Florentine works of art vanished behind enemy lines during the summer of 1944 than a frantic search began to uncover their ultimate destination. As paintings and statues traveled farther away from Tuscany and deeper into Nazi-controlled territory, Allied officers and Italians, Fascists and non-Fascists alike, engaged in a fierce struggle for their restitution. The pursuit of the missing artworks began in mid-July. "I need to inform you of something extremely grave that just happened," the Florentine superintendent Giovanni Poggi wrote in a confidential letter to the Fascist fine arts general director Carlo Anti, upon learning of the abduction of nearly three hundred paintings from the villa of Montagnana and the subsequent disappearance of Lucas Cranach's *Adam* and *Eve* from the deposit at Oliveto. As he wrote to Anti, within days of the German-conducted evacuation Poggi was informed by Consul Wolff that the artworks had been taken to a villa at Marano s Panaro, a village in the Apennines some fifteen miles south of Bologna. F months, this was all that Poggi and the Allied officers would know of artworks' fate, except for a few more, and rather disturbing, details

transfer alarming. The villages of San Leonardo and Campo Tures were located in South Tirol, or Alto Adige, as it is called in Italian, the upper Adige valley. Ranged within the Italian Alps, the area had been occupied by the German Wehrmacht in September 1943, in the aftermath of the Italian armistice with the Allies. It was now called the Voralpenland zone of operations, and it comprised the towns of Belluno, Bolzano, and Trento. Although it formally fell under the jurisdiction of Mussolini's resurrected Fascist Republic, the military had been expelled and its Italian officials replaced by German and Austrian personnel under Gauleiter, or High Commissar, Franz Hofer, who ruled the region, as Ernest De Wald later wrote, like an "uncrowned king." Antonino Rusconi and Pietro Zampetti had been removed by the Trento superintendency, and Dr. Josef Ringler, who had previously directed the Innsbruck Museum, was now the fine arts superintendent for the area.

Langsdorff's secretiveness with Anti shrouded the operation in mystery. The Wehrmacht's intervention—the "foolhardy" lieutenant at Marano, the army trucks employed in the evacuation—seemed to rule out the possibility of a random theft perpetrated by a bunch of retreating soldiers, and pointed instead to a carefully orchestrated abduction. Anti understood that Langsdorff had snatched control over the artworks from Italian hands, although it would have been impolitic to state so in writing. Anti-Italian sentiment was endemic in South Tirol, and Gauleiter Hofer's especial dislike of Italians made the prospect of cooperation with the Fine Arts Directorate remote. What Anti did say was that San Leonardo was only a few miles south of the Brenner Pass, a major gateway to the Reich, and that the entire area was likely to become a military zone soon. Also, he could not recall any suitable building in Campo Tures that could safely house such a large number of artworks. He could only hope, he concluded in his note to Langsdorff, that the art had ended up there by mistake, and suggested that it be moved to the Italian deposit of Sondalo, in the much safer Valtellina, which lay at not too far a distance to the west, across the Stelvio Pass. Brisk and succinct, Langsdorff's letter confirmed Anti's fears. The transfer, he wrote, had been executed on orders "from high up."

As captured Nazi and Fascist documents were to reveal in May 1945, the artworks' journey had been tortuous, with every new stage of their northbound progress casting a more sinister interpretation on their abduction. On May 8, 1945, just six days after the cessation of hostilities in Italy, Francesco Arcangeli, an inspector at the Bologna superintendency, wrote a dramatic account of the events he had witnessed during the previous summer to Poggi. In early August 1944, several truckloads of artworks had arrived in Bologna. The city, at that date, was still in Axis territory. Two German officers asked the city's archbishop to take them into his custody. Taken aback by the unexpected request, the high prelate declined, citing the huge responsibility and lack of space. He suggested that the German officers contact the superintendency, but they refused, as their orders, they claimed, were to talk only to the ecclesiastical authorities. By the time a Dominican friar broke the news to the superintendency, the trucks had left the city. Since rumors of the German art removals from Tuscany had spread fairly quickly across Italy, Arcangeli guessed that their cargo was the paintings from the Pitti and Uffizi that German troops had taken from Montagnana in July.

Seized Kunstschutz papers later revealed that one of the two Germans was Leopold Reidemeister, Langsdorff's deputy and a major in the German army. He was to guide many more convoys of art through Bologna between the last days of August and early September; in fact, all the paintings and statuary evacuated by the Germans from five Tuscan deposits— Montagnana, Poggio a Caiano, Dicomano, Poppi, and Soci, with a total of almost six hundred artworks—temporarily stopped in the city. Arcangeli saw Michelangelo's *Bacchus*, Donatello's *David*, and the rest of the sculptures taken from Poggio a Caiano stored in the hallways of the city's Fine Arts Academy for a few days, before they were driven north on August 27. Among the statues, Arcangeli also noticed several remarkable paintings that he knew belonged to the private collection of Count Contini Bonacossi. He made a mental note of them: a still life attributed to Murillo, a Madonna by Tintoretto, and a half dozen others. There was little that he and his colleagues Barbacci and Antonino Sorrentino could do to oppose

Langsdorff's orders and Reidemeister's actions, which were mightily supported by the German army. "Hundreds of artworks," Arcangeli commented with bitterness as he helplessly witnessed one passage after another of great Italian art through his city, "were falling into the 'protective net' cast by the German Kunstschutz."

In a flurry of correspondence discovered after the German capitulation, Anti persistently requested that the art be redirected to Sondalo in Valtellina, or to yet another art refuge in the royal villa at Strà, near Venice. Langsdorff's replies were as punctual and his words as suavely pacifying as his conduct ran ruthlessly counter to the Italian director's wishes. Sondalo, the SS colonel asserted, was unsafe, whereas San Leonardo and Campo Tures were "excellent deposits." As for operations in Bologna, these had been carried out in close cooperation with the superintendents Barbacci and Sorrentino. "We can really consider this," Langsdorff wrote on September 15, "as a successful result of our combined efforts."

This was the time when, in the words of the monuments officers' final report on the German Kunstschutz, "the Italians realized that they were powerless to oppose Langsdorff's high-handed behavior, as they had practically no petrol or means of transportation of their own." They changed their tactics. At Anti's instigation, Education Minister Biggini asked the German ambassador Rudolf Rahn to intervene with his government on behalf of the Italian artworks. In September, Poggi and Hartt, who still were in the dark as to their movements and whereabouts after they had been sighted at Marano, pleaded with the city's archbishop, Cardinal Dalla Costa, to invoke the Vatican's help in tracking down Florence's missing art. The response from the secretary of state of the Holy See was two months in coming and was perplexingly inaccurate. Signed by Monsignor Giovanni Battista Montini, the future pope Paul VI, the message relayed the information it had received from the apostolic nuncio in Bern to the cardinal. The artworks, Monsignor Montini wrote, were at Neumelans in Sand. The name puzzled Hartt and Poggi, because it meshed, as Hartt later realized, Castle Neumelans, the fortress where the paintings had been stored, and Sand in Taufers, the German name of the village of Campo Tures. The Vat-

ican's note did not comment on the condition of the artworks, and neglected to mention the deposit at San Leonardo. While wrapped in very reverential language, it was laconic, inaccurate, and incomplete, and seemed to indicate the Vatican's unwillingness, at that stage, to get involved in the affair. By comparison, Ambassador Rahn's response was prompt, if bland. In mid-September, Rahn conveyed the Führer's official reassurance that the Florentine works of art had been taken to South Tirol for reasons of safety and that, whatever the circumstances, their integrity would be respected.

"This was all very nice," Anti noted, yet hardly what he wanted to hear. Uppermost in his mind was the concern over what he described as "rumors coming from Venice" about the Germans' intentions with regard to the displaced Florentine art. He did not elaborate on the substance of his information, which probably came from partisan cells and was filtered by the Venice superintendent Ferdinando Forlati. During the same period, Leonard Woolley, in London, alerted the British Committee on the Preservation and Restitution of Works of Art to intelligence he had received about an alleged order from Hitler to destroy all monuments and works of art likely to fall into Allied hands. Woolley's source was Max Goering, an art historian unrelated to the *Reichsmatschall*, who would perish in an air raid on Munich. The waning months of 1944 were rife with the direst predictions surrounding the impending fall of the Reich. Allen Dulles, who headed the Office of Strategic Services in Switzerland and conducted the secret Allied negotiations that led to the German surrender, wrote later, "From reports reaching us in Switzerland it was clear that when the German military defenses finally crumbled, Hitler hoped to drag all of Europe down with him. The German Army leaders might put into force orders to 'scorch the earth,' to wreck what was left of the industry and economy of the countries they had occupied, and even of Germany itself." Within this monstrous plan of wholesale destruction, it was only too credible that the Florentine masterpieces might be one of the many victims of Hitler's *Götterdämmerung*.

Anti, in the words of the Allied final report on the Kunstschutz, started "clamoring" for the restitution of the missing artworks. As a first step toward

their safe return, he insisted on being allowed to inspect them. While Karl Wolff, high commander of the SS forces in Italy, looked favorably on Anti's trip, probably as a way to stress the legitimacy of their abduction, the fiercely anti-Italian gauleiter Hofer opposed it. Anti's pleading was favored by a fall Allied press campaign that questioned with growing intensity the German responsibility in the disappearance of the Florentine masterpieces. The German Kunstschutz, or "art salvaging" organization, the British press surmised, looked increasingly like a cover-up for a *Kunstraub* operation, an "art theft." To counter an October British broadcast that claimed the artworks had been taken to Germany, Minister Biggini was persuaded by Nazi authorities to declare, on Fascist Radio, that these were "safely in Italian hands," without, however, revealing their location. Langsdorff worried about the negative propaganda, but other members of the Kunstschutz, the "honest personnel," as the Venus Fixers later described them—Lehmann-Brockhaus, Professor Leo Bruhns, and Ludwig Heydenreich, who had helped Poggi in Florence until June 1944—were sincerely concerned about the ultimate fate of Florence's masterworks. With help from Gerhard Wolf, the former consul of Florence, Heydenreich bravely pressed Langsdorff to obtain an order from Hitler that declared that the works of art were being "held in trust for the Italian nation" and that accepted full responsibility for their maintenance and security. Wolf and Heydenreich pushed Langsdorff to hand complete lists of the contents of the deposits to Anti and allow him to visit them. Langsdorff's reply to Heydenreich was brisk and slightly threatening. Gauleiter Hofer, he wrote, did not allow Italian visitors; as for the artworks, their fate depended on SS general Wolff alone. And, why was Heydenreich, who, incidentally, was not a member of the Nazi Party, showing such a keen interest in the Italians?

Langsdorff, however, relented. He did not pursue an order from the Führer, but on November 27 he allowed Anti to travel to South Tirol "as a special favor." On the second day of his visit, he gave the Fascist fine arts director the inventories of the works he was there to examine. As a captured Kunstschutz memorandum later showed, the colonel had done a little editing to the list prior to Anti's trip. He had omitted its original, much earlier

date, which would have revealed that while Anti had been pleading with him for the inventory, it had been sitting on the colonel's desk for almost two months. In the same memo, Langsdorff also meticulously noted that a copy of the lists had been sent to Mussolini, after the names of the two deposits and their locations had been erased from the cover, as a precaution, most likely, against a possible attempt by the desperate dictator to seize the artworks. On December 11, a rather subdued Fascist Radio broadcast announced Anti's visit to the two deposits, its restrained character a departure from the habitually inflated tones of the Fascist media. By not revealing where the art refuges were located, the communication did little to allay fears of Nazi looting, and to dispel the suspicion of complicity on the part of the Fascist government. As for the artworks themselves, the broadcast reported that Professor Anti had found them in relatively good condition, considering their long journey across Italy without proper packaging. Only three or four canvases, out of hundreds of masterworks, had suffered scratches, and it was damage that a good restorer could fix.

A few days after his trip, however, Anti expressed his real anxiety, or part of it at least, in a confidential letter to Langsdorff. Subserviently, as was his wont in his exchanges with the SS officer, Anti thanked his organization for "taking the Florentine works of art to safety." Still, three months after their removal from Tuscany, the paintings at San Leonardo were all uncrated. Surely, Anti had the nerve to say, there was no dearth of timber in the woody Alpine valleys of South Tirol; nor was there lack of time or man power to fashion sturdy boxes in which to pack the paintings for what the fine arts director steadfastly wished to believe was their imminent transfer to an Italian deposit. Fearful of irritating the power-wielding Langsdorff, Anti did not dwell on the poor condition of some of the artworks. But he must have seen the hole in the foreground of *Pallas and the Centaur*, the canvas that Botticelli painted at around the same time as *Primavera* for Lorenzo di Pierfrancèsco de' Medici; or the two long scratches that marred Giovanni Bellini's *Pietà*, as Ringler, the South Tirol superintendent, later testified and Hartt was to ascertain in May 1945.

After the German surrender in early May 1945, Ringler's long testimony

to his Allied interrogators, Ernest De Wald and the British wing com-
mander Douglas Cooper, filled in the many details that Anti probably omit-
ted so not as to alienate Langsdorff entirely, and that painted a damning
picture of the SS colonel's conduct. It was Ringler who selected the two de-
posits of San Leonardo and Campo Tures immediately upon realizing that
the one suggested by Langsdorff, in the vicinity of Bolzano, was an ammu-
nition dump. Ringler, a museum director, took the cause of the Florentine
artworks to heart. He deemed the Trentino and the areas of Bolzano and
Merano too dangerous because of the daily Allied bombings, and with Reide-
meister he went on a journey of investigation down the quieter, backwater
Passeier and Taufers valleys while six truckloads of sculptures from Dico-
mano were left parked on a street in Bolzano. Ringler scouted an old un-
used jail at San Leonardo in Passeier, by far the best building the place
could offer; it had several large vaulted rooms, but also many narrow cells
where paintings would have to be stacked very closely. At Sand in Taufers,
or Campo Tures, he drove to the sixteenth-century turreted Castle Neume-
lans and asked for hospitality for the Poggio a Caiano sculptures from
Rosita von Ottenthal, the château's owner. Fräulein Ottenthal willingly let
him have the Gothic rooms of the manor and also offered the use of an old
coach house on the estate to which trucks could have direct access. As more
convoys unloaded their valuable cargo at either deposit all through August,
Ringler noticed that the pictures were laid on straw and covered with army
blankets. "As far as I could tell during the speed of the unloading," Ringler
stated, "they were dusty, a few marked with damp, others slightly scratched.
I even noticed some tears in some of the pictures." He also reported that on
August 29 a convoy of five trucks, one of which carried Lucas Cranach's
Adam and *Eve*, had run out of gas and was left on the street in Merano. The
shortage of fuel had become so severe that on September 1, Ringler was in-
structed by the chief of the military administration to "load the five lorries
into closed furniture vans, harness with horses or oxen and convey to de-
posits." More paintings were protected at Campo Tures with wicker from
fruit baskets fetched from the convent of Gries in Bolzano. Ringler posted
guards at both deposits and asked that basic safety measures be taken at the

jail at San Leonardo, an alarm bell, fire extinguishers, and iron bars to be installed on the windows that opened onto the street. Three months later, none of these protective devices had been introduced in the deposits; in March, a panzer camp was established close to the château with about one hundred gasoline tanks dumped around it. For an operation that Langsdorff did his best to present as a salvaging mission performed on behalf of the Italian people, it was an eminently sloppy enterprise.

Anti considered his trip a first step toward the transfer of the artworks to an Italian deposit. Whether or not he realized how hopeless his wish was, restitution was simply not on his German counterparts' minds. Unbeknownst to Anti, less than two weeks after his inspection, on December 12 the Tirolean art refuges were unexpectedly visited by five representatives of Martin Bormann, head of the Nazi Party's chancellery and Hitler's private secretary. They were Dr. Hans Helmut von Hummel, Professor Leopold Ruprecht, the director of the armory in Vienna, the Munich art dealer Eugen Brüschwiller, and a fifth man that Cooper and De Wald believed to be the Vienna historian and dealer Hans Schedelmann. No reason was given for the visit. One month later, though, in a letter to Himmler, Bormann indicated that on the Führer's orders, all works of art sequestered in the Reich or in Reich-occupied territories were to be made known to a number of specialists appointed by the Führer, so that Hitler himself could decide how to utilize these "acquired" treasures. The expert selected by Hitler for paintings was Professor Ruprecht.

At around the same time of the five men's visit to the South Tirolean deposits, Gen. Karl Wolff—as he was to tell his Allied interrogators, Cooper and De Wald, in June 1945—received an order from SS commander Himmler, his direct superior in Germany, to evacuate the contents of the deposits to the salt mines at Altaussee, in Austria. Tucked in the mountains near Salzburg, the site had been chosen in 1942 as a refuge for Austrian art. Since 1943, the Nazis had been using it as a repository for an ever-growing number of paintings, sculptures, and objets d'art confiscated or acquired through forced sales and auctions from Reich-occupied countries. These were the artworks that were being assembled for the large museum that

Hitler was planning to build in Linz, his mother's birthplace and his child-hood home. Many of the cases at Altaussee were labeled "A.H., Linz."

General Wolff refused to obey Himmler's order, claiming that he had no vehicles or gas for the transport. He instructed his staff instead to prepare a photo album of the pictures cached at Neumelans and San Leonardo. Whether the album was meant as a conciliatory gesture or a distracting maneuver to cover his insubordination, Wolff declared that he intended to offer it to Hitler as a birthday present. As the American journalist Janet Flanner remarked, "the Nazis had an adolescent passion for photograph albums." The project infuriated Ringler, who, on a surprise visit to Neume-lans, discovered that a Fräulein Holz had taken some of the artworks out of their frames and was photographing them outside in the snow. Seemingly the only voice of sanity among colleagues and superiors who treated these art treasures as their own private property, Ringler complained to Langs-dorff, who replied by reminding him that his role was strictly limited to the local responsibility of the artworks' maintenance. The frustrated superin-tendent then asked to share the supervision of the deposits with two Italian art officials, and Anti backed his request. Predictably, Langsdorff refused. As De Wald and Cooper's final report on the Kunstschutz concluded, "The Germans meant to keep what they had got."

Wolff in particular was determined not to let go of the fruit of Langs-dorff's summer raids of Tuscan deposits. If Hitler, Himmler, and Bormann wanted the looted Florentine art within the Reich's borders, Wolff had other plans. In March 1945, he initiated secret negotiations for the surren-der of the German army in Italy with the OSS office in Switzerland. Since the fall of the previous year, the man who had authorized some of the worst atrocities perpetrated by the SS in Italy had become convinced that the war was lost for Germany and that every additional day of fighting meant the pointless sacrifice of thousands of lives. He felt fairly confident that Gen. Heinrich von Vietinghoff, who had replaced Kesselring in March in the Italian theater, could eventually be persuaded to pursue a cease-fire against Hitler's orders. In his account of the negotiations, *The Secret Surrender,* Dulles insisted that at no time during their months-long secret dealings did

Wolff ask for his own safety in exchange for his collaboration. Before his first meeting with Dulles, Wolff submitted his "credentials" to him. These were mostly names of Italian churchmen and aristocrats whom the SS commander had helped in one way or another; also included in this list of good deeds was a written statement that claimed that on his orders, hundreds of Florentine treasures had been saved from the battlefield.

The Allied armies' spring offensive began on April 9, 1945. The Eighth Army launched the attack from the winter line along the small river Senio near Faenza, some thirty miles inland from the Adriatic coast, while the Fifth Army was to advance toward Bologna, a major industrial town and the largest communication hub between northern and peninsular Italy, and, farther north, to Verona. From the very beginning of the renewed hostilities, it became clear that the Germans were no longer the fierce opponent of the earlier phases of the campaign. During the fall and through the earlier months of 1945, massive Allied air strikes all over northern Italy had battered the lines of supply with the Reich; the cost in civilian lives was tremendous, but the mighty German army had been crippled, with little fuel, ammunition, and transportation left. On April 20, the Allies broke through the German defenses and burst into the Po valley. The wide expanse of the plain, stretching for roughly twenty-five thousand square miles across northern Italy from the Adriatic Sea near Ferrara to the river's source on Mount Monviso in the Piedmont Alps, offered, finally, ideal fighting terrain for the Allied heavy artillery. On April 21, the Fifth Army captured Bologna. Deane Keller, who drove into the city with the first troops, reported: "Entered Bologna at 11.30 . . . in blackout, burning houses and mines being exploded by engineers on the way into the southern part of the city. Outside the inner ring, especially in the region of the R.R. station, there is enormous destruction—as bad as any seen to date." The bombing, however, as Keller noted in his report, had been accurate, and as a result the city's many monuments had suffered little harm from the air.

As Eric Linklater wrote, "Within twenty-four hours of the fall of Bologna the signs of rout, the evidence of panic, were already showing." Af-

ter almost two years of the toughest resistance, it was hard to believe, even for those who were witnessing it, that this for the German army was the beginning of the end. "The line moves so fast," Keller wrote home on April 27. "I have seen thousands of German prisoners . . . well it all looks like collapse." During the previous winter, the Venus Fixer had wondered, in despair, whether the Germans would ever give up. In the final days of April, an estimated million German troops were captured, as the northern Italian towns were liberated by the Allies and by partisan-instigated insurrections. After almost five years of war, city after city was conquered in rapid succession: Genoa on April 27, Vicenza on the twenty-eighth, Padua and Venice on the twenty-ninth. Milan, taken by the partisans on April 29, was entered by the Allies on the following day. On April 30, the Allies reached Turin, which had rebelled against the German occupation the day before. On April 26, Benito Mussolini, disguised in a Luftwaffe greatcoat and helmet and tucked amid a group of German soldiers, was arrested at Dongo, on Lake Como and a few miles from the Swiss border, by the partisans' Fifty-second Garibaldi Brigade. He was executed two days later with five of his closest men and his mistress, Claretta Petacci. On May 2, the New Zealanders reached Trieste. On the same day, Germany's unconditional surrender to the Allied forces in Italy was announced, and hostilities ended in the European theater. It was the first major German surrender. "Peace has come to Italy," Keller wrote to his wife on May 3.

After a grueling twenty-two-month campaign, the sudden collapse of the north opened up a vast new territory for the Venus Fixers to cover. "I wish I were several people all at once and I'd be able to do what I am supposed to do," Keller wrote, as he traveled hundreds of miles, from Milan to Trieste, at a precipitous pace, surveying one liberated town after another. Shortly, more monuments officers were to be called up north to act on his preliminary reports. Contrasting images struck him in quick succession: "The people look different . . . up north they have not been starved, but they have been so filled with propaganda . . . that it takes several days before they will be friendly and smile." Ground war had been swift, but most northern cities were badly eroded by years of intense air strikes. Genoa, an

industrial center with an important harbor, had been bombed in June 1940 by the French, bombarded from the sea by the British fleet in February 1941, and repeatedly hit by air raids between 1942 and 1945. From Vicenza, Keller reported, "Situation very bad. There is frankly a feeling among the people, a sort of wonderment as to why this place was so severely bombed. Undersigned is recording a fact here, not a personal feeling." After a devastating series of air strikes in mid-August 1943, Milan had burned for a week because there was not enough water to extinguish the fires. Keller's dispatch from the city was harrowing: the facade of the Brera museum had suffered a direct hit, and its roof had been almost entirely devoured by fire; the massive Renaissance pile of the Castello Sforzesco was badly damaged, and in the twelfth-century Church of Sant'Ambrogio the cloister by the Renaissance architect Bramante was largely destroyed. The world-renowned opera house La Scala, which the neoclassical architect Piermarini built in 1778, was gutted. On May 7, Keller wrote to his wife, "Have seen the Last Supper behind sandbags. The roof was hit, and no one knows in what condition the great picture is."

In early June, Perry Cott was glad to report that Leonardo's *Last Supper* had "escaped damage by a miracle as the immediate surroundings were badly knocked about. As the natives say," he concluded, *"meno male"*— "thank God." Cott, who had taken over responsibility for Lombardy from Keller, who kept moving east, was charmed by the beauty of the region, and its people's work ethic was an unexpected bonus at the end of an exhausting campaign. "This is marvelous country," he wrote, "and in its broad, fertile fields with the Alps as background is entirely different from any other part of Italy . . . I am enjoying Milan in some respects though it is disappointing after Rome and Umbria. The people, however, are on the whole much more alive and rational than any I have worked with thus far, and this I find refreshing." In fact, before the monuments officers could reach their posts in the north—Croft-Murray in Bologna, Gardner in Liguria, Norman Newton and Marriott in the Veneto, and Enthoven in Piedmont— a tremendous amount of repair work had bravely been initiated by local superintendents. As a result, the character of the work was less dramatic for

the Venus Fixers than it had been in Florence and the rest of Tuscany, for the emergency in most cases was over by the time they happened on the scene. But the injury to the monuments was extensive and the scale of the destruction bewildering: fifty-five churches had been hit in Genoa, and sixty-seven Baroque and eighteenth-century palaces had been gutted or demolished in Turin alone. After almost five years of war, in the spring of 1945 the superintendents were gravely short of funds and resources.

No longer spearheading first aid intervention, the monuments officers stood by the superintendents' side liaising between them and the Public Works and Finance sections of the AMG. By then, they had also honed their skills as diplomats, nudging along the less-enterprising officials while reining in the enthusiasm of others. "With Liguria," Enthoven wrote to John Ward-Perkins, "it's a question of curbing Ceschi, who wants to reconstruct everything, while in Piemonte I have the greatest difficulty in extracting anything at all out of Mesturino. I wish they could be combined." With some of the monuments officers already pulled out of Italy and reassigned to Austria, the already-small MFAA outfit was shrinking, its men strained to the limit. Yet the men's hard-earned efficiency made up for their dwindling numbers, while the atmosphere of peacetime colored their efforts with a novel sense of hope. Many dozens of restoration projects were approved, and several initiated, before the end of 1945. The men who had struggled to salvage and repair while the war was still raging were bringing that febrile momentum to the new phase as they endeavored to get as much work as possible started before the AMG folded its operations at the end of the year and their mission in Italy was over. It was a crucial time to clear the mess of war and begin to reconstruct the postwar face of Italian cities. In 1955, Alfredo Barbacci, superintendent of monuments in Bologna, wrote with palpable pride to Cecil Pinsent, "I have finished restoring all of my monuments."

However important, the Venus Fixers' work in the north was eclipsed in the spring and summer of 1945 by the unfolding drama of the displaced Florentine art. In the days leading to the German surrender, the actions of

all parties involved became more convulsed, while the Allied monuments officers, in liberated Italy, held their breath. Carlo Anti continued his efforts, an added undertone of despair to them, to counter the German tug to deport everything across the border. Once he realized the inevitability of the German defeat, he sought the partisans' help. Having belatedly understood that Langsdorff was no ally, and was never going to return custody of the artworks to Italian hands, the Fascist fine arts director acted in betrayal of his government and out of concern for the art. He knew of the insurrections that the partisans were organizing in various northern cities to end the German occupation, and with the Venice superintendent Forlati as his intermediary he informed their Venetian cells of the exact location of the art deposits in South Tirol. He asked that the partisans be prepared to dispatch guards to the repositories, so that in the chaos surrounding the routing of the Germans, these might not be destroyed or vandalized. Also on the eve of the surrender, Karl Wolff made good on his word to Allen Dulles, and on April 25 he revealed that the artworks were stored at Campo Tures and San Leonardo.

On May 2, news of the discovery of the two repositories and their fabulous contents spread quickly. The partisans, having been alerted to them by both Anti and the OSS, immediately posted their guards at San Leonardo and Campo Tures. Meanwhile, in Bologna, Teddy Croft-Murray heard of the deposits from Superintendent Zampetti, who had inspected the paintings abducted from Montagnana at Marano sul Panaro back in the summer of 1944, and telephoned the news to Fred Hartt in Florence. Ferdinando Forlati, Professor Antonino Rusconi, and Lehmann-Brockhaus were the first men allowed to visit the deposits on May 5 and 6. On returning to Venice, an emotional Forlati recorded, "All is in order, all is miraculously in order, if you think that most paintings have no protection: true masterpieces of the early Tuscan Renaissance and the Venetian school, Botticelli, Raphael, Titian, a whole world of light, a whole world of beauty!"

In mid-May, Deane Keller traveled from Milan to South Tirol; with Hartt and Superintendent Filippo Rossi, who joined him from Florence, he would spend the next several weeks checking the deposits. Although they

were somewhat inured, by then, to the devastations of war, the utter destruction of the Alto Adige valley struck both Keller and Hartt. More shocking still was the defiant stance of the German officers who lingered in the area in large numbers despite the surrender. "They were everywhere, armed, riding around in cars, free as can be," Keller recalled. As Hartt explained, the collapse had happened so quickly that the Allied presence in the region was still very light, and had been instructed to avoid all possible incidents with the Germans. "We began to wonder," a bewildered Hartt noted upon arriving in Bolzano, "which side had surrendered eight days before." Alexander Langsdorff, full of spite and conceit, was waiting for them at Castle Neumelans to show them around the deposit. Hartt found his posturing as the artworks' solicitous guardian profoundly irritating. "The executor of the greatest single art-looting operation in recorded history received us with a certain amount of petulance, as if we had not really been fulfilling our duty to Art by arriving so late. He . . . made it clear that he expected not only praise for his idealistic labor in protecting art but also the deference due his superior rank." A few weeks in the prisoner-of-war cages, Hartt noted, would take care of Langsdorff and his deputy Reidemeister's hauteur. "But at Campo Tures," he wrote, "their arrogance was still magnificent."

Only with the subsequent interrogations of Wolff, Langsdorff, and Reidemeister could the Allied officers Ernest De Wald and Douglas Cooper weave together the many threads of a complicated plot. The seized Kunstschutz papers, matched with interviews with Heydenreich and Lehmann-Brockhaus and with the written depositions of Ringler and Anti, helped them establish a hierarchy of responsibilities within the organization. While most of its members seemed guiltless, and indeed unaware of any hidden agenda behind their salvaging operations, the evidence weighed heavily against two of its men's actions.

As he was driving to South Tirol, Keller met Ludwig Heydenreich at Blevio, on Lake Garda. "Found—me—the second top man, a German . . . questioned him (in Italian) got a lot out of him and the Monuments on our side are profiting," he wrote to his wife. Keller enjoyed this unexpected role

shift. "I am becoming a bit of a detective as we are tracking down pictures etc.," he wrote. The interview, however, revealed that Heydenreich was far from being the "second top man," not in the last phase of Kunstschutz operations at least; in fact, Heydenreich did not seem to believe that Langsdorff had anything else in mind besides his purported rescuing of Italian art from the war front. The German art historian's many years of life and work in Italy further exculpated him from the suspicion of having played a role in the abductions from Montagnana and the other Tuscan repositories: he had protected the safety of both Bernard Berenson and his collection, and assisted Poggi in his evacuations of Florentine art to the countryside in 1943 and early 1944. He counted many friends among the partisans and had a cordial relationship with Ranuccio Bianchi Bandinelli, the newly appointed director of fine arts of liberated Italy and, in the words of the art historian Charles Rufus Morey, "that uniquely Italian thing, an aristocrat and a Communist all in one person." There emerged with stark clarity from Keller's report that the man the monuments officers wanted to talk to was Langsdorff. Unfortunately for Keller, who felt slighted for being pushed aside by higher-ranking colleagues, this would require a more structured questioning by interrogators who were fluent in German.

In Lehmann-Brockhaus's words, Langsdorff was "a man with a divided soul, one half SS and the other half genuinely in Kunstschutz," perhaps too generous an opinion of the German officer. The final report on Kunstschutz emphasized that Langsdorff was an archaeologist of the Near East who knew nothing about Italy and Italian art; this, in the Venus Fixers' eyes, was an aggravating circumstance in its implication that Langsdorff did not care for Italian art. Face-to-face with Cooper and De Wald, Langsdorff defended the military character of what he insisted on calling his "salvaging operations"; these, he asserted, had been dictated by the fierce fighting in the battle for Florence and the need to wrench the Florentine masterpieces away from the front. He brushed aside the fact that in ostensibly serving the best interest of Italian art, he had acted in consistent disregard of the Italian superintendents' counsel. A case in point was Dicomano, the art repository in the hills of Mugello where the ancient statuary from the Uffizi had

been cached. The village, to the north of Florence, was perilously near the Gothic Line in the summer of 1944, and Poggi himself had asked for Langsdorff's help to bring the sculptures back to the city. Langsdorff had obliged, but once the trucks were loaded, they headed north to Bologna rather than south to Florence. In his own version of the story, Reidemeister stated that the village had been demolished by Allied raids and that the Oratory of Saint Onofrio, where the artworks were sheltered, was the only building "miraculously" to have escaped destruction; he also peevishly reported that none of the villagers had helped him and his crew in hauling the statues onto the trucks. According to local witnesses, however, the population had been forcibly evacuated by the Germans, who had then mined and razed Dicomano. In their view, the oratory's survival was anything but a miracle.

Multiple instances pointed to Langsdorff's duplicity, the most egregious example being the disappearance of Lucas Cranach's two paintings *Adam* and *Eve*. Back in mid-July 1944, the two canvases, from the collection of the Uffizi Gallery, had been evacuated by the Germans with eighty-four other paintings from their refuge at Oliveto in the Val d'Elsa to German-held Florence. Unlike the rest of the cargo, though, the two Cranachs had never reached Florence. They were apparently immediately recognized as "Germanic art" by Colonel von Hofmann, who seized them, separating them from the rest of the pictures that were returned to Florence. Langsdorff, as he wrote in his deposition, had "personally brought them to safety," first to Verona and a few days later to South Tirol. At the end of July, Langsdorff had reassured a very concerned Poggi that the artworks were safe, although he could not reveal their location; however, as his interrogation revealed, at the time of his conversation with Poggi, the filched *Adam* and *Eve* were sitting in the colonel's room at the Excelsior Hotel awaiting departure for the north. Göring, as Allied interrogators in Austria were learning, was very fond of Cranach.

In De Wald and Cooper's reconstruction of the final months of the Kunstschutz's activities, between July 18 and July 23, 1944, Langsdorff had visited General Wolff at Fasano, the seat of the German Embassy on Lake

Garda. Although the Allied officers were unclear as to what exactly Langsdorff told the SS commander, Himmler was informed of their conversation, and a few days later Wolff issued an order "to go and remove whatever could be saved of the endangered works of art belonging to the Uffizi and the Palazzo Pitti in Florence," and supplied Langsdorff with the fuel and the vehicles needed for the operation. Langsdorff, who had already amassed 280 paintings taken from the villa of Montagnana in early July and the two Cranachs, now had the means, the support of his army, and the orders "from high up" to continue his spoliations. He acted quickly, taking advantage of the slowness with which the war front was moving around Florence. In early August, while all the art deposits to the south of Florence had been liberated by the Allies, the repositories due north of the city were still behind German lines, and their only defense was a bunch of mostly unarmed custodians. Langsdorff could raid them, while claiming that he was rescuing their contents from the front line, before the Allies reached them. On August 8, he attempted to empty the Medici Villa of Poggio a Caiano, but the intensity of the artillery fire was such that he was forced to postpone the evacuation. Ten days later, Gen. Heinz Greiner signaled that there had been a lull in the fight around the villa; on August 23, Reidemeister, with help from Greiner's aide-de-camp, Lieutenant Wawrowetz, despoiled the cache. On its way to the north, the convoy stopped by Trefiano, the estate of Count Contini Bonacossi, where the two added a selection from the nobleman's famed collection of paintings to their cargo.

Although Cooper and De Wald did not dwell on Langsdorff's motivations, advancement seems to be the likeliest. The two Allied officers pointed out how the abductions from Tuscany happened to coincide with the removal, on orders from Himmler, of the Bayeux Tapestry from the Louvre Museum to Germany and of a Madonna by Michelangelo and fourteen paintings from the Bruges cathedral in Belgium. Single-handedly and on his own initiative, Langsdorff had trumped that booty.

Gen. Karl Wolff had a more far-reaching plan for the Florentine treasures than his colonel. As soon as Langsdorff began to drop them in his lap, Wolff probably realized that he could use them as bargaining chips: the

Michelangelos and the Donatellos were to be part of his exit strategy, a token of his goodwill to his Allied counterparts. He insisted to his interrogators that the project for removing the Florentine deposits originated with Langsdorff and emphatically affirmed his independence from Berlin. He had not looted, as Göring and Hitler had, systematically and for years all over Europe, but protected Italian art for the Italian people, and this art he had handed over to the Allies. He had not acted on Hitler's orders. In fact, he had disobeyed Himmler's directive to transfer the artworks to Altaussee, and that decision made him the arbiter of their fate. Had he transported paintings and sculptures to the Salzburg mine, these would likely have been destroyed. Shortly before the Allied Third Army's arrival at Altaussee in early May, the SS had planned to blow up the site, and only the tacit insubordination of the German restorer Karl Sieber, the supervisor of the art deposit, averted the disaster. Sieber set off enough dynamite to blow up the entrance to the mine, thus making it look as if the entire site had been destroyed. It is hard to acknowledge that Italy probably owes the survival of six hundred of its most remarkable works of art to the ferocious SS commander's long-ranging vision and sangfroid.

One aspect of the removal of Italian art set it apart from almost all other Nazi-perpetrated abductions and acquisitions, and this particularly intrigued Fred Hartt. As the pictures hidden at Altaussee were slowly being brought back out and to the light again, "many hundreds," he wrote, "were worthless German nineteenth and twentieth century paintings, and the majority were perfectly competent Dutch, Flemish, and occasionally Italian masters." Hartt intuited what was soon to be confirmed by the interrogations of Hitler's art advisers: the Führer loved the early Romantic Carl Spitzweg, Hans Thoma's idyllic landscapes, and Eduard von Grützner's humorous scenes of everyday life. By comparison, half of the works amassed by Langsdorff in South Tirol were masterpieces. Also, while Hitler and Göring had insisted on at least the semblance of legality in the acquisition of works of art, the artworks in South Tirol were all looted from state-owned museums. The only exceptions were Count Contini Bonacossi's paintings, and the two collections belonging to the Duke of Bourbon-

Parma and the French banker Finaly-Landau, whose presence among the cache in South Tirol Wolff could not explain. By the monuments officers' final count, 532 pictures and 153 cases of sculptures had been taken away from Florentine museums during the summer of 1944. The sheer hubris of Langsdorff's looting wasn't lost on Hartt.

Langsdorff's other occupation had been to keep Carlo Anti quiet, and he had had a relatively easy job of it. Interviewed by Norman Newton in June, Anti "made a quite unprepossessing impression" on the monuments officer. "Anti seems at first glance a pathetically weak person," Newton wrote in his report to the MFAA subcommission. He did not feel compelled to arrest him, but submitted to the former fine arts director a set of written questions prepared by Douglas Cooper. Anti's answers matched the picture that emerged from the seized correspondence of the Fascist directorate: a string of ineffective, if sincere, attempts to persuade the Nazi authorities to do what they had no intention of doing. Upon hearing that he had been recommended for suspension by the committee for defascistization, the Venetian superintendents, Ferdinando Forlati, Giovanni Battista Brusin, and Vittorio Moschini, came to Anti's defense. Newton encouraged Brusin to prepare a written statement for the MFAA subcommission. In this, the three superintendents declared that Anti had only very reluctantly accepted the fine arts directorship in 1943; he had done so at their insistence, since they feared that someone more politically motivated and less technically competent might otherwise accept the position. Anti, they stated, had never pressured them into taking the oath of allegiance to Fascism, and had let the ministry's letters on the matter sit unanswered on his desk. According to Brusin and his colleagues, at the time of the Allies' advance in Tuscany, it was Anti who had suggested to Poggi to signal the location of the deposits to their command; for this, he had been accused of "collaborating with the enemy" by the most extreme elements at the ministry, but had been kept at his place by Minister Biggini's intervention. The Allied monuments officers had no reason to doubt Carlo Anti's professed innocence in the looting of the Florentine masterpieces. As for the rest

of Italian art, though, it is just as well that Pasquale Rotondi, Emilio Lavagnino, and Giulio Carlo Argan did doubt his Fascist loyalty.

A snapshot taken on the day when the artworks were returned to Florence, July 22, 1945, shows Giovanni Poggi wearing a white Panama hat, while Fred Hartt and Deane Keller pore over a list, a freight train car in the background; on the back of the small photo, a penciled note: *"tempo caldissimo"*—"a very hot day."

Since the early days of the artworks' discovery in Alto Adige, Keller and Hartt agreed that it was of tremendous importance for the image of the Allied forces in Italy to return them to Florence under Allied military protection. Hartt credited Keller with convincing the AMG Fifth Army of the urgency of the shipment, as well as for supervising in all its many details an operation that was to prove complicated, at times nerve-racking, and very lengthy. In the first flush of excitement at discovering the sculptures at Campo Tures, all still protected by the careful packaging by the Florence superintendency, Keller thought that the transfer could be started right away; once crated, the paintings at San Leonardo could follow. An understandably elated Keller felt that a ceremony, in Florence, would be appropriate to salute the returning treasures; in an unusually chirpy mood, he wrote to Col. Arthur Sutherland, executive officer of the AMG Fifth Army, "Remember how crowded the Piazza della Signoria was when they put up Michelangelo's David? You don't and neither do I, but that's the idea! . . . Who says that the Fine Arts Officer has nothing to do?"

Despite his optimistic forecast, it took Keller's tireless efforts to rally man power and secure packing materials, Hartt and Rossi's inventorying, ten army units, the joint work of the superintendencies of Florence, Trento, and Milan, the help of the Merano partisan cell, and the better part of three months to return the masterpieces to their home. Workmen knocked together crates out of wood left behind by German troops. Everything seemed ready on June 27. "All but one of the pictures are packed at San Leonardo," Keller wrote to De Wald on that date. The artworks were to be transported

by trucks for a trip of about three days. Hartt left with Rossi on a scouting journey to identify overnight stops where the men could be accommodated and fed and the trucks and their very valuable cargo safely parked. As it turned out, however, the AMG Fifth Army could not spare the vehicles, which were hauling desperately needed rations to Milan and Turin. "Redeployment and winning the Japanese war have a priority over us," Keller wrote to De Wald as he began to explore the idea of using the railroad. The trip, however, would have to wait until a bridge was rebuilt across the Po River. Nerves, at this point, were beginning to fray after two months of frustrated arrangements. "Poggi . . . is not happy. Hartt is very unhappy," Keller wrote to De Wald. "I would say this," he continued, "if Poggi kicks too much about the R.R., and he may not, as he seems to have confidence in us, I would tell him, 'OK, get them down yourself.'"

On July 20, twenty-two railroad cars, thirteen of which were loaded with the sculptures and the paintings, began their twenty-two-hour journey to Florence. As Hartt recorded, Lt. Col. Elmer Holmgreen, who had been the governor of Anzio during the days of the beachhead, was in command of the train, and sixty military policemen accompanied it. Asked to estimate the value of that phenomenal cargo, Filippo Rossi put it at 500 million dollars. "Yeah," Keller's driver Charlie Bernholz confirmed when it was all over, "we merely jackassed half a billion worth of artworks from Alto Adige."

Hartt and Rossi drove in advance of the train in Lucky 13, along a road of which by then they knew "every bomb's crater." As they climbed the Apennines, across which the artworks had been driven with stealth a year earlier, Hartt felt deep pride in his outfit's achievement. He reflected on the curious twists of history. One of the battles he had waged most recently was over the centuries-old forest of Camaldoli, in the Casentino, whose fir trees, as tall and slender as Gothic spires, had been felled by the British Second Forestry Group. He had argued and pleaded for their preservation, and all for naught. The trees, he was told, were needed to rebuild smashed bridges. As the train approached the Po—the first train to cross the river since the German retreat—he realized that it was going to travel across a massive bridge built with the logs sacrificed from Camaldoli. In the afternoon of

July 21, Hartt, Keller, Rossi, and Poggi all met at the Campo di Marte, the station that the late Benjamin McCartney had reduced to a tangle of steel while carefully avoiding all of Florence's monuments a year and a half before. They discussed what to paint on the truck that was to lead the convoy to the Piazza della Signoria on the following day. Superintendent Poggi had the last word: *"Le opere d'arte fiorentine tornano dall'Alto Adige alla loro sede"*—"The Florentine works of art return from the Upper Adige to their home."

In Hartt's telling, the procession of the next day, Sunday, July 22, seemed to unfold as if to the happy notes of the march from Prokofiev's *Peter and the Wolf.* Lucky 13, all cleaned and shiny, carried Hartt, Poggi, and Rossi; Keller and Holmgreen followed, driven by Bernholz. As they slowly snaked through the Florentine streets, the crowds waved, cheered, and wept; they shouted, *"Bravi"* and *"Grazie."* Once on the Piazza della Signoria, they were saluted by trumpeters in medieval costume. General Hume, chief of the AMG Fifth Army, spoke briefly. De Wald called his men's mission in Italy accomplished. In the next days, whenever he thought back to the last three months, Keller felt a sense of "Blessed Relief." Hartt sat down and wrote a long and detailed report of the monuments officers' one-year work in Florence. Then he could delay it no longer, and aboard Lucky 13 he followed his orders to Austria. He left Florence in a tumult of emotions, a sense of accomplishment for what he and his colleagues had done, a terrible heartbreak, and a promise to himself to come back. As he wrote to Berenson one year later, "I fell in love with Florence in its agony and it is a possession which only my presence there can ever assuage."

Epilogue

A NECESSARY DREAM

If you remember, when some of that looting was going on, people were being killed,
people were being wounded . . . It's as much as anything else a matter of priorities.
—Gen. Richard Myers, chairman of the Joint Chiefs of Staff,
Iraq war, on the April 2003 looting of the Baghdad museum

P eace, it's wonderful," Fred Hartt wrote to Bernard Berenson from
Salzburg in September. Work, though, he added a month later, was
"awfully dull, after Italy." Inventorying caches of Austrian and Ger-
man art just did not measure up to salvaging monuments while the bombs
were still falling in Italy, however arduous, convulsed, and nerve-racking a
job that had felt at the time. The sheer volume of his team's achievement
was impressive. By December 1, when the Subcommission for Monuments,
Fine Arts, and Archives ended its activities in Italy and transferred full re-
sponsibility for the country's artistic patrimony to the Italian government,
twenty-seven monuments officers, fourteen of them American and thirteen
British, had visited one thousand Italian towns, cities, and villages and sur-
veyed twenty-five hundred damaged monuments from Sicily to the Alps. At
the time of their leaving, two and a half million dollars had been advanced
by the Allied Military Government for reconstruction, and seven hundred
buildings of historical or artistic significance were being repaired. In Tus-
cany alone, 100 major restoration projects had been completed, and 160
more were under way.

The recovery of the nearly six hundred Florentine paintings and sculp-

tures was the "Italian" Venus Fixers' crowning accomplishment. As for the rest of their activities, the end result, within a conflict of such scope and brutality, was inevitably mixed. "Anyone who writes about the destruction to art in Europe without a full realization of its enormity is being frivolous," Herbert Matthews wrote in *Harper's Magazine* in May 1945. "The best you can say," he continued, "is that it might have been worse and that many men have worked hard to minimize the damage and to repair it when it was done." A fair, unheroic assessment of the monuments officers' work, the article stressed how much had been done with so little, few men, scant resources, and no previous experience to guide their action. Their performance could not be compared with earlier examples of military art protection in wartime, as there were no such precedents. Regrettably, their efforts have not inspired similar initiatives in recent conflicts.

In their final report, the monuments officers offered their own lucid evaluation of two years' hard work in Italy. Edited by Norman Newton, the report was the result of the Venus Fixers' monthly "gatherings" from the field; shaken dry of the passions of the moment, and composed in a muted setting where there were no more bullets hissing, tempers flaring, broken vehicles, and dysenteric officers, it presented a thorough list of losses, salvages, and survivals. It covered the national territory region by region, and from city to hamlet named every damaged monument and the repairs that were in progress or had been completed; it acknowledged responsibility for incidents that could have been handled more expertly, and respectfully but firmly denounced instances of uncalled-for destruction by Allied forces.

Ninety-five percent of the damage, the Venus Fixers established, had been inflicted to monuments by strategic and tactical bombardments. As a result of a closer cooperation between the MFAA outfit and the air forces, since the early months of 1944 the precision of the air raids had greatly improved, despite the increase in the force and frequency of the attacks in the later stages of the campaign. The Venus Fixers cited the air strikes on Florence, Siena, and the harbor of Venice as particular examples of successful precision bombings that had smashed those cities' railroad stations while leaving their incomparable historic centers intact. Conversely, they singled

out Viterbo, the medieval town in northern Lazio that was savaged by bombs in order to create a roadblock that the enemy cleared up in half an hour, as one glaring instance of ill-guided and unnecessary devastation. As for the sticks of bombs that were dropped on Pompeii in September 1943, the report deemed them "two hundred wasted bombs."

As the monuments officers gauged the toll of war on Italian art and architecture, bridges and towers all over the country stood out as the worst casualties. Scores of *campanili* had been doomed either by their wartime use as observation posts or by suspicion that the enemy might be using them as such. Among the dozens of demolished bridges from south to north, the loss of the Ponte Santa Trinita in Florence was compounded by the demolition of five medieval fortified bridges in Umbria and by the destruction of the Ponte di Mezzo, the oldest Roman bridge in Italy, razed with all the other bridges of Verona by German mines one week before the final surrender. Architectural styles had fared very differently, some as the result of weaker building techniques and materials, some through chance. Ancient monuments in general had withstood bombs and the hailstorms of shells and mortar better than Renaissance buildings. The Venus Fixers attributed some escapes to luck, as in the case of the temples of Agrigento, in southern Sicily, and of Paestum, south of Salerno, both located near the sites of landings, and all unscathed. But they were positively impressed by the toughness of Roman masonry. Hadrian's Villa at Tivoli, encircled, in the spring of 1944, by heavy artillery fighting, showed "a little more than a few scars." Sadly, Baroque churches and palaces and their elaborate and fragile stucco decorations, which were concentrated in heavily hit cities like Palermo, Naples, Genoa, and Turin, were ruined in large numbers.

Ground warfare had inflicted less destruction, and this was mainly limited to the winter lines of 1943–1944 and 1944–1945. The region of Lazio, the scene of the 1944 spring offensive toward Rome, had been particularly pummeled at a time when the monuments officers were all still stationed behind the front in Naples; Umbria, by contrast, "which had so much to lose, had in fact lost the least," the report noted, as a result of the rapid passage of the battle through the small region. Along the Adriatic coast, where

the fighting had been bitter and protracted, the ancient city of Ancona, built on an "elbow," *ancon* in ancient Greek, protruding into the sea, was gravely damaged: its Romanesque cathedral had received several hits, as did the archaeological museum. The museum director had turned down Pasquale Rotondi's offer to evacuate its contents to the fortress of Sassocorvaro, and its important collection of pre-Roman artifacts was destroyed. Farther north along the coast, the celebrated Tempio Malatestiano in Rimini suffered great injury. Designed by the architect and humanist Leon Battista Alberti, the Renaissance church and mausoleum of the town's ruling family, the Malatesta, was repeatedly hit by shells: the apse, a later addition to the shrine, was mostly destroyed, and its arcaded, unfinished marble facade leaned perilously outward and sideways.

Deemed one of the war's worst artistic disasters at the time of its bombing, the Tempio Malatestiano would in fact be salvaged. Its facade required dismantling, stone by stone, a costly and lengthy operation, but it was *reparable*. And so were the eighteenth-century palaces of Turin, the many churches of Pisa, and the Gothic palazzi of Vicenza. With the exception of the pulverized Mantegna frescoes of the Ovetari Chapel in Padua and the Angevin tombs at Santa Chiara in Naples, both declared a complete loss, most of the unroofed churches, gutted palaces, and battered villas could be restored. And the thousands of fragments of marble tracery, stone friezes, gilded ceilings, stucco moldings, wooden carvings, broken statues, and splintered mosaics would all, in time, and with ample funds, patience, and skill, be pieced together again. For two years, this had been the objective of the Venus Fixers and their Italian counterparts, and all their buttressing of tottering walls and waterproofing of punctured roofs and shattered windows: to salvage every architectural structure, however skeletal, and preserve every decorative sliver so that the restoration of all these ailing monuments would be possible once peace had been reestablished. A bittersweet measure of their success is how invisible their work is in today's beautifully restored churches and palaces of Italy.

A discreet unobtrusiveness was their goal from the start of the Italian campaign. Ever since they set foot in Sicily, they realized that most of their

efforts would be devoted to damage control, rather than the damage prevention that the Roberts Commission had optimistically envisaged when planning their mission. As lieutenants and captains—a few of them were promoted to majors in the final stages of the war—the monuments officers could only strive to keep as close as possible to the battle and be ready to intervene as soon as it was over. They accepted the secondariness of their role: only after the needs of starving, wounded, and displaced civilians had been addressed could their requests for funds and materials be justified. Their quiet heroism, which salvaged so much great art, can only be glimpsed past the long inventories and the requisitions of bricks and timber. This, together with the unassuming nature of most of them, might be why their story was long overlooked.

Timeliness was their strength, and the secret of their good results. They landed in war-torn Italy at a time when their Italian counterparts were psychologically exhausted and penniless. Out of the 250 million lire—roughly 250,000 dollars—that represented the budget of the Italian Ministry of Education for 1944–1945, 22 million had been allocated to fine arts: barely enough, the final report remarked, to repair one single large monument. Most of the money had been poured into protecting monuments and evacuating mobile art during the early years of the conflict. The former had been carried out with the same methods employed in World War I, sandbags and brick walls; the gap between the rudimentary methods, scanty resources, and the size of the achievement had been filled by sheer willpower. Determination was one shared trait of the Allied monuments officers and many Italian superintendents. Moved by a common cause, the Italians had the expertise, which the Allied officers infused with administrative vigor; it is no surprise that in most cases, they found each other *simpatici*.

"We were not so noble," Deane Keller wrote years after the war, "we were just doing a job." His Venus Fixer colleagues would have agreed. But Italy suited their personalities, and Italian art often benefited from their wanderlust and nosy ways. "In Italy, if perchance you get bored, you can always go out and wander around and find something to divert your mind and soul," Ernest De Wald wrote to Norman Newton. It was during one of

those walks, in Florence, in the summer of 1945, that he noticed a beautiful Byzantine icon in the window of an antiques store. He mentioned it to Berenson during a visit at I Tatti a little later, and the two checked it out in a book from the critic's magnificent library: the icon belonged to the bombed Church of the Santa Annunziata in Livorno; alerted to its reappearance in a Florentine dealer's store, Hartt was to find eight more that a man living in the vicinity of the church had stashed away in his house.

Perhaps "the consuls of Italian art," as they were once described, would have suited them better. In the midst of a life of mostly solitary intellectual pursuits, the war in Italy came as an interlude of action and decision making; Italian art, the object of their research, their teaching, and their writings, was for two years the prize of their fight. For some Venus Fixers, a call to serve in Italy came like the summons to the bedside of an old dear friend now critically ill; for some, it was the beginning of a love affair. Keller's relationship with the country was one of love and hate, with the Italians often bringing out the feisty side of his personality. "We must begin with Italian children and teach them how to come together, how a meeting should be run, that all people don't talk all at once, or even all the time, that they live in society and therefore have rights and privileges, BALANCED by duties and obligations of a nature not always touching on what is nearest to them," he wrote after having attended a meeting too many in Pisa. But he always regrouped. "Funny," he wrote a little while later, "with all the things you can say against Italians, one likes them just the same." Pisa acknowledged the excellent work of Deane Keller, whose ashes are interred in the Camposanto. To leave Italy for most of the Venus Fixers had the bittersweet flavor of the end of an adventure.

They exited the Italian theater at the moment when art protection, for the first time in the conflict, was making headlines. Having foiled Nazi attempts at wholesale theft, they drew their activities in Italy to a close at a time when, in Austria and Germany, the Allied armies were discovering more treasures looted by the German Reich, which other monuments officers in those areas would haul out of their hideaways, inventory, and eventually repatriate to their various countries of origin. In a copper mine at

Merkers, in Thuringia, on April 6, the American Third Army unearthed the entire gold reserve of the Nazis' Reichsbank, hundreds of bags containing a total of 250 million dollars in gold. At the end of April, the Seventh Army discovered Hermann Göring's air-raid shelter near his house at Berchtesgaden in the Bavarian Alps, where he had gathered the choicest pieces of his art collection in one last, desperate effort to salvage them from Allied air raids and seizure. Previously displayed in Göring's eight residences, the collection counted more than one thousand paintings and included furniture and tapestries; fabulous and ill acquired, it was the Pantagruelian banquet of the *Reichsmarschall*'s gluttony. The rest of it was discovered a couple of days later in the salt mines of Altaussee near Salzburg together with the plundered art destined for Hitler's unbuilt Linz museum. There, in the *Kammergrafen*, the largest and remotest chamber of the mine, among six thousand paintings and sculptures, were the fifteen cases from Monte Cassino, the birthday present from the Göring Division to their leader that the latter, much to his regret, had rejected: by accepting it, he would have sanctioned a blatant theft, and had handed the heist to Martin Bormann, who had hoarded it up at Altaussee. The *Kammergrafen* hid the bronzes from Herculaneum and Pompeii and the paintings from Capodimonte: filched from Monte Cassino, they had been temporarily deposited at Spoleto; they had been driven first to Berlin and later to Munich and, ultimately, hidden away in the folds of the Austrian mountains. The taste in selecting the canvases for once had been superb: Titian's *Danae* and *Lavinia*, Raphael's *Madonna of Divine Love*, Pieter Brueghel's *Blind Leading the Blind*, Filippo Lippi's *Annunciation*, Parmigianino's *Antea*. "Did we have this?" Ernest De Wald wrote to John Ward-Perkins after having inspected the paintings, for apparently the list in his hands did not show the celebrated sixteenth-century portrait of an Italian woman, the pale, perfect oval of her face framed by a rich gown of embroidered gold, her identity still a subject of speculation after centuries. The pictures, De Wald announced to his colleague in Rome, were "safe and found . . . Keep the Italians quiet," he added prophetically. Because of the enormous quantity of displaced art-

works that were gathered at the Allied collecting points of Munich and Wiesbaden, much to the anxiety of the Neapolitan superintendents, the Capodimonte paintings and the Pompeian bronzes were only returned to their homes in 1947.

The identification of the abducted Neapolitan artworks was De Wald's last responsibility as a monuments officer. He returned to the United States in the spring of 1946 and went right back to teaching art and archaeology at Princeton. In a letter to Berenson in early 1947, he confessed to still having "sharp twinges of nostalgia for Italy." For Ward-Perkins there was no melancholic farewell, as upon his release from army duty he stepped straight into his new role as the director of the British School at Rome. He was known among his students for using his old military maps on the archaeological walks and field trips he led around the Roman countryside. Cecil Pinsent traveled to Italy for brief periods, and mostly to visit old friends. "A long spell of English simplicity makes one ready for a little Latin guile," he wrote to Berenson on the eve of one of these trips. Only very sporadically did he work in Italy again. In 1947, upon turning down a request from a friend to work on a deconsecrated church in Assisi, he confided to Berenson: "The flash of conviction has gone, and in these days there is something quite unreal about turning churches into studios for female amateur painters. But I can't say that to her."

On their return to civilian life, they lectured extensively on their wartime activities in Italy at all the country's major museums. Hartt, Keller, Pennoyer, and De Wald were involved in the work of the American Committee for the Restoration of Italian Monuments. In private, however, they did not reminisce about their experience, not with one another, and little with their families. Roddy Enthoven did not recount much, except for his boasting, jokingly, that he "had carried Cosimo on his shoulders." Teddy Croft-Murray defended his partiality for patrician mansions as his wartime accommodation by maintaining that his presence in them had dissuaded troops from misbehaving. For his part, in 1963 Basil Marriott gave in to nostalgia and decided to revisit Venice, which his "over-privileged military

occupation" had "dropped on his plate as a Military Officer" in the summer and fall of 1945. He recounted his impromptu trip at Easter time for the British architectural magazine *The Builder*. Against the background of the Veneto, which in the early 1960s was peaceful, thriving, and comfortably uneventful, wartime memories "nudged" him constantly. While in Padua, admiring Giotto's frescoes, he averted his eyes from the nearby Ovetari Chapel; while lunching on trout at Bassano, he remembered tea with Freya Stark in Asolo, "in welcomely English chintzy oasis"; the sight of the Villa Malcontenta evoked the Palladian headaches caused by the smashed palazzi of Vicenza. He left Torcello for last, for in 1945 on the little island in the lagoon Marriott had spent "halcyon birthday No. 44, in treacly October sunshine and heaven-sent tranquility." He hinted at the presence of a woman on that day; a local cottager offered them a basket of sweet figs and a ride back to Venice in a "mud-scow along channel afterwards found to be un-mine swept."

The excitement that had colored Marriott and his companions' mission in Italy was tightly wrapped with the horror of the war, the loss of life, the maiming wounds, the danger, the fear, the devastation, and the separation from loved ones. It was hard to explain that what they did was, in part at least, exhilarating, without the risk of being misunderstood. Would they be called frivolous if they revealed that Italy, wrecked and on its knees, had held such a fascination for them? Unsentimental Keller called it "a necessary dream." Hartt turned it into the inspiration of a lifetime of studies. He kept returning to Florence. For his services to the city he was made an honorary citizen; his ashes are buried in the Porte Sante Cemetery on the hill of San Miniato, with a sweeping view of the Arno and the city. Over the years, he never forgot how even through the pall of war the city's loveliness had first struck him. As he told an audience of students at Syracuse University some forty years after the war, "If you think Florence is beautiful now, you should have seen it then."

NOTES

Prologue

4 *"one of the greatest responsibilities"*: "Return to Florence," Lieutenant McCartney's beautiful account of his mission over Florence, was published by *The National Geographic Magazine* in March 1945. The day after the manuscript was received, the War Department announced McCartney's death from wounds he had received in a subsequent air raid on Cassano d'Adda, near Milan, on September 22, 1944. With his co-pilot and friend, Bob Cooke, he had planned to write a play on the raid on Florence, "at night in the orderly room and in our tent."

5 *Reluctantly*: General Alexander to General Wilson, Jan. 14, 1944, WO 204/2987.

6 *Ovetari Chapel*: Alberta de Nicolò Salmazo, Anna Maria Spiazzi, and Domenico Toniolo, eds., *Andrea Mantegna e i maestri della Cappella Ovetari* (Milan: Skira, 2006); Ferdinando Forlati and Maria Luisa Gengaro, *La chiesa degli Eremitani a Padova: Collezione i monumenti italiani e la guerra* (Florence: Electa, 1945); Vittorio Moschini, "Vicende di guerra delle opere d'arte venete," *Arte Veneta* 1 (1947); *Works of Art in Italy*, vol. 2, pp. 39, 127.

7 *"Dear Maj."*: De Wald Papers.

Chapter One: Italian Art Goes to War

9 *These were the protective measures*: Boi, *Guerra e beni culturali*; Carniani and Paoletti, *Firenze, guerra & alluvione*; Direzione Generale Antichità e Belle Arti, *La protezione del patrimonio artistico nazionale*.

10 *"War Law"*: The law was approved on July 8, 1938: Boi, *Guerra e beni culturali*, p. 2.

10 *the inadequacy of these defenses*: Ceschi, *I monumenti della Liguria e la guerra*, pp. 9–12.

10 *dangerously unpatriotic*: Cesare Fasola, "Perché non si impedì l'esodo delle opere d'arte fiorentine?" *Il Ponte*, May 1945, pp. 141–46.

10 *"Rome-Berlin axis"*: Duggan, *Concise History of Italy*, p. 234.

10 *make them tough*: Ibid., p. 236.

11 *ill equipped and poorly trained*: Mack Smith, *Italy and Its Monarchy*, p. 289.

11 *at the right time*: Ridley, *Mussolini*, p. 312.

11 *a disastrous rout*: Duggan, *Concise History of Italy*, p. 238.

11 *vulnerable Italian cities*: Poggi Report, June 5, 1945, Poggi Papers.

12 *In Naples, a small open van*: Molajoli, *Musei ed opere d'arte*, p. 24.

13 *the Rocca of Sassocorvaro*: Giannella and Mandelli, *L'arca dell'arte*.

15 *"a profile on a Renaissance medallion"*: Filippo Rossi, "Giovanni Poggi," *Bollettino d'Arte del Ministero della Pubblica Istruzione* 4 (1961).

16 *"the quiet but large and worrisome"*: Poggi Report.

17 Venus of Urbino: Antonio Paolucci, "Histoire et fortune de la Vénus d'Urbino," in *Vénus devoilée* (Brussels: 2003).

17 Urbino Diptych: Melania Ceccanti, "Ritratti e trionfi di Federico da Montefeltro e Battista Sforza," in Paola Dal Poggetto, ed., *Ricerche e studi sui "Signori di Montefeltro" di Piero della Francesca* (Urbino: QuattroVenti, 2001).

18 *a man of letters and arms*: Marinella Bonvini Mazzanti, "Su Federico da Montefeltro," in Dal Poggetto, *Ricerche*.

18 *"Born to rule"*: Marinella Bonvini Mazzanti, "Su Battista Sforza," in Dal Poggetto, *Ricerche*.

18 *The statue's ten-mile trip*: Deane Keller Report, Feb. 17, 1945, RG 331, 10 000/145/72; Roddy Enthoven Report, Feb. 21, 1945, RG 331, 10 000/145/72.

18 *"the cold and rainy months"*: Poggi Report.

19 *"The war must continue"*: Quoted in Mack Smith, *Italy and Its Monarchy*, p. 296.

19 *lost touch with reality*: Duggan, *Concise History of Italy*, p. 236.

19 *Fascist Grand Council*: Mack Smith, *Italy and Its Monarchy*, p. 265.

20 *Gran Sasso*: Ridley, *Mussolini*, p. 343.

20 *"through his long complicity"*: Quoted in Mack Smith, *Italy and Its Monarchy*, p. 319.

20 *"Hottentots, Sudanese"*: Ibid.

21 *prisoners to Germany*: Kesselring, *Soldier's Record*, p. 224; Lamb, *War in Italy*, p. 21.

21 *the Neapolitan art treasures*: Molajoli, *Musei ed opere d'arte*, pp. 37–44; Maiuri, *Taccuino napoletano*, pp. 112–15.

22 *"who would take care"*: Bucarelli, *1944*, p. 10.

23 *early retirement*: Giulio Battelli, "Archivi, biblioteche e opere d'arte: ricordi del tempo di guerra (1943–46)." *Miscellanea Bibliothecae Apostolicae Vaticanae VII* (Vatican City, 2000), p. 56.

23 *"the Padua gang"*: Lavagnino, "Diario di un salvataggio artistico," p. 536.

23 *January 8*: Poggi Report.

24 *Rotondi*: Giannella and Mandelli, *L'arca dell'arte*, p. 10.

25 *Marino Lazzari*: Ibid., pp. 105, 119; Lazzari to Poggi, Nov. 11, 1943, Poggi Papers.

25 *"The Vatican will welcome"*: Cited in Giannella and Mandelli, *L'arca dell'arte*, p. 109.

26 *"Our fate is to be crushed"*: Lavagnino, "Diario," p. 532.

26 *"I am quite adamant"*: Giannella and Mandelli, *L'arca dell'arte*, p. 123.

27 *"more sympathetic"*: Ibid., p. 132.

27 *Concetto Marchesi*: Barbanera, *L'archeologia degli italiani*, p. 150.

28 *On June 15*: Poggi Report.

28 *Göring Division*: Subcommission for Monuments, Fine Arts, and Archives, Report on the German Kunstschutz in Italy Between 1943 and 1945, June 30, 1945, RG 239/ M 1944, roll 71; De Wald to John Ward-Perkins, Oct. 20, 1945, De Wald Papers; Giorgio Castelfranco, memo, Jan. 8, 1947, Ward-Perkins Papers; Haas, *Kunstraub und Kunstschutz*; Nicholas, *Rape of Europa*, pp. 240–44.

29 *"It is imperative"*: Giannella and Mandelli, *L'arca dell'arte*, p. 114.

29 *"It is hard work"*: Lavagnino, "Diario," p. 523.

30 *Titian's voluptuous* Danae: Mariella Utili, "La Danae per Alessandro Farnese," in Alabiso, *La "Danae" di Tiziano*, pp. 9–15.

31 *"wartime rapine"*: Maiuri, *Taccuino napoletano*, p. 146.

32 *Ugo Procacci*: Procacci Report, Jan. 1944, Poggi Papers.

32 *"What was I to do?"*: Marco Ciatti and Cecilia Frosinini, eds., *Ugo Procacci a cento anni dalla nascita, 1905–2005: Atti della giornata di studio, Firenze 31 marzo 2005* (Florence: Edifir, 2006).

32 *obstinate and reckless*: Bucarelli, *1944*, p. 79; Argan to Anna Maria Ciaranfi, Dec. 12, 1943, Poggi Papers.

33 *an order that Hitler had issued*: Quoted in Hapgood and Richardson, *Monte Cassino*, p. 50; Lamb, *War in Italy*, pp. 45–46.

33 *"open city"*: Vedovato, "Firenze 'città aperta'"; Poggi Report.

33 "Ja, die Stadt": Quoted in Tutaev, *Man Who Saved Florence*, p. 93.

33 *Hitler had visited Florence*: Carniani and Paoletti, *Firenze, guerra & alluvione*, pp. 13–14.

34 *"if Florence were to be declared"*: Tutaev, *Man Who Saved Florence*, p. 135.

34 *"tried-and-true friend"*: Poggi Report.

35 *Alfred Jodl*: Tutaev, *Man Who Saved Florence*, p. 169.

35 *artillery batteries*: Vedovato, "Firenze 'città aperta.'"

35 *Alexander Langsdorff*: MFAA, Kunstschutz Report.

35 *"unapproachable"*: Tutaev, *Man Who Saved Florence*, p. 208.

36 *Pavolini*: Poggi Report.

36 *The little-known treaty*: Fasola, *Florence Galleries and the War*, pp. 44–45.

37 *"our tragic days began"*: Fasola, "Perché non si impedì," p. 145.

38 *"I managed to deal"*: Ibid.

Chapter Two: "Men Must Manoeuvre"

39 *"We were told"*: Fasola, *Florence Galleries and the War*, p. 54.

39 *Paestum's ancient Greek temples*: Minutes of a special meeting of the American Commission for the Protection and Salvage of Artistic and Historic Monuments in War Areas, Oct. 8, 1943, RG 239/ M 1944, roll 5.

39 *"What can Ravenna mean"*: "Immortal Ravenna," Fascist Radio Monitoring Report, Dec. 12, 1944, RG 331, 10 000/145/86.

40 *a bunch of Jewish dealers*: "Allied Looting of Art Treasures," Radio Rome, May 21, 1944, RG 331, 10 000/145/26; Hartt, *Florentine Art Under Fire*, p. 77.

41 *In November 1942*: Nicholas, *Rape of Europa*, pp. 209–14.

42 *On June 23*: RG 165, 000.4 (3-25-43); Coles and Weinberg, *Civil Affairs*, pp. 84–88; *Report of the American Commission for the Protection and Salvage of Artistic and Historic Monuments in War Areas.*

42 *"all possible publicity"*: Minutes of the Roberts Commission, Oct. 8, 1943, RG 239/M 1944, roll 5.

43 *"To win this war"*: Ibid.

43 *"without historical precedence"*: Ibid.

44 *"What we are trying to do"*: Ibid.

44 *"It is my policy"*: Eisenhower to Marshall, Oct. 22, 1943, RG 165, 000.4 (3-25-43).

44 *The "Harvard Lists"*: List of Monuments, prepared by the American Defense, Harvard Group, Ward-Perkins Papers.

46 *Helen Frick*: RG 165, 000.4 (3-25-43); Knox, *Story of the Frick Art Reference Library*, pp. 78–90.

46 *Lionello Venturi*: Barbanera, *L'archeologia degli italiani*, p. 150.

46 *"There are today"*: Quoted in Coles and Weinberg, *Civil Affairs*, p. 85.

47 *the School of Military Government*: Ibid., pp. 10–13

48 *"Apparently the Secretary"*: Sizer to Sawyer, June 29, 1943, De Wald Papers.

48 *Husky*: Harris, *Allied Military Administration of Italy*, pp. 1–32.

49 *Mortimer Wheeler*: Jacquetta Hawkes, *Adventurer in Archaeology: The Biography of Sir Mortimer Wheeler* (New York: St. Martin's, 1982).

49 *hospitalized in Alexandria*: Ward-Perkins obituary, *Times* (London), June 5, 1981.

50 *"easy meat for any dog"*: Wheeler, *Still Digging*, p. 153.

50 *"sprang from the established Italian tradition"*: Ibid., p. 152.

51 *"We bluffed our way"*: Ibid., p. 154.

52 *"the rare combination"*: Ibid., p. 158.

52 *flew from Tunis to Cairo*: Ibid., pp. 159–63.

53 *"two Americans"*: Ibid., p. 162.

54 *Wheeler had kept Woolley informed*: Winstone, *Woolley of Ur*, p. 226.

54 *"Since I happened to be in the War Office"*: Woolley to Dinsmoor, March 2, 1944, RG 165, 000.4, sec. 2.

54 *"sweet to callers in many tongues"*: Quoted in Winstone, *Woolley of Ur*, p. 66.

54 *"I had just been reading"*: Agatha Christie, *An Autobiography* (New York: Dodd, Mead, 1977), p. 48.

55 *"Leonard Woolley saw"*: Ibid., p. 363.

55 *"but presence, yes!"*: Woolley, *As I Seem to Remember*, p. 9

56 *"impress people on the spot"*: Crawford to Keeling, Oct. 23, 1943, T 209.1.

56 *"Woolley does not care"*: Clark to Mann, Oct. 13, 1944, Kenneth Clark Papers.

56 *"a great putdowner of people!"*: Conversation with the author, Oct. 2004.

56 *went on the attack*: Woolley to Lord Lang of Lambeth, March 8, 1944, WO 220/584.

57 *"personally and solely responsible"*: Woolley to Dinsmoor, March 2, 1944, RG 165, 000.4, sec. 2.

57 *"a number of people"*: Extracts from Hansard, p. 856, of Feb. 16, 1944, WO 220/584; Churchill to Lord Lang of Lambeth, Jan. 31, 1944, WO 220/584.

57 *"The idea that we should"*: Extracts, WO 220/584.

57 *the British Committee*: RG 165, 000.4, sec. 3.

58 *"successful sabotage"*: Francis Henry Taylor Report, Sept. 6, 1944, RG 239/M 1944, roll 5.

58 *every party complained*: Mason Hammond to Finley, Oct. 28, 1943, WO 204/2986; Finley to John McCloy, Jan. 14, 1944, RG 165, 000.4, sec. 2.

59 *"We love beauty without extravagance"*: Thucydides, *The Peloponnesian War*, book 2, 40.

59 *"We protect the arts"*: Winstone, *Woolley of Ur*, p. 229.

Chapter Three: Sicilian Prelude

60 *"We wanted the Mediterranean"*: Moorehead, *Eclipse*, p. 20.

60 *"There was no moon"*: Tregaskis, *Invasion Diary*, p. 4.

60 *"filled commanding officers"*: Linklater, *Campaign in Italy*, p. 25.

61 *"no stomach for fighting"*: Tregaskis, *Invasion Diary*, p. 5.

61 *"a mountainous island"*: Linklater, *Campaign in Italy*, p. 22.

62 *"We saw a beautiful"*: Tregaskis, *Invasion Diary*, p. 23.

62 *"We reached the water-front"*: Ibid., p. 25

63 *"a dead city"*: Guiotto, *I monumenti della Sicilia*, p. 52.

63 *spared others*: Mason Hammond Report from Palermo, Sept. 3, 1943, RG 165, 000.4 (3-25-43).

63 *"its most distinctive character"*: Guiotto, *I monumenti della Sicilia*, p. 51.

64 *the time of his "solitude"*: Ibid., p. 9.

65 *"the Sicilians welcomed us"*: Demaree Bess, "How We're Ruling Sicily," *Saturday Evening Post*, Sept. 25, 1943.

65 *"one of uncertainty"*: Guiotto, *I monumenti della Sicilia*, p. 51.

65 *Mason Hammond*: Peter J. Gomes, "Harvard's Hammond," *Harvard Magazine*, March–April 2003, pp. 65–67.

66 *North Africa in June*: Hammond to Dinsmoor, July 24, 1943, RG 165, 000.4 (3-25-43).

66 *"senatorial" voice*: *Harvard Crimson Online*, Oct. 2002.

66 *"Most people appear"*: Hammond to Berenson, July 15, 1940, Berenson Archive.

67 *"to a considerable degree lukewarm"*: Mason Hammond, Notes for Schools of Military Government on the Functions of an Adviser on Fine Arts and Monuments in the Headquarters of a Military Government, Oct. 22, 1943, RG 165, 000.4 (3-25-43).

67 *"endless sympathy"*: Ibid.

68 *"We're not trying"*: Tregaskis, *Invasion Diary*, pp. 193–94.

68 *"A certain knowledge"*: Hammond, Notes.

68 *necessary technical background*: Hammond and Maxse, Memorandum to Superintendents and Others Concerned with the Administration of Fine Arts, Monuments, and Similar Institutions in Sicily Which Were Formerly Financed by the Italian Government, Oct. 20, 1943, RG 165, 000.4, sec. 3.

68 *"It is unwise to be too accessible"*: Hammond, Notes.

68 *"Italian Museum people"*: Keller to his wife, Aug. 30, 1945, Keller Papers.

69 *"I do not like Bishops"*: Keller to his wife, May 12, 1945, Keller Papers.

69 *the first landings*: Harris, *Allied Military Administration of Italy*, p. 34.

69 *"I am frank enough"*: Quoted in ibid., p. 37.

69 *"Aged Military Gentlemen On Tour"*: Ibid., p. 82.

69 *"cracking on a bicycle?"*: Quoted in ibid., p. 35.

69 *"at best a luxury"*: Hammond to Dinsmoor, July 24, 1943, RG 165, 000.4 (3-25-43).

69 *"'Hammond's Peril'"*: Hammond and Maxse Report from Sicily, Nov. 1, 1943, RG 331, 10 000/145/24.

70 *"I learned far more"*: Sizer, "Walpolean at War," p. 12.

71 *"Ref. Palermo-Archivio di Stato"*: Bernard Peebles Report, Jan. 29, 1944, RG 331, 10 000/145/24.

72 *MFAA*: The Subcommission for the Protection of Monuments, Fine Arts, and Archives, Final Report on Sicily, RG 239/ M 1944, roll 75.

72 *"outstanding authority"*: Finley to John McCloy, Oct. 9, 1943, RG 165, 000.4 (3-25-43).

73 *"il Baroccone"*: Mario Tschinke's testimony to the author.

73 *"the Ancient Monument"*: Fielden, *Natural Bent*, p. 239.

73 *"under control"*: MFAA, Final Report on Sicily.

73 *"from history into oblivion"*: Frederick Hartt and Ugo Procacci, "Le devastazioni barbariche," *Il Ponte*, Sept. 1954, pp. 1415–27.

Chapter Four: The Birth of the Venus Fixers

74 *"There were no Germans"*: Moorehead, *Eclipse*, p. 26.

74 *"The end will not come"*: Tregaskis, *Invasion Diary*, p. 91

74 *Taranto, Bari, and Brindisi*: Moorehead, *Eclipse*, pp. 30–33.

75 *a fizzy new drink*: De Marco, *Polvere di piselli*, pp. 4–5.

75 *The target*: Lambiase and Nazzaro, *L'odore della guerra*, pp. 57–62.

75 *"largely in ruins"*: Quoted in Harris, *Allied Military Administration of Italy*, p. 163.

75 *"smelled of charred wood"*: Lewis, *Naples '44*, p. 25.

75 *barrage balloons*: Deane Keller to his wife, Aug. 8, 1945, Keller Papers.

76 *"Ce distruggeno!"*: Eduardo De Filippo, *Napoli milionaria!* (1945; Turin: Einaudi, 1950).

76 *a whole underworld*: Lambiase and Nazzaro, *L'odore della guerra*, pp. 52–56.

77 *all twelve metropolitan jails*: De Marco, *Polvere di piselli*, p. 30.

77 *back into the Middle Ages*: Aurelio Lepre in ibid., pp. ix–x.

77 *venereal diseases*: De Marco, *Polvere di piselli*, pp. 39–50.

77 *"What we were witnessing"*: Moorehead, *Eclipse*, p. 61.

77 *"To bury the dead"*: Quoted in Harris, *Allied Military Administration of Italy*, p. 37.

77 *swept the port of mines*: De Marco, *Polvere di piselli*, p. 27.

77 *DDT*: Ibid., p. 32.

79 *"temptingly convenient"*: Leonard Woolley Report to the director of the Civil Affairs Office, Dec. 7, 1943, WO 204/2986.

79 *every reason to be alarmed*: Maiuri, *Taccuino napoletano*, pp. 130–40; Amedeo Maiuri, Requisizione del Museo Nazionale, Dec. 31, 1943, Archives of the Superintendency for

Archaeology of Naples; Paul Gardner to General Hume, memo, Nov. 18, 1943, RG 331, 10 000/145/31.

80 *Dying Barbarian*: Maiuri, *Taccuino napoletano*, pp. 131–32.

81 *"a promising face"*: Ibid., p. 130.

81 *Maiuri's Fascist record*: Regional security officer to De Wald, June 10, 1944, RG 331, 10 000/145/10.

81 *"let sleeping dogs lie"*: Mason Hammond, Notes for Schools of Military Government on the Functions of an Adviser on Fine Arts and Monuments in the Headquarters of a Military Government, Oct. 22, 1943, RG 165, 000.4 (3-25-43).

82 *"he, his motorcycle, and maps disappeared"*: Sizer, "Walpolean at War," p. 8; Reynolds to Gardner, Dec. 11, 1943, RG 331, 10 000/145/233.

82 *"While damage is being done"*: Paul Baillie Reynolds, Second Monthly Report for December 1943, Jan. 4, 1944, WO 204/2987.

82 *Royal Palace of Naples*: Memo for the chief of the Civil Affairs Division, Damage to Monuments, Fine Arts, and Archives by Allied Troops in Sicily and Italy, Jan. 5, 1944, RG 165, 000.4, sec. 2; Collier Commission Report, Jan. 21, 1944, RG 165, 000.4, sec. 3.

83 *conversation with Lord Rennell*: Memo to Brig. Gen. Julius C. Holmes, Dec. 17, 1943, WO 204/2986.

84 *Administrative Instruction No. 10*: MFAA Final Report, Frances Loeb Library, Harvard Design School.

85 *the information they contained*: See Ruth Meyer, "The Roberts Commission," in Farmer, *Safekeepers,* p. 132.

85 *"discrepancies in his reports"*: Clay to Mann, Dec. 14, 1944, T 209 8.

85 *"pastiche of unnecessary error"*: Ward-Perkins to Norman Newton, Aug. 23, 1945, RG 331, 10 000/145/226.

86 *"How he got there"*: Holmes to Hilldring, Sept. 11, 1944, RG 165, 000.4, sec. 4.

86 *"a failure, in practice"*: Woolley to Lord Lang of Lambeth, March 8, 1944, WO 220/584.

87 *"the scholarly mouse type"*: Quoted in Coles and Weinberg, *Civil Affairs*, p. 422.

87 *"It's no fun"*: Keller to his wife, Sept. 29, 1944, Keller Papers.

87 *"A less military-looking lot"*: Fielden, *Natural Bent*, p. 264.

87 *"Oh God"*: Paul Karlstrom, "10 July: Loaded Bruges Madonna," *Archives of American Act Journal* 22, no. 2 (1982).

87 *"A great deal of time and thought"*: Sachs to Cairns, Oct. 18, 1943, RG 239/ M 1944, roll 19.

88 *"thoroughly acquainted"*: Minutes of the Roberts Commission meeting, Oct. 8, 1943, RG 239/ M 1944, roll 5.

88 *"the monastic spirit"*: Ernest De Wald, note, n.d., De Wald Papers.

88 *"the most difficult person"*: Brooke to Hilary Jenkinson, Jan. 28, 1945, Jenkinson Papers, 30/75/44.

88 *"a charming and lovable person"*: Hartt to Berenson, Oct. 14, 1945, Berenson Archive.

89 *"breathed and lived"*: Sheldon Pennoyer, "Montegufoni," unpublished manuscript, Pennoyer Archives.

90 *"with little trouble"*: Quoted in Coles and Weinberg, *Civil Affairs*, p. 418.

90 "rarissimo *group*": Flanner, *Men and Monuments*, p. 266.

90 *Albert Sheldon Pennoyer*: Edward Streeter, Memorandum on Sheldon Pennoyer, Feb. 1, 1958, Century Association Archive; obituary, *New York Times*, Aug. 19, 1957.

90 *"an amusing talker"*: Christopher Taylor to author, Jan. 15, 2006; Richard Taylor to author, Jan. 18, 2006.

Chapter Five: The Conflict of the Present and the Past

93 *"I've never been so cold"*: Keller to his wife, March 18, 1944, Keller Papers.

93 *"a rather ramshackle flat"*: Fielden, *Natural Bent*, p. 287.

93 *"No electricity tonight"*: Keller to his wife, Feb. 9, 1944, Keller Papers.

93 *"a grim and spooky affair"*: Ernest De Wald, penciled note, n.d., De Wald Papers.

94 *"I have seen the destruction"*: Keller to his wife, Feb. 8, 1944, Keller Papers.

94 *"that eternal Neapolitan crowd"*: Anna Maria Ortese, *Il mare non bagna Napoli* (Milan: Rizzoli, 1975), p. 89.

94 *five miles of the city*: De Marco, *Polvere di piselli*, p. 51.

94 *"I enjoy walking"*: Benedetto Croce, *Storie e leggende napoletane* (Milan: Adelphi, 1990), p. 17.

95 *"an antique map"*: Lewis, *Naples '44*, p. 40.

96 *"Dear Mann"*: Croft-Murray to Mann, May 16, 1944, T 209 4.

98 *ill-advised soldiers*: De Wald, memo, April 21, 1944, RG 331, 10 000/145/34.

98 Soldiers' Guide to Rome: RG 239/ M 1944, roll 75.

98 *"The European grew up"*: La Farge, *Lost Treasures of Europe*, p. 9.

99 *"The emotion of an archaeologist"*: Undated text, De Wald Papers.

100 *"I had a personal interest"*: Ibid.

101 *"The clearing of rubble"*: Gardner and Molajoli, *Per i monumenti d'arte*, p. 14.

101 *"To seek help"*: Ibid., p. 6.

101 *"the greatest first aid program"*: Molajoli, *Musei ed opere d'arte*, p. 49.

103 *"The Fifth Army took one strong point"*: Clark, *Calculated Risk*, p. 231.

103 *"The battle of Cassino"*: Ibid., p. 311.

103 *British general Bernard Freyberg*: Hapgood and Richardson, *Monte Cassino*, pp. 154–59.

104 *the impregnability of the place*: Ibid., p. 163.

104 *February 15*: Ibid., p. 211.

104 *"a tragic mistake"*: Clark, *Calculated Risk*, pp. 312–23.

104 *"When soldiers are fighting"*: Alexander of Tunis, *Alexander Memoirs*, p. 121.

106 *"The German press"*: Berenson, *Rumor and Reflection*, pp. 248–52.

107 *"sentimental criminals"*: Quoted in Hapgood and Richardson, *Monte Cassino*, p. 212.

107 *Herbert Matthews*: Conversation among Herbert Matthews, Francis Henry Taylor, and Henry Newton, April 24, 1944, RG 165, 000.4, sec. 2.

108 *"weep his eyes out"*: Berenson, *Rumor and Reflection*, p. 270.

108 *"Germans maneuvring us"*: Minutes of the Roberts Commission meeting, Oct. 8, 1943, RG 239/ M 1944, roll 5.

108 *Brig. Gen. Lauris Norstad*: MFAA Final Report, Frances Loeb Library, Harvard Design School; Viscount Stansgate to commander in chief April 13, 1944, RG 165, 000.4, sec. 4.

108 *Shinnie Maps*: John Ward-Perkins, memo, Feb. 3, 1944, RG 165, 000.4, sec. 3.
109 *a "convert"*: Ernest De Wald, undated text, De Wald Papers.
109 *"in a goddam art museum"*: quoted in Sizer, "Walpolean at War," p. 17.

Chapter Six: Treasure Hunt

110 *"a shattering time"*: Ward-Perkins to Gardner, Aug. 7, 1944, RG 331, 10 000/145/233.
110 *"with all possible speed"*: Linklater, *Campaign in Italy*, p. 293.
111 *"Modern Valkyries"*: Ibid., p. 333.
112 *Montegufoni*: Pestelli, *Castle of Montegufoni*.
112 *"air of forlorn grandeur"*: Sitwell, *Great Morning!* p. 83.
113 *Their wealth was built on steel*: Hibbert, *Florence*, p. 328.
113 *"where one could take one's meals"*: Sitwell, *Great Morning!* p. 83.
114 *"strongest and strangest physical sensations"*: Ibid., pp. 186–97.
115 *"What a house party!"*: Philip Ziegler, *Osbert Sitwell* (New York: Knopf, 1999), p. 294.
115 *On that July day*: Linklater, *Art of Adventure*, pp. 254–72.
115 *"incongruities"*: Ibid., p. 256.
116 *the "Professore"*: Ibid., p. 260.
117 *Counselor Metzner*: Ugo Procacci, transcript of conversation between Superintendent Poggi and Counselor Metzner, July, 20, 1944, Poggi Papers; Poggi Report, June 5, 1945, Poggi Papers; Hartt, *Florentine Art Under Fire*, pp. 21–22.
117 *the villa of Oliveto*: Poggi Report; Hartt, *Florentine Art Under Fire*, pp. 32–34.
118 *Cesare Fasola*: Cesare Fasola Report for July and Aug. 1944, Oct. 9, 1944, Poggi Papers.
118 *Tommaso Puccini*: Fasola, *Florence Galleries and the War*, pp. 46–50.
119 *"Of course they're valuable"*: Procacci, transcript of conversation, July 20, 1944, Poggi Papers.
120 "Santini, aiutateci voi!": Fasola, *Florence Galleries and the War*, p. 60.
120 *"a group of soldiers wandering aimlessly"*: Fasola Report.
121 *"May every potato they steal explode"*: Giulia Guicciardini, "La campana degli smarriti, 1944–1945," unpublished.
122 *"I wonder whether"*: Ibid.
122 *"stabbed a girl in the neck"*: Fasola, Report for July and Aug. 1945, Poggi Papers.
122 *"We all ran down"*: Fasola, *Florence Galleries and the War*, p. 63.
122 *"I could have hugged them all"*: Ibid., p. 64.
123 *"highly agitated"*: Eric Linklater, "Botticelli Among the Mahrattas: How We Found Five-Starred Florentine Treasures Abandoned in No Man's Land by the Fleeing Germans," *Town and Country*, July 11, 1945.
123 *"the good fortune"*: Hartt, *Florentine Art Under Fire*, p. 5.
124 *"There's a million bucks"*: Lang, "Letter from Florence," pp. 64–71.
124 *parachuted into Montegufoni*: Radio Berlin, Aug. 17, 1944, RG 331, 10 000/145/69.
124 *"a world important personal discovery"*: Sheldon Pennoyer, "Montegufoni," typescript, n.d., Pennoyer Archives.
124 *the Tuscan art deposits*: Hartt, *Florentine Art Under Fire*, p. 16.

125 *"terrifying"*: Ibid., p. 12.

126 *"I unwrapped* Primavera *entirely"*: Fasola Report for July and Aug. 1944.

127 Primavera: Mandel, *Botticelli*; Cecchi, *Botticelli*; Umberto Baldini, *La "Primavera" del Botticelli: Storia di un quadro e di un restauro* (Milan: Mondadori, 1984); Caterina Caneva, *La "Primavera" di Sandro Botticelli* (Milan: TEA, 1998).

127 The Battle of San Romano: Ennio Flaiano, "Il tempo dentro il tempo," in Lucia Tongiorgi Tomasi, ed., *Paolo Uccello* (Milan: Rizzoli, 1971); Romagnoli, *Le storie del secolo d'oro*; Corsini, *Paolo Uccello*.

129 *"Homeric hero at rest"*: Fasola, *Florence Galleries and the War*, p. 67.

129 *Gen. Oliver Leese*: Hartt, *Florentine Art Under Fire*, p. 24.

130 *"fraught with tragic possibilities"*: Berenson, *Rumor and Reflection*, p. 376.

130 *Careggi*: Ibid., p. 125.

130 *"I begin the New Year"*: Ibid., pp. 59–62.

132 *"I cannot believe that Mussolini"*: Ibid., p. 163.

132 *William Phillips*: Sprigge, *Berenson*, p. 251.

132 *Kriegbaum*: Berenson, *Rumor and Reflection*, p. 138.

132 *Bottai*: Bottai to Mussolini, memo, Feb. 2, 1942, envelope 108, "Ville fiorentine," Archivio Centrale dello Stato, Direzione Generale Beni Artistici e Culturali.

133 *"The Berenson Affair"*: La Vita Italiana (Rome), Dec. 1941.

134 *Marchese Serlupi*: Poggi Report, June 28, 1945, Poggi Papers.

135 *he had gone to Portugal*: Tutaev, *Man Who Saved Florence*, pp. 49–51.

136 *"They must defend the hillside"*: Berenson, *Rumor and Reflection*, p. 387.

136 *"Giotto's campanile"*: Ibid., p. 166.

136 *"blow up all the bridges"*: Ibid., p. 347.

137 *"the well-known triad of Sitwells"*: Ibid., p. 380.

137 *"to burst from the heart of Florence"*: Ibid., p. 382.

137 "Carissimo Anti": Poggi to Anti, July 19, 1944, Poggi Papers.

137 *SS colonel Baumann*: Poggi Report, June 5, 1945, Poggi Papers; Giovanni Poggi, Relazione del soprintendente alle gallerie e musei di Firenze, n.d., Poggi Papers; Hartt, *Florentine Art Under Fire*, pp. 67–68.

139 *a detailed map*: Hartt, *Florentine Art Under Fire*, p. 39; Steinhauslin, "Che cosa ho fatto per Firenze?" p. 157.

139 *the same mistake*: Casoni, *Diario fiorentino*, p. 207.

139 *"Wolf's departure"*: Ibid., p. 178.

139 *"I realize that perhaps"*: Steinhauslin, "Che cosa ho fatto per Firenze?" p. 192.

139 *a proclamation*: Ibid., pp. 157–61; Casoni, *Diario fiorentino*, pp. 193–96; Carniani and Paoletti, *Firenze, guerra & alluvione*, pp. 52–56.

140 *order of the Umiliati*: Lewis, *City of Florence*, p. 249.

140 *Florentine bridges*: Bargellini, *This Is Florence*, pp. 173–74.

140 *"like a slingshot"*: Piero Calamandrei, "Il Ponte a Santa Trinita," *Il Ponte*, Sept. 1954, pp. 1312–15.

140 *"tall and squarish"*: Casoni, *Diario fiorentino*, p. 208.

141 *"Florence or Smolensk"*: Steinhauslin, "Che cosa ho fatto per Firenze?" p. 158.

141 *"Reason tells me"*: Ibid., p. 177.

142 *"the responsibility for acts"*: Casoni, *Diario fiorentino*, pp. 201–4; Hartt, *Florentine Art Under Fire*, pp. 39–42.

142 *"This is not the time"*: Baroni, *Diario dei Cinquemila*, unpublished.

142 "Indo' tu vaite?": Guicciardini, "La campana."

144 *"Oh, we were lucky"*: Giuliana Guicciardini, conversation with the author, June 2004.

144 *"an almost cheerful calm reigned"*: Carlo Levi, "Palazzo Pitti," *Il Ponte*, Sept. 1954, pp. 1325–28.

144 *"At around eleven o'clock"*: Baroni, *Diario*.

145 *"I arrived at the arch"*: Hartt, *Florentine Art Under Fire*, p. 42.

146 *"The thought of the bridges"*: Gladys Hutton, "Dieci anni dopo," *Il Ponte*, Sept. 1954, pp. 1411–14.

146 *"we thought it was the end"*: Hartt, *Florentine Art Under Fire*, p. 43.

146 *"the ruin was catastrophic"*: Casoni, *Diario fiorentino*, p. 234.

Chapter Seven: Florence Divided

147 *"Where are the Germans?"*: Hartt, *Florentine Art Under Fire*, p. 42

148 *"Never before"*: Giorgio Querci, "Firenze alla guerra," *Il Ponte*, Sept. 1954, pp. 1405–10.

148 *"stuffed with propaganda like Strasbourg geese"*: Elisabetta Mariano, "Un mese in prima linea tra i paracadutisti," *Il Ponte*, Sept. 1954, pp. 1376–1400.

148 *"These are horrible stories"*: Giulia Guicciardini, "La campana degli smarriti, 1944–1945," unpublished.

149 *"Don't look out"*: Hartt, *Florentine Art Under Fire*, p. 44.

149 *"Unbelievable like death"*: Elsa de' Giorgi, "Un partigiano arriva a Firenze," *Il Ponte*, Sept. 1954, pp. 1345–52.

149 *"There was nothing else to do"*: Querci, "Firenze alla guerra."

150 *"This is not danger"*: Hutton, "Dieci anni dopo."

150 *"The Florentines would crowd"*: Lang, "Letter from Florence."

151 *"These were military decisions"*: Hubert Howard, "Entrata a Firenze," *Il Ponte*, Sept. 1954, pp. 1340–44.

152 *"I learnt to love Florence"*: Cecil Sprigge, "Agosto 1944," *Il Ponte*, Sept. 1954, pp. 1329–33.

153 *"In little time, the Fascist fold"*: Guicciardini, "La campana."

153 *"Partisan bands . . . began to be a nuisance"*: Kesselring, *Soldier's Record*, p. 265.

153 *"three thousand brave men"*: Lang, "Letter from Florence."

155 *"a food orgy"*: Corrado Tumiati, "Emergenza al Ponte Rosso," *Il Ponte*, Sept. 1954, pp. 1428–35.

155 *"why don't you leave?"*: Steinhauslin, "Che cosa ho fatto per Firenze?" p. 188.

157 *Torre del Castellano*: Hartt, *Florentine Art Under Fire*, pp. 26–27.

157 *"When it is a matter of acquiring"*: Hibbert, *Florence*, p. 128.

159 *"General Alex"*: Linklater, *Art of Adventure*, pp. 3–24.

159 *Wellington Barracks*: Sitwell, *Great Morning!* p. 210.

159 *Brig. Gen. Ralph Tate*: Hartt, *Florentine Art Under Fire*, p. 75.

161 *"Vermouth"*: Henry Newton, Report on MFAA Deposits in Vicinity of Florence, Italy, Aug. 15, 1944, RG 165, 000.4, sec. 4.

162 *"I decided to continue"*: Hartt, *Florentine Art Under Fire*, p. 29.

163 *"speechless with wonder"*: Hartt, *Michelangelo*, p. 9.

164 *"the new dynastic hopes"*: Frederick Hartt, "The Meaning of Michelangelo's Medici Chapel," in Oswald Goetz, ed., *Essays in Honor of Georg Swarzenski* (Chicago: Henry Regnery, 1951), p. 146.

164 *no one would ever know*: Ibid., pp. 147–48.

164 *"The Day and the Night talk to each other"*: Umberto Baldini, *Michelangelo scultore* (Milan: Rizzoli, 1973), p. 9.

164 *"poor, humble and mad"*: Frederick Hartt, *Michelangelo: The Complete Sculpture* (New York: Harry Abrams, 1985), pp. 192–93.

164 *"Fame holds the epitaphs"*: Hartt, "Meaning," p. 146.

165 "Grato m'è 'l sonno": Baldini, *Michelangelo scultore*, p. 9.

165 "It is my pleasure": Neil R. Bonner, ed., *Michelangelo Buonarroti Website*, Dec. 14, 2001, Michelangelo. COM, Inc., michelangelo.com/buonarroti.html, Mid Years.

166 *"In 1942, the superintendency had shielded the statues*: Carniani and Paoletti, *Firenze, guerra & alluvione*, p. 28.

166 *The transfer . . . was one of the most complicated*: Poggi Report, June 5, 1945, Poggi Papers.

166 *the* strappo: Leonetto Tintori, "Methods Used in Italy for Detaching Frescoes," *Studies in Conservation* 6, no. 4 (1961).

167 *"Long and fantastic story later"*: Hartt to Keller, Aug. 21, 1944, Keller Papers.

168 *"All of us at Montegufoni"*: Hartt, *Florentine Art Under Fire*, p. 31.

168 *"an unfortunate Fascist history"*: Hartt to Keller, Aug. 14, 1944; Keller to Hartt, Aug. 17, 1944, RG 331, 10 000/145/12.

168 *Piero Sanpaolesi*: See Lamberini, "Il soprintendente e gli alleati," pp. 129–74.

169 *"the arguments are very weak indeed"*: Hartt to Keller, Aug. 14, 1944, RG 331, 10 000/145/12.

170 *"The recollection of the sights"*: Hartt, *Florentine Art Under Fire*, p. 36.

171 *Santa Felicita*: Cesati, *Le strade di Firenze*, pp. 573–74.

171 *"serpentine artery"*: James, *Italian Hours*, p. 276.

172 *the "Old Bridge"*: Cesati, *Guida insolita*, pp. 253–56; Bargellini, *This Is Florence*, pp. 201–204.

172 *The interrogation of German Kunstschutz*: Hartt, *Florentine Art Under Fire*, p. 46.

173 *Ponte Vecchio's charm*: Hibbert, *Florence*, pp. 319–20.

173 *"a giant set of Erector"*: Casoni, *Diario fiorentino*, p. 280.

173 *"it paralyzed the city"*: Hartt, *Florentine Art Under Fire*, p. 46.

174 *"Immemorial houses"*: James, *Italian Hours*, p. 273.

174 *"a city vaulting the river"*: Hartt, *Florentine Art Under Fire*, p. 45.

174 *"matrix of it all"*: Ibid., p. 47; Florence Superintendency for Monuments, Report on Damages to Florentine Monuments, Direzione Generale Beni Artistici e Culturali, Div. II, 1940–1945.

174 *"I never built"*: Quoted in Leonardo Castellucci, *Antologia degli Uffizi: i capolavori della galleria* (Florence: FMG, 1994); Cesati, *Le piazze di Firenze*, pp. 301–304.

176 *"strangely lonely"*: Hartt, *Florentine Art Under Fire*, p. 46.

Chapter Eight: A Time to Rend, a Time to Sew

177 *"a terrible story"*: Herbert Matthews, "Experts Salvaging Tuscan Art Works," *New York Times*, Dec. 27, 1944.

177 *"first taste"*: Hartt, *Florentine Art Under Fire*, p. 51.

179 *pulled it out of the Arno*: Bargellini, *This Is Florence*, p. 175.

179 *"We could not sit and watch"*: Hartt, *Florentine Art Under Fire*, p. 50.

180 *a conversation between the two men*: Hartt to Keller, Aug. 21, 1944, Keller Papers.

180 *"as if it were yesterday"*: Anna Corsini, interview with the author, June 2004.

181 *"always at war"*: Paul Barolsky, conversation with the author, Jan. 2006.

182 *"Armored tanks are driving"*: Corrado Tumiati, "Emergenza," *Il Ponte*, Sept. 1954, p. 1435.

184 *In 1294*: Bargellini, *This Is Florence*, p. 201.

184 *the demolished Colombaria*: Frederick Hartt, Report on Archives of La Colombaria, Sept. 4, 1944, RG 331, 10 000/145/71; Luigi de Gregori, Report on Tuscan Libraries, RG 331, 10 000/145/71; Hartt, *Florentine Art Under Fire*, pp. 52–53.

184 *"zeal in clearing up Florence"*: Lush to Coxwell-Rogers, Sept. 16, 1944, and Coxwell-Rogers to Lush, Oct. 4, 1944, RG 331, 10 000/145/71.

185 *"poetic justice"*: Ellis to Hilary Jenkinson, Sept. 14, 1944, Jenkinson Papers, 30/75/42.

185 *"I had a few hours"*: Enthoven to Ward-Perkins, Oct. 29, 1944, RG 331, 10 000/145/232.

186 *to call him pedantic*: Peter Jenkins, Notes on Roddy Enthoven at Goldsmiths' (letter to the author), Feb. 2004.

186 *the Rubble Commission*: Hartt, *Florentine Art Under Fire*, p. 52.

186 *Torre di Parte Guelfa*: Frederick Hartt, Report of Chief Royal Engineer, Sept. 22, 1944, RG 331, 10 000/145/71.

187 *"Had the time spent"*: Enthoven Report, Sept. 10, 1944, RG 331, 10 000/145/71.

187 *"RED INDICATES"*: RG 331, 10 000/145/71.

188 *The towers*: Mercanti and Straffi, *Le torri di Firenze*.

188 *Torre degli Amidei*: "Come è stata salvata la Torre degli Amidei," *Corriere del Mattino* (Florence), April 3, 1944.

189 *Ponte Santa Trinita*: Paoletti, *Il Ponte a Santa Trinita*; Lewis Vulliamy, *The Bridge of the SS Trinita over the Arno at Florence* (London, 1822).

190 *"After some scurrying"*: Lee to De Wald, n.d., RG 331, 10 000/145/69.

190 *"Some day Florence"*: Matthews, "Experts Salvaging."

191 *"I am glad"*: Pinsent to Ward-Perkins, Sept. 24, 1944, RG 331, 10 000/145/71.

191 *"venerable age"*: Ward-Perkins to Lieutenant Colonel Hartley, June 1, 1945, RG 331, 10 000/145/226.

191 *"in a frail sort of way"*: Quoted in Dunn, *Geoffrey Scott and the Berenson Circle*, p. 45.

191 *in 1906*: Ethne Clarke, "Cecil Pinsent: A Biography," in Fantoni, Flores, and Pfordresher, *Cecil Pinsent and His Gardens*, pp. 15–32.

192 *"An unassuming"*: Quoted in Weaver, *Legacy of Excellence*, p. 69.

192 *"Settecento room"*: Mariano, *Forty Years with Berenson*, p. 307.

192 *"the Boys"*: Moorehead, *Iris Origo*, p. 34.

192 *"That insolent"*: Bernard Berenson to Mary Berenson, quoted in Weaver, *Legacy of Excellence*, p. 82.

192 *"bookworm's heaven"*: Quoted in Moorehead, *Iris Origo*, p. 35.

192 *"theorem clipped in box"*: Giorgio Galletti, "A Record of the Works of Cecil Pinsent in Tuscany," in Fantoni, Flores, and Pfordresher, *Cecil Pinsent and His Gardens*, pp. 51–69.

193 *"all the beauty I need"*: Quoted in Moorehead, *Iris Origo*, p. 38.

193 *"Anglo-Florentine"*: Ibid., p. 73; Yoi Maraini, "The English Architect Abroad," *Architectural Review* 71 (Jan.–June 1932), pp. 6–7.

193 *"What I have offered"*: Quoted in Clarke, "Cecil Pinsent," p. 25.

193 *"Being here"*: Pinsent to Ward-Perkins, Sept. 24, 1944, RG 331, 10 000/145/71.

194 *"partly redesigned"*: Galletti, "Record," p. 106.

194 *Villa Le Balze*: Vincent Shacklock, "A Philosopher's Garden: Pinsent's Work for Charles Augustus Strong at Villa Le Balze, Fiesole," in Fantoni, Flores, and Pfordresher, *Cecil Pinsent and His Gardens*, pp. 71–90.

195 *Villa Gamberaia*: Osmond, *Revisiting the Gamberaia*; Hartt, Report on Villas in Florence Area, Sept. 15, 1944, RG 331, 10 000/145/71.

196 *"the passionate plumber"*: Moorehead, *Iris Origo,* p. 87.

196 *"Though I wouldn't have missed"*: Pinsent to Berenson, Sept. 30, 1945, Berenson Archive.

196 *"I had one good fortune"*: Pinsent to Barbacci, May 5, 1955, Pinsent Archive, Chloe Morton family.

197 *"Donatello"*: RG 331, 10 000/145/71.

197 *tabernacles*: Enthoven Report, April 20, 1945, RG 331, 10 000/145/72; Bargellini, *Cento tabernacoli a Firenze*.

198 *Cosimo I*: Keller Report, Feb. 17, 1945, and Enthoven Report, Feb. 21, 1944, RG 331, 10 000/145/72.

198 *Smokey*: Keller Papers.

Chapter Nine: The Duelists

200 *"This is truly a most beautiful land"*: Keller to his wife, July 7, 1944, Keller Papers.

200 *"at times quite gruff"*: Keller Papers.

201 *"I'll be glad to be out of here"*: Keller to his wife, April 3, 1944, Keller Papers.

201 *"The rains and the floods"*: Linklater, *Campaign in Italy*, p. 403.

201 *"to delay the Allies' advance"*: Kesselring, *Soldier's Record*, p. 250.

201 *"This was the dusty"*: Keller to his wife, Nov. 22, 1944, Keller Papers.

202 *"Am on the road"*: Keller to his wife, May 27, 1944, Keller Papers.

202 *"I saw one town 90% destroyed"*: Keller to his wife, March 17, 1944, Keller Papers.

202 *"I can get used to"*: Keller to his wife, June 2, 1944, Keller Papers.

203 *"I . . . go in"*: Sizer, "Walpolean at War," p. 19.

204 *Colle Val d'Elsa*: Keller to his wife, Nov. 22, 1944, Keller Papers.

204 *"how can we expect"*: Matthews, "Italian Art Under Shellfire," p. 559.

205 *the roof was repaired*: MFAA Final Report on Tuscany, 1945, Frances Loeb Library, Harvard Design School.

205 *"No English schoolboy"*: Robert Hughes, "The Glory That Was Not Rome," in Klara Glowczewska, ed., *The Condé Nast Traveler Book of Unforgettable Journeys* (London: Penguin, 2007), p. 215.

205 *"the strangeness" of Florence*: Sitwell, *Great Morning!*, p. 186.

206 *"Ercole Settembre"*: Keller to his wife, July 11, 1944, Keller Papers.

206 *"bend my knee"*: Keller to his wife, Sept. 22, 1944, Keller Papers.

206 *Cortona*: "Come furono salvate le opere di Cortona," unsigned report, n.d., Poggi Papers.

207 *"Among things seen"*: Keller to his wife, Dec. 11, 1944, Keller Papers; on the restoration of the two triptychs, Poggi Report, Jan. 1945, Direzione Generale Beni Artistici e Culturali, Div. II, 1940–1945.

207 *As it turned out*: *Mostra di opere d'arte trasportate a Firenze durante la guerra*, Florence: Giuntina, 1947.

207 *"a jack-of-all-trades"*: Ellis to Hilary Jenkinson, June 25, 1944, Jenkinson Papers, 30/75/42.

208 *Church of Santa Maria del Carmine*: "Inspection of Monuments in Florence," Aug. 11, 1944, RG 331, 10 000/145/71.

208 *"the destruction . . . was terribly complete"*: Ellis to Jenkinson, June 3, 1944, Jenkinson Papers, 30/75/42.

208 *"Archives are regarded"*: Ibid.

208 *San Paolo Bel Sito*: Account of the Destruction of the Naples Archives by the Conte Filangieri, Superintendent of Archives, Naples, WO 220/596; MFAA Final Report Campania, 1945, RG 239/ M 1944, roll 75.

209 *Roger Ellis*: Felicity Strong, Roger Ellis obituary, *Journal of the Society of Archivists* 19, no. 2 (1998).

209 *"My shadow plan"*: Ellis to Jenkinson, Sept. 30, 1944, Jenkinson Papers, 30/75/42.

209 *"a torpid and unsatisfactory place"*: John Walker, text of lecture, n.d., RG 165, 000.4, sec. 5.

209 *"Archivist discovered"*: Roger Ellis, Report on Archives in Florence and Tuscany, Oct. 26, 1944, RG 331, 10 000/145/71.

210 *"gladly have stayed indefinitely"*: Ellis to Jenkinson, Sept. 30, 1944, Jenkinson Papers, 30/75/42.

210 *"narrow escapes"*: John Ward-Perkins, Report on Bomb-Damage at Ravenna, Dec. 7, 1944, WO 204/2989; Brig. M. G. Lush, Monuments of Ravenna, RG 165. 000.4, sec. 4; RG 331, 10 000/145/10.

210 *Barga*: Keller to his wife, June 25, 1945, Keller Papers; Linklater, *Campaign in Italy*, pp. 416–17.

211 *"so that the sun caresses"*: Quoted in Gianfranco Bruno and Umberto Sereni, *Alberto Magri, un pittore del '900* (Florence: Artificio, 1996), pp. 40–42.

211 *"I am sick of broken homes & monuments"*: Keller to his wife, Sept. 14, 1944, Keller Papers.

211 *"How often do you have your hair frizzed?"*: Keller to his wife, Oct. 29, 1945, Keller Papers.

211 *"I was just thinking"*: Keller to his wife, Nov. 2, 1944, Keller Papers.

211 *"Rome in 1944–46"*: Fielden, *Natural Bent*, p. 297.

212 *"Cott splendid"*: Bucarelli, *1944*, p. 78.

212 *"We are comfortably settled"*: Marriott to Ward-Perkins, July 12, 1944, RG 331, 10 000/145/237.

213 *"The majors & a lt."*: Keller to his wife, April 3, 1944, Keller Papers.

213 *"Two of my British Capt. companions"*: Keller to his wife, April 6, 1944, Keller Papers.

213 *"happily colored"*: Herbert Matthews, "Experts Salvaging Tuscan Art Works," *New York Times*, Dec. 27, 1944.

213 *"gross error"*: Keller to his wife, Jan. 24, 1945, Keller Papers.

214 *"Have seen a lot of Fred Hartt"*: Keller to his wife, Oct. 18, 1944, Keller Papers.

214 *flamboyant*: Eve Borsook, conversation with the author, March 2005.

214 *Excelsior Hotel*: Hartt, *Florentine Art Under Fire*, pp. 64–66.

215 *"After all the humanity"*: Sheldon Pennoyer, "Berenson, an Old American Florentine," unpublished manuscript, Pennoyer Archives.

216 *"the happiest hours"*: Hartt, *Florentine Art Under Fire*, p. 66.

216 *"I must frankly say"*: Hartt to Keller, Jan. 23, 1945, Keller Papers.

216 *"Many have told me"*: Keller to his wife, July 15, 1945, Keller Papers.

216 *"I shall* always *regret"*: Keller to his wife, Jan. 7, 1945, Keller Papers.

217 *"He could have gotten"*: Keller to his wife, May 28, 1945, Keller Papers.

217 *"The Republic of Pisa"*: James, *Italian Hours*, p. 319.

217 *"ought to walk gowned"*: The Autobiography of Leigh Hunt, with Reminiscences of Friends and Contemporaries* (New York: Dutton, 1903), p. 413.

218 *"I have dreamed of such buildings"*: Guy Chapman, ed., *The Travel-Diaries of William Beckford of Fonthill* (Cambridge, U.K., 1928), p. 154.

218 *they would shield the entire city*: Franchi, *Arte in assetto di guerra*, p. 51.

218 *"On the south side of the river"*: Deane Keller, Report on Pisa, Sept. 7, 1944, Keller Papers.

219 *"a landscape on the moon"*: Hartt, *Florentine Art Under Fire*, p. 84.

219 *"We hit the cathedral"*: Herbert Matthews, "Vast Pisa Ruins Seen on Tour," *New York Times*, Jan. 22, 1945.

219 *Bruno Farnesi*: Hartt, *Florentine Art Under Fire*, pp. 80–82.

219 *a water tank*: Franchi, *Arte in assetto di guerra*, p. 50.

220 *the Camposanto*: Enrico Castelnuovo, "Grandezza e decadenza," in Baracchini and Castelnuovo, *Il Camposanto di Pisa*, pp. 3–12.

220 *"The place is neither sad nor solemn"*: Chapman, *Travel-Diaries*, p. 156.

220 *"The best idea"*: *Autobiography of Leigh Hunt*, p. 408.

220 *"All the characters"*: Castelnuovo, "Grandezza," p. 3.

221 *"Briefly"*: John Ruskin, *Praeterita and Dilecta* (New York: Knopf, 2005), p. 310.

221 *"pitiful rags"*: Hartt, *Florentine Art Under Fire*, p. 80.

221 *"grayish shadows"*: Quoted in Franchi, *Arte in assetto di guerra*, p. 88; also, "The Camposanto of Pisa Now," *Burlington Magazine*, Feb. 1945, pp. 35–39.

221 *"No civilian agency"*: Hartt, *Florentine Art Under Fire*, p. 83.

221 *"I have gotten a good deal"*: Keller to his wife, Aug. 26, 1944, Keller Papers.

222 *"a lean-to roof"*: Hartt, *Florentine Art Under Fire*, p. 83.

222 *"Despite his lurid past"*: Keller to Ward-Perkins, Oct. 12, 1944, RG 331, 10 000/145/ 235.

223 *"one of the greatest laboratories"*: Quoted in Franchi, *Arte in assetto di guerra*, p. 98; "Camposanto of Pisa Now," p. 39.

223 *"Up to ears in work"*: Keller to his wife, Sept. 26, 1944, Keller Papers.

223 *"as dry as a 15th century tibia"*: Keller to Ward-Perkins, Oct. 12, 1944, RG 331, 10 000/ 145/235.

223 *"This is the biggest job"*: Keller to his wife, Oct. 9, 1944, Keller Papers.

224 *Poggio a Caiano*: Hartt, *Florentine Art Under Fire*, pp. 68–70; "Resoconto dell'opera svolta nei sotterranei della villa medicea dal 30/7 al 10/9/44," Poggi Papers; also, Florentine Works of Art Stolen by the Germans, Report on Conditions in Liberated Italy, Oct. 26, 1944, RG 165, 000.4, sec. 5; Frederick Hartt, Report on Deposits of Works of Art, Aug. 22, 1944, WO 204/2988.

225 *Leopold Reidemeister*: Jonathan Petropoulos, *The Faustian Bargain* (Oxford, U.K.: Oxford University Press, 2000), p. 332, n. 257.

225 *"Here's what they stole"*: Hartt to De Wald, Sept. 7, 1944, RG 331, 10 000/145/71.

225 *Bacchus*: Umberto Baldini, *Michelangelo scultore* (Milan: Rizzoli, 1973), p. 91.

226 *"a fact long known"*: Report, Aug. 1945, De Wald Papers.

226 *Poppi*: Hartt, *Florentine Art Under Fire*, pp. 72–73.

Chapter Ten: Alpine Loot

229 *"I need to inform you"*: Poggi to Anti, July 20, 1944, Poggi Papers.

230 *"A partisan from Bologna"*: Fasola to Hartt, Nov. 20, 1944, Hartt Papers.

230 *He instructed Pietro Zampetti*: Subcommission for Monuments, Fine Arts, and Archives, Report on the German Kunstschutz in Italy Between 1943 and 1945, June 30, 1945, RG 239/ M 1944, roll 71; Carlo Anti, Report on Removal of Works of Art from Tuscany to Bolzano, June 23, 1945, RG 331, 10 000/145/18; Pietro Zampetti, Relazione sull'attività svolta per salvaguardare il patrimonio artistico dai pericoli della guerra, May 9, 1945, RG 239/ M 1944, roll 75.

230 *"They inform me"*: Anti to Langsdorff, Aug. 25, 1944, Archivio Siviero.

231 *"uncrowned king"*: MFAA Kunstschutz Report.

231 *Ringler*: Hartt, *Florentine Art Under Fire*, p. 98.

231 *ended up there by mistake*: Anti to Langsdorff, Aug. 25, 1944, Archivio Siviero.

231 *"from high up"*: Langsdorff to Anti, Sept. 15, 1944, Ward-Perkins Papers.

232 *Bologna*: Arcangeli to Poggi, May 8, 1945, Poggi Papers.

233 *"a successful result"*: Anti to Langsdorff, Sept. 2, 1944; Langsdorff to Anti, Sept. 15, 1944, Ward-Perkins Papers; MFAA Kunstschutz Report.

233 *ambassador Rudolf Rahn*: MFAA Kunstschutz Report; Mazzoni to Rahn, Sept. 20, 1944, Ward-Perkins Papers.

233 *Vatican's help*: Hartt, *Florentine Art Under Fire*, p. 96; Montini to Dalla Costa, note, Nov. 15, 1944, Poggi Papers.

234 *"This was all very nice"*: Anti, Report on Removal.

234 *Woolley, in London*: Minutes of the meeting of the Macmillan Committee, London, Nov. 7, 1944, T 209 2.

234 *"From reports reaching us"*: Dulles, *Secret Surrender*, p. 28.

235 *"honest personnel"*: MFAA Kunstschutz Report.

235 *a keen interest in the Italians?*: Ibid.

235 *a little editing*: Alexander Langsdorff, filing report, Dec. 2, 1944, Ward-Perkins Papers.

236 *Fascist Radio broadcast*: "Works of Art Preserved," Fascist Radio, Dec. 11, 1944, Poggi Papers.

236 *his real anxiety*: Anti to Langsdorff, Dec. 12, 1944, Archivio Siviero.

236 *Ringler's long testimony*: Dr. Josef Ringler, Report on the Removal of Works of Art Belonging to the Italian State from Tuscany to the Alto Adige and Their Safe-Keeping by the Protector of Monuments in the Operational Area, n.d., Ward-Perkins Papers.

237 *Douglas Cooper*: Peter Harclerode and Brendan Pittaway, *The Lost Masters: World War II and the Looting of Europe's Treasurehouses* (New York: Welcome Rain Publishers, 1999), p. 80.

238 *letter to Himmler*: Policy instruction from Hitler to Himmler via Reichsleiter Bormann, Jan. 26, 1945, Ward-Perkins Papers.

238 *an order from SS commander Himmler*: MFAA Kunstschutz Report.

238 *Altaussee*: Howe, *Salt Mines and Castles*, pp. 144–55.

239 *"A.H., Linz"*: Flanner, *Men and Monuments*, pp. 231–35.

239 *"the Nazis had an adolescent passion"*: Ibid., p. 243.

239 *a surprise visit to Neumelans*: Ringler Report.

240 *"credentials"*: Dulles, *Secret Surrender*, p. 93.

240 *"Entered Bologna"*: Keller Report, April 26, 1945, Keller Papers.

240 *"Within twenty-four hours"*: Linklater, *Campaign in Italy*, p. 451.

241 *"I wish I were several people"*: Keller to his wife, April 27, 1945, Keller Papers.

241 *"The people look different"*: Keller to his wife, June 11, 1945, Keller Papers.

242 *"Situation very bad"*: Keller Report, May 3, 1945, Keller Papers.

242 *"escaped damage"*: Cott to Charles Sawyer, June 11, 1945, RG 239/ M 1944, roll 11.

243 *"With Liguria"*: Enthoven to Ward-Perkins, Sept. 15, 1945, RG 331, 10 000/145/232.

243 *"I have finished restoring"*: Barbacci to Pinsent, May 31, 1955, Pinsent Archive, Chloe Morton family.

244 *the exact location of the art deposits*: Anti, Report on Removal.

244 *made good on his word*: Dulles, *Secret Surrender*, p. 184.

244 *the OSS*: OSS to Allied command, telegram, May 3, 1945, Ward-Perkins Papers.

244 *Ferdinando Forlati*: Forlati Report from Alto Adige, May 11, 1945, Ward-Perkins Papers.

244 *"All is in order"*: Pietro Ferraro, "La resistenza veneta in difesa delle opere d'arte," *Il Ponte*, Jan. 1954, pp. 127–32.

245 *"They were everywhere"*: Keller to his wife, May 15, 1945, Keller Papers.

245 *"We began to wonder"*: Hartt, *Florentine Art Under Fire*, p. 103.

245 *"their arrogance was still magnificent"*: Ibid., pp. 105–106.

245 *at Blevio, on Lake Garda*: Deane Keller, Report on Ludwig H. Heydenreich, May 13, 1945, Keller Papers.

245 *"the second top man"*: Keller to his wife, May 12, 1945, Keller Papers.

246 *Heydenreich did not seem to believe*: Heydenreich to Poggi, May 6, 1945, Poggi Papers.

246 *"that uniquely Italian thing"*: Marcello Barbanera, conversation with the author, Rome, July 2004.

246 *the man the monuments officers wanted*: De Wald to Ward-Perkins, June 9, 1945, RG 331, 10 000/145/225.

246 *"a man with a divided soul"*: MFAA Kunstschutz Report.

246 *"salvaging operations"*: Alexander Langsdorff, Report on the Salvaging of Works of Art from the Area of Florence in July and Aug. 1944, May 11, 1945, Poggi Papers.

246 *Dicomano*: Leopold Reidemeister, "Salvaging Trips from the Battlefield," n.d., Poggi Papers.

247 *Oliveto*: Hartt, *Florentine Art Under Fire*, p. 32–34.

247 *very fond of Cranach*: Howe, *Salt Mines and Castles*, p. 182.

248 *"to go and remove"*: MFAA Kunstschutz Report.

248 *Poggio a Caiano*: Ibid.; Langsdorff, Report on the Salvaging; Reidemeister Report; Hartt, *Florentine Art Under Fire*, pp. 68–70.

249 *to blow up the site*: Howe, *Salt Mines and Castles*, pp. 154–56.

249 *"many hundreds"*: Hartt, *Florentine Art Under Fire*, pp. 100–101.

249 *Spitzweg*: Howe, *Salt Mines and Castles*, p. 78.

250 *"a pathetically weak person"*: Norman Newton, interview with Carlo Anti, June 21, 1945, RG 331, 10 000/145/11.

250 *Anti's defense*: Letter signed by Forlati, Brusin, and Moschini, June 1945, RG 331, 10 000/145/11.

251 *A snapshot*: Keller Papers.

251 *Hartt credited Keller*: Hartt, *Florentine Art Under Fire*, pp. 106–107.

251 *"Remember how crowded"*: Keller to Sutherland, memo, May 16, 1945, Keller Papers.

251 *"All but one of the pictures"*: Keller to De Wald, memo, June 27, 1945, RG 331, 10 000/145/235.

252 *"we merely jackassed"*: Bernholz to Keller, n.d., Keller Papers.

252 *forest of Camaldoli*: Hartt, *Florentine Art Under Fire*, pp. 93–94, 109.

253 *In Hartt's telling*: Ibid., pp. 108–10.

253 *"Blessed Relief"*: Keller to his wife, July 26, 1945, Keller Papers.

253 *"I fell in love with Florence"*: Hartt to Berenson, April 6, 1946, Berenson Archive.

Epilogue: A Necessary Dream

254 *"Peace, it's wonderful"*: Hartt to Berenson, Sept. 5, 1945, Berenson Archive.

254 *"awfully dull, after Italy"*: Hartt to Berenson, Oct. 14, 1945, Berenson Archive.

255 *"Anyone who writes"*: Matthews, "Italian Art Under Shellfire," pp. 559–68.

255 *two years' hard work in Italy*: MFAA Final Report, Jan. 1, 1946, Frances Loeb Library, Harvard Design School.

257 *Pasquale Rotondi's offer*: Giannella and Mandelli, *L'arca dell'arte*, p. 138.

258 *"We were not so noble"*: Myra Tolchin, "Yale Portraitist Helped Save Art Looted by Nazis," *New Haven Register*, July 16, 1978.

258 *"if perchance you get bored"*: De Wald to Newton, Nov. 10, 1945, RG 331, 10 000/145/227.

259 *a beautiful Byzantine icon*: *Weekly Bulletin*, July 7, 1945, De Wald Papers.

259 *"We must begin with Italian children"*: Keller to Ward-Perkins, Oct. 12, 1944, Keller Papers.

259 *"Funny"*: Keller to his wife, July 2, 1945, Keller Papers.

260 *Berchtesgaden*: Flanner, *Men and Monuments*, pp. 242–90.

260 *the* Kammergrafen: Howe, *Salt Mines and Castles*, pp. 150–53.

260 *"Did we have this?"*: De Wald to Ward-Perkins, Aug. 23, 1945, RG 331, 10 000/145/226.

261 *"sharp twinges of nostalgia"*: De Wald to Berenson, Jan. 7, 1947, Berenson Archive.

261 *archaeological walks*: *Times* (London), obituary, June 5, 1981.

261 *"A long spell"*: Pinsent to Berenson, Feb. 14, 1947, Berenson Archive.

261 *"The flash of conviction"*: Pinsent to Berenson, Jan. 17, 1947, Berenson Archive.

261 *"had carried Cosimo"*: Simon Enthoven, conversation with the author, London, Dec. 2003.

261 *"over-privileged military occupation"*: Basil Marriott, "Veneto Rivisto," *Builder*, Aug. 30, 1963.

262 *"you should have seen it then"*: Hartt Papers.

SELECT BIBLIOGRAPHY

Unpublished Sources

Archivio della Soprintendenza per i Beni Archeologici di Napoli e Caserta, Naples

Archivio Siviero, Rome

Baroni, Nello, "Diario dei Cinquemila," Nello Baroni Papers, Archivio di Stato, Florence

Berenson Archive, Harvard Center for Italian Renaissance Studies, Florence

Kenneth Clark Papers, Tate Archive, London

Ernest De Wald Papers, Department of Rare Books and Special Collections, Princeton University Library

Direzione Generale Antichità e Belle Arti, Divisione II, 1940–1945, Archivio Centrale dello Stato, Rome

Giulia Guicciardini, "La campana degli smarriti, 1944–1945," Guicciardini Archive, Poppiano (Montespertoli), Florence

Frederick Hartt Papers, Archives of the National Gallery of Art, Washington, D.C.

Hilary Jenkinson Papers, Public Record Office, National Archives, London

Deane Keller Papers, Department of Manuscripts and Archives, Yale University Library

Pennoyer Archives, Department of Art and Archaeology, Princeton University

Giovanni Poggi Papers, Soprintendenza per i Beni Artistici e Culturali, Florence

Record Group 165, Civil Affairs Division, National Archives, College Park, Md.

Record Group 239, Records of the American Commission for the Protection and Salvage of Artistic and Historic Monuments in War Areas, National Archives, College Park, Md.

Record Group 331, Records of the Allied Control Commission (Italy), 1943–1947, National Archives, College Park, Md.

T 209, British Committee on the Preservation and Restitution of Works of Art, Archives, and Other Material in Enemy Hands (Macmillan Committee), 1943–1947, Public Record Office, National Archives, London

John Ward-Perkins Papers, British School at Rome

WO 139-751, Operations in Italy, September 1943–May 1945, Public Record Office, National Archives, London

WO 204-1908, Lessons from Operations in Italy, May 1944–November 1945, Public Record Office, National Archives, London

Books

Alabiso, Anna Chiara, ed. *La "Danae" di Tiziano.* Naples: Electa, 2005.

Alexander of Tunis. *The Alexander Memoirs, 1940–1945.* New York: McGraw-Hill, 1962.

Astarita, Tommaso. *Between Salt Water and Holy Water: A History of Southern Italy.* New York: W. W. Norton, 2005.

Baracchini, Clara, and Enrico Castelnuovo, eds. *Il Camposanto di Pisa.* Turin: Einaudi, 1996.

Barbanera, Marcello. *L'archeologia degli italiani.* Rome: Editori Riuniti, 1998.

———. *Ranuccio Bianchi Bandinelli: Biografia ed epistolario di un grande archeologo.* Milan: Skira, 2003.

Bargellini, Piero. *Cento tabernacoli a Firenze.* Florence, 1971.

———. *This Is Florence.* Florence: Sansoni, 1977.

Beevor, Kinta. *A Tuscan Childhood.* London: Viking, 1993.

Berenson, Bernard. *Rumor and Reflection.* New York: Simon & Schuster, 1952.

Boi, Maria Marta. *Guerra e beni culturali, 1940–1945.* Pisa: Giardini, 1986.

Bucarelli, Palma. *1944: Cronaca di sei mesi.* Rome: De Luca, 1997.

Burmeister, Joachim, Barbara Deimling, and Alick McLean, eds. *The House of Gigliucci in Florence at Villa Romana and Villa Rossa.* Florence: Edizioni Salone Villa Romana, 1999.

Capretti, Elena. *Michelangelo.* Florence: Giunti, 2006.

Carniani, Mario, and Paolo Paoletti. *Firenze, guerra & alluvione.* Florence: Becocci, 1991.

Casoni, Gaetano. *Diario fiorentino: Giugno–agosto 1944.* Florence: Civelli, 1946.

Cecchi, Alessandro. *Botticelli.* Milan: Motta, 2005.

Cesati, Franco. *Guida insolita ai misteri, ai segreti, alle leggende e alle curiosità di Firenze.* Rome: Newton Compton, 1999.

———. *I Medici: Storia di una dinastia europea.* Florence: La Mandragora, 1999.

———. *Le piazze di Firenze: Storia, arte, folclore e personaggi.* Rome: Newton Compton, 1995.

———. *Le strade di Firenze.* Rome: Newton Compton, 1994.

Ceschi, Carlo. *I monumenti della Liguria e la guerra, 1940–1945.* Genoa: AGIS, 1949.

Churchill, Winston. *The Second World War.* vol. 5: *Closing the Ring.* Boston: Houghton Mifflin, 1951.

Clark, Mark. *Calculated Risk.* New York: Harper, 1950.

Coles, H. L., and A. K. Weinberg. *Civil Affairs: Soldiers Become Governors.* Washington, D.C.: Office of the Chief of Military History, Department of the Army, 1964.

Corsini, Diletta. *Paolo Uccello: La battaglia di San Romano.* Florence: Giunti, 1998.

de' Giorgi, Elsa. *L' eredità Contini Bonacossi.* Milan: Mondadori, 1988.

De Marco, Paolo. *Polvere di piselli.* Naples: Liguori, 1996.

Direzione Generale per le Antichità e Belle Arti. *La protezioine del patrimonio artistico nazionale dalle offese della guerra aerea.* Florence: Le Monnier, 1942.

Duggan, Christopher. *A Concise History of Italy*. Cambridge, U.K.: Cambridge University Press, 2002.

Dulles, Allen. *The Secret Surrender*. New York: Harper & Row, 1966.

Dunn, Richard M. *Geoffrey Scott and the Berenson Circle: Literary and Aesthetic Life in the Early 20th Century*. Lewiston, N.Y.: Edwin Mellen Press, 1998.

Edsel, Robert. *Rescuing Da Vinci*. Dallas: Laurel, 2006.

Fantoni, Marcello, Heidi Flores, and John Pfordresher, eds. *Cecil Pinsent and His Gardens in Tuscany: Papers from the Symposium, Georgetown University, Villa Le Balze, 22 June 1995*. Florence: Edifir, 1996.

Farmer, Walter. *The Safekeepers: A Memoir of the Arts at the End of World War II*. Berlin, Walter de Gruyter, 2000.

Fasola, Cesare. *The Florence Galleries and the War*. Florence: Monsalvato, 1945.

Fielden, Lionel. *The Natural Bent*. London: André Deutsch, 1960.

Flanner, Janet. *Men and Monuments*. New York: Harper, 1957.

Forman, Denis. *To Reason Why*. London: André Deutsch, 1991.

Franchi, Elena. *Arte in assetto di guerra*. Pisa: ETS, 2006.

Gardner, Paul, and Bruno Molajoli. *Per i monumenti d'arte danneggiati dalla guerra nella Campania*. Naples, 1944.

Garibaldi, Luciano. *Mussolini e il professore: Vita e diari di Carlo Alberto Biggini*. Milan: Mursia, 1983.

Giannella, Salvatore, and Pier Damiano Mandelli. *L'arca dell'arte*. Milan: Delfi, 1999.

Guiotto, Mario. *I monumenti della Sicilia occidentale danneggiati dalla guerra: protezioni, danni, opere di pronto intervento*. Palermo: Soprintendenza ai Monumenti di Palermo, 1946.

Haas, Günther. *Kunstraub und Kunstschutz, eine Dokumentation*. Hildesheim: Georg Olms, 1991.

Hamilton, Olive. *Paradise of Exiles: Tuscany and the British*. London: André Deutsch, 1974.

Hapgood, David, and David Richardson. *Monte Cassino*. New York: Congdon & Weed, 1984.

Harris, C. R. S. *Allied Military Administration of Italy, 1943–1945*. London: HMSO, 1957.

Hartt, Frederick. *Florentine Art Under Fire*. Princeton, N.J.: Princeton University Press, 1949.

———. *Michelangelo*. New York: Abrams, 1964.

Hibbert, Christopher. *Florence: The Biography of a City*. New York: W. W. Norton, 1993.

Howe, Thomas. *Salt Mines and Castles*. New York: Bobbs-Merrill, 1946.

James, Henry. *Italian Hours*. Boston: Houghton Mifflin, 1909.

Katz, Robert. *The Battle for Rome*. New York: Simon & Schuster, 2003.

Kesselring, Albert. *A Soldier's Record*. New York: William Morrow, 1954.

Knox, Katherine McCook. *The Story of the Frick Art Reference Library: The Early Years*. New York: The Library, 1979.

La Farge, Henry, ed. *Lost Treasures of Europe*. New York: Pantheon, 1946.

Lamb, Richard. *The War in Italy, 1943–1945: A Brutal Story*. London: John Murray, 1993.

Lambiase, Sergio, and G. Battista Nazzaro. *L'odore della guerra: Napoli, 1940–1945*. Milan: Longanesi, 1978.

Lambourne, Nicola. *War Damage in Western Europe: The Destruction of Historic Monuments During the Second World War*. Edinburgh: Edinburgh University Press, 2001.

Lavagnino, Alessandra. *Le bibliotecarie di Alessandria.* Palermo: Sellerio, 2002.

———. *Un inverno, 1943–1944.* Palermo: Sellerio, 2006.

Lavagnino, Emilio. *Cinquanta monumenti danneggiati dalla guerra.* Rome: Associazione Nazionale per il Restauro dei Monumenti Italiani Danneggiati dalla Guerra, 1947.

Lewis, Norman. *Naples '44.* London: Collins, 1978.

Lewis, R. W. B. *The City of Florence: Historical Vistas and Personal Sightings.* New York: Farrar, Straus and Giroux, 1995.

Linklater, Eric. *The Art of Adventure.* London: Macmillan, 1948.

———. *The Campaign in Italy.* London: HMSO, 1951.

Mack Smith, Denis. *Italy and Its Monarchy.* New Haven, Conn.: Yale University Press, 1989.

———. *Mussolini.* New York: Knopf, 1982.

Maiuri, Amedeo. *Taccuino napoletano, giugno 1940–luglio 1944.* Naples: Vairo, 1956.

Mandel, Gabriele, ed. *Botticelli.* Milan: Rizzoli, 1967.

Mariano, Nicky. *Forty Years with Berenson.* New York: Knopf, 1966.

McCarthy, Mary. *The Stones of Florence.* New York: Harcourt, Brace, 1959.

Mercanti, Lara, and Giovanni Straffi. *Le torri di Firenze e del suo territorio.* Florence: Alinea, 2003.

Molajoli, Bruno. *Musei ed opere d'arte di Napoli attraverso la guerra.* Naples: Soprintendenza alle Gallerie, 1948.

Moorehead, Alan. *Eclipse.* London: Hamish Hamilton, 1946.

Moorehead, Caroline. *Iris Origo: Marchesa of Val d'Orcia.* London: John Murray, 2000.

Nicholas, Lynn. *The Rape of Europa: The Fate of Europe's Treasures in the Third Reich and the Second World War.* New York: Knopf, 1994.

Origo, Iris. *War in Val d'Orcia.* Boston: David R. Godine, 1948.

Osmond, Patricia J., ed. *Revisiting the Gamberaia: An Anthology of Essays.* Florence: Centro DI, 2004.

Paoletti, Paolo. *Il Ponte a Santa Trinita.* Florence: Becocci, 1987.

Pestelli, Andrea. *The Castle of Montegufoni.* Florence: Il Fiorino, 2002.

Petrescu-Comnène, Nicolae. *Firenze, "città aperta."* Florence: Vallecchi, 1945.

Pond, Hugh. *Sicily.* London: W. Kimber, 1962.

Pozzana, Mariachiara. *Gardens of Florence and Tuscany: A Complete Guide.* Florence: Giunti, 2001.

Report of the American Commission for the Protection and Salvage of Artistic and Historic Monuments in War Areas. Washington, D.C., 1946.

Ridley, Jasper. *Mussolini: A Biography.* New York: St. Martin's, 1998.

Rocca, Gianni. *L'Italia invasa, 1943–1945.* Milan: Mondadori, 1998.

Romagnoli, Anna Maria. *Le storie del secolo d'oro.* Milan: Mursia, 1966.

Rorimer, James. *Survival: The Salvage and Protection of Art in War.* New York: Abelard, 1950.

Simpson, Elizabeth, ed. *The Spoils of War: World War II and Its Aftermath: The Loss, Reappearance, and Recovery of Cultural Property.* New York: Abrams, 1997.

Sitwell, Osbert. *Great Morning!* Boston: Little, Brown, 1947.

Sprigge, Sylvia. *Berenson: A Biography.* Boston: Houghton Mifflin, 1960.

Steinhauslin, Carlo. "Che cosa ho fatto per Firenze?" In *Banca C. Steinhauslin & C., 1868–1968: Cento anni di attività.* Florence: Olschki, 1968.

Tamassia, Marilena, ed. *Firenze 1944–1945: danni di guerra.* Livorno: Sillabe, 2007.

Tregaskis, Richard. *Invasion Diary.* New York: Random House, 1944.

Tutaev, David. *The Man Who Saved Florence.* New York: Coward-McCann, 1966.

Vannucci, Marcello. *L'avventura degli stranieri in Toscana.* Aosta: Musumeci, 1981.

War's Toll of Italian Art: An Exhibition Sponsored by the American Committee for the Restoration of Italian Monuments, 1947.

Weaver, William. *A Legacy of Excellence: The Story of Villa I Tatti.* New York: Abrams, 1997.

Wheeler, Mortimer. *Still Digging.* New York: Dutton, 1956.

Winstone, H. V. F. *Woolley of Ur: The Life of Sir Leonard Woolley.* London: Secker & Warburg, 1990.

Woolley, Leonard. *As I Seem to Remember.* London: Allen, 1962.

———. *A Record of the Work Done by the Military Authorities for the Protection of the Treasures of Art and History in War Areas.* London: HSO, 1947.

———. *Works of Art in Italy: Losses and Survivals in the War.* 2 vols. London: HMSO, 1945.

Articles

"La battaglia di Firenze." *Il Ponte,* Sept. 1954.

Crosby, Sumner. "The Venus Fixers Won Their War Too." *New York Times Magazine,* June 20, 1946.

Hammond, Mason. "Remembrance of Things Past." *Proceedings, Massachusetts Historical Society* 92 (1980).

Klinkhammer, Lutz. "Die Abteilung 'Kunstschutz' der Deutschen Militärverwaltung in Italien 1943–1945." *Quellen und Forschungen aus italienischen Archiven und Bibliotheken,* 1992.

Lamberini, Daniela. "Il Soprintendente e gli Alleati: L'attività di Piero Sanpaolesi alla Soprintendenza di Pisa nel 1944–'46." *Bollettino Storico Pisano* 75 (2006).

Lang, Daniel. "Letter from Florence." *New Yorker,* Sept. 9, 1944.

Lavagnino, Emilio. "Diario di un salvataggio artistico." *La Nuova Antologia,* Aug. 1974.

Linklater, Eric. "Botticelli Among the Mahrattas." *Town & Country,* May 1945.

Matthews, Herbert. "Italian Art Under Shellfire." *Harper's Magazine,* May 1945.

McCartney, Benjamin. "Return to Florence." *National Geographic Magazine* 87, no. 3 (March 1945).

Plaut, James. "Loot for the Master Race." *Atlantic Monthly,* Sept. 1946.

———. "Hitler's Capital." *Atlantic Monthly,* Oct. 1946.

Sizer, Theodore. "A Walpolean at War." *Walpole Society Note Book* (1946).

Vedovato, Giuseppe. "Firenze 'città aperta.'" *San Sebastiano: Periodico della Misericordia di Firenze* 212 (July–Aug. 2002).

ACKNOWLEDGMENTS

The historian seeks to abstract principles from human events. My approach was the other; for the two years that I lived among the documents I sought to reconstruct the human story as best I could.

—V. S. Naipaul, *The Enigma of Arrival*

As an Italian born in Padua ten years after the end of World War II, I grew up hearing stories of the Ovetari Chapel. My favorite remains that of the local artist Paolo De Poli, who with a group of art students rushed to pick up the pieces after the "all clear" and gathered them in boxes fashioned with wood from the smashed pews; for weeks, De Poli walked around the site armed with a gun to prevent looting, a measure of which, according to legend, occurred nonetheless. Italy in the fifties and sixties was peaceful, hopeful, and going through an economic boom that, unfortunately, remains the only one I've experienced to date. The sad story of the Ovetari's destruction seemed locked in a past that felt remote as the Barbarian invasions. The chapel walls were bare, except for the three scenes that had been detached for restoration before the war and were now the only survivors. Many years later, and by then a journalist, I picked up *Monte Cassino*, by David Hapgood and David Richardson, from the library of Iris Origo at La Foce. Reading the full account of that tragic chapter of the Italian campaign stirred my curiosity to find out what exactly happened on March 11, 1944, in Padua and why the Ovetari was destroyed. As I delved into my research, I discovered that the Allies had set up a commission for the protection of

our monuments, and I first learned of the existence of the monuments offi-cers. I mentioned these men to Domenico Toniolo, a professor of physics at the University of Padua, who was leading an extraordinary virtual restora-tion of Mantegna's shattered frescoes. Intrigued by these art historians and architects who had put their knowledge and their passion at the service of their army to protect our country's art, he thought they would make a very good subject for one or more doctorate theses for the students who were working with him on the Mantegna project. I chose to write about the mon-uments officers myself and am profoundly grateful to Professor Toniolo for sparking the idea of this book. His superb mind, his modesty, and his un-daunted enthusiasm in tackling the disheartening mound of Mantegna's broken shards have been a powerful inspiration for my work. He also told me that the best ideas are those that take long in developing, and that too has been helpful.

Although I cannot pinpoint the moment when my focus shifted from the Ovetari to the monuments officers and their mission in Italy, research for this book took about seven years. I couldn't have done it without help from many friends and family who generously put me up in the various places where it took me: Tommaso Astarita, Francesca Covelli, Gloria Dagnini Messana and Joe Messana Mattravers, Penelope Eckersley, Margie Fries-ner, Alessandra and Ernesto Mazzucato, Nicoletta Polo and Gioacchino Lanza Tomasi, Anna Tarchiani, Rosalind Thomas, and Michael Drolet.

With the exception of Mason Hammond, who passed away in October 2002 at age ninety-nine, all of the Venus Fixers I write about were no longer with us when I started researching this book. I am very grateful to their families, who received me graciously, wrote me beautiful letters, and shared memories and photographs with me: Carol Clark and Charles Parkhurst, Jill Croft-Murray, Simon Enthoven, Ursula Jane Gibson, Elizabeth Ham-mond Llewellyn, Flossie Hammond, Charlotte Ellis, James Ellis, Deane Keller Jr., Eugene Markowski, Jenny Marriott, Victoria Marriott, Chloe Morton, Lyyli Newton, Robert Pennoyer, Nancy Sizer, Christopher Taylor, Richard Taylor, Bryan Ward-Perkins.

I particularly cherish the memory of a conversation I had with Andrea

Emiliani, professor emeritus of art history at the University of Bologna, on a particularly hot day in June 2003. I had learned by then that people of my parents' generation don't usually talk much about the war, which robbed them of a chunk of their youth. Of a slightly younger age, by his own admission Professor Emiliani loves to tell those old stories. Prominent among them is his sighting of a Venus Fixer, on the August 1944 day when Urbino, his hometown, was liberated. Professor Emiliani was fifteen at the time and working as an assistant to the painter Nino Caffè, who kept his studio in the basement of the Ducal Palace. While Caffè was frightened at the thought that these might be German troops returning to town, Emiliani watched from a window as the first Allied armored cars rolled into Urbino and saw an officer who dismounted from his jeep holding a travel guide in his hand. His young and impressionable mind was struck by the image of a man who was going to war wielding a Baedeker. For me, this remains the only first-hand description of a Venus Fixer, as seen through Italian eyes.

In Italy, I received help, advice, and encouragement from Cristina Acidini Luchinat, superintendent of Galleries, Florence; Mariella Utili, director of the Capodimonte Museum; the late professor Umberto Baldini; Antonio Paolucci, former superintendent of Galleries in Florence; and professor Eugenio Riccomini. I owe special thanks to Donna Anna Corsini, Ferdinando and Anna Maria Guicciardini, Giuliana Guicciardini, and Daniela Lamberini. I am thankful to Professor Francesco Adorno, Fiamma Arditi, Daniel Berger, Mario Bondioli Osio, Claudio di Benedetto, and Maria Rosaria De Divitiis. At I Tatti, Eve Borsook, Fiorella Minervi, and Giovanni Pagliarulo. And to: Marcello Barbanera, Roberta Battaglia, Maurizio Bonicatti, Paola Carucci, Remo Casini, Fr. Emilio Contardi, Ferdinando Creta, Stefano Dede, Laura Desideri, Michele Di Girolamo, Don Raffaele Farina, Zeno Forlati, Daulo Foscolo, Giorgio Galletti, Salvatore Giannella, Alessandra Giovenco, Salvatore Italia, Fausto Lamberti, Alessandra Lavagnino, Elena Lombardi, Gaetano Macchiaroli, Mauro Magliani, Francesca Mannelli, Elvia Masti, Roberto Middione, Elena Molajoli, Andrea Monda, Matteo Musacchio, Alessandro Olschki, Benedetta Origo, Massimo and Marina Paramatti, Desideria Pasolini, Niccolò Pasolini, Barbara Piovan, Massimo

Procacci, Graziano Raveggi, Angela Rensi, Stefania Renzetti, Giovanna Rotondi Terminiello, Maria Sframeli, Ilaria Spadolini, Carlo Alberto Steinhauslin, Luca Steinhauslin, Jean Léon Steinhauslin, Mario Tschinke, and Tommaso Wenner.

The preceding and the following are, inevitably, a long list of names; yet I would like to record that behind the names there are many individual stories that lightened the strenuousness of the research and turned it into a unique human experience: an old bookseller who helped me nimbly to negotiate the many hurdles of Neapolitan bureaucracy, or a librarian who skipped her lunch so that I could continue working; an architect who trespassed on a cordoned-off church to check on the exact location of a statue for me, thus incurring the initial wrath—later turned into sympathy—of a restorer, or an archivist who called me in the middle of a general transportation strike in London to tell me that he was waiting for me, no matter how late I would show up.

In the United States, Shari Kenfield (Princeton University, Department of Art and Archaeology), Ann Ritchie (Archives of the National Gallery of Art, Washington, D.C.), and Mary Daniels (Harvard University, Graduate School of Design) were unstintingly supportive. I am also grateful to Professor James Ackerman, Paul Barolsky, Francesca Bewer, Margaret Black, Sally Brazil, Paul Brown, Susan Chore, the late professor David Coffin, Becky Collier, the late Craig Hugh Smyth, Christopher Cwynar, Yasmine Ergas, Steve Flanders, Robyn Fleming, Russell Flinchum, Nancy Green, Rick Henderson, Diane Kelder, Anna Lee Pauls, Jordan Love, James McKean, Lisa Messenger, General Indar Rikhye, Deborah Roldàn, Theresa Roy, Constance Sayre, George Sheehan, Georgiana Silk, Michael Vitale, Elizabeth Wilson, and George Xillas. In England, I was assisted and advised by Philip Abbott, Professor Roger Absalom, David Beasley, Andrea Gilbert, Stuart Hood, Peter Jenkins, Bernard Nurse, Agnes Selby, Anne Sproat, Laura Warren, and Victor Winstone.

I am grateful to Ruth Ben Ghiat, professor of history and Italian studies at New York University, for reading the manuscript and checking it for historical accuracy; to my friends Federica Anichini, Cornelia Bessie, Mel

Brey, Susanna Carollo, Timothy Eckersley, and Alessandro Pasetti Medin for reading it in its various stages, and for their comments; and to three books that were an inspiration for mine: Lynn Nicholas's *The Rape of Europa*, Anna Maria Romagnoli's *Le storie del secolo d'oro*, and Frederick Hartt's *Florentine Art Under Fire*.

I would like to acknowledge my friends for their support and patience during these years: Stefano Albertini, Gini Alhadeff, Alessandra Baldini, George Black, Dorothy Cesar, Sandy Gilbert, Daniela Giussani, Gege Marogna, Michaelyn Mitchell, Anne Nelson, Margaret Poser, Natalia Rancati, Stephanie Solomon, Adele Ursone. My thoughts also go to some friends who saw the beginning of this book but not its publication: Alfredo De Marzio, Julio Parrado, Elena Piccolomini, Raffaella Piva, Penny Proddow, and Paolo Tarchiani.

I thank my agent, David Kuhn, for embracing this project when it was a one-page-long proposal and for trusting my capacity to pull it off; and I thank Anne Edgar for introducing me to David. My editor, Courtney Hodell, licked this book into shape like the mother bear of the old Roman legend: fiercely critical but always kind, almost impossibly demanding but tirelessly supportive, she was the ideal coach who dragged me through the finish line of this marathon-like effort. Any factual mistake, lapse of taste, or infelicity of style is entirely my own.

Writing this book would not have been possible without the love and support of my family: my mother and sister, my husband and my two children, and my mother-in-law. My father passed away three years ago and thoughts of him have accompanied me as I wrote the book: whether it has any merit or not, he would have been proud.

INDEX